THE FRICK COLLECTION

VOLUME VII · PORCELAINS

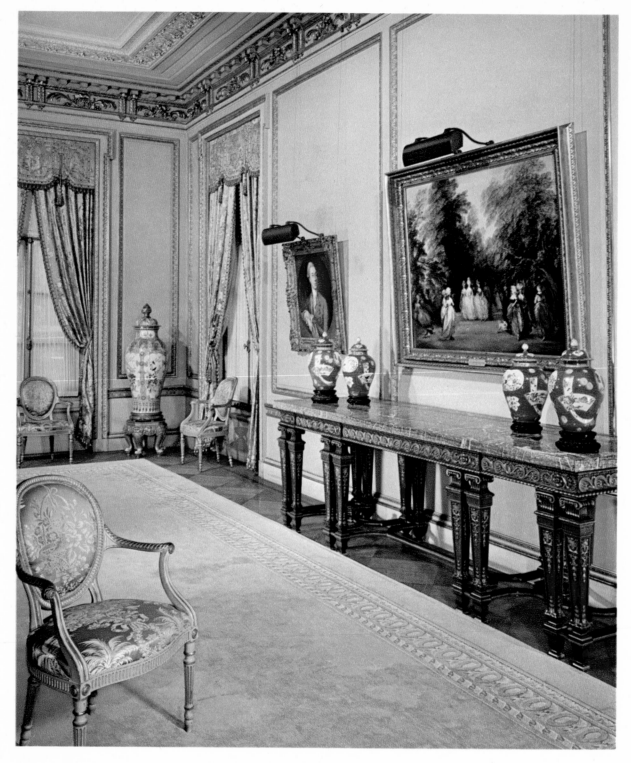

DINING ROOM · THE FRICK COLLECTION

THE
FRICK COLLECTION

AN ILLUSTRATED CATALOGUE

VOLUME VII · PORCELAINS

Oriental and French

THE FRICK COLLECTION · NEW YORK · 1974

DISTRIBUTED BY PRINCETON UNIVERSITY PRESS

JOHN A. POPE

—

ORIENTAL PORCELAINS

MARCELLE BRUNET

Translated by Joseph Focarino

—

FRENCH POTTERY AND PORCELAINS

TABLE OF CONTENTS

ORIENTAL PORCELAINS

JOHN A. POPE

FAMILLE ROSE

FRENCH POTTERY AND PORCELAINS

MARCELLE BRUNET

CONCORDANCE

PREFACE

The present volume of *The Frick Collection: An Illustrated Catalogue* advances the project of a new, complete catalogue of the works of art in The Frick Collection initiated by Franklin M. Biebel, the Collection's second Director, with the first four volumes brought to publication by his successor, the late Harry D. M. Grier. As with previous volumes in the series, this one is indebted to the folio catalogue published by Miss Helen C. Frick in memory of her father, *An Illustrated Catalogue of the Works of Art in the Collection of Henry Clay Frick,* and specifically to the texts of Walter Read Hovey included in Volume VIII, issued in 1955.

When Mr. Frick began to enlarge the scope of his collection after concentrating primarily on paintings, it was natural that he should have acquired porcelains as well as furniture and other examples of the decorative arts for the residence he had built in 1913–14. His group of Oriental porcelains recalls the widespread enthusiasm for such objects in the late nineteenth century, not only on the part of artists Mr. Frick especially admired, such as Whistler, but also among the founder's peers—Freer, Altman, Salting, Widener, Morgan—who continued with him the tradition of great European collectors of earlier periods. Mr. Frick's Oriental porcelains, purchased largely from the estate of J. Pierpont Morgan, enhance the Collection in the same manner as the other art forms that captured Mr. Frick's interest in the last years of his collecting. Similarly, the Sèvres porcelains, most of which were acquired in 1916 and 1918, are the natural historical and visual complements to the French eighteenth-century paintings and furniture that Mr. Frick added to his collection during the same period, including Fragonard's *The Progress of Love,* purchased in 1915, and Boucher's *The Four Seasons* and *The Arts and Sciences,* both series acquired in 1916. The fact that Madame de Pompadour was a principal patron both of Boucher and of the Sèvres manufactory is of interest in relation to their juxtaposition here.

Certain of the Sèvres porcelains were bequeathed by Mr. Frick to his widow and reentered The Frick Collection in 1934 as the generous gift of Miss Helen C. Frick, along with porcelains she herself had acquired. In 1965 the range of

Oriental porcelains was extended by a bequest from Childs Frick, the founder's son, of the blue-and-white porcelains he and his wife had collected over many years. A select number of these are included in the present volume.

The Collection was fortunate in being able to engage as authors for this volume of the quarto catalogue outstanding scholars in the fields of Oriental and French porcelain. John A. Pope, who prepared the text concerning the Oriental pieces, retired in 1971 as Director of the Freer Gallery of Art in Washington and has subsequently been named Far Eastern Adviser to the Virginia Museum of Fine Arts, Richmond. His publications and lectures have established Mr. Pope's reputation internationally.

Marcelle Brunet, who prepared the entries dealing with the Vincennes and Sèvres porcelains and the Saint-Porchaire ewer, was formerly Librarian and Archivist of the Manufacture Nationale de Sèvres. Her familiarity with the factory's historical collections enabled her to include in this catalogue archival material never before published. Mademoiselle Brunet's contributions to the study of French porcelains include numerous articles as well as the authoritative *Les Marques de Sèvres,* the most complete work on this subject to date.

Colleagues of the authors and of the Collection staff who so generously assisted in the preparation of this catalogue are acknowledged within the entries. In addition to all the others who facilitated her work in various ways, Mademoiselle Brunet wishes to extend here her thanks to Serge Gauthier, Director of the Manufacture Nationale de Sèvres, and Henry-Pierre Fourest, Chief Curator of the Musée National de Céramique de Sèvres. The Frick Collection also takes this opportunity to express its special appreciation to Carl Dauterman, Curator Emeritus of Western European Arts at the Metropolitan Museum of Art, New York, who for many years has aided us with advice and documentation in the field of French porcelain.

This volume was produced at a time when the members of the Collection staff were burdened with unusually heavy responsibilities. It is a pleasure to acknowledge here their unfailing cooperation. In working with the authors, photographers, and printers, Bernice Davidson, Research Curator, has continued the valuable role she assumed in the production of the original volumes of this catalogue. Once again Joseph Focarino has skillfully edited the text and coordinated its special features with other volumes of the catalogue. In addition

Mr. Focarino assumed the delicate burden of translating, to the author's full satisfaction, Mademoiselle Brunet's entries. David Monroe Collins, Business Administrator, was as always generous with wise counsel and careful supervision of the complex matters relating to production of the catalogue. Peter O'Sullivan capably and imaginatively dealt with the challenging problems of both color and black-and-white photography; all the photographs reproduced are his except for certain of the Oriental porcelains taken by Francis Beaton and Raymond A. Schwartz and for the view of the Boucher Room by Lionel Freedman. Rostislav and Svetoslao Hlopoff provided valuable assistance in the restoration and study of many of the objects published in this volume. All members of the Collection staff have, in fact, contributed in one way or another to this catalogue, and their devoted daily services are warmly acknowledged. The Trustees, through the interest of their Publications Committee, have continued their encouragement of this scholarly undertaking.

EDGAR MUNHALL
CURATOR
THE FRICK COLLECTION

EXPLANATORY NOTE

A few remarks may be useful regarding the methods of presentation within each entry of this catalogue.

TITLES: In the absence of traditional titles, all the porcelains have been given descriptive titles based on their form and decoration. In the case of the Vincennes and Sèvres porcelains, most of which bear date-letters, the year of manufacture has been added at the end of the title.

MEDIUM, DIMENSIONS, AND MARKS: Because of their special nature, the Vincennes and Sèvres soft-paste porcelains are identified as such immediately below the title; the Oriental pieces are of traditional composition except where indicated. The heights of the pieces—abbreviated H.—are those of the porcelains alone, and in no instances include the metal or wooden stands on which many of them are now exhibited. The abbreviation D. indicates diameter when applied to objects that are circular in plan, and depth when referring to items of rectangular, oval, or other forms. The abbreviation W. indicates width, which is used here as interchangeable with length. All incised and painted marks are reproduced except in cases where identical marks appear on two or more pieces in the same group.

DESCRIPTION: In all descriptions, right and left refer to the spectator's right and left unless otherwise indicated.

CONDITION: In general, the breaks mentioned in the condition reports have been repaired unless otherwise specified, while most routine wear, including scratches, small chips, and abrasion, has been left untouched. A number of the Oriental porcelains have at some time been partially overpainted to conceal various damages, and where extensive damage is mentioned in the reports it can usually be assumed that the pieces have been locally retouched.

EXHIBITIONS AND COLLECTIONS: References to exhibitions and provenance are taken for the most part from purchase records and inventories and from the 1955 folio catalogue, *An Illustrated Catalogue of the Works of Art in the Collection of Henry Clay Frick*. In some cases it has been possible to verify these references through photographs and descriptions in the catalogues of the collections of James A. Garland, who owned many of the Oriental pieces, and J. Pierpont Morgan, who bought the Garland collection through Duveen in 1902 and incorporated it within his much larger collection. Both of these collections were exhibited over a number of years at the Metropolitan Museum of Art, New York; for convenience, the years given for those exhibitions are generally abbreviated to the publication dates of the respective catalogues—1895 for the Garland collection and 1907 for the Morgan Oriental porcelains. Additional information on provenance has been culled from nineteenth-century sale catalogues, particularly that of the Blenheim Palace sale in 1886, and from correspondence with the exhibiting institutions.

ORIENTAL PORCELAINS

INTRODUCTION

The Chinese porcelains in The Frick Collection fall into three groups—blue-and-white, enamelled wares, and monochromes[1]—each of which illustrates an aspect of the final development of the ceramic art in China. Before this lay almost two millennia of accidental discovery, patient experiment, and gradual improvement. Any review of this history must start by pointing out that the word "porcelain" does not mean the same thing in China that it means in the West. To the Chinese, any high-fired stoneware that gives off a ringing tone when struck may be called *tz'u-ch'i* which is their word for porcelain. Western usage demands that porcelain be not only sonorous but also pure white and translucent. In some countries, notably France, there are very carefully specified physical properties such as the degree of translucence, porosity, and thickness that are determined by law and must be present before the word porcelain may be used by the manufacturer. The Chinese had a very high-fired, fine-grained gray stoneware called Yüeh ware, named after the region in southeastern China where it orginated, in the early Han dynasty (207 B.C.–A.D. 8). Also in Han times another high-fired type of stoneware was developed in Shensi province some eight hundred miles to the northwest of Yüeh. Chemical analysis of this latter ware shows that the essential ingredients (silica, alumina, iron, lime, and the rest) are present in proportions not very different from those found in Chinese and Japanese porcelain today. For that reason, the great handsomely potted jars from Shensi are commonly called "protoporcelain" in the literature. By the T'ang dynasty (618–906) translucent white porcelain was in production, notably at Hsing Chou in the northeast; and the ware that we know as *ch'ing-pai* (literally: bluish-white) and also known as *ying-ch'ing* (shadowy blue) was being made at the town in Kiangsi province that in Sung times was to take the name of Ching-te Chen after the reign period Ching-te (1004–08). Some centuries later at the beginning of the Ming dynasty (1368–1644), Ching-te Chen was designated the site of the imperial factories and thereafter became world-famous as the place where the finest of all Chinese porcelains were made.

Even though Ching-te Chen was the location of the imperial factory, and was the

site of one of the best deposits of porcelain clay which supported several thousand private factories as well, it was by no means the only place in China where porcelain was made. Production was thriving in many other centers of which Te-hua in Fukien and Swatow in Kuangtung are among the best known; and even today we have much to learn about the types of wares that originated in what are generally known as the "provincial kilns." It is certain that by the Ming dynasty many of these were producing blue-and-white and other wares both for the domestic market and for export. After the Ch'ing dynasty became firmly established in the second half of the seventeenth century, the provincial kilns must have multiplied even more rapidly. Many questions remain to be answered about the identification of the wares they turned out.

It is by no means belittling the superb masterpieces of the Sung dynasty (960–1279) to say that the ceramic art of China reaches its technical and artistic peak in Ming and Ch'ing. The art of decorating white porcelain with cobalt oxide painted under the glaze that may have begun in Sung and was certainly flourishing in Yüan reached its ultimate glory in Ming; and the refinements that were achieved under the patronage of the Manchu emperors, while less robust and imaginative than the best Ming work, produced results of a delicacy and precision that had not been seen before. The same, of course, is true of those porcelains decorated with enamel colors over the glaze; and the very best of these, made for the imperial court and the nobility, reveal a mastery of the technical aspects of the craft and a degree of restraint and elegance in the decoration that put them in a class that has no equal anywhere. These are the wares that are today described as being "in the Chinese taste," and they have no resemblance to the boldly overdecorated wares that came in such great quantities to Europe and the Western world.

The exportation of porcelain to foreign lands was already an old story with the Chinese by the time the first shipments reached Europe in the sixteenth century. Celadon wares of various types had been carried to such widely separated places as Japan, Indonesia, and the east coast of Africa in Chinese and Arab ships as early as the tenth century. By the middle of the fourteenth century a splendid vase of white porcelain had reached Europe and been mounted in silver gilt and enamels by a goldsmith at Prague. Thereafter it was not uncommon to find porcelain in the inventories of the royal and noble houses of Europe, and most of the pieces seem to have been mounted. A celadon bowl with a silver mount of about 1450 survives

6

in the Landesmuseum at Kassel, and another with a mount dated 1530 is among the treasures of New College, Oxford. Many mounted pieces of the sixteenth century are known, notably the famous blue-and-white dishes and bowls from Burghley House that are now in the Metropolitan Museum of Art, New York. It was at the beginning of the seventeenth century that the real flood began when something like one hundred thousand pieces of blue-and-white were brought into the harbor at Amsterdam in 1603 aboard the captured Portuguese carrack *Santa Catarina* and were sold at auction. Thereafter Chinese porcelain became almost commonplace in European homes of the better class.

It is not clear that in the early days certain porcelains were made specifically for export. The Chinese probably shipped overseas the same kind of thing they made for ordinary use at home and used it as a trading medium for exotic products that were marketable in China. The making of "export porcelain," that is to say porcelain of types made to order for the trade, began in the sixteenth century when the Portuguese commissioned blue-and-white wares decorated with Portuguese coats of arms and inscriptions in the Portuguese language. Thus began a practice that developed into a considerable business in the eighteenth and nineteenth centuries when the so-called "armorial wares" were manufactured for the noble families of Europe and for other special purposes. Perhaps the best known of those made for the American market was the service decorated with the arms of the Society of the Cincinnati that was ordered in Canton in 1784 by Maj. Samuel Shaw for George Washington; and many American families had services with their initials or devices of various kinds and special designs made to order. But the Chinese were very quick to learn the nature of the Western taste and to meet the demand; and, in the nineteenth century especially, they made and shipped abroad all kinds of things that were otherwise never seen in China at all.

NOTES

1 The three pairs of Chinese monochromes in The Frick Collection are no longer in their original state. The two vases have been cut down at the neck, and the other two pairs are actually fabrications concocted in eighteenth-century France out of parts of entirely unrelated vessels. All the pieces were then embellished with elaborate gilt-bronze mounts. For these reasons, the mounted monochromes are discussed, along with other examples of eighteenth-century French metalwork, in Vol. VI of *The Frick Collection: An Illustrated Catalogue.*

BLUE-AND-WHITE

Except for the four ginger jars purchased by Henry Clay Frick in 1915 (Nos. 15.8.1–15.8.4), the blue-and-white porcelains included in this catalogue were selected as representative from a group of one hundred and forty-seven pieces collected by Mr. and Mrs. Childs Frick and bequeathed to The Frick Collection in 1965. They by no means illustrate the whole history of blue-and-white in China. The beginnings of that art are still uncertain, but little doubt remains that the Chinese were decorating white porcelain with cobalt blue as early as the thirteenth century. By the later years of the Yüan dynasty (1260–1368) the technical aspects of the art had been fully mastered, and from that time on magnificent pieces were produced in a wide variety of shapes and styles all through the Ming (1368–1644). Ming was in fact the golden age of blue-and-white. Styles changed, as was inevitable, and there is no point in comparing the products of late Ming and K'ang-hsi with the great masterpieces of the Ming dynasty in its fullest flower.

But the refinement that characterized all the arts of China in the seventeenth and eighteenth centuries is to be found in this little collection of blue-and-white; and it was blue-and-white that remained the most difficult test of skill. There was no chance to distract the viewer's attention with a bold show of brightly colored enamels. The potter was on his own in the creation of a finely potted vessel; and the decorator had only his draughtsmanship and his imagination in the disposition of the composition to serve him as he worked. And his was a most exacting medium. He painted with cobalt oxide and water mixed to the consistency of ink, and his surface was the highly porous dried (but yet unfired) porcelain clay. As Brankston has described it, "Painting with cobalt oxide may be compared to writing in ink on blotting paper, if the brush hesitates the result is a smudge, and if too quick there is no result at all."[1] And the line, once drawn, was forever; no change was possible. The skill involved is clearly demonstrated in the pieces illustrated. While there may have been a falling off of the imagination, and the decorative compositions perhaps became a bit more stylized and routine, the dexterity of the man with the

brush in his hand remained at a very high level all through the eighteenth century and well into the nineteenth.

The degree of skill is all the more remarkable when we remember that this was mass production on a very large scale. As early as the sixteenth century, orders amounting to more than one hundred thousand pieces of porcelain of all kinds were filled for the palace at Peking; and in the eighteenth century one of the great directors of the imperial factory, T'ang Ying, estimated that between 1728 and 1735 some three to four hundred thousand pieces were supplied to the palace. Any single type of dish or bowl or vase was made in hundreds of duplicate copies; and vessels were made, decorated, and fired by different hands and in different kilns. For this reason there is no sense in speaking, as we do today, of "pairs" or "sets" or "garnitures." Those are Western terms used by dealers to appeal to their customers in recent times, and they have been avoided as much as possible in the present text.

NOTES

1 A. D. Brankston, *The Early Ming Wares of Chingtechen,* Peking, 1938, p. 66.

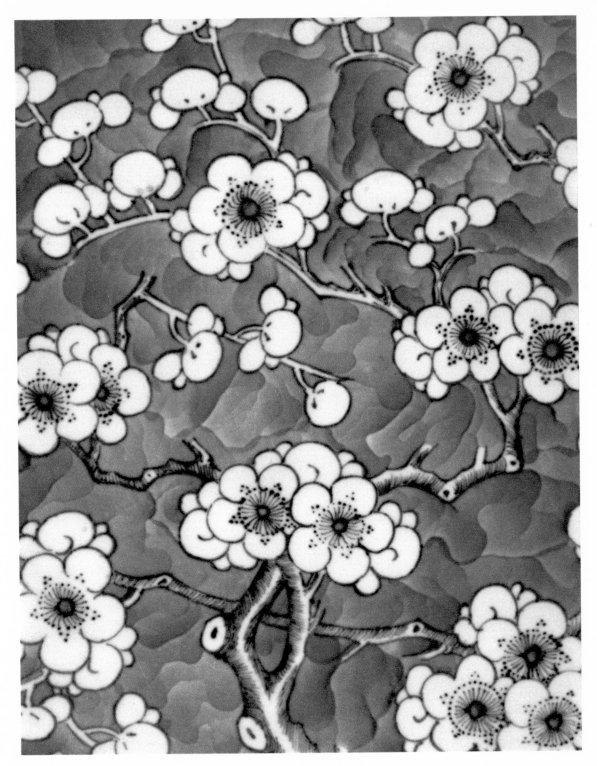

65.8.203 · DETAIL

Small Octagonal Saucer (65.8.60)

H. 1⅞ in. (4.8 cm); D. 5⅛ in. (13 cm). Ming dynasty, Chia-ching period (1522–66).

Description: Inside the rim is a continuous scroll band; below this each of the eight quadrilateral panels is pierced by a circular area of reticulation surrounded by four white clouds on a blue ground. The openwork circles are filled alternately with scale patterns and interlocking cash patterns. In the center is a pond with two ducks swimming among water plants. The outside border has a wave in the center of each section, alternately facing up and down, and a blossom at each angle. The eight panels are the same as inside, and below them is a row of cloud collar patterns and a scalloped band. The six-character mark of the Chia-ching reign (1522–66) is written on the base in a double circle.

Condition: There is one chip on the rim, and minor flaws are seen in the glaze. There is one hair crack.

The technique of drawing the design in outline and filling it with washes of various shades of blue began in the latter half of the fifteenth century and was popular on and off thereafter. Openwork reticulation has an even longer history dating from the late thirteenth or early fourteenth century, and was also used sporadically thereafter. The Chia-ching mark is poorly written, but there seems to be no reason to consider the piece later than that reign.

Collections: Roland Moore. Bequest of Childs Frick, 1965.

14

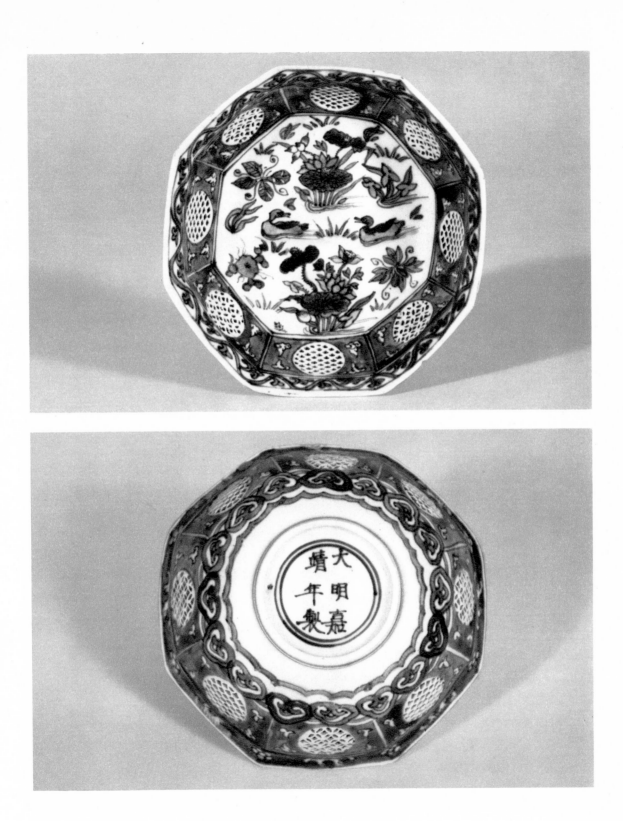

Stem Cup (65.8.71)

H. 4 in. (10.2 cm); D. 6 in. (15.2 cm). Ming dynasty, late sixteenth century.

Description: The broad bowl has rounded sides and a flaring rim. It stands on a tall hollow stem that widens slightly at the foot and has a gently swelling flange around the base. The foot rim and the inside of the stem are unglazed. The central composition inside the bowl is a circular painting of a man in a landscape setting with a cliff, a pine tree, and a moon in the sky. The inner border of the lip has a broad band of diamond diaper pattern with each diamond framing a cross. On the outside is a continuous scene of scholars gathered near a pavilion in a garden, some reading books, some admiring a scroll of calligraphy, two playing *wei-ch'i,* and others engaged in conversation. The stem of the cup is decorated with pendent stylized leaves and encircling bands.

Condition: The cup is intact except for minor flaws in the glaze on the central composition, some abrasion on the rim, and one slight hair crack.

Although the cup bears no reign mark, the decoration in both style and subject matter is typical of the late Chia-ching (1522–66) and early Wan-li (1573–1620) periods. The game of *wei-ch'i* is very ancient and is played on a board with 324 squares, and each player has 150 counters. It is often mistakenly called chess by Western writers.

Collections: Roland Moore. Bequest of Childs Frick, 1965.

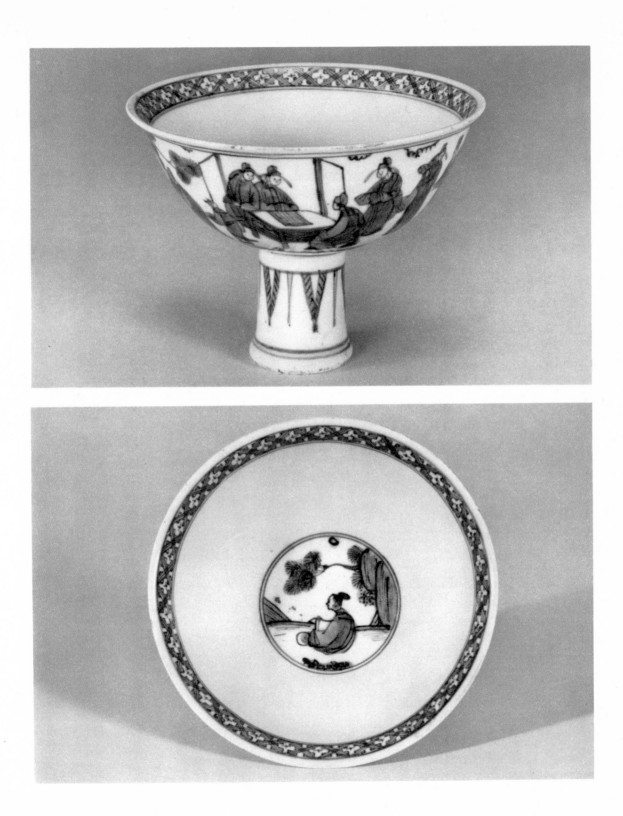

Small Melon-Shaped Jar (65.8.63)

H. 4⅜ in. (11.1 cm); D. 4⅛ in. (10.5 cm). Ming dynasty, c. 1600.

Description: The body of the jar is lobed vertically in ten sections. Each pair of lobes is framed, and the resulting five panels enclose two large plants of chrysanthemum type, two scenes each showing a scholar seated in a garden, and a composition of bamboo, rocks, and clouds. The base is roughly cut, slightly convex in form, and has a certain amount of sand adhering to one side.

Condition: The piece is intact.

The style of drawing is striking in that it consists only of lines with no areas of wash, a style often referred to as "pencilled decoration" for it does in fact look as though it were drawn with a pencil instead of a brush. Drawing of this kind is usually associated with the Wan-li period (1573–1620) and dated not far from the year 1600, give or take a decade or so.

Collections: Roland Moore. Bequest of Childs Frick, 1965.

18

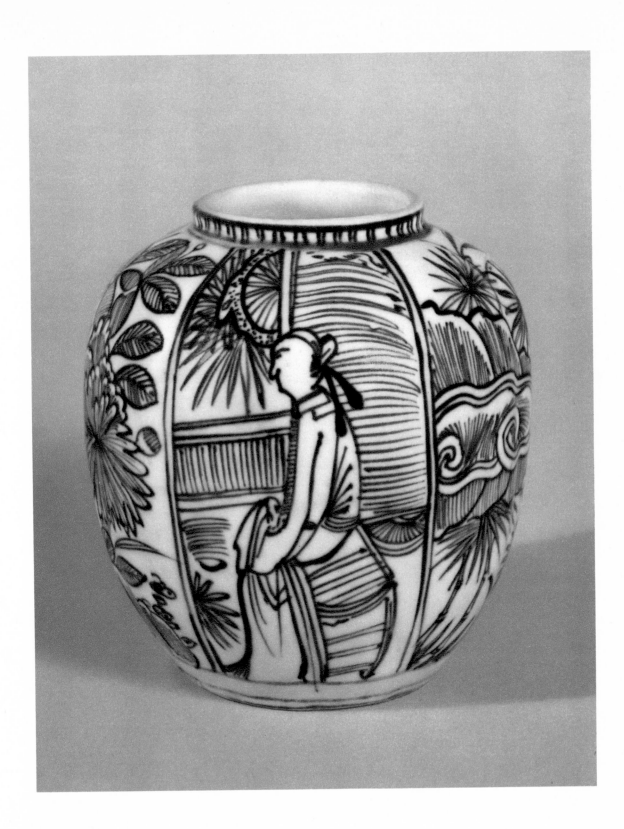

Bowl (65.8.69)

H. 2⅝ in. (6.7 cm); D. 5⅝ in. (14.3 cm). Seventeenth century.

Description: The high rounded sides of the bowl end in an almost imperceptible flare. Both inside and out the decoration consists of lily scrolls. Inside the high foot the base is flat, and it bears the six-character mark of the Wan-li reign (1573–1620) within a double circle.

Condition: The piece is intact.

Bowls of this type were called "palace bowls" by Brankston,[1] and they are now generally known by that term even though there is no evidence that they were used in the palace. The classic examples date from the Ch'eng-hua reign (1465–87) and are characteristically decorated with floral scrolls. The lily that appears on the present bowl is one of those commonly used. The painting in outline-and-wash technique also follows the Ch'eng-hua tradition, but here the drawing is noticeably stiffer and the blue is flatter and not so subtly modulated as on the originals.

Excellent copies of the Ch'eng-hua "palace bowls" were made in the K'ang-hsi reign (1662–1722), and these also bore very good copies of the Ch'eng-hua mark. The bowl in The Frick Collection seems to be the only one that has come to light so far with the mark of the late Ming reign of Wan-li (1573–1620); and while the calligraphy of the mark is good, the decoration of the bowl shows no signs of the style usually associated with that period. On the other hand, as the K'ang-hsi copyists well knew, bowls of this type should always bear the mark of Ch'eng-hua, a reign that ended some eighty-six years before Wan-li began.

So the bowl presents an enigma. The most likely possibility for the time being seems to be to call the bowl seventeenth-century, which covers the end of Wan-li and the beginning of K'ang-hsi and the four decades between them.

Collections: Roland Moore. Bequest of Childs Frick, 1965.

NOTES

1 A.D.Brankston, *The Early Ming Wares of Chingtechen,* Peking, 1938, p.46.

20

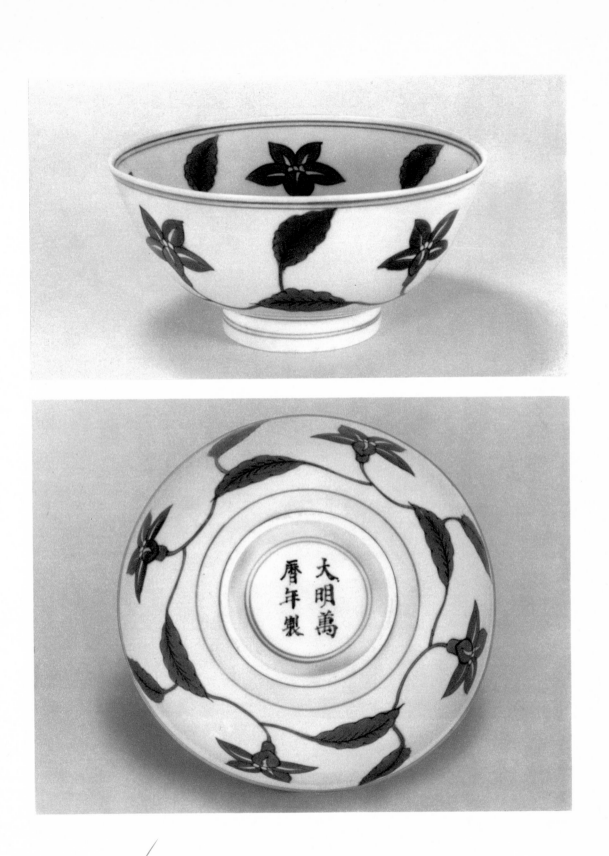

Covered Jar of Inverted Baluster Shape (65.8.104)

H. 11½ in. (29.2 cm); D. 4⅛ in. (10.5 cm). Late seventeenth or early eighteenth century.

Description: The lid has a slightly flaring knob with flat top, and around this are dancing boys above a border of diamond diaper pattern. A similar border drawn with better definition surrounds the lip of the jar, and below this is a broad band of floral sprays; fruit sprays surround the foot of the vessel. The main area is covered with a continuous scene of four slender ladies in a garden which includes the usual tree, an elaborately articulated rock, a banana tree, and two tables. The lower part of the scene includes some ordinary rocks and the top of a fence.

Condition: The piece is intact.

In traditional Chinese garden architecture stones served to represent mountains, and the selection of exactly the right stone to produce the right effect was of the utmost importance. The deeply scooped, furrowed, and perforated rocks from the lake called T'ai Hu and other lakes of south China were special favorites.[1] They were essential features in the properly designed garden of a Chinese gentleman and scholar.

Collections: Roland Moore. Bequest of Childs Frick, 1965.

NOTES

1 O. Sirén, *Gardens of China,* New York, 1949, pp. 19–28.

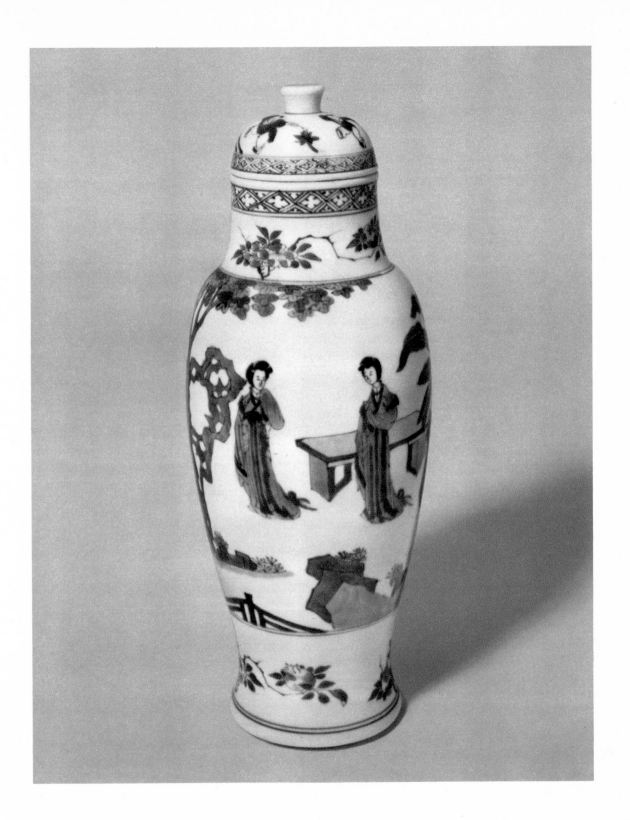

Dish with Broad Flat Rim (65.8.197)

H. 1¼ in. (3.2 cm); D. 10⅛ in. (25.7 cm). K'ang-hsi period (1662–1722).

Description: The rim is decorated with four different diaper patterns—diamonds, interlocking cash, waves, and swastikas—separated by four panels framing scenes of scholars in various landscape settings. The plain white cavetto frames a central scene of three ladies coming out of a door onto a terrace. Beside the house is a garden with a banana tree, a plum tree, and two bamboo shoots. On the outside of the rim are four auspicious objects. On the base is the six-character mark of the K'ang-hsi reign (1662 to 1722).

Condition: There are small chips on the rim.

A set of thirty dishes, somewhat smaller in size (20.5 cm) and similarly decorated, is in the collection formed by Augustus the Strong at Dresden and was listed in the inventory of 1721. The borders are the same, and the scenes in the center differ in subject matter. All but two have landscapes on the outside, and two have auspicious objects as is the case here. All have well-written marks of either the Ch'eng-hua reign (1465–87), which was commonly used in K'ang-hsi times, or of the K'ang-hsi reign itself. The presence of these pieces—so similarly treated in style and technique, painted with the same strong, clear cobalt blue, and marked with the same firm calligraphy—in Dresden before the end of the K'ang-hsi reign does much to strengthen our confidence in the type of work characteristic of the period.

Collections: Duveen. James A. Garland sale, January 17, 1924, American Art Association, New York, Lot 148. Bequest of Childs Frick, 1965.

24

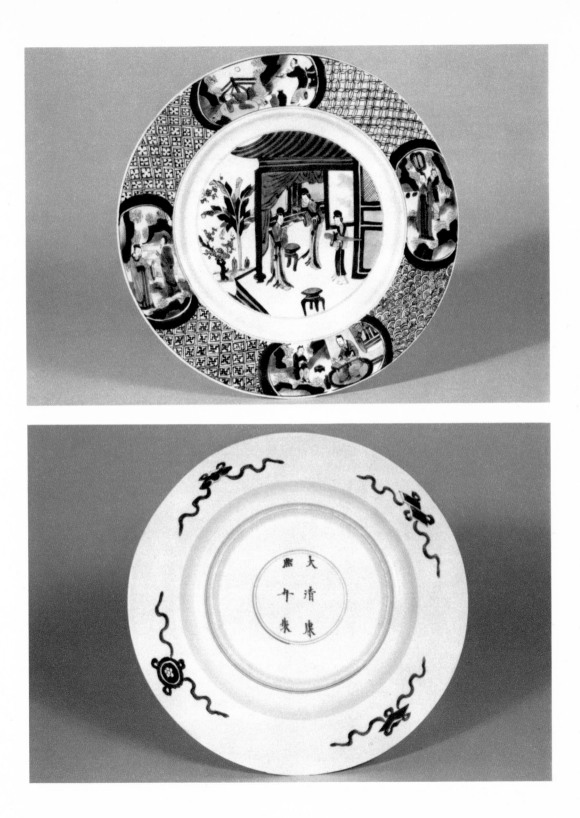

Two Covered Jugs with Handles (65.8.193 and 65.8.194)

Number 65.8.193: H. 5¼ in. (13.3 cm); D. 3⅝ in. (9.2 cm). Number 65.8.194: H. 5½ in. (14 cm); D. 3⅞ in. (9.8 cm). K'ang-hsi period (1662–1722).

Description: The lid knobs are painted solid dark blue, and there are floral sprays on the lids and handles. A band of blossoms surrounds each lip; and the principal decoration of two ladies admiring a potted plant appears on both sides of each jug. On one side the plant is a plum, and on the other it is a chrysanthemum. The scene is depicted on a terrace with a railing. On the base of each jug is the artemisia-leaf mark.

Condition: Both jugs are intact.

For the sake of convenience the two jugs are treated as a pair although one is larger than the other and there are differences in the decoration. The two knobs are of different shapes; the floral band is set lower on No. 65.8.193; and the second jug has a double line around the slightly flaring foot.

Collections: Roland Moore. Bequest of Childs Frick, 1965.

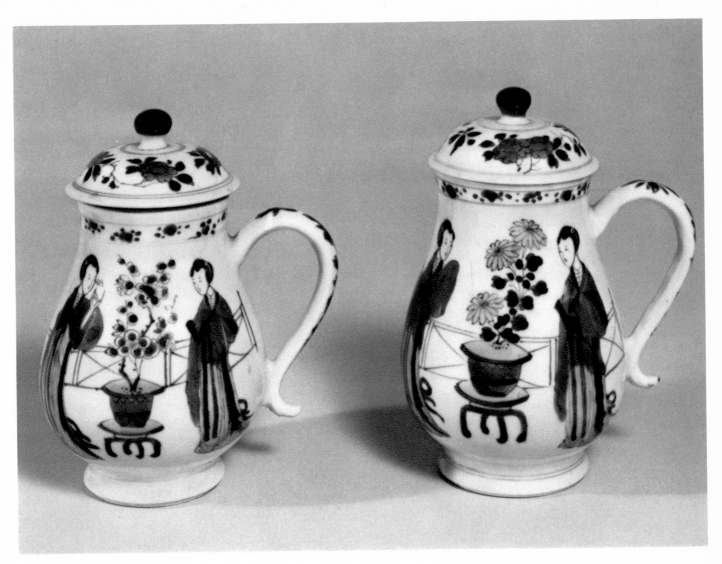

65.8.193 65.8.194

Slender Beaker with Broad Rim (65.8.79)

H. 6¾ in. (17.2 cm); D. 4½ in. (11.5 cm). K'ang-hsi period (1662–1722).

Description: The upper section is decorated with a scene showing two ladies under a pine tree with birds flying above. On the swelling central band are chrysanthemum sprays and grasses bordered by rows of crosses and dots. Around the foot is a mountainous landscape with two small figures seated on the ground before a pavilion. The mark on the base is an empty double ring.

Condition: The piece is intact.

The shape is that of an archaic Chinese ceremonial bronze vessel of the type known as *ku*. The empty double ring is thought to have been one of the marks used when, for a short period of uncertain duration beginning in 1677, the potters at Ching-te Chen were forbidden to use the imperial reign mark. The very skillful painting of the decoration in rich, deep cobalt blue is in the best K'ang-hsi tradition.

Collections: Roland Moore. Bequest of Childs Frick, 1965.

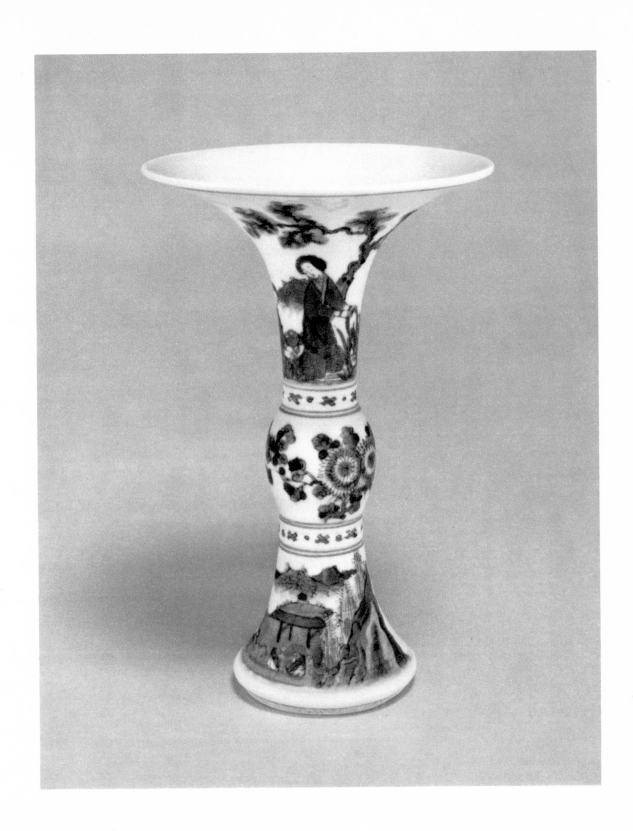

Bottle-Shaped Vase (65.8.191)

H. 7½ in. (19 cm); D. 3¾ in. (9.5 cm). K'ang-hsi period (1662–1722).

Description: Just below the slightly flaring lip is a hatched band. The rest of the surface is covered with a continuous landscape scene in which horsemen gallop away from a palace, ride to a lake, and there signal with a fan to a boatman. In the distance are trees and mountains.

Condition: The piece is intact.

Scenes of this kind often illustrate episodes from the *San-kuo-chih-yen-i,* a popular novel written in the Yüan dynasty (1260–1368) based upon the complex historical events leading up to and following the fall of the Han dynasty in A.D. 220. It is sometimes called *The Romance of the Three Kingdoms,* and it served as subject matter for innumerable illustrations in the centuries following its publication. In most cases, as here, it is impossible to identify any individual event with certainty.

Collections: Roland Moore. Bequest of Childs Frick, 1965.

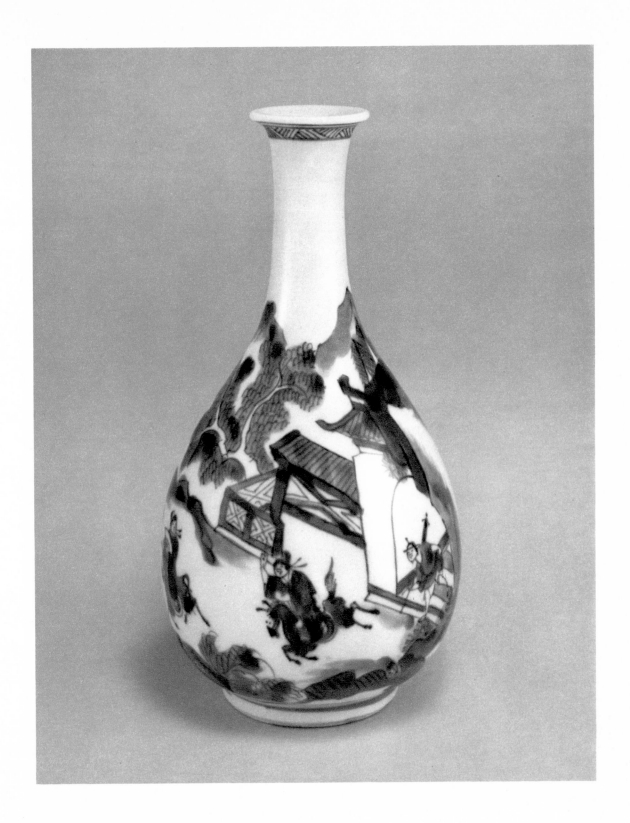

Bottle-Shaped Vase (65.8.105)

H. 8⅜ in. (21.3 cm); D. 4¼ in. (10.8 cm). K'ang-hsi period (1662 to 1722).

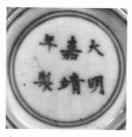

Description: A band of very stylized classic scroll surrounds the neck just above a torus ring about one-third of the way up from the shoulder. The rest of the decoration consists of rocks and flowering plants including magnolias and camellias. There is a single flying bird. The six-character mark of the Chia-ching reign (1522–66) is written on the base in three lines of two characters each.

Condition: The piece is intact.

The calligraphy of the mark is poor. The form in which it is written, three vertical lines of two characters each, does not appear to have been used for six-character marks before the K'ang-hsi reign.

Collections: Roland Moore. Bequest of Childs Frick, 1965.

32

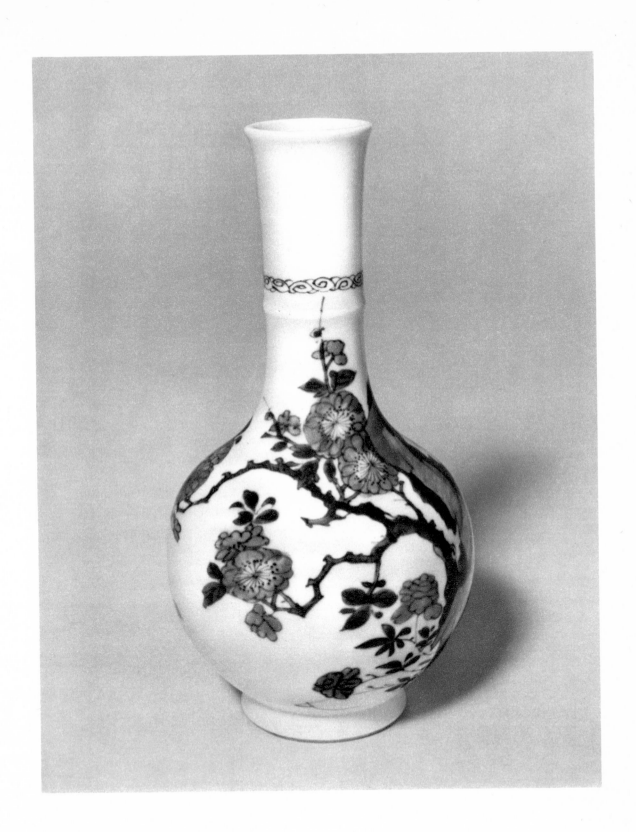

Small Bottle-Shaped Vase (65.8.180)

H. 5½ in. (14 cm); D. 3 in. (7.6 cm). K'ang-hsi period (1662 to 1722).

Description: A band of very stylized classic scroll surrounds the

neck below a row of dots and just above a slight torus ring. The decoration of the body is divided into two sections: on one side is a framed landscape scene; on the other are shown some of the Hundred Antiques. On the base is the six-character mark of the Chia-ching period (1522–66) written in three lines of two characters each.

Condition: The piece is intact.

Collections: Roland Moore. Bequest of Childs Frick, 1965.

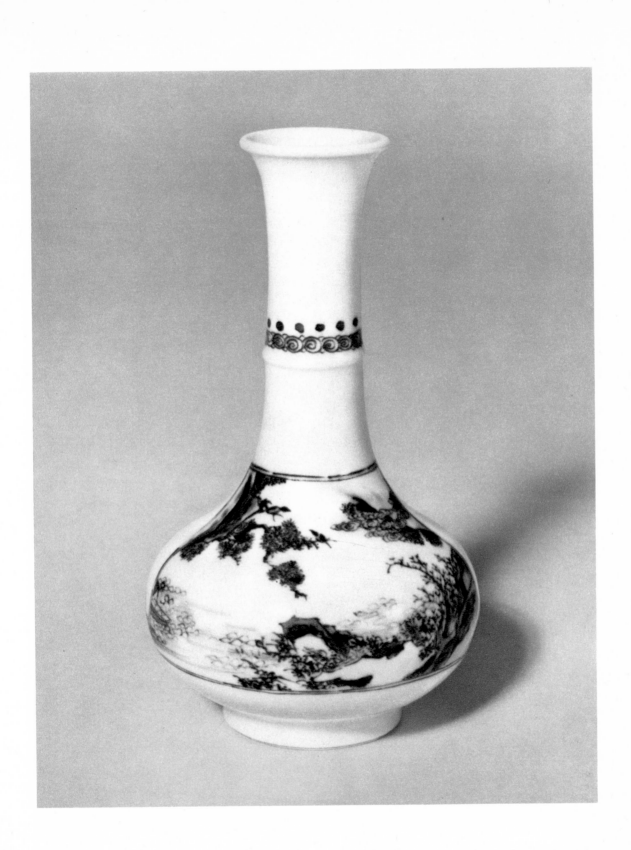

Two Small Bottle-Shaped Vases (65.8.94 and 65.8.95)

Number 65.8.94: H. 5 in. (12.7 cm); D. 3 3/16 in. (8.1 cm). Number 65.8.95: H. 5⅛ in. (13 cm); D. 3 1/16 in. (7.8 cm). K'ang-hsi period (1662–1722).

Description: A band of hatching surrounds the lip of each vase, and below this are chrysanthemum sprays and rocks above a similar hatched band. The bodies of both vases are painted with flowers and rockery all around. Under the base of each is the six-character mark of the Chia-ching reign (1522–66) written in three lines of two characters each.

Condition: Both vases are intact.

As in the case of the two covered jugs with handles illustrated on p. 27, these vases are treated as a pair although they are not identical in size and shape.

Collections: Roland Moore. Bequest of Childs Frick, 1965.

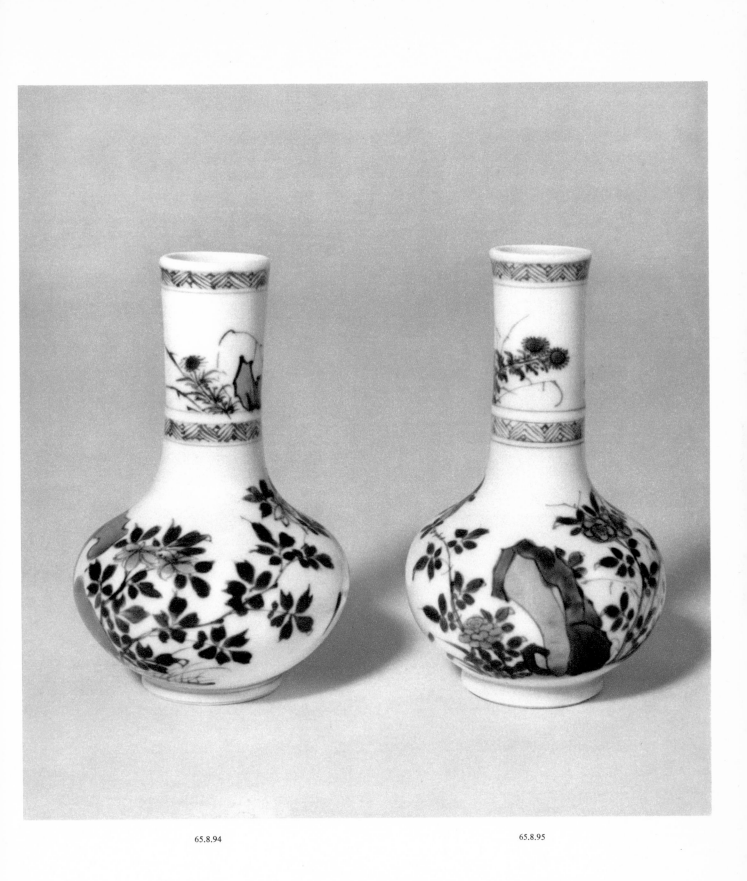

65.8.94 65.8.95

Four Ginger Jars with Plum-Blossom Decoration (15.8.1–15.8.4)

H. (average) 10⅛ in. (25.8 cm); D. (average) 8½ in. (21.6 cm). Eighteenth century.

Description: Both jars and covers are decorated with sprays of plum blossoms reserved in white on a ground of blue wash laid on in varying tones. The four large sprays on each jar are arranged in alternately ascending and descending positions. The intervening spaces are filled with smaller sprays placed at various angles. At the top of the shoulder each jar is surrounded by a stylized comb pattern. The neck inside each cover is unglazed as is the thick, rounded foot rim. The bases are covered with a thin transparent glaze.

Condition: Number 15.8.3 has a long crack down one side. The cover of Number 15.8.1 has been broken into several pieces and repaired.

There are similar jars in the collection formed by Augustus the Strong at Dresden and listed in the inventory of 1721. On the other hand, it must be noted that no such pieces are found in the National Palace Museum in Taiwan, which includes what is probably the largest collection of Chinese porcelain in the world. Jars of this type were evidently made for export and became well known in Europe while they were largely unknown to the Chinese.

Exhibited: New York, Metropolitan Museum, 1895, Case 9, lent by James A. Garland. New York, Metropolitan Museum, 1907, Case B (Nos. 5–8), lent by J. Pierpont Morgan.

Collections: Two of the set are said to have been owned by the Duke of Marlborough.[1] A third is said to have been imported from China by the Paris dealer Bing. The fourth was in the Brayton Ives collection. All were in the James A. Garland collection, which was bought by J. Pierpont Morgan, through Duveen, in 1902. Duveen. Frick, 1915.

NOTES

1 According to *The Frick Collection Catalogue* of 1955 (VIII, p. 7), "Two of the set were owned by the Duke of Marlborough and sold in the sale of treasures of Blenheim Palace in 1887 [sic]." A torn label penciled with what appears to be the name "Blenheim" is affixed to the bottom of No. 15.8.3, but none of the other jars is so marked. In the 1907 *Catalogue of the Morgan Collection of Chinese Porcelains* (S. W. Bushell and W. M. Laffan, New York, p. 5, Nos. 5–8), a Blenheim provenance is suggested for only one of the four jars: "the one with a wooden cap is known as the Blenheim vase, having come from the Marlborough collection." Similarly, the description of the four jars in the 1895 catalogue of the Garland collection (J. Getz,

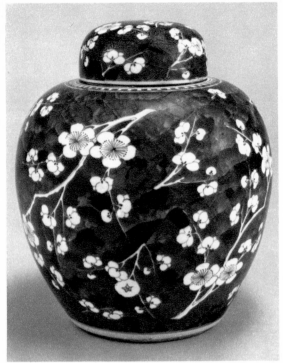

15.8.1

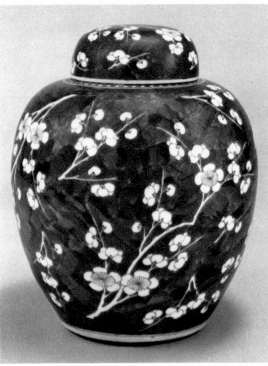

15.8.2

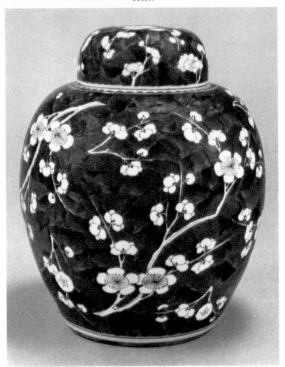

15.8.3

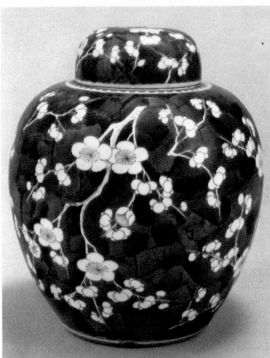

15.8.4

Metropolitan Museum of Art: Hand-Book of a Collection of Chinese Porcelains Loaned by James A. Garland, New York, p. 42, Case 9, repr. facing p. 40), includes the statement: "Among them is the celebrated one from the Blenheim collection, which is considered the gem, but it has not the original cover." The Blenheim sale catalogue *(Catalogue of the Collection of Pictures and Porcelains from Blenheim Palace,* July 24 *et seq.,* 1886, Christie's) nowhere employs the term "ginger jar," nor does it give measurements for any of the 487 lots of porcelain included. However, a possible candidate for Frick No. 15.8.3 is Lot 349, listed among a group of Chinese blue-and-white: "A globular jar, with sprays of hawthorn on marbled-blue ground."

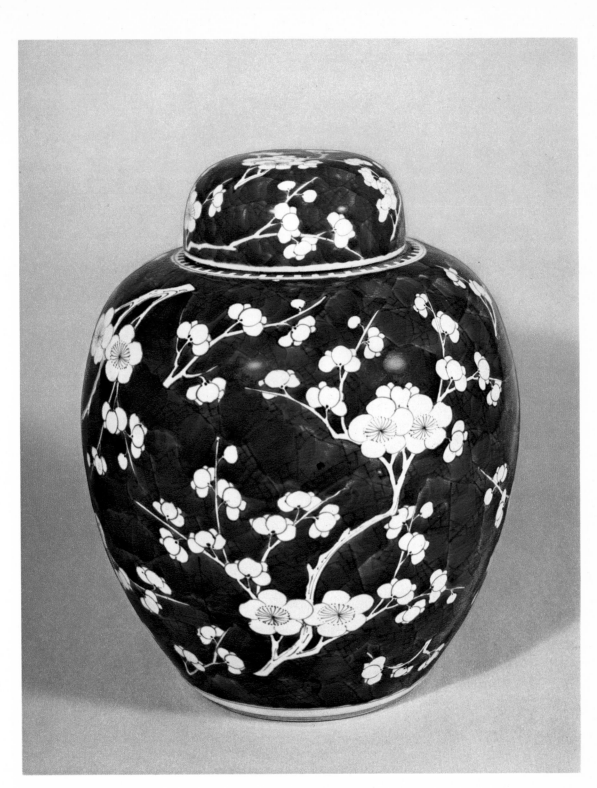

15.8.4

Dish with Plum-Blossom Decoration (65.8.203)

H. 1½ in. (3.8 cm); D. 9⅞ in. (25.1 cm). Eighteenth century.

Description: The dish has a plain upturning rim with a white lip. Inside is an allover decoration of white plum blossoms on branches and stems on a ground of blue wash in varying tones. On the outside are three flying bats. The base has been ground down so that if there ever was a mark, no trace of it remains.

Condition: The dish is intact except for the ground-down base.

This is the same pattern seen on the four preceding ginger jars; but it occurs relatively rarely on vessels of other forms. A bottle-shaped vase in the Victoria and Albert Museum[1] is an outstanding example of fine quality, but there seems to be no published reference to a dish like this.

Collections: Roland Moore. Bequest of Childs Frick, 1965.

NOTES

1 W. B. Honey, *The Ceramic Art of China and other Countries of the Far East,* London, 1945, Pl. 121.

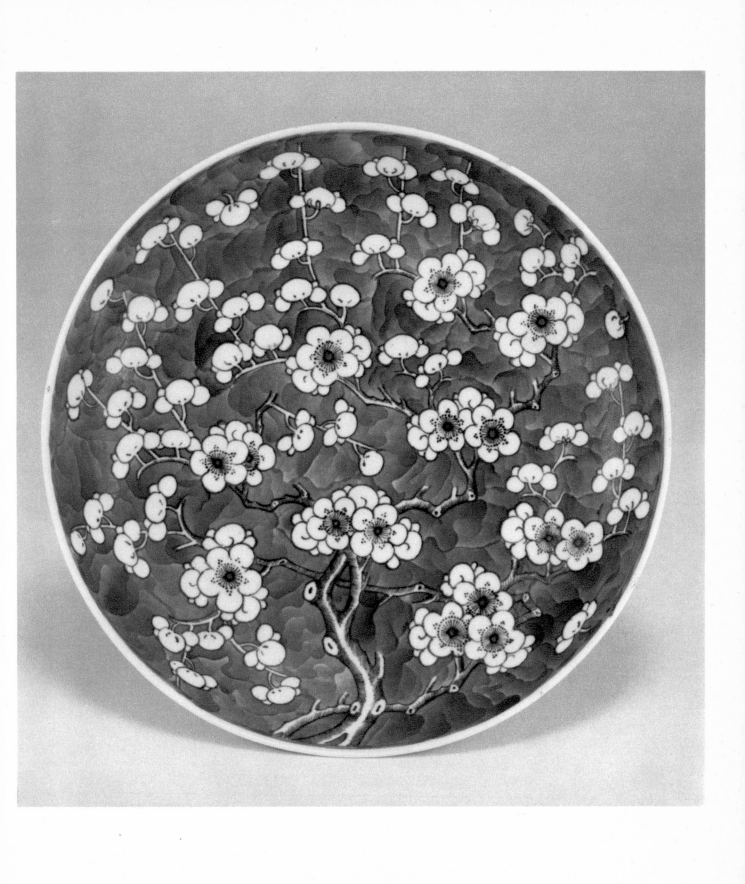

Bowl with Everted Lip (65.8.155)

H. 3¾ in. (9.5 cm); D. 8¼ in. (21 cm). K'ang-hsi period (1662–1722).

Description: Around the lip, both inside and out, is a border of small trefoil forms based on the cloud collar motif. The rest of the surface is covered with a ground of very pale gray-blue over a network of fine dark blue lines. On this ground are individual plum blossoms, regularly spaced and drawn in more precise detail than usual. A band of highly stylized leaf pattern surrounds the low, straight foot on the outside. On the base is the six-character mark of the Ch'eng-hua reign (1465–87) written within a double circle.

Condition: The piece is intact.

The ground pattern on this bowl is related to the "ice crackle" pattern commonly found on ginger jars but is much more formal in concept. It closely resembles, and may be based upon, a lattice pattern traceable to the early Han dynasty.[1] The overall effect makes this an exceptionally beautiful bowl, and apparently it is very rare.

Collections: Frank Partridge. Bequest of Childs Frick, 1965.

NOTES

1 D. S. Dye, *A Grammar of Chinese Lattice,* Cambridge, Massachusetts, 1946. See especially his Nos. X 3 b on p. 299; X 5 a on p. 300; and & f 40 c on p. 424 and the accompanying text.

44

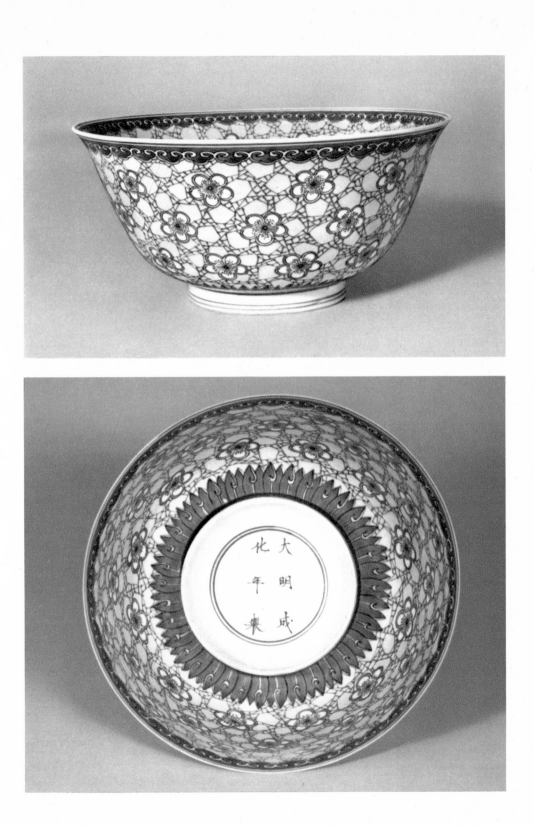

Bowl with Relief Design Below Lip (65.8.75)

H. 3 in. (7.6 cm); D. 7½ in. (19 cm). K'ang-hsi period (1662–1722).

Description: A lattice-like band in sharp relief surrounds the lip on the outside. Below this are four floral sprays: plum, peony, lotus, and chrysanthemum, the customary flowers of the four seasons: winter, spring, summer, and autumn. Inside the bowl is the figure of a woman with a hoe on her shoulder shown four times, and from the hoe hangs a basket of flowers. In a circle around the center are eight auspicious objects. The center is in the shape of an almost hemispherical dome, hollow underneath, which the Chinese call *man-t'ou-hsin* (loaf center).

Condition: There are a minor chip and a repair on the foot rim, and slight flaws in the glaze on the inside.

Although the relief band below the lip seems to resemble some of the patterns of Chinese window lattices, it does not exactly duplicate any of the published examples.[1] There are five similar bowls in the collection formed by Augustus the Strong at Dresden and listed in the inventory of 1721.

Collections: Roland Moore. Bequest of Childs Frick, 1965.

NOTES

1 D.S.Dye, *A Grammar of Chinese Lattice,* Cambridge, Massachusetts, 1946, *passim.*

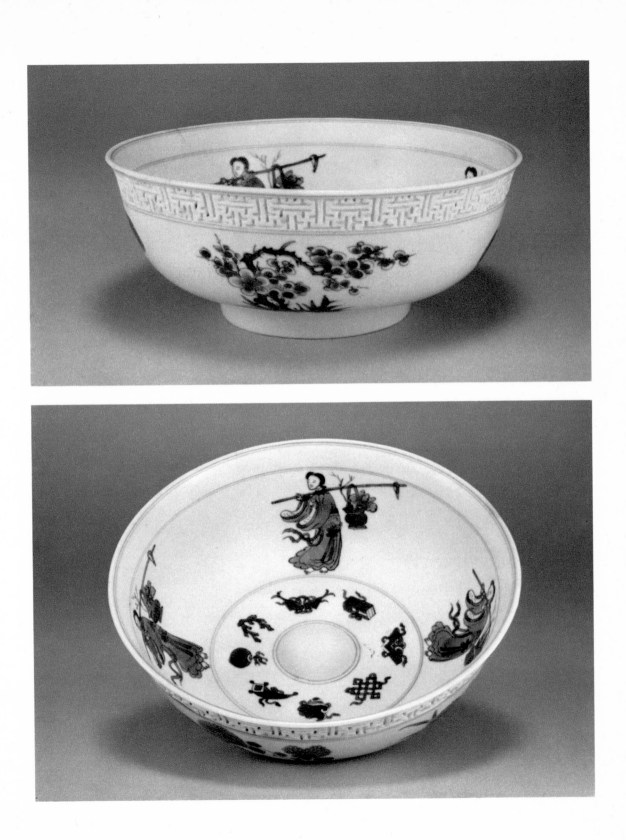

Bowl with Everted Lip (65.8.74)

H. 3¾ in. (9.5 cm); D. 8⅛ in. (20.7 cm). K'ang-hsi period (1662 to 1722).

Description: Inside the rim is a band of diaper pattern of several different kinds including diamond, swastika, interlocking stars, and semicircles. This border is interrupted by five ogival panels framing flower sprays. In the bottom is a single large character partly obscured by a circle framing a picture of Shou-lao (the god of longevity) seated with a deer. On the outside are peaches and *fu* characters (for happiness) around the rim, and below each character is a basket of peaches. Between the baskets are five large *shou* characters (for longevity), each with a superimposed circle framing a picture of Shou-lao, shown four times with a deer and once with a scroll on which are written the characters *lu-fu* (prosperity and happiness). On the base is the six-character mark of the Ch'eng-hua reign (1465–87) written within a double circle.

Condition: There is one repair on the rim.

The large character in the center of the bowl has not been found in any of the standard Chinese dictionaries and has not so far been identified.

Collections: Mrs. W. Storrs Wells sale, November 14, 1936, American Art Association Anderson Galleries, New York, Lot 326. Roland Moore. Bequest of Childs Frick, 1965.

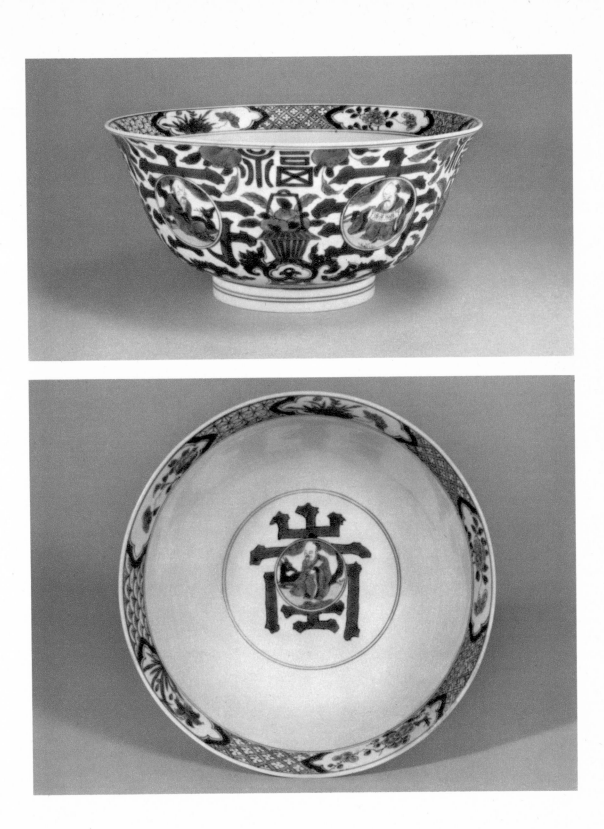

Two Bottle-Shaped Vases (65.8.135 and 65.8.136)

Number 65.8.135: H. 7½ in. (19 cm); D. 4⅛ in. (10.5 cm). Number 65.8.136: H. 7⅜ in. (18.7 cm); D. 4 in. (10.2 cm). K'ang-hsi period (1662–1722).

Description: Around the lip of each bottle is a row of heart-shaped curving forms based on the trefoil version of the cloud collar pattern. Below this, a row of pendent leaf forms points down to an upright row of similar forms below. An intricate band of cloud collar patterns is worked into a complex scroll system around the shoulder. On the main body are three large and three small medallions linked together by bands and framing floral patterns reserved in white on a blue ground.

Condition: There is a chip on the rim of No. 65.8.136.

Here again is a case where two vessels that, at first glance, look alike are not really a pair. There are differences in height, in the number of trefoils around the necks and shoulders, and also in the treatment of the feet: the foot of No. 65.8.135 flares and is notched both inside and out, while that of its companion is straight and is notched on the outside only. Similar bottles are in the Dresden collection and recorded in the inventory of 1721.

Collections: Roland Moore. Bequest of Childs Frick, 1965.

50

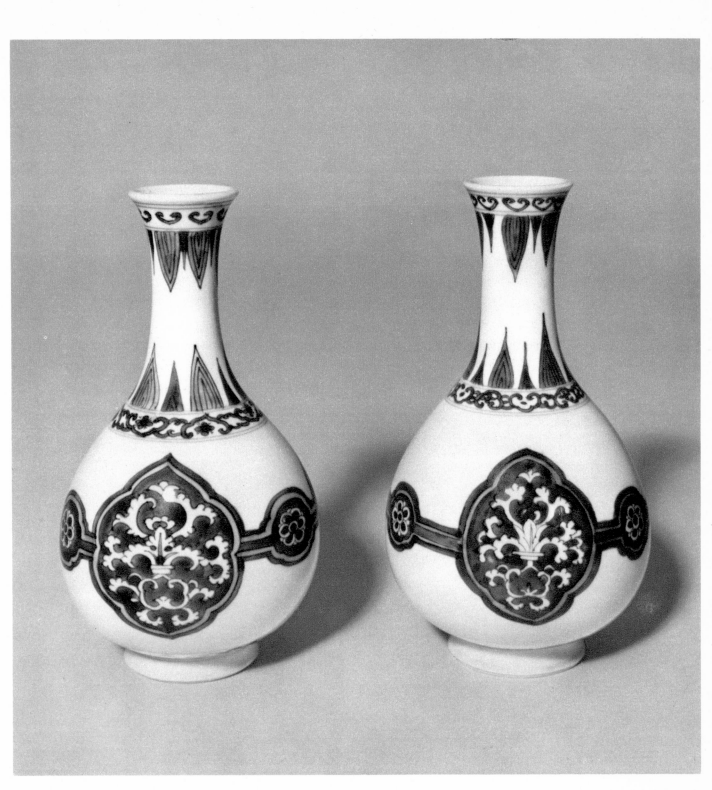

65.8.136 65.8.135

Two Tall Candlesticks (65.8.80 and 65.8.81)

H. 7 in. (17.8 cm); D. 4 in. (10.2 cm). Eighteenth century.

Description: An elaborately conceived baluster-shaped stem rises from a dome-like hemispherical base, and at the top of the stem is a cup-shaped holder for the candle. At the lip and the top of the base are trefoil bands in white reserved on blue grounds. Below each cup is a scale diaper band with three reserved frames in which are single plum blossoms on blue grounds. Flowering sprays and flying insects decorate the main areas, and below these are scrolling leaves with more plum blossoms. The Hundred Antiques pattern surrounds the lower part of each base. The bodies of the cups and the middle zones of the domed bases are decorated with rows of crosses and crosses with dots respectively.

Condition: The lip of No. 65.8.81 has been broken and repaired almost all the way around.

The so-called Hundred Antiques design is made up of a group of implements usually including a tripod, a vase with feathers in it, a book, a piece of jade, and other such motifs. This design with many variations in detail served as a sort of comprehensive symbol of the gentleman-scholar and was frequently used in Ch'ing dynasty decoration in many media.

Collections: Roland Moore. Bequest of Childs Frick, 1965.

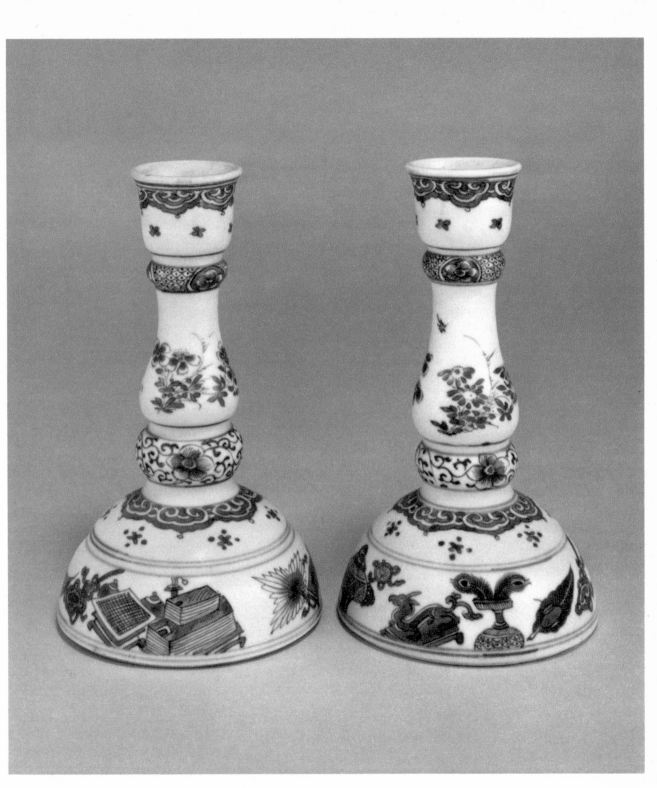

65.8.81 65.8.80

Bottle-Shaped Vase with High Flaring Foot (65.8.112)

H. 9¾ in. (24.8 cm); D. 4½ in. (11.5 cm). K'ang-hsi period (1662–1722).

Description: Stylized banana-leaf patterns hang down from the flaring lip, and these frame floral devices reserved in white on blue grounds. An upright row of similar forms surrounds the base of the neck. Between these two is a hatched band separating erect and pendent rows of stylized banana leaves somewhat differently treated. In the white areas above and below this central band are scattered blossoms, and the high flaring foot is similarly decorated with blossoms and up-right leaves. On the shoulder is a band of triangular forms each of which frames three petals. The main body of the vessel is divided vertically into six panels: two narrower ones on each side frame compositions of the Hundred Antiques, and the two broader ones each frame a scene showing a lady on a terrace with flowers, with additional compositions of the Hundred Antiques above and below. There is an empty double circle on the base.

Condition: There is an unglazed patch inside the rim and some pitting of the glaze here and there.

Collections: Mrs. W. Storrs Wells sale, November 14, 1936, American Art Association Anderson Galleries, New York, Lot 302. Roland Moore. Bequest of Childs Frick, 1965.

Vase of Inverted Baluster Shape with Short Neck (65.8.166)

H. 8 in. (20.3 cm); D. 5 in. (12.7 cm). K'ang-hsi period (1662–1722).

Description: A single blue line surrounds the lip, and upright stylized leaves decorate the base of the neck. The body is covered with a boldly drawn scroll pattern with leaves which is interrupted by two large superimposed panels. Each of these frames a composition of the Hundred Antiques.

Condition: The piece is intact.

The top of the lip is unglazed and at first glance appears to have been cut down. Closer examination, however, reveals that the glaze comes to a perfectly natural stop at the lip, and that the unglazed area extends about ⅝ in. down the inside. The area is finished just like the foot rim, and there is no sign of cutting. Furthermore, the decoration of the neck has not been interrupted and is entirely harmonious with its size and shape. Clearly the vase is complete as it stands.

Collections: Roland Moore. Bequest of Childs Frick, 1965.

Bronze-Form Vase (65.8.110)

H. 9 ½ in. (24.1 cm); D. 4⅞ in. (12.4 cm). K'ang-hsi period (1662 to 1722).

Description: Boldly drawn lotus scrolls in the outline-and-wash

technique cover the entire vase from top to bottom. In some places the design is interrupted by the swelling central section, and in others it is continuous. On the base is a *ling-chih* fungus mark.

Condition: A hair crack runs down one side from the lip.

The vase, with broad lip, slightly swelling central section, and flaring foot, is based on the shape of an ancient ceremonial bronze vessel of the type known as *tsun*. The *ling-chih* fungus was one of the plants that was believed to possess the property of prolonging life and consequently became a popular symbol in the Taoist repertory. It was used as an auspicious mark on a great many porcelains of the Ch'ing dynasty.

Collections: Roland Moore. Bequest of Childs Frick, 1965.

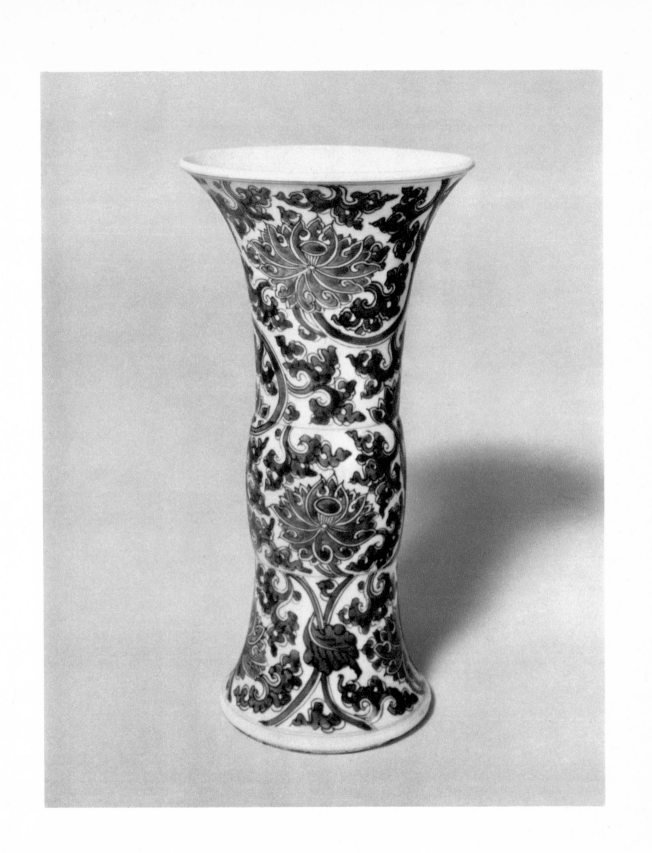

Small Jar with Cylindrical Lid (65.8.190)

H. 4¾ in. (12.1 cm); D. 3 in. (7.6 cm). K'ang-hsi period (1662–1722).

Description: The flat top of the lid is decorated with a single stylized blossom, and there is a pendent leaf pattern around the sides. On the shoulder of the jar is a band of triangular devices each framing three petals. The entire body is covered with an uninterrupted pattern of lotus scrolls with blossoms and leaves in highly stylized versions, all boldly painted in the outline-and-wash technique. The base is marked with an empty double circle.

Condition: The piece is intact.

Collections: J. Pierpont Morgan, London and New York. Roland Moore. Bequest of Childs Frick, 1965.

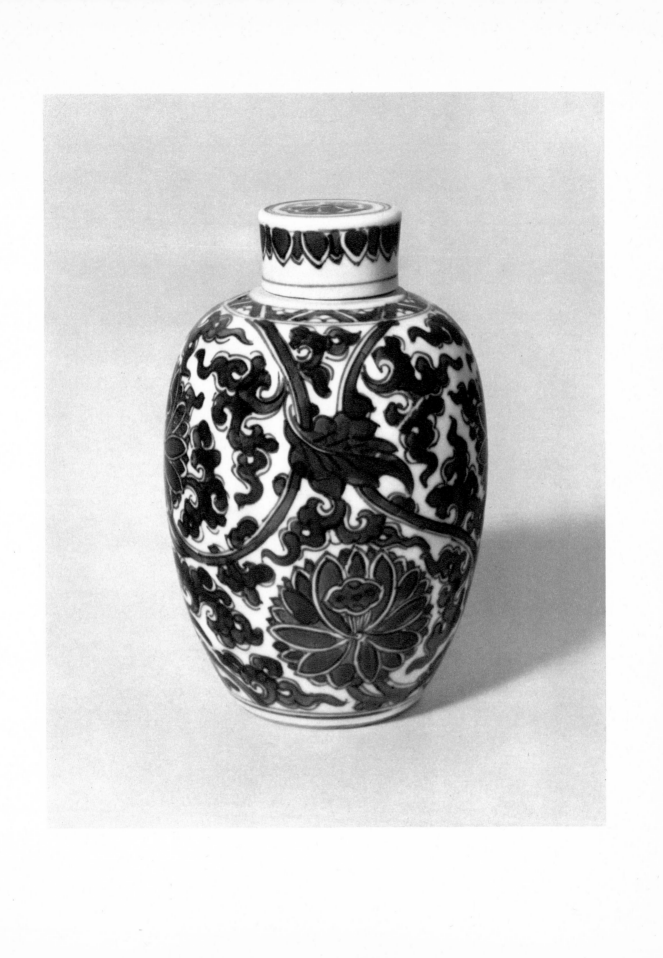

Vase with Broad Neck and Slightly Everted Lip (65.8.116)

H. 7½ in. (19 cm); D. 4 in. (10.2 cm). K'ang-hsi period (1662 to 1722).

Description: Around the lip is a band of triangular devices each framing three petals as seen on the preceding piece and on No. 65.8.112 (p. 55). On the neck are tall standing banana leaves in stylized

form. Below them is a plain white band on which are two torus rings molded in the biscuit under the glaze. The rest of the vessel is covered with the continuous stylized lotus scroll we have already seen. On the base is the six-character mark of the Hsuan-te reign (1426–35) written in three lines of two characters each.

Condition: There are a few chips on the foot rim.

This and the two preceding pieces are grouped together to demonstrate the popularity of this design in K'ang-hsi times and to show the variety of detail and the difference in quality of execution that may be found in repetitions of the same design as done by several decorators.

The occurrence of Ming marks on Ch'ing pieces has already been noted, but that of Hsuan-te is somewhat less usual than those of Ch'eng-hua and Chia-ching. As in other cases the writing of the six characters in three lines leaves us in no doubt that this is a K'ang-hsi version.

Collections: Roland Moore. Bequest of Childs Frick, 1965.

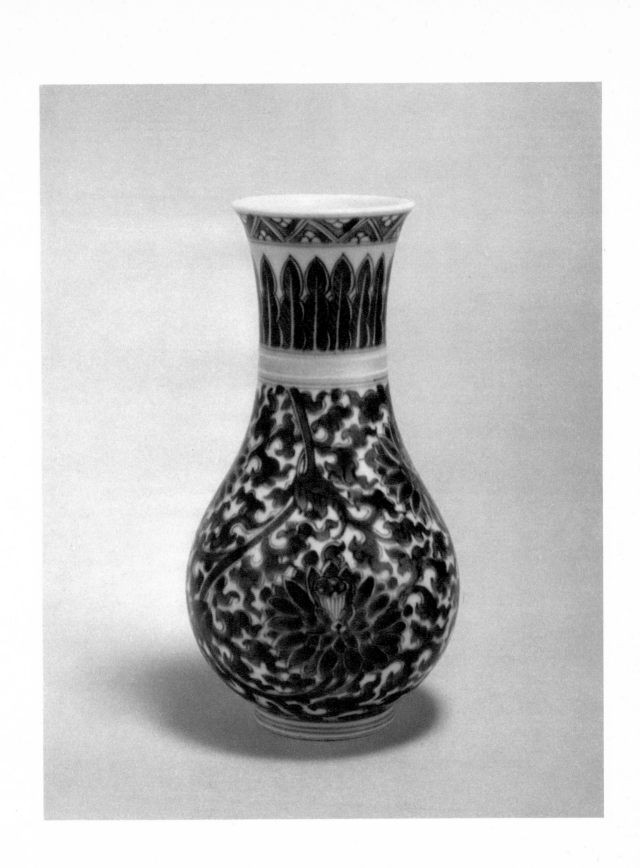

Bottle-Shaped Vase with Globular Body (65.8.111)

H. 9½ in. (24.1 cm); D. 5⅜ in. (13.7 cm). K'ang-hsi period (1662–1722).

Description: A double ring surrounds the lip, and the neck is decorated with a band of tall stylized banana leaves above a hatched chevron band. The body is covered with a flower-and-leaf scroll on which are reserved two large ogival panels. Each of these frames a different landscape scene with mountains and a pavilion beyond a lake and houses on the near shore. The base of this vessel is unusual in that it is completely flat and unglazed with deep concentric striations in the paste.

Condition: The piece is intact.

Collections: Roland Moore. Bequest of Childs Frick, 1965.

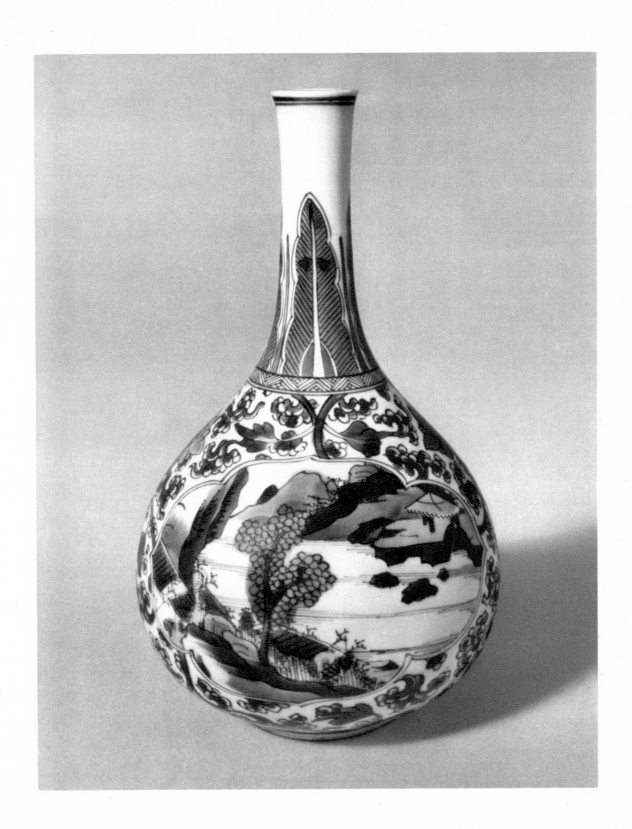

Dish with Foliate Rim (65.8.201)

H. 2⅛ in. (5.5 cm); D. 10⅜ in. (26.3 cm). K'ang-hsi period (1662–1722).

Description: A broad band of four different diaper patterns lies inside the lip, and centered in each is a single auspicious object: a cash, a book, a musical instrument, and an artemisia leaf. The band is broken by four reserve panels framing peach sprays. Below this is a row of twenty-four molded lotus-leaf sections of which every third one is broader than the others. These frame eight different musical instruments separated each from the other by two flower sprays. In the center is a landscape scene with a group of scholars in a boat passing a cliff on a river bank. On the outside is a similar band of diapers and peach sprays with a stylized version of the character *shou* (longevity) written in a different form in a frame in the middle of each diaper section. On the large molded sections below are alternating sprays of plum and bamboo. The six-character mark of the Hsuan-te reign (1426–35) is written on the base.

Condition: There is a chip on the rim.

The central composition is an illustration of the famous poem *The Red Cliff,* by the celebrated scholar, statesman, and poet Su Tung-p'o. The event commemorated by this poem was a battle that took place in the period of the Three Kingdoms when in A.D. 280 the fleet of the great general Ts'ao Ts'ao was burned on the Yangtze River by forces under the command of his adversary Chou Yü. So great was the conflagration that the cliff was discolored by the fire and was ever afterward known as the Red Cliff. The historic site was visited by Su Tung-p'o in 1082 when he and some friends took a boat and drifted below the cliff on the south bank of the Yangtze River some seventy-five miles upstream from the present-day Hankow. It was during this visit that the poem was written; and the scene, with the boat full of scholars drinking wine and singing songs, was a popular subject for artists from the Ming dynasty onward.

Collections: Roland Moore. Bequest of Childs Frick, 1965.

66

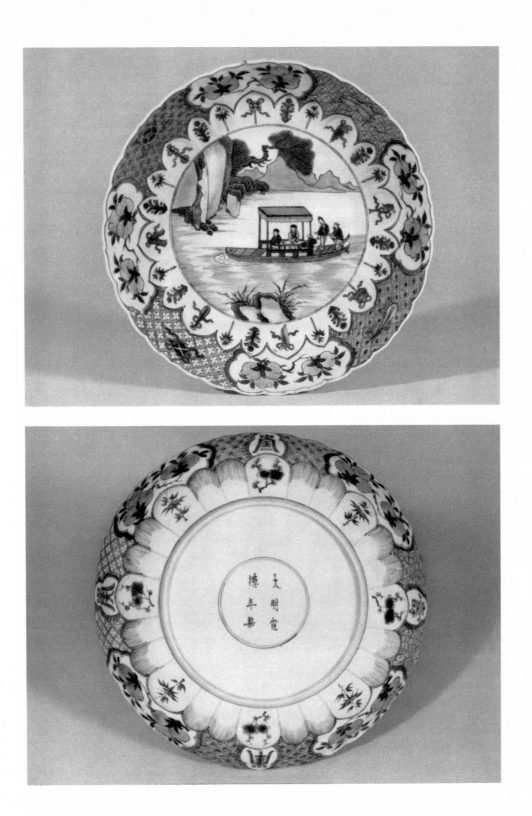

Two Miniature Jars (65.8.124 and 65.8.125)

H. 2⅛ in. (5.4 cm); D. 2¼ in. (5.7 cm). Yung-cheng period (1723–35).

Description: Cloud patterns decorate the necks of the jars, and

around the shoulders are bands of degenerate classic scrolls. The bodies are covered with continuous compositions showing the pine, the plum, and the bamboo. On the base of each is the six-character mark of the Yung-cheng reign (1723–35).

Condition: Both jars are intact.

The plant forms that decorate the bodies of the jars are the traditional Three Friends of Winter, so called because the pine and the bamboo remain green all year round, and the plum tree blooms in the winter months.

Collections: Roland Moore. Bequest of Childs Frick, 1965.

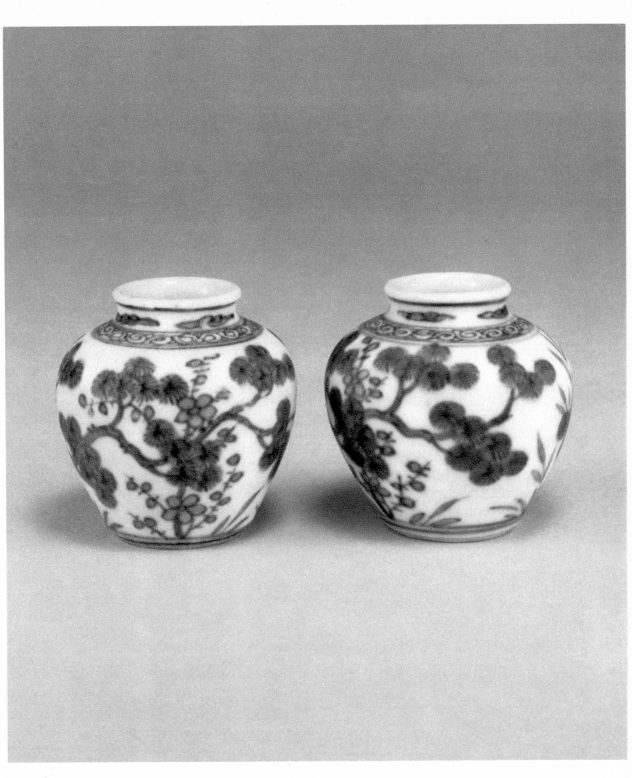

65.8.124 65.8.125

Small Vase with Flaring Foliate Lip (65.8.149)

H. 4 in. (10.2 cm); D. 3½ in. (8.9 cm). Eighteenth century.

Description: The vase is made in the shape of a fruit, probably a pomegranate, and is painted with two fruit sprays. One of these shows peaches, and the other the Buddha's Hand Citron.

Condition: There are some chips in the glaze at the foot and a few small chips on the lip.

The clay of this vessel is of the exceptionally fine type generally known as "soft paste" (*hua shih* in Chinese) which appears to have been a new discovery in the early part of the eighteenth century. Father d'Entrecolles wrote about it in his letter of 1722[1] in which he described in detail the manufacture of porcelain at Ching-te Chen. He said it was a kind of chalk from which Chinese doctors made an infusion which they considered cleansing, aperitive, and refreshing. The mixture of this material into porcelain clay, in place of kaolin, produced a cleaner, whiter, finer surface; and the difference between painting on ordinary porcelain and on soft paste has been described as the difference between painting on paper and on vellum. The extremely fine quality of the two fruit sprays on this piece clearly demonstrates the difference. This was also a much more expensive material and was reserved for the small and very choice objects that graced the scholar's desk (brush rests, water droppers, decorative vases, small wine and tea cups, and the like). The Buddha's Hand Citron (*C. medica digitata*) was grown in China as a potted plant and was often used for gifts as it was reputed to bring good luck.

Collections: Roland Moore. Bequest of Childs Frick, 1965.

NOTES

1 Father d'Entrecolles' letters were originally published in the reports of Jesuit missionaries to their superiors entitled *Lettres édifiantes et curieuses*.... They are reproduced in S. W. Bushell, *Description of Chinese Pottery and Porcelain,* Oxford, 1910. The passage referred to here is on p. 211.

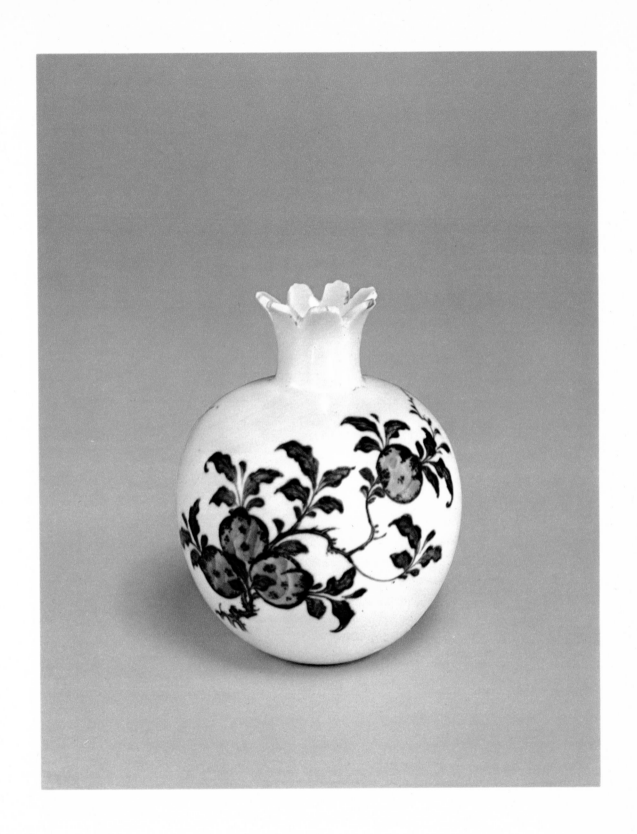

Two Bottle-Shaped Vases with Onion Mouths

(65.8.108 and 65.8.109)

H. 11½ in. (29.2 cm); D. 5½ in. (14 cm). Ch'ien-lung period (1736–96).

Description: Bands of *lei-wen,* the "thunder pattern" borrowed from ancient ceremonial bronzes, surround the lip and shoulder. A stylized lotus scroll decorates the bulbous mouth; and the lower part of the neck is covered with flame-like patterns in inverted lotus panels. The main zone, a broad area filled with various fruits and flowers, is bounded above by a row of pendent trefoils and below by standing lotus panels. A border of breaking waves surrounds the foot. On the base the six-character mark of the Ch'ien-lung reign (1736–96) is written in seal characters.

Condition: Both vases are intact.

Collections: Roland Moore. Bequest of Childs Frick, 1965.

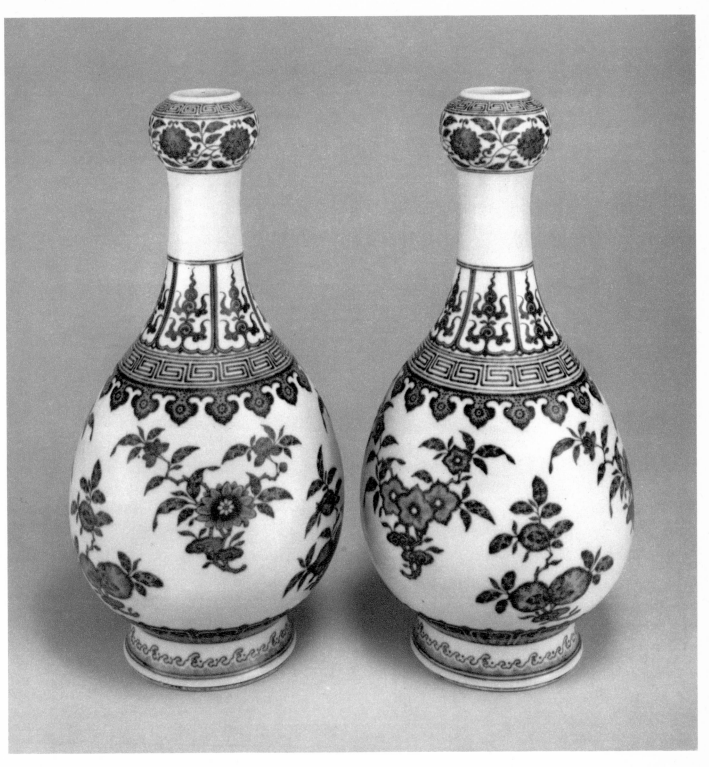

65.8.109 65.8.108

Two Pricket Candlesticks (65.8.144 and 65.8.145)

H. 5¼ in. (13.3 cm); D. 3⅞ in. (9.9 cm). Ch'ien-lung period (1736–96); dated 1744.

Description: The complex forms of the candlesticks are deco-

rated with various stylized wave and flower patterns, and there is a fine classic scroll around the base. In the upper tray is written a poem of forty characters; and on the base is the four-character mark of the Ch'ien-lung reign (1736–96) written in seal style.

Condition: There is a chip in the foot rim of No. 65.8.144, and the metal prickets of both candlesticks are broken off.

The poem written on the upper tray of each candlestick may be translated as follows:

Who compares a Ta-i porcelain
With a Chiu-hua lamp?
Tranquil, unsoiled by earthly dust, the night
Is transformed into day by the lamp's glow.

It burns while poems are composed,
Its cast shadow a companion to the studious.
What need, then, for a Chao-yang Palace
Boasting lamps of gold and jade?

Following the poem are the words: "Imperially written in the second month of spring in the *chia-tzu* year of Ch'ien-lung." That month fell between March 12 and April 11, 1744, by our calendar.

The references to Ta-i porcelain and to the Chiu-hua lamp are allusions to the writings of the eighth-century poet Tu Fu. The Chao-yang Palace was a Han dynasty structure (second century B.C.) that became legendary for its lavish appointments. A similar pair of candlesticks, with the metal prickets intact, and inscribed with the same poem and the same date, is in the National Palace Museum in Taipei, Taiwan. Another single candlestick of the same type was recorded in 1959 in the collection of S. C. Coles.[1] There are frequent references to candles in Chinese literature before the beginning of the Christian era, and what appear to be pricket candlesticks of bronze have been excavated from tombs of the Warring States Period (403–221 B.C.) at Ch'ang-sha in Hunan province.

Collections: Roland Moore. Bequest of Childs Frick, 1965.

NOTES

1 S. Jenyns, *Later Chinese Porcelain,* London, 1959, Pl. XCIV(2).

74

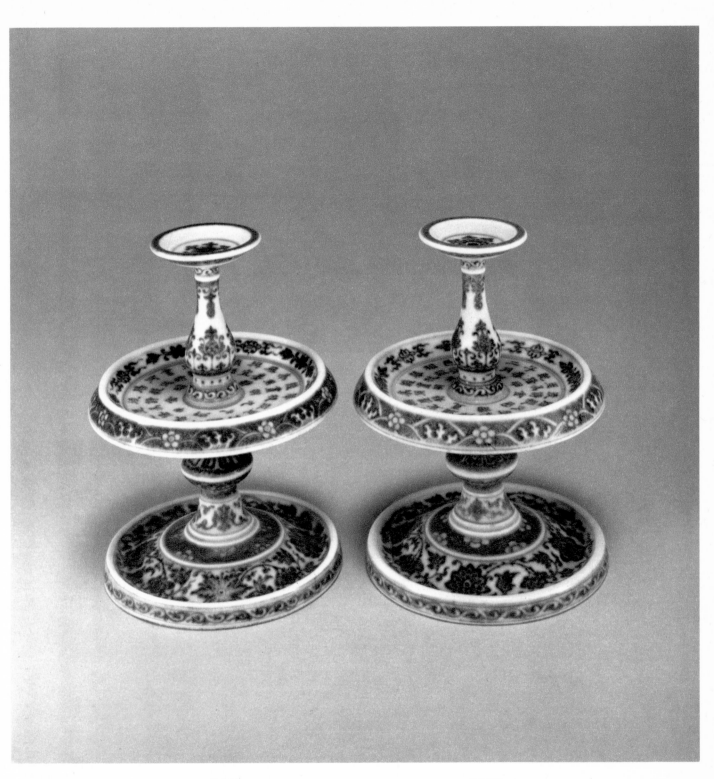

65.8.144 65.8.145

Two Low Candlesticks (65.8.140 and 65.8.141)

H. 2⅜ in. (6 cm); D. 2⅞ in. (7.3 cm). Eighteenth century.

Description: Elaborately stylized banana leaves surround the base of each neck; and below this is a slightly raised ring from which the dome-like base spreads out and down. At the top of the base is a band of degenerate classic scroll, and the main area is decorated with floral scrolls having several kinds of blossoms on each. The flat base is pierced by a central hole surrounded by four smaller holes.

Condition: Both candlesticks are intact.

The rippled surface of the glaze on the bases suggests a date toward the latter part of the eighteenth century, and this feature was to become more common on glazes produced in the early part of the nineteenth century.

Collections: Roland Moore. Bequest of Childs Frick, 1965.

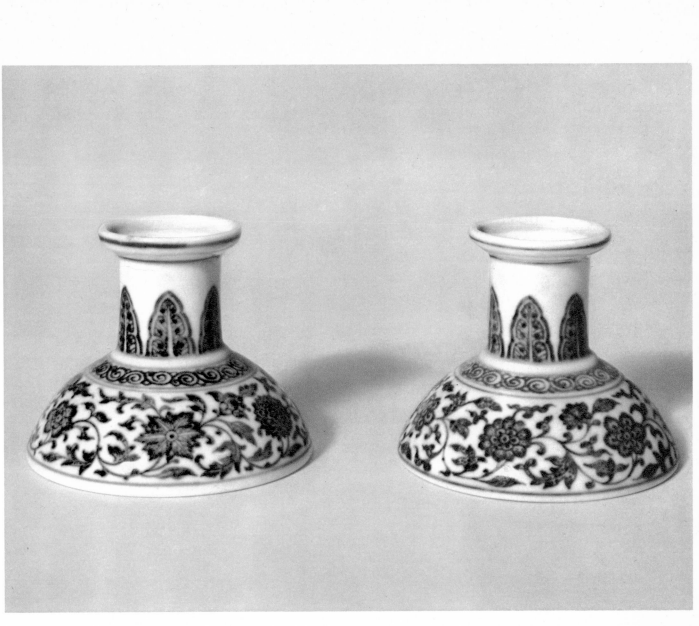

65.8.140 65.8.141

Miniature Four-Legged Vessel with Spout and Handle (65.8.187)

H. 4⅜ in. (11.1 cm). Ch'ien-lung period (1736–96).

Description: Bands of *lei-wen* "thunder pattern" appear on the edge of the lid and on the shoulder of the vessel; and the lid, neck, handle, spout, and legs are covered with *ling-chih* fungus scrolls. Around the body are the Eight Lucky Emblems of Buddhism: the endless knot, the pair of fish, the vase, the canopy, the royal parasol, the conch, the wheel, and the lotus. On the base, between the four solid legs, is the six-character mark of the Ch'ien-lung reign (1736–96) written in tiny seal characters.

Condition: The piece is intact.

The form of the vessel is a miniature reproduction of an ancient ceremonial bronze of the type known as *huo*.

Collections: Roland Moore. Bequest of Childs Frick, 1965.

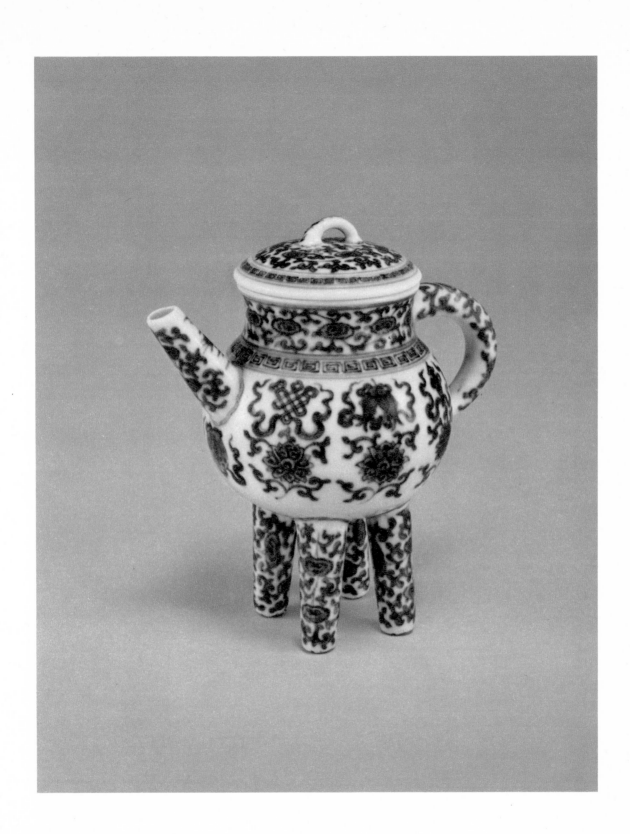

Dish with Foliate Rim (65.8.202)

H. 1⅞ in. (4.8 cm); D. 11 in. (27.9 cm).
Eighteenth century.

Description: The rim is divided into eight segments, and the lip is gilded. Each indentation is marked by a curious tusk-like form in relief and outlined in blue that curves downward toward the center. Between these divisions are four butterflies alternating with four flower sprays. In the center is a landscape scene with a lake bordered by mountains and trees. In the foreground is a house on the terrace of which two men watch a boat approaching across the lake. Four birds fly in the sky, and there are clouds among the trees and mountains at the right in front of a pavilion. In the distance at the left is a pagoda. The outside is completely undecorated, with only the eight tusk-like forms showing in sunken relief.

Condition: There are flaws in the glaze at the ends of all but one of the tusk-like elements.

Collections: Roland Moore. Bequest of Childs Frick, 1965.

80

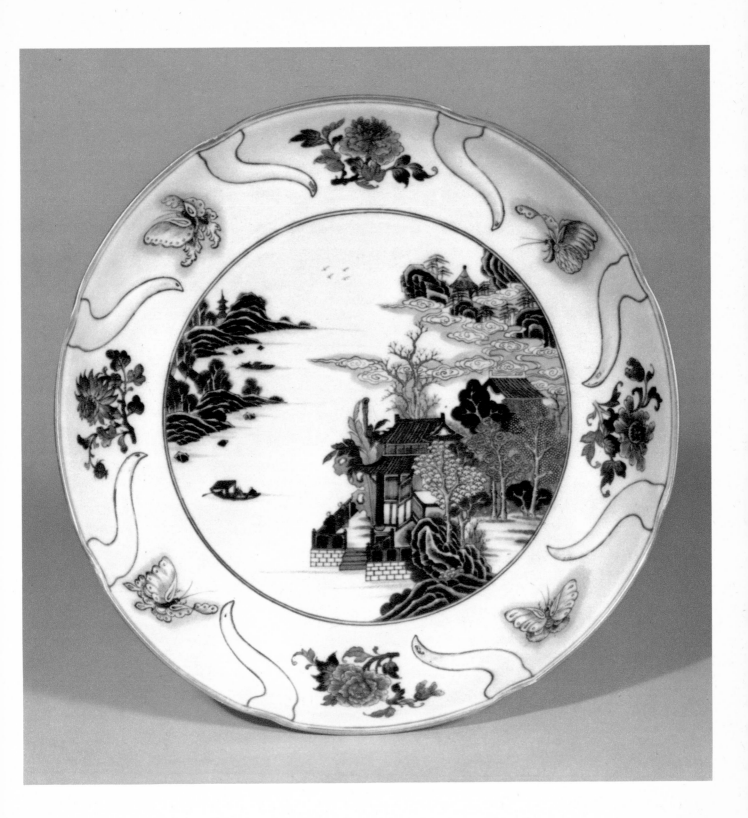

Small Cup with Plain Rim (65.8.179)

H. 2½ in. (6.4 cm); D. 3⅛ in. (7.9 cm). Chia-ch'ing period (1796–1820).

Description: The little cup has slightly curving sides rising to an almost vertical rim. The surface is decorated with two dragons and two phoenixes flying among clouds. The six-character mark of the Chia-ch'ing reign (1796–1820) is written in seal script on the base.

Condition: There is a short hair crack at the rim.

The piece is noteworthy as a good-quality example of blue-and-white from a period that is little represented in most collections.

Collections: Roland Moore. Bequest of Childs Frick, 1965.

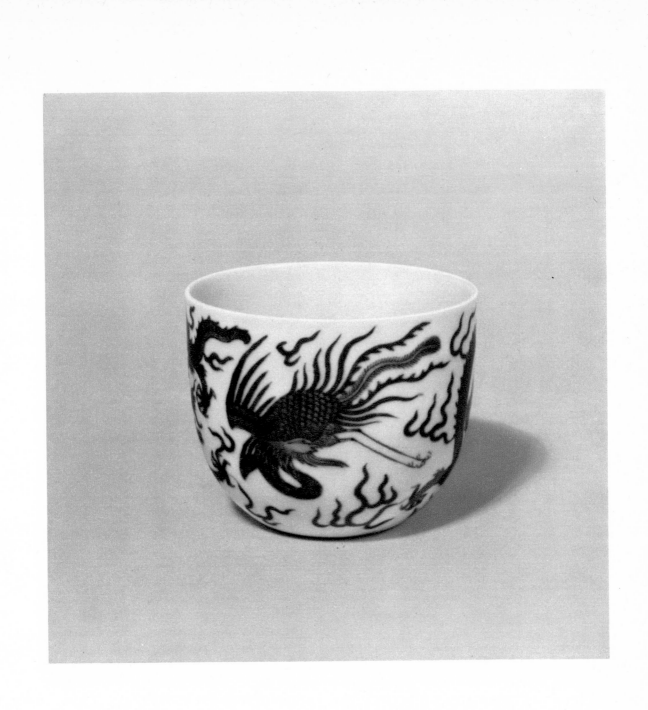

ENAMELLED WARES

Most of the Chinese porcelains bought by Henry Clay Frick were decorated with enamels. The great majority of these were purchased from the estate of J. Pierpont Morgan in 1915, and a few more were added in 1916 and 1918. The dates are important because this was the end of the era when porcelains solidly covered with enamel colors were very much in fashion. Most of them were bought by the wealthy collectors (Altman, Frick, Grandidier, Leverhulme, Morgan, Rockefeller, Salting, Widener) in the decade or two before and after the turn of the century. These included, above all, the large vases with black grounds and, most often, plum-tree decoration that were known by the French as *famille noire,* and by the British as black hawthorn. Then there were the human and animal figures splendidly painted with green, yellow, aubergine, and other colored enamels; and there were the covered jars with solid pink grounds known as *famille rose* in which were reserved white panels of various shapes painted with flowers, birds, landscapes, genre scenes, and whatnot over the glaze. This group of enamelled wares comprised what people meant when in those days they spoke of Chinese porcelain. It is only fair to add that the men who bought them at astronomical prices were not collectors of Chinese porcelain at all. They were collectors of old-master paintings, sculpture, furniture, and the like. These porcelains were a side issue and were urged upon the collectors by the dealers of the time as appropriate to the general ambiance in which the paintings and other works of art should be shown. Among the men who were then seriously collecting Chinese art, only William Thompson Walters and his son Henry of Baltimore bought anything of this kind. The other major collectors in the field like Bigelow and Weld of Boston, Charles Freer of Detroit, and Alfred Hippisley had none of them; and it is noteworthy that the latter did most of their buying in the Far East.

As the *famille noire* and *famille rose* vases and jars and the enamelled figurines started to multiply in the collections of France, England, and the United States, they began to be studied by the early writers on the subject, and, based almost entirely on the word of the dealers who supplied them, history and chronology were

constructed to fit them. We were assured that the black hawthorn vases were made in K'ang-hsi times (1662–1722) at the imperial factories of Ching-te Chen which produced them as "temple ornaments" and "for the emperor's pleasure." These and similar fanciful phrases, originating no doubt in the fertile minds of Shanghai dealers, provided what information we had on the subject. The beginnings of the *famille rose* palette were carefully traced, and the jars and vases and dishes of this type were assigned to the succeeding reigns of Yung-cheng (1723–35) and Ch'ien-lung (1736–96). The enamelled figurines were assigned to K'ang-hsi when the colors were purely *famille verte,* and to the later reigns as the rose-pink enamel began to creep into the color scheme. All these types loomed large in the publications of the late nineteenth and early twentieth centuries, and they are illustrated in handsome color plates in the most important books of that era.

In recent decades the whole view of these wares has undergone a drastic change. Writing in 1951 Soame Jenyns said, "The *famille noire* group has in the past occupied a place entirely out of proportion to its interest or aesthetic value."[1] And while he did not say so then, it is becoming clearer and clearer that the same is true of a great deal of the *famille verte* and the *famille rose.* Many very fine wares in the latter techniques were made, and the extremely delicate and tasteful porcelains that are now described as being "in the Chinese taste" are decorated in those palettes. But the big wares, often completely covered with heavy enamel coatings, are in quite a different category. Serious research on the origins of these has only recently begun, but the evidence so far tends to suggest that they were made for the European market, and that not so very long ago.

The earliest illustrations of large *famille noire* vases appear to be those of Du Sartel in 1881,[2] and such porcelains were evidently well known by his time. In addition to one of his own pieces, he illustrates two belonging to the English collector Salting, and one each belonging to the Paris dealer Marcel Bing and to a M. Fournier, *père.* The group includes one large beaker vase,[3] one of the square-bodied vases, a *rouleau* vase, and two small beaker types, one with a lid. The heights range from 15¾ to 27½ in. Beginning with this pioneer publication, the first handsomely illustrated work on Chinese porcelain to be published in the West, the *famille noire* vases could be counted upon to appear regularly in most publications for the next fifty years or so. It is worthy of note that, just as the collectors who bought in the Far East had none of these in their collections, so none of them

appeared in the books of authors who worked in the Far East or who based their research on Chinese sources.

Further, it must be pointed out that none of the scholars working on porcelain in the National Palace Museum in Taiwan had ever seen any such thing until a *famille noire* vase was presented to the museum in 1950. There are none among the twenty-three thousand pieces in that museum, which has as its nucleus the collection assembled by the Ch'ien-lung emperor in the eighteenth century and increased by further imperial benefactions during the remaining years of the Chinese empire. From the European side it should be noted that no such pieces were in the collection formed at Dresden by Augustus the Strong, Elector of Saxony and King of Poland between 1694 and 1733. The first inventory of that collection, made in 1721, and a later inventory of 1779 list only five small cups and saucers with black enamel decoration in the first case, and two small figures of green lions holding black enamelled jars in the second. The one large black hawthorn jar in the collection was a gift received in 1939. Two vases of the square-bodied type now in the Rijksmuseum in Amsterdam came from the collection of J.C.J. Drucker. These appeared on the market in an auction at Christie's in 1888 when some of the treasures of Burghley House were sold. The present Lord Exeter thinks they may have come into the family at the time of the ninth Earl of Exeter (1754–93), who was known as a collector of *objets d'art;* yet there appears to be no record of them in the family inventories.[4] This is the only instance where there has been any chance of tracing large *famille noire* vases to a time earlier than the middle of the nineteenth century; but the end result is not very encouraging. The so-called documentation of some other pieces carries even less conviction. James Henry Duveen, for example, tells us that a set of four black hawthorn vases was "brought over from Holland by William III, to whom they had been sent as a gift by the Emperor of China when he was appointed Stadtholder of Holland and Zeeland in 1673, and that the vases had remained at Kensington Palace until 1837, when the Duke of Cumberland had left his London residence to occupy the throne of Hanover. Before leaving London he presented these vases to his English mistress, from whose last descendant I had bought them." After abortive attempts to sell them to Mrs. Arabella Huntington and to Benjamin Altman, James Henry Duveen sold them to Joseph Widener, and they are now in the National Gallery of Art in Washington.[5] From the historical side there is no evidence that the K'ang-hsi emperor ever sent gifts to William of

Orange at that or any other time. Other suggested "documentation" is even less convincing. It has been pointed out that the French painter François Boucher bought, in 1752, an "urne de porcelaine la Chine sur un fond noire."[6] But this description is very far from suggesting one of the large black hawthorn vases.

As for the other wares concerned, it is a striking fact that both the enamelled figurines of persons and of animals and the covered jars with rose-pink grounds are completely unknown in the collection of the National Palace Museum. In reply to questions directed to our learned colleagues in Taiwan, scholars who have spent their lifetimes studying the largest, finest, and most authentic Chinese porcelain collection in the world, the answer is invariably that they know of nothing like them, and that they can only assume they were made in some minor provincial kilns for export to Europe in the nineteenth century.

From quite another angle, there is one more point to be added. It has long been rumored that these wares were copied in Japan. This rumor was substantiated in 1971 by definite evidence that many late Ch'ing wares including *famille verte, famille noire,* and *famille rose* were in fact imitated in the porcelain town of Arita in Saga prefecture on the island of Kyushu. Between the twenty-fifth and thirtieth years of the Meiji period (1892–97) thousands of them were made for export to Europe and America.[7]

In view of all the uncertainty that now surrounds the origins of these enamelled wares of the three major types *(verte, noire,* and *rose)*, it is impossible to say whether any of them were made before the nineteenth century or not. For that reason the enamelled wares described and illustrated in this catalogue have simply been dated Ch'ing dynasty (1644–1912). At the present state of our knowledge it is not reasonable to try to be more accurate than that.

NOTES

1 S. Jenyns, *Later Chinese Porcelain,* London, 1951, p. 34.

2 O. du Sartel, *La Porcelaine de Chine,* Paris, 1881, p. 194, Figs. 108, 109, Pls. IV, XXI.

3 Vases of this type (for example, Frick No. 15.8.17, p. 107) were called *yen-yen* by Hobson and other early writers. Chinese scholars in the field today do not know this term, and presumably it was an invention of the Shanghai dealers of the time.

4 Letter of August 24, 1970.

5 J. H. Duveen, *The Rise of the House of Duveen,* New York, 1957, pp. 283 ff.

6 *Livre-Journal de Lazare Duvaux,* ed. L. Courajod, Paris, 1873, II, p. 119.

7 This information was given to me verbally by Yoshinori Imaizumi, son of the present head of the family that has made Nabeshima ware since the seventeenth century. On my visit to Arita in April 1971 I saw these imitation Chinese wares in the Nabeshima factory museum, and we discussed the matter at that time.

FAMILLE VERTE

Two Five-Piece Sets with *Famille Verte* Decoration

(18.8.5–18.8.9 and 15.8.10–15.8.14)

H. of jars, including lids and porcelain stands (average), 10⅛ in. (25.7 cm); H. of vases, including porcelain stands (average), 8⅝ in. (22 cm). Ch'ing dynasty (1644–1912).

Description: The three covered jars and two vases with handles in the first set (Nos. 18.8.5–18.8.9) have bodies molded to resemble clusters of bamboo stalks. The segments of the bamboo serve as frames for a variety of flowers and foliage painted largely in green and yellow enamels with occasional touches of aubergine and iron red. The flat areas on the necks of the vases are covered with diamond diaper pattern; and the handles are molded to simulate short sections of bamboo. A band of petals held by a ribbon surrounds the neck of each jar. Each piece has an individual porcelain stand to which it has been fastened with metal clamps.

The second set (Nos. 15.8.10–15.8.14) is similar in form, but here the bodies are vertically segmented and covered with diamond diaper pattern on which are reserved ogival panels each framing a stylized flower. On the necks of the vases the flowers are placed directly on the diaper ground without any frames. The same bands of petals as on the first set surround the necks of the jars, and from the waist down is a band of long pendent banana leaves. The handles of the vases are not molded but have the same outline as the others. Again the color scheme is dominated by green and yellow with touches of aubergine.

Condition: Nine of the ten pieces have various cracks, chips, breaks, repairs, and restorations which need not be enumerated in detail.

The two sets were acquired separately, one in 1915 and one in 1918. They were divided into two lots based on the decoration of the bodies. But there is so much confusion among the lids and the stands that they may all be discussed here as a single group. The lids vary greatly in size and shape and in most instances are ill suited to the vessels they cover. Some are too large, some are too small, and rarely does the decoration match. The same is true of the stands; only three pieces out of the ten have their proper stands; in the rest of the cases there is no relation between the two. And the two six-legged stands under the vases in the first set obviously belong to some entirely unrelated pieces.

By way of explanation we must recall that wares of this kind were made by tens and hundreds if not by thousands. Furthermore, it was Chinese practice to fire lids and stands separately from the vessels which they were destined to serve. So between the infinite amount of handling that took place in the factory itself and the

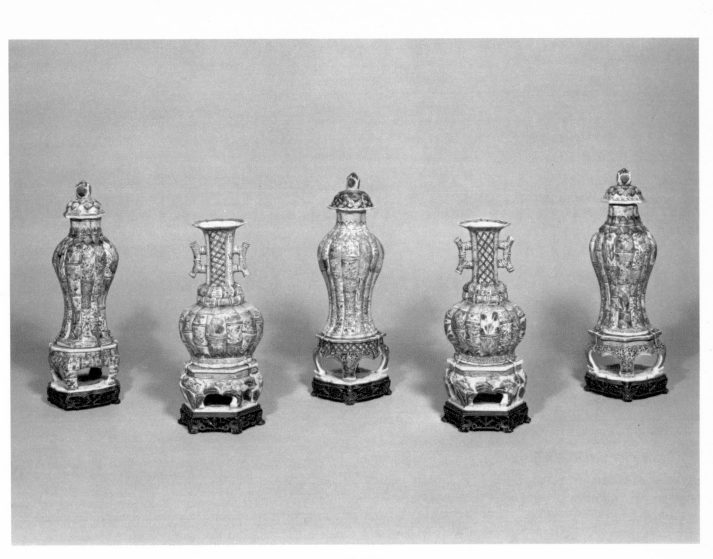

18.8.5–18.8.9

subsequent packing and shipping and unpacking at the hands of innumerable shippers and dealers and collectors, there was ample time for confusion and substitution.

Exhibited: New York, Metropolitan Museum, 1907, Case XXIV (Nos. 581–85), lent by J. Pierpont Morgan.

Collections: James Orrock, London. J. Pierpont Morgan, London and New York, 1904. Duveen. Frick, 1918.

Exhibited: New York, Metropolitan Museum, 1895, Case 14, lent by James A. Garland. New York, Metropolitan Museum, 1907, Case XXVI (Nos. 687–91), lent by J. Pierpont Morgan.

Collections: Duke of Marlborough (?).[1] James A. Garland. Duveen. J. Pierpont Morgan, London and New York, 1902. Duveen. Frick, 1915.

NOTES

[1] Frick Nos. 15.8.10–15.8.14 were described as "From the Blenheim collection" in the 1895 catalogue of the Garland collection (J. Getz, *Metropolitan Museum of Art: Hand-Book of a Collection of Chinese Porcelains Loaned by James A. Garland,* New York, p. 47, repr. facing p. 46). A five-piece set loosely fitting the description of the Frick group did appear as Lot 828 in the August 9, 1886, session of the Blenheim Palace sale *(Catalogue of the Collection of Pictures and Porcelains from Blenheim Palace,* July 24 *et seq.,* 1886, Christie's, p. 123): "A set of three hexagonal vases and covers; and a pair of beakers, with foliage in lavender and green on chequered yellow and green ground." It is possible that the first Frick set, Nos. 18.8.5–18.8.9, the provenance of which can be traced with certainty only back to 1904, also appeared in the Blenheim sale, inasmuch as the description of Lot 402 in the August 3 session (p. 83) fits this group quite closely: "A set of three bamboo-pattern vases and covers; and a pair of two-handled bottles, with flowers in green, yellow and lilac—on openwork stands."

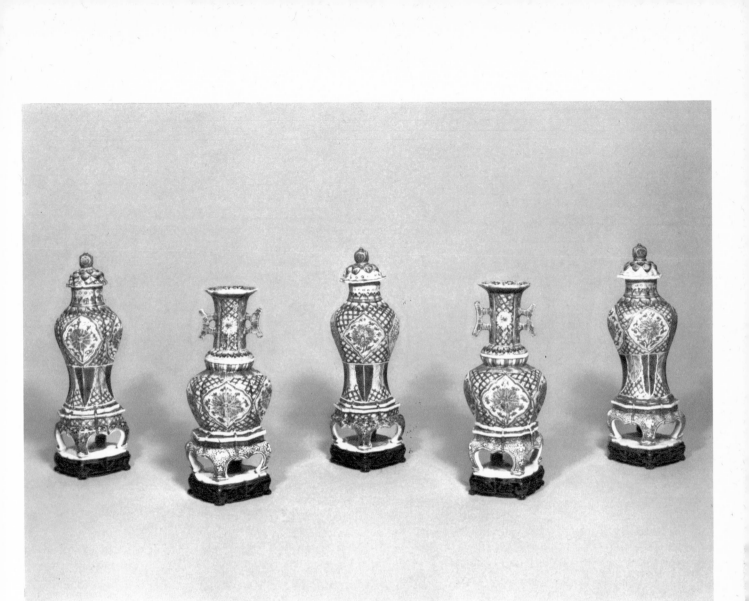

15.8.10–15.8.14

Pair of Lions (15.8.15 and 15.8.16)

H. 19 in. (48.3 cm). Ch'ing dynasty (1644 to 1912).

Description: The bodies of the lions are covered with a washy, uneven green enamel over the biscuit. On parts of the mane and ears and on the tail is a blotchy grayish-blue enamel painted over thin black lines which simulate hair. Alternating with the blue areas of the mane and ears are similar thin stripes of iron red and gold on areas glazed in white especially to receive these overglaze colors. All three schemes occur together on the curls.

On the chest and the fronts of the legs are stripes of yellow enamel with black speckling. Across the tops of the paws are blue enamel stripes over black spirals, and this design extends up the inside of the forelegs. Gold flames edged with red appear in some areas. On the flat, unglazed base the paste is very coarse and roughly finished. There is a large, uneven circular opening near the back of each base. The wooden stands are modern.

Condition: The long lower left tooth of No. 15.8.15 is missing.

Sometimes called "Dogs of Fo," these lions originated as the guardians of the Buddha when Buddhism came to China from India in the early centuries of the Christian era. By the time these porcelain figures were made, they had long since lost all spiritual meaning and were simply produced as ornaments for the export trade to Europe.

Exhibited: New York, Metropolitan Museum, 1907, Case H (Nos. 15, 16), lent by J. Pierpont Morgan.

Collections: J. Pierpont Morgan, London and New York, 1907. Duveen. Frick, 1915.

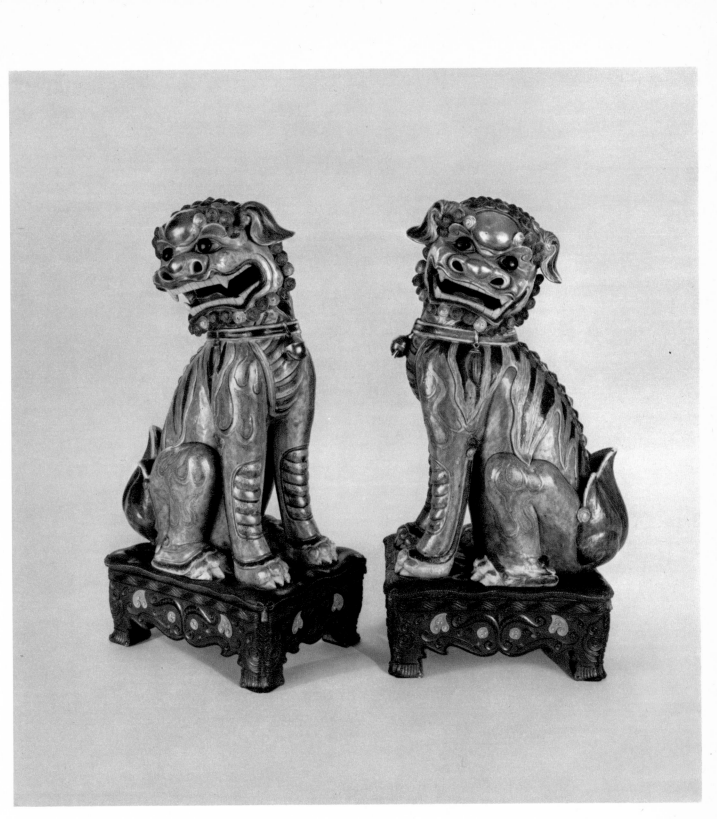

15.8.15 15.8.16

Two Figures of Ladies on Stands (18.8.39 and 18.8.40)

H. 38 in. (96.5 cm). Ch'ing dynasty (1644 to 1912).

Description: Number 18.8.39 has a green skirt decorated with alternating chrysanthemum and rose blossoms between two rows of smaller trilobate floral sprays. The robe has an aubergine ground covered with dense scrolls on which are large flowers evenly spaced. Number 18.8.40 has a yellow skirt with evenly spaced medallions of flying storks between two rows of trilobate peach sprays. Her robe is decorated with large blossoms very closely spaced over the scrollwork on the green ground. The two stands are very similar, with openwork sides in swastika patterns, chrysanthemum scrolls on the canted corners, and a simulated cloth over the top with a corner hanging down on each side. The bottom section is carved in high relief to simulate an elaborate arching base with two legs at each corner. Typical colors of the *famille verte* palette are used throughout.

Condition: The head, ears, neck, and collar of No. 18.8.39 have been repaired; and the left side of the face is a complete restoration. The companion piece has been broken in two at the waist and again about 3½ in. below the waist, and is repaired at both points. The head, neck, and collar of this figure are also repaired, and in this case the right side of the face is new. The hair on both figures has been tampered with in some undetermined way.

The floral patterns on the garments and the scrollwork and geometric decoration on the stands are intricately conceived and skillfully executed. There is a textile imprint on the unglazed base and the inside walls of each stand. The bases of the figures also are unglazed, and the paste is very fine. There is a crack across the wide axis of the bottom of each figure from the left extremity of the skirt to the right, showing the joint between the two molds with which the front and back halves of the figures were modelled. The join is visible up the side of No. 18.8.39 as far as the sleeve.

Exhibited: New York, Metropolitan Museum, 1907, Case K (Nos. 1, 2), lent by J. Pierpont Morgan.

Collections: J. Pierpont Morgan, London and New York, 1907. Duveen. Frick, 1918.

100

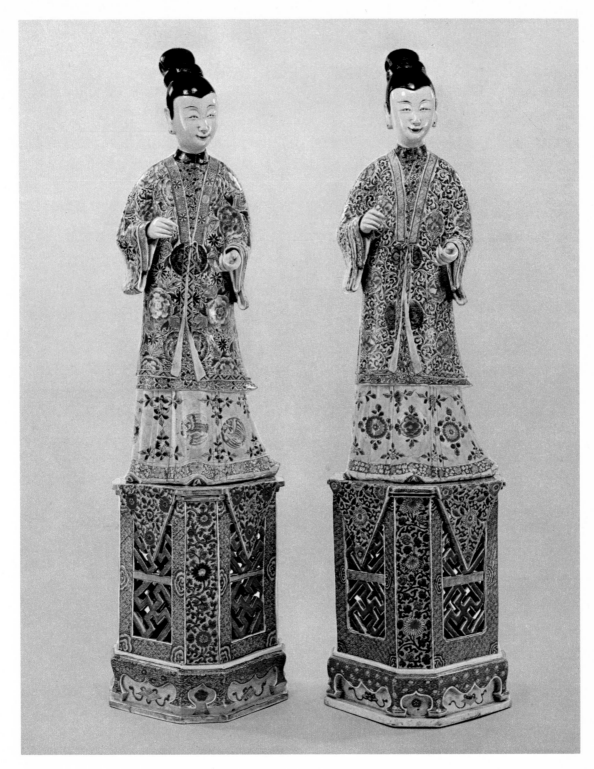

18.8.40 18.8.39

Tall Vase with Green Ground (15.8.27)

H. 27 in. (68.6 cm); D. 10½ in. (26.7 cm). Ch'ing dynasty (1644–1912).

Description: A single large plum tree growing from behind rocks spreads its two main trunks and many blossom-filled branches around the vase and upward, gradually covering most of the surface and providing the principal decoration. Some bamboo and peony plants also grow from behind the rocks, and green-and-yellow birds fly and perch among the branches on both the body and the neck.

Condition: Breaks and repairs in several places on the lip have been covered with paint. Two large areas of similar paint are on the shoulder where there is considerable brown spotting on one side which may result from the decomposition of the paint.

Vases of this size with green ground and plum-tree decoration are rare, and in fact only six such pieces are known. These include one in the Metropolitan Museum of Art, New York (Altman Collection); one in the Victoria and Albert Museum, London (Salting Collection); one in the William Rockhill Nelson Gallery of Art, Kansas City; one in the Gulbenkian Collection, Lisbon; and one in the hands of a New York dealer. A similar piece, admittedly twentieth-century, belongs to another New York dealer.

Exhibited: New York, Metropolitan Museum, 1897 (?), lent by James A. Garland. New York, Metropolitan Museum, 1902, No. 806, lent by J. Pierpont Morgan.

Collections: Thomas B. Clark, who is said to have bought it from a M. Vapereau (or Vaperan), attaché to the French legation at Peking. James A. Garland, 1897. Duveen. J. Pierpont Morgan, London and New York, 1902. Duveen. Frick, 1915.

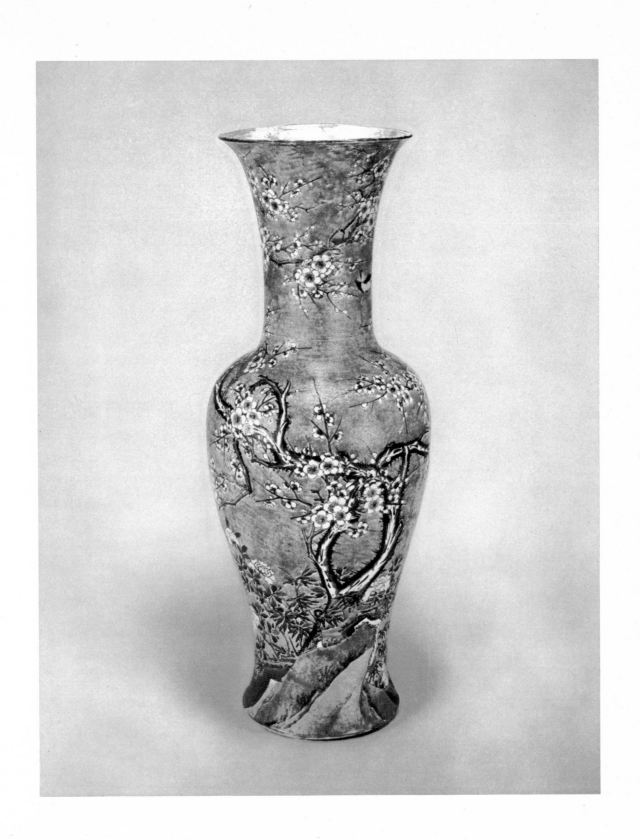

FAMILLE NOIRE

Tall Vase with Black Ground (15.8.17)

H. 27 in. (68.6 cm); D. 10½ in. (26.7 cm). Ch'ing dynasty (1644 to 1912).

Description: The main decoration is a single plum tree that grows from a cluster of rocks and spreads its double trunk and numerous branches to cover the surface of the vase. The trunks and branches are drawn in brownish-purple, and the abundant white blossoms against the greenish-black ground constitute the most striking aspect of the decoration. Ten small yellow-and-green birds fly among the branches and perch upon them. Bamboos also grow from the green rocks at the base of the composition. The six-character mark of the Hsuan-te reign (1426–35) is written on the base in three lines of two characters each.

Condition: Two large pieces have been broken out of the lip and replaced by pieces of similar shape from a blue-and-white vase. The replacements were then painted over with black to match the rest of the vase, but some of the paint has since chipped off.

The painting and enamels on this vase are mediocre. The brownish-black undercoat is unevenly painted so that the green enamel over it looks blotchy in places. There are three different shades of green: *(i)* a dark green for the twigs and leaves; *(ii)* a very pale green for some of the rocks; and *(iii)* a muddy yellowish-green on other rocks. In places the dark green runs down over the white plum blossoms and covers the branches; here and there it overlaps the tree trunks. The strongly written Hsuan-te mark on the base has no double circle around it. The characters were presumably written in cobalt oxide as is customary, but not enough glaze was applied to the base so the cobalt did not turn blue but remained a dull brown.

Collections: Frick, 1915.

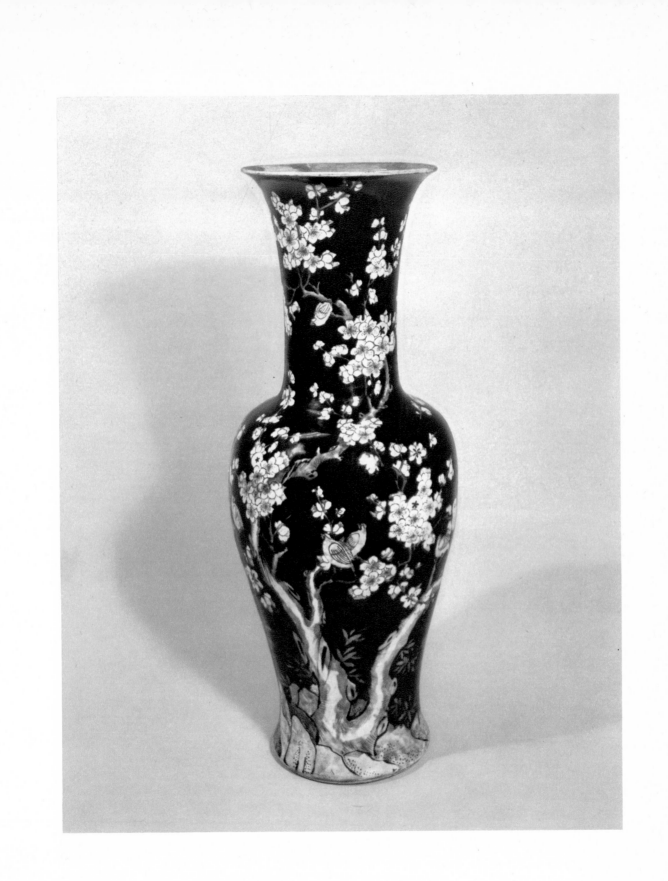

Tall Vase with Black Ground (15.8.18)

H. 26¼ in. (66.7 cm); D. 10¾ in. (27.3 cm). Ch'ing dynasty (1644–1912).

Description: A single plum tree grows out of a clump of rocks to form the main decoration. The trunk and the branches are strongly marked with bold dark strokes. Eleven yellow birds are seen among the branches and foliage.

Condition: One large break in the lip has been repaired. On one side the lip was bent out of line while the clay was still soft before the vessel was fired.

Except for a muddy green, the enamels are of good quality and well painted. In some areas the black is particularly good and strong; in others it is blotchy.

Exhibited: New York, Metropolitan Museum, 1907, Case XXX (No. 784?), lent by J. Pierpont Morgan.

Collections: J. Pierpont Morgan, London and New York, 1904. Duveen. Frick, 1915.

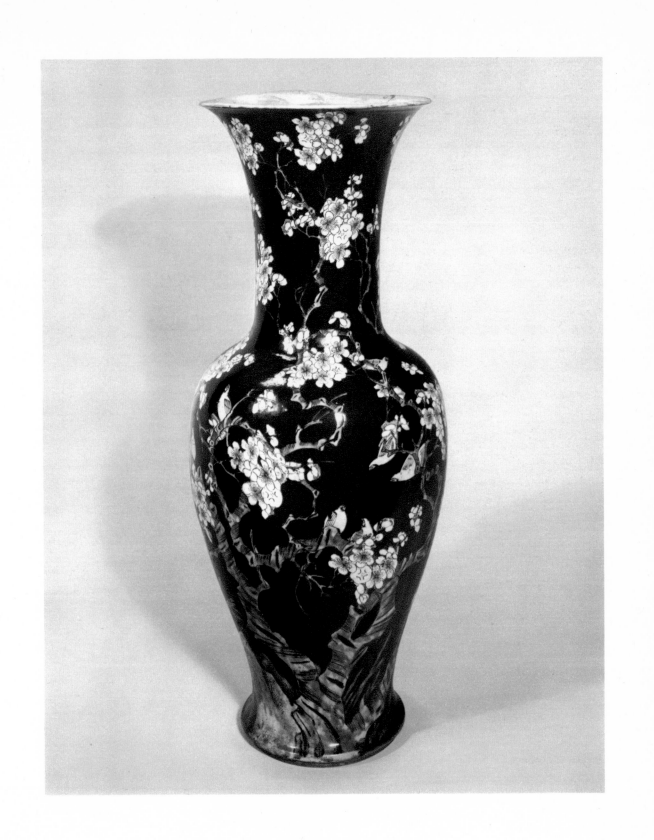

Tall Vase with Black Ground (15.8.19)

H. 27¼ in. (69.2 cm); D. 10¾ in. (27.3 cm). Ch'ing dynasty (1644–1912).

Description: One large plum tree dominates the design as on the three preceding vases. In this case the trunk is strongly accented with large white loop-like figures of various shapes. Three small yellow birds fly among the blossoms and three are perched on twigs and branches, all on the neck of the vase. The wings of the latter group are indicated in outline only.

Condition: There is one large repair on the lip. The joint between the neck and the body is clearly visible ⅜ in. above the shoulder.

The trees are unusually freely and boldly painted. This style, with white loops accenting the trunks and branches, is found on black-ground vases in various collections and may represent the personal style of one decorator. In some places the black slip shows through to accentuate knots. The black is good and solid. On the roughly finished base is a very thin coating of glaze.

Collections: Thomas B. Clark, who is said to have imported it from China before 1903. Marsden J. Perry, Providence, Rhode Island. J. Pierpont Morgan, London and New York, 1911. Duveen. Frick, 1915.

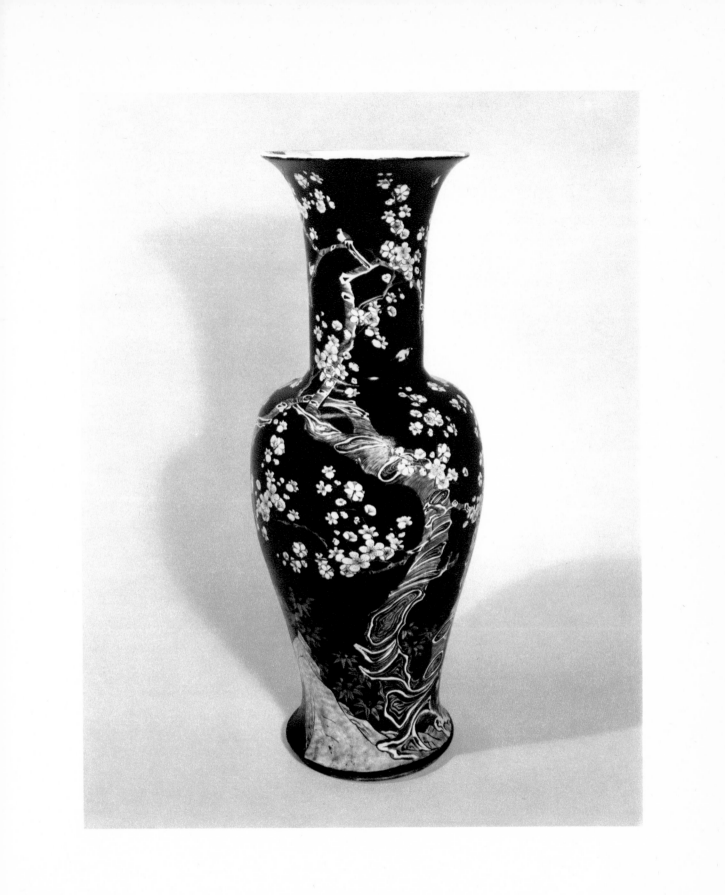

Tall Vase with Black Ground (15.8.24)

H. 27 in. (68.6 cm); D. 11 in. (28 cm). Ch'ing dynasty (1644–1912).

Description: Great masses of rock pile up almost to the shoulder of the vase; growing out of this and above it are large white peonies, hydrangeas, and magnolias. Although, as in all these compositions, botanical accuracy is not the main concern and all blossoms seem to grow everywhere, the tree trunks in this scene appear to be those of the magnolia.

Condition: The piece is intact.

The green is muddy here and there, and often it overruns the other colors. The base of this piece is unusual in being covered with a coating of black enamel. Another piece with a black enamel base in the Victoria and Albert Museum, London, has a spray of white plum blossoms on the center of the base.

Exhibited: New York, Metropolitan Museum, 1895, No. 943, lent by James A. Garland. New York, Metropolitan Museum, 1907, Case XXIX (No. 764), lent by J. Pierpont Morgan.

Collections: James A. Garland, 1895. Duveen. J. Pierpont Morgan, London and New York, 1902. Duveen. Frick, 1915.

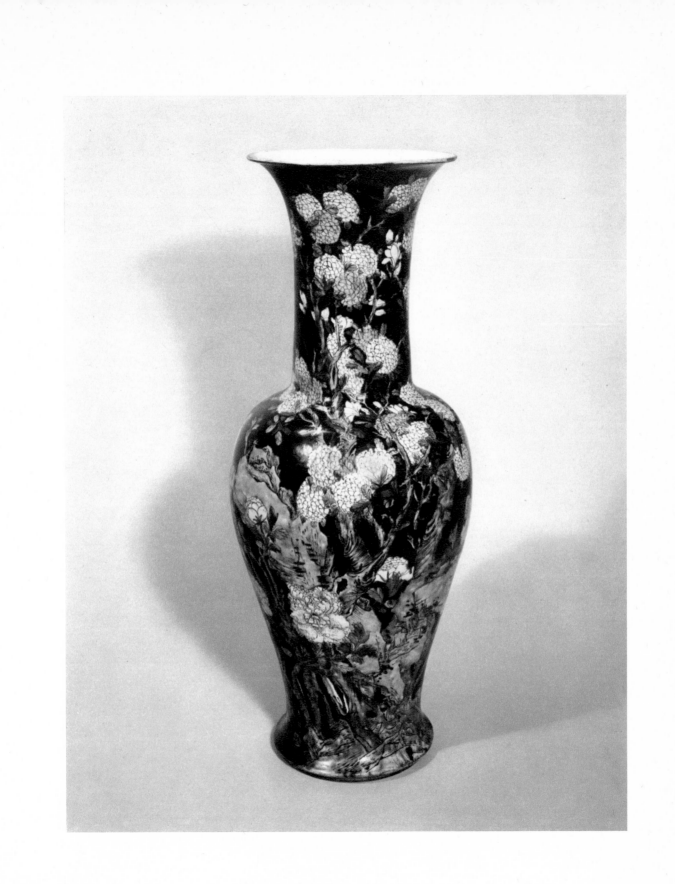

Tall Vase with Black Ground (15.8.25)

H. 27 in. (68.6 cm); D. 10½ in. (26.7 cm). Ch'ing dynasty (1644–1912).

Description: The vase is decorated with highly piled rocks out of which grow white peonies, hydrangeas, and magnolias.

Condition: The piece is intact.

This vase and the last have heretofore been treated as a pair; but comparison of the flare of the base, the curve of the shoulder, the proportions of the neck, and the flare of the lip at the top, makes it quite clear that the only thing the two have in common is the decoration. The two foot rims are treated entirely differently; and the base of this piece is covered with a thin glaze.

Exhibited: New York, Metropolitan Museum, 1895, No. 944, lent by James A. Garland. New York, Metropolitan Museum, 1907, Case XXIX (No. 765), lent by J. Pierpont Morgan.

Collections: James A. Garland, 1895. Duveen. J. Pierpont Morgan, London and New York, 1902. Duveen. Frick, 1915.

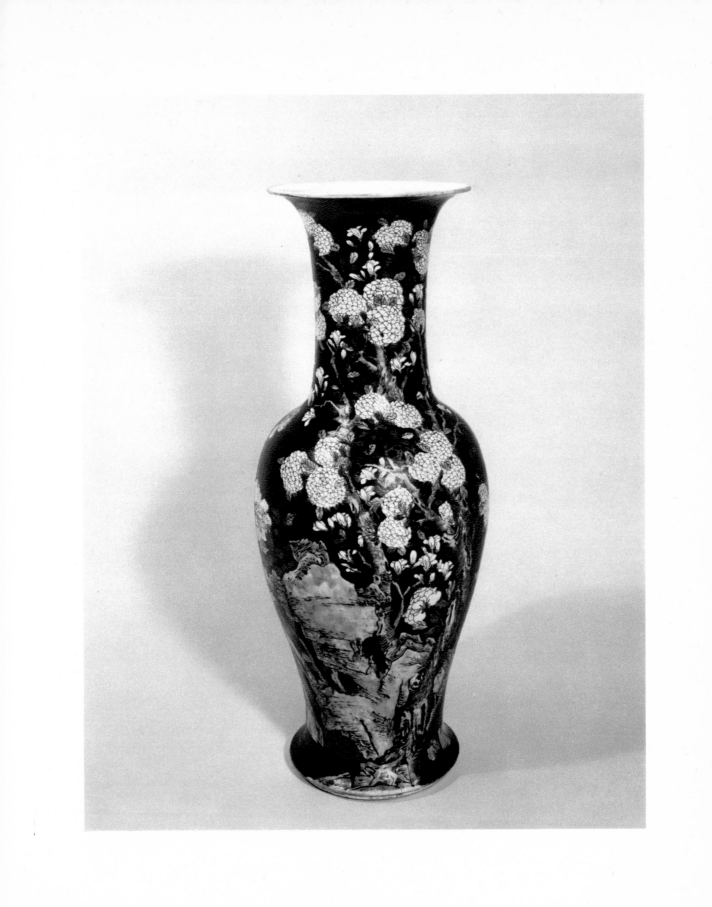

Tall Vase with Black Ground (15.8.26)

H. 27¼ in. (69.2 cm); D. 10½ in. (26.7 cm). Ch'ing dynasty (1644–1912).

Description: As on the last two vases the main decoration here is hydrangeas, magnolias, and peonies growing from highly piled rocks. There are two large birds of the pheasant family, one perched on a tree and the other flying. The six-character mark of the Ch'eng-hua reign (1465–87) is written in three columns on the base.

Condition: The lip is much repaired, and there are large areas of paint over the surface of the vase evidently covering up various chips and blemishes.

The glaze on the base is thick enough to make the mark blue, but is of poor quality with many cracks and black specks. Again it is worth noting the differences in shape among the beaker vases; while many of them look alike at first glance, it is rare that they are identical.

Collections: M.C.D.Borden. Frick, 1915.

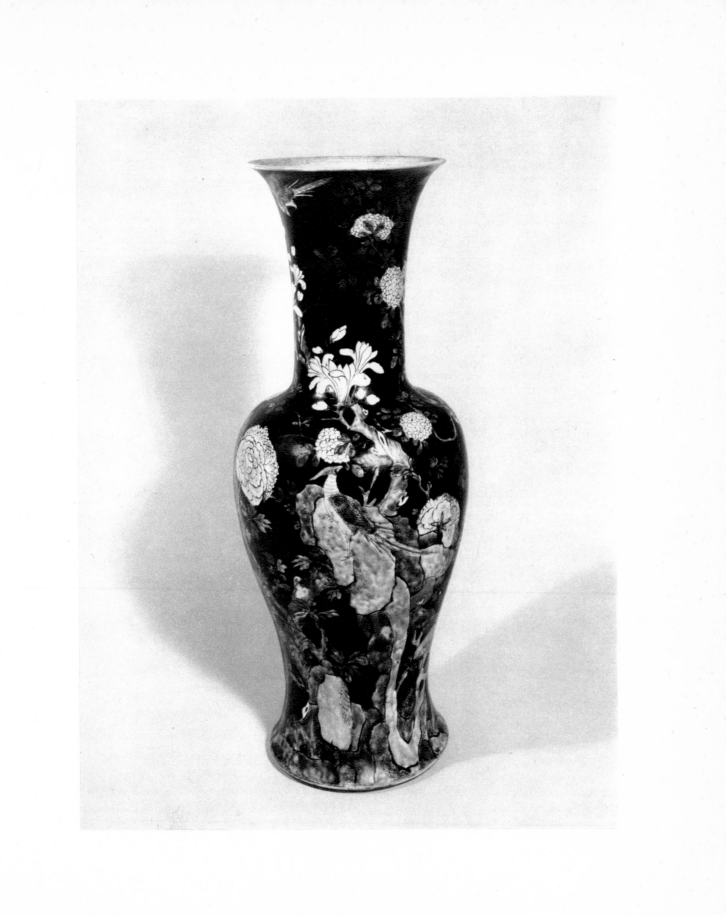

Tall Vase with Black Ground (15.8.22)

H. 22¼ in. (56.5 cm); D. 10 in. (25.4 cm). Ch'ing dynasty (1644–1912).

Description: The well-known design of plum trees growing out of clustered rocks and covering the whole vase is varied in this case by the presence of a broad band of green ground with black scroll pattern and white blossoms around the base of the neck. Above this the main pattern begins again with a new clump of rocks. Birds with yellow breasts, lavender backs, and green wings and tails appear in both compositions. The trunks of the plum trees are skillfully painted but almost excessively grotesque.

Condition: The vase appears to be intact, but the entire surface has been covered with a coat of varnish. This gives a muddy yellowish look to the blossoms.

Exhibited: New York, Metropolitan Museum, 1907, Case XXIX (No. 770), lent by J. Pierpont Morgan.

Collections: Van Gelder, Amsterdam. Duveen, 1888–90. J. Pierpont Morgan, London and New York, 1904. Duveen. Frick, 1915.

118

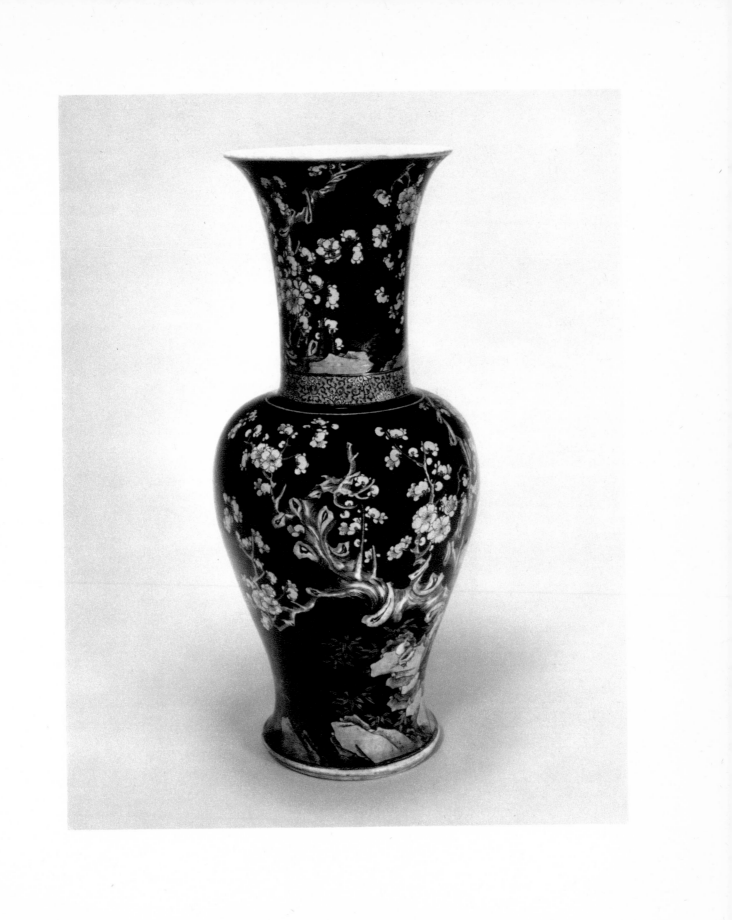

Vase with Black Ground (15.8.21)

H. 16¾ in. (42.5 cm); D. 7⅛ in. (18.1 cm). Ch'ing dynasty (1644–1912).

Description: The plum tree growing out of the clump of rocks is the usual design on vases of this type; and

the bamboos in the lower part of the composition also are customary. On the base is an auspicious mark of a *ling-chih* fungus surrounded by a double ring.

Condition: There are two hair cracks extending 3 and 4 in. down inside the neck, and at the top of one of these is a chip in the rim. There are also some chips on the foot rim.

The vase is well enough painted in thick, glossy enamels. The most striking feature is the very long neck which, in fact, equals the height of the body and gives the whole vase a very unusual proportion. Three-quarters of an inch above the shoulder the joint between the neck and the vase shows clearly both inside and out.

Collections: Thomas B. Clark, who is said to have imported it from China before 1903. Marsden J. Perry, Providence, Rhode Island. J. Pierpont Morgan, London and New York, 1911. Duveen. Frick, 1915.

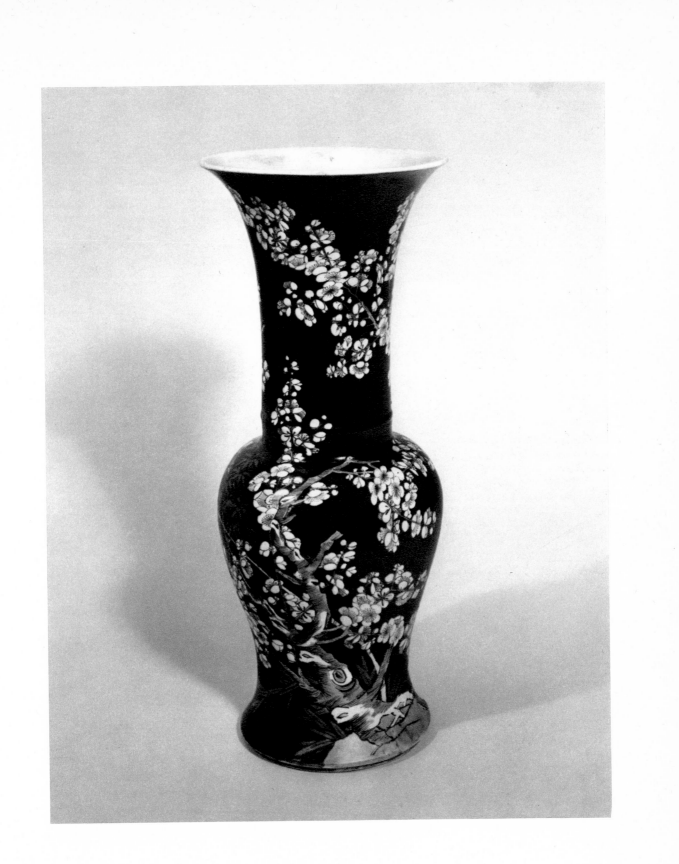

Tall Vase with Black Ground (16.8.20)

H. 24¼ in. (61.6 cm); D. 9⅝ in. (24.5 cm). Ch'ing dynasty (1644–1912).

Description: A plum tree grows from behind a rock to cover the whole vase with its trunks and branches and blossoms. In this case the contours of the trunks and branches are fluidly drawn with fine lines, and the rocks are shaded with stylized arrangements of thin, short lines and dots. Bamboos also grow behind the rocks, and a few small pine tufts are shown. A green bird is perched on a branch and two lavender birds fly among the blossoms; in each case the wings of the birds are painted in the color opposite to that on their bodies.

Condition: The piece is intact.

The neck of this vase is almost straight and lacks the customary flare. The lip is disproportionately narrow. As a result of these two factors the vase as a whole is rather awkward in shape. The enamel is, for the most part, thick and fairly even; but in one area it is unusually lumpy.

Collections: Duveen, who is said to have bought it in Paris. Frick, 1916.

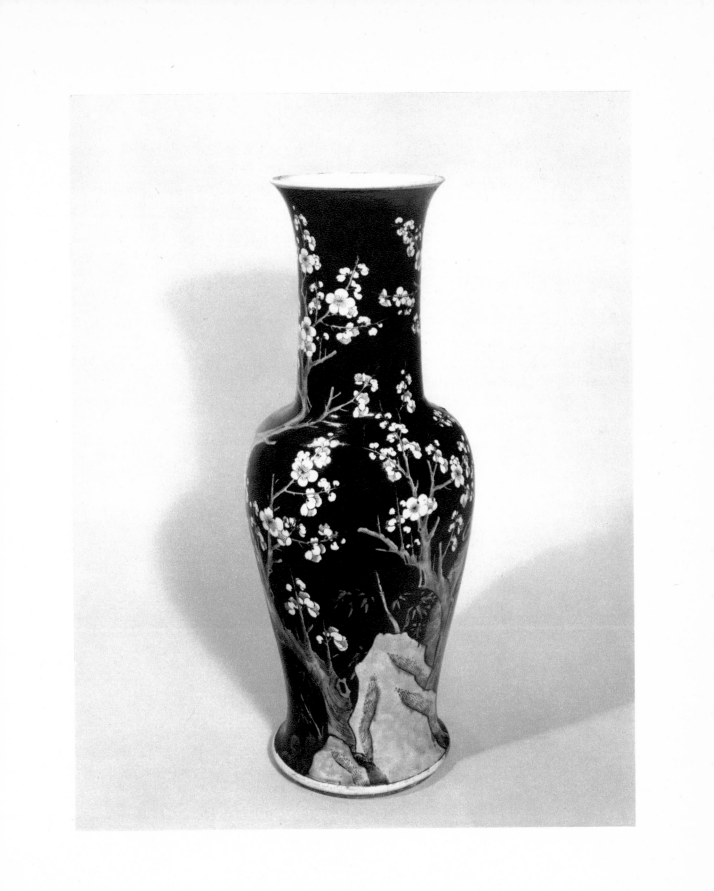

Vase with Black Ground (15.8.23)

H. 17½ in. (44.5 cm); D. 8⅛ in. (20.6 cm). Ch'ing dynasty (1644–1912).

Description: The decoration consists of the plum tree, bamboo, and bird design; and the trunks and branches and rocks are very close in style to the work on the preceding example. Here there are two lavender birds and one yellow one, all with green wings. An unidentified maker's mark of three white characters in seal style is reserved in a blue square on the base.

Condition: There are two hair cracks in the rim, and a chip in the foot.

The vase has a short, broad neck and is not to be compared with the so-called beaker types shown on the last ten plates. The black here is very uneven and washy looking, and the enamels are sloppily painted on the birds and bamboo leaves.

Collections: Marsden J. Perry, Providence, Rhode Island. Duveen, 1892. J. Pierpont Morgan, London and New York, 1911. Duveen. Frick, 1915.

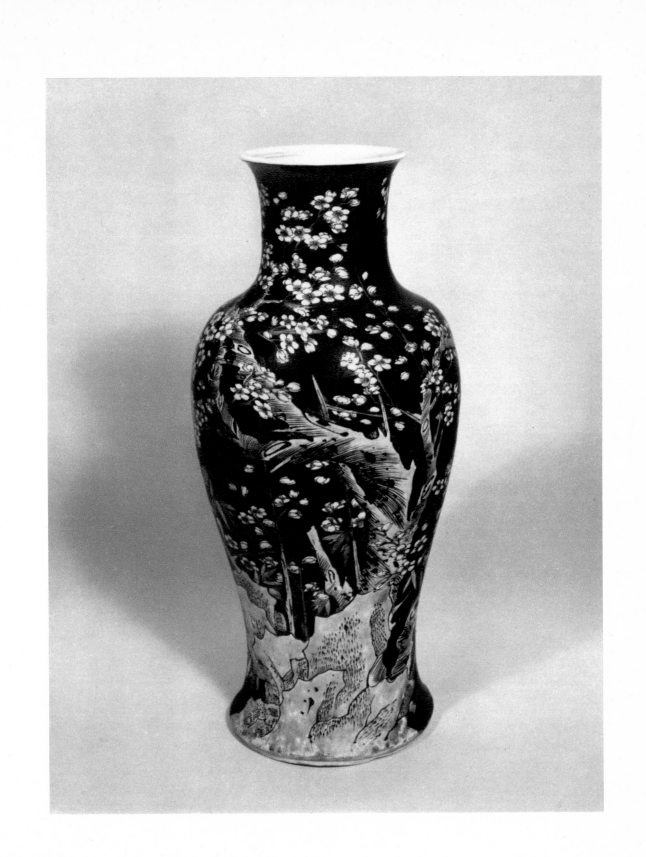

Two Bronze-Form Vases with Black Ground (16.8.35 and 16.8.36)

Number 16.8.35: H. 18 in. (45.7 cm); D. 9 in. (22.8 cm). Number 16.8.36: H. 18¼ in. (46.4 cm); D. 9 in. (22.8 cm). Ch'ing dynasty (1644–1912).

Description: The form of these vases imitates that of an ancient ceremonial bronze of the type known as *tsun*. It rises from a flaring foot to a swelling center section, and above that the neck curves gradually outward and suddenly flares widely to the rim. In this Ch'ing dynasty version transmuted into porcelain, each section is a separate unit of the decoration. The top and bottom sections, in both cases, are covered with the familiar scene of plum trees growing from behind rocks and covering the whole area with blossoming branches. The swelling central section is bordered below by a band of triangular devices pointing alternately up and down and framing flower-petal patterns related to those that have been noted on some of the K'ang-hsi blue-and-white vessels—e.g., the pieces illustrated on pp. 55, 61, and 63. The top border of the section consists of a row of circles framing spoke-like forms with from seven to nine spokes each. The central section between these two borders again shows a design of flowering plants growing among rocks.

Condition: The whole neck and lip of No. 16.8.35 are badly broken and repaired, and the entire upper section of the vase has been repainted. On No. 16.8.36 a chip is missing from the lip and the foot rim is warped.

These two vases are unlike the usual *famille noire* types in many ways. The whole scheme of the decoration is more crowded than customary. On the lower section, in both cases, the plum-tree composition is painted upside down with the rocks at the top and the tree trunks and branches growing downward toward the bottom of the vases. On the other hand, in the same scenes the four birds with yellow breasts, green backs, and blue wings are painted right side up as seen when the vase is properly standing on its foot. It should also be noted that these two vases are very thinly potted, and are far lighter in weight than is usual with pieces of comparable size.

Exhibited: New York, Metropolitan Museum, lent by James A. Garland. New York, Metropolitan Museum, 1907, Case XXXI (Nos. 791, 792), lent by J. Pierpont Morgan.

Collections: James A. Garland. Duveen. J. Pierpont Morgan, London and New York, 1902. Duveen. Frick, 1916.

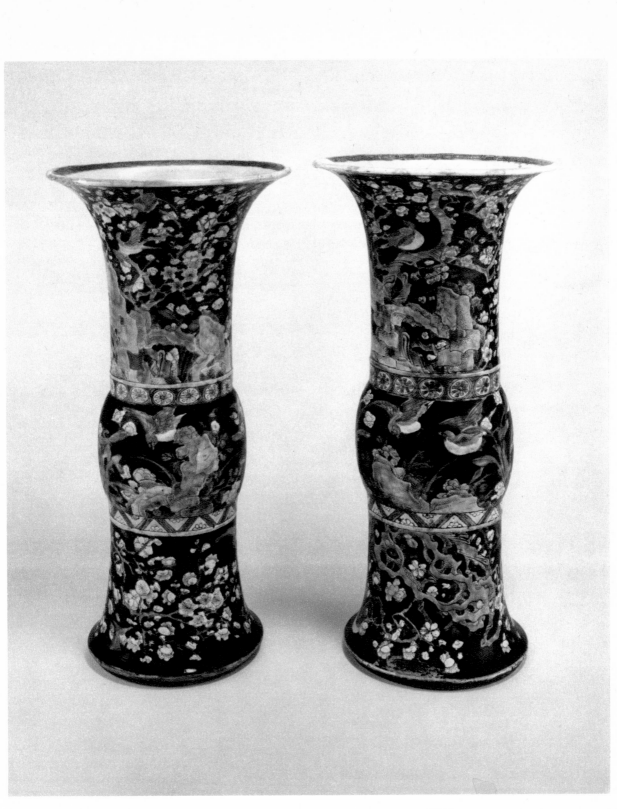

16.8.35 16.8.36

Square Vase with Black Ground (15.8.28)

H. 19¼ in. (48.9 cm). Ch'ing dynasty (1644–1912).

Description: Each side is boldly painted with a composition of one of the flowers of the four seasons—peony, lotus, chrysanthemum, and plum—and three of the sides have birds on them. The neck, which is round in section and flares slightly at the top and bottom, is decorated with roses; and there are ogival patterns at the corners of the shoulders. The four sides of the vase are bordered by bands of light yellow enamel, and these carry across the shoulder and the base forming a frame for each panel. The artemisia leaf is drawn in blue in a sunken square with glazed surface on the otherwise unglazed base.

Condition: There is a hair crack in the lip, and two long scratches mar the surface on the lotus and plum sides.

Exhibited: New York, Metropolitan Museum, 1907, Case XXX (No. 782), lent by J. Pierpont Morgan.

Collections: J. Pierpont Morgan, London and New York, 1904. Duveen. Frick, 1915.

128

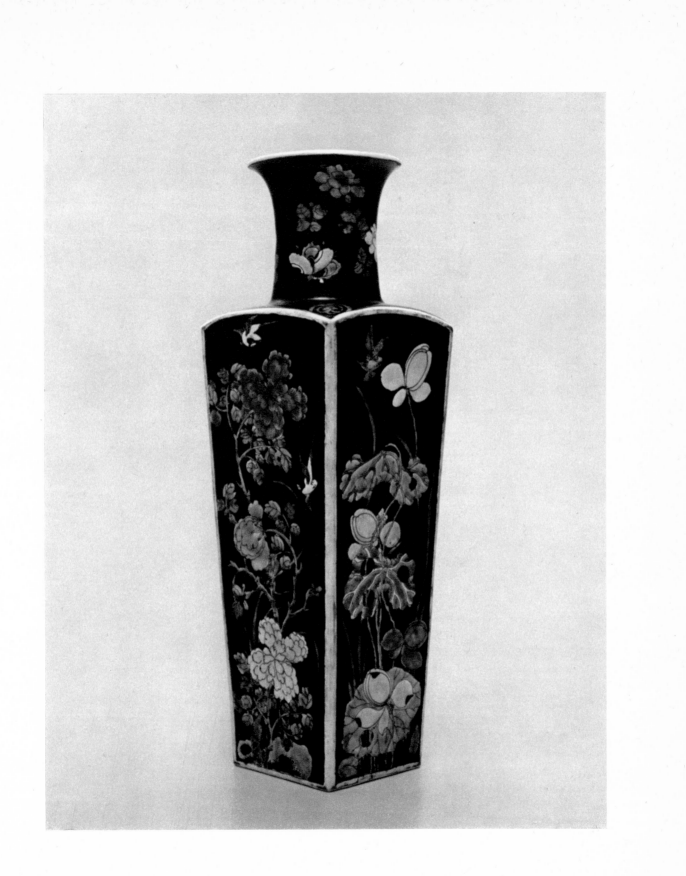

Square Vase with Black Ground (15.8.29)

H. 19¼ in. (48.9 cm). Ch'ing dynasty (1644–1912).

Description: The decoration of this vase is similar to that on the preceding one but not identical. The flowers of the four seasons are more delicately painted and smaller in scale, and the same is true of the roses on the neck. The borders of the compositions are white, and the ogival patterns on the shoulders are replaced by flowers. Again the mark is the artemisia leaf in underglaze blue with ribbons placed in a sunken square on the otherwise unglazed base.

Condition: The piece is intact except for abrasions along the borders.

Collections: J. Pierpont Morgan, London and New York, 1911. Duveen. Frick, 1915.

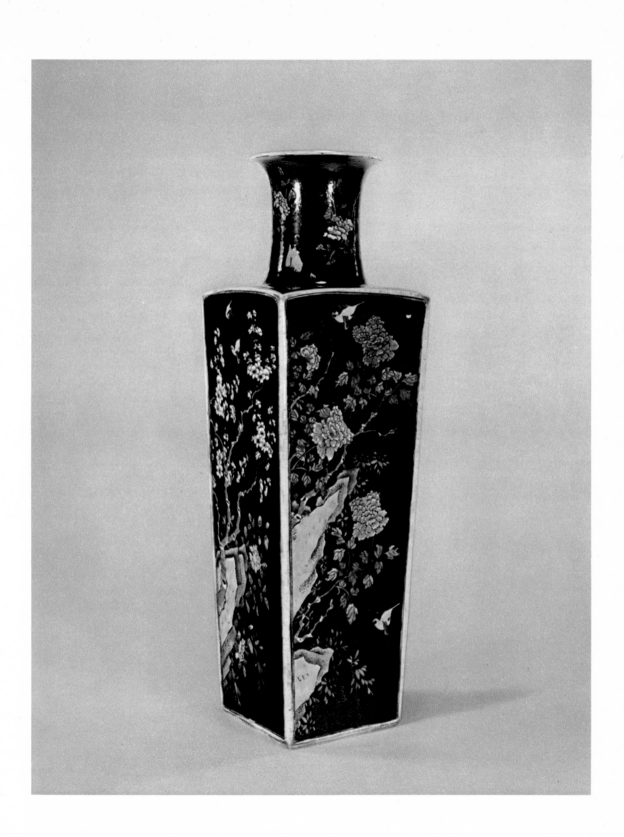

Two Square Covered Vases with Black Ground

(16.8.31 and 16.8.32)

H. 19¼ in. (48.9 cm). Ch'ing dynasty (1644–1912).

Description: The four sides of the vases are adorned with the flowers of the four seasons: lotus, peony, chrysanthemum, and plum. Plum blossoms also decorate the shoulders, necks, and covers. The borders are white. On the top of each cover is a small green lion; both beasts have been broken off, and what we see now is a restoration with only the original feet remaining. The artemisia leaf with ribbon appears in underglaze blue in a sunken square in the middle of each otherwise unglazed base.

Condition: Number 16.8.31 has the lip broken and repaired on one side. Number 16.8.32 has the lip broken and repaired on three sides, and there are two long diagonal cracks down the sides decorated with the lotus and the plum. The base of each piece has been drilled so that the vases could be mounted as lamps.

Collections: Frick, 1916.

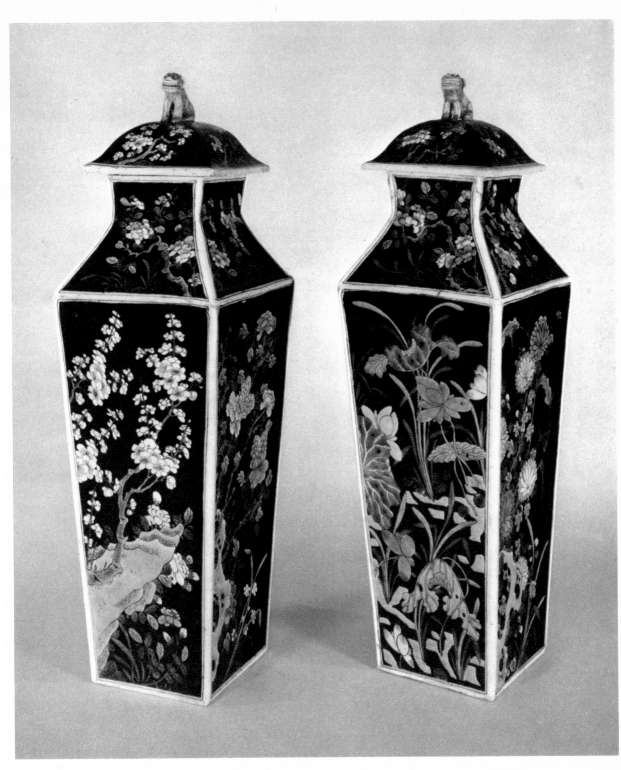

16.8.31 16.8.32

Quadrilateral Vase with Handles and Black Ground (15.8.33)

H. 22 in. (55.9 cm). Ch'ing dynasty (1644 to 1912).

Description: The vase has a pyramidal base which supports a bulbous body that soon contracts into a long slender neck, flaring again very slightly near the top. There is a flange around the lip; and on each side is a scroll-shaped loop handle. Both the lip and the handles are covered with reddish-brown slip and appear to have been gilt; there is no sign of enamel in these areas. The top of the pyramidal base marks the bottom of the inside of the vase; and the base is hollow and covered over with a second bottom. The vase itself is decorated with flowering plum trees with flying and perching birds here and there. On the four sides of the base is a stippled design on a pale green ground that contrasts sharply with the rest of the vessel. Some of the dark green enamel on the body has dribbled over the top of the base.

Condition: The vase is intact. A small hole has been punched in the bottom of the base.

Exhibited: New York, Metropolitan Museum, 1895, Case 2 (?), lent by James A. Garland. New York, Metropolitan Museum, 1907, Case XXVII (No. 731), lent by J. Pierpont Morgan.

Collections: Winternitz. Duveen, about 1889. James A. Garland. Duveen. J. Pierpont Morgan, London and New York, 1902. Duveen. Frick, 1915.

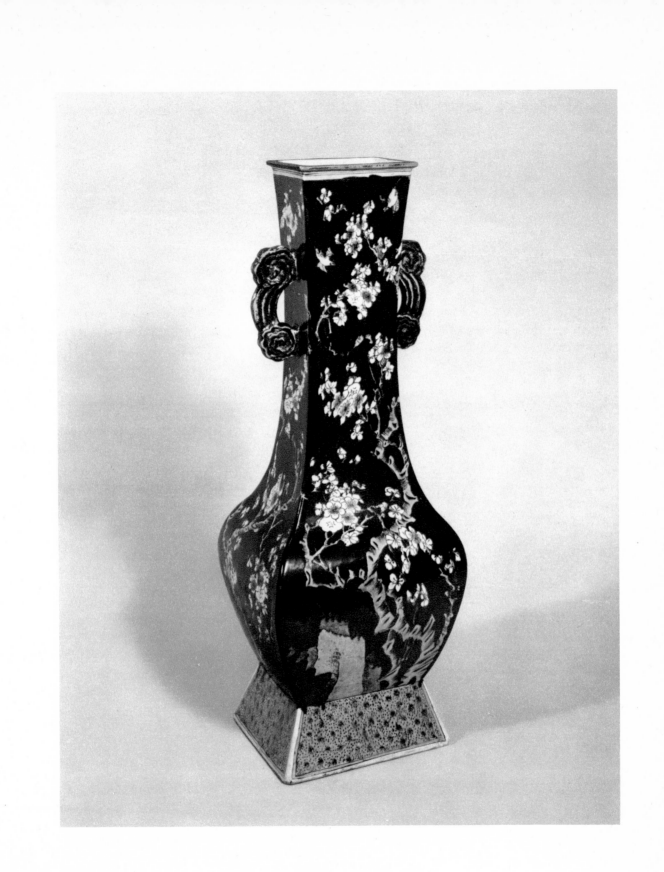

Quadrilateral Vase with Black Ground (15.8.34)

H. 20¾ in. (52.7 cm). Ch'ing dynasty (1644–1912).

Description: The vase resembles the preceding one in shape, but here the black ground covers the pyramidal base as well. White borders mark all four corners, the base, and the flanged lip. The sides are decorated with magnolia, chrysanthemum, plum, and lotus; and originally there were handles on the chrysanthemum and lotus sides. A bird which appears to be some sort of pheasant is perched on the magnolia tree while another flies above.

There are four lavender birds among the plums, two perching and two flying; two flying ducks are seen among the lotus; and among the chrysanthemums are two butterflies and a bug.

Condition: The vase once had two handles, presumably like those on the preceding example; but they have been broken off, and the areas where they joined the sides have been smoothed down and painted over. A small hole has been punched in the bottom of the base.

Exhibited: New York, Metropolitan Museum, 1907, Case XXVII (No. 733), lent by J. Pierpont Morgan.

Collections: J. Pierpont Morgan, London and New York, 1904. Duveen. Frick, 1915.

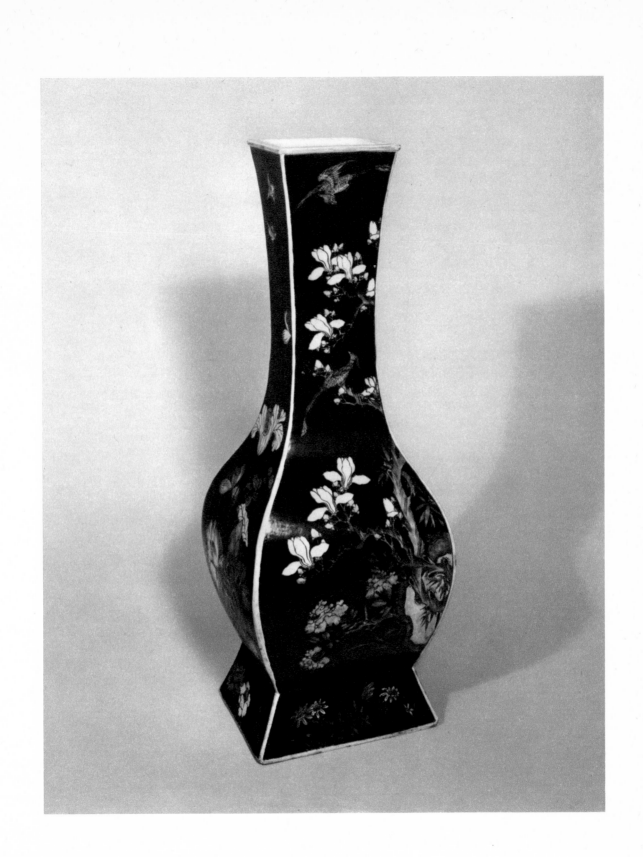

Cylindrical Club-Shaped Vase with Black Ground (15.8.37)

H. 22 in. (55.9 cm); D. 8 in. (20.3 cm). Ch'ing dynasty (1644–1912).

Description: A large-scale, bold banana-leaf band surrounds the neck; and the body is covered with two rows of large lotus blossoms in white, yellow, and lavender. The leafy scrolls that accompany these blossoms are a deep green. A tight band of stylized small leaves surrounds the lower part of the vase just above the swelling base rim.

Condition: There is a silver-gilt rim on the lip. The bulge around the base is painted black, and there is a large chip in the foot rim.

Vases of this shape were called *rouleau* by the French, and that term was often used in English works on the subject.

Exhibited: New York, Metropolitan Museum, 1895, lent by James A. Garland. New York, Metropolitan Museum, 1907, Case XXVII (No. 732), lent by J. Pierpont Morgan.

Collections: Bing, Paris, who is said to have imported it from China. Duveen, about 1889–90. James A. Garland, 1895. Duveen. J. Pierpont Morgan, London and New York, 1902. Duveen. Frick, 1915.

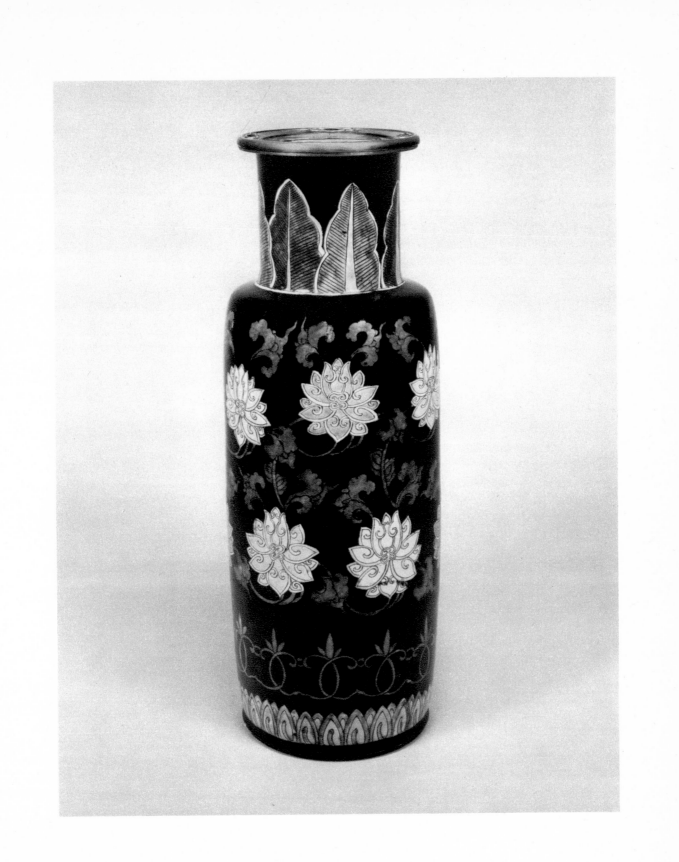

Covered Jar with Black Ground (15.8.273)

H. 16 in. (40.7 cm); D. 10 in. (25.4 cm). Ch'ing dynasty (1644–1912).

Description: The main decoration is a very crowded arrangement of peonies and hydrangeas growing by a clump of rocks. Among the flowers are two pheasants, two blue birds, and two birds with yellow breasts. In addition to the usual range of enamel colors there is iron red on two of the peonies on the lid, on alternate blades on the neck, and on four of the peonies on the body. Iron red is also liberally spotted around the white glazed ring that borders the flaring foot.

Condition: There is one repair on the neck, and the base has been drilled so the piece could be mounted as a lamp.

Jars of this shape with swelling shoulder, contracted waist, and flaring foot, and with a short, broad vertical neck, are generally classified as *kuan*-shaped.

Collections: Frick, 1915.

142

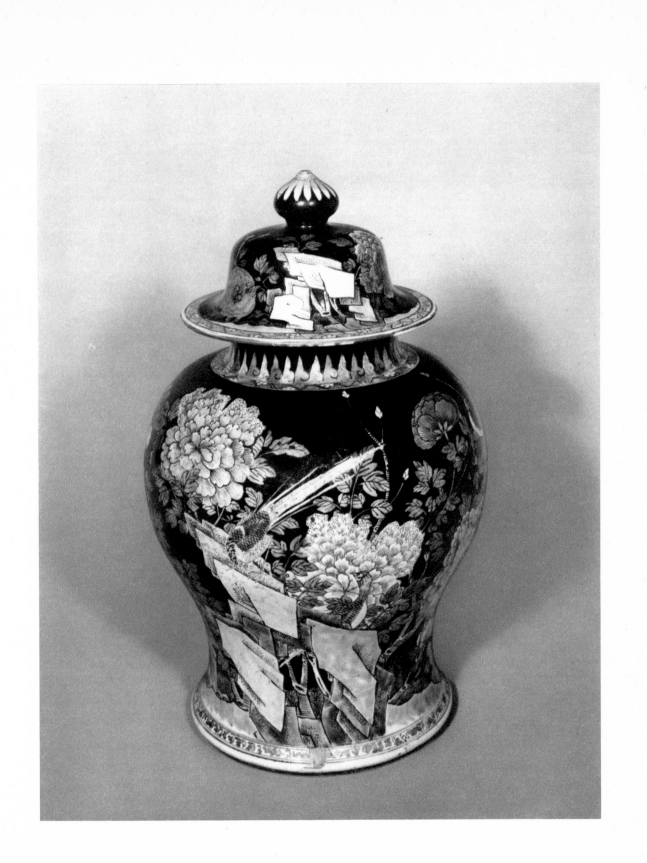

Bowl with Flaring Rim and Black Ground (15.8.38)

H. 3⅜ in. (8.6 cm); D. 7½ in. (19 cm). Ch'ing dynasty (1644–1912).

Description: The decoration consists of one green and one yellow dragon cavorting among waves, with clouds and two flaming jewels in the sky above. Inside the bowl is a flaming jewel painted in black on a pale green ground.

Condition: The bowl has been broken and repaired in several places.

It is unusual to find the dragons drawn, as they are here, so that no claws are showing. The quality of the drawing, as of the enamels, is poor throughout.

Collections: J. Pierpont Morgan, London and New York, 1911. Duveen. Frick, 1915.

Bowl with Flaring Rim and Black Ground (15.8.271)

H. 3⅝ in. (9.2 cm); D. 7⅞ in. (20 cm). Ch'ing dynasty (1644 to 1912).

Description: The decoration outside consists of two large white reserves on the black ground. One of these, in the shape of a peach, frames a group of chrysanthemums growing behind a reticulated garden rock. The other reserve, in the shape of a leaf, frames narcissus and rocks. Inside the bowl a central flower spray is surrounded by four more flower sprays in green and aubergine on a yellow ground. Around the inside of the rim is a hatched band in green and aubergine. On the base in underglaze blue is the character *fu* (happiness) in a double square surrounded by a double circle.

Condition: The rim has been broken and repaired, and there are hair cracks.

Collections: J. Pierpont Morgan, London and New York. Duveen. Frick, 1915.

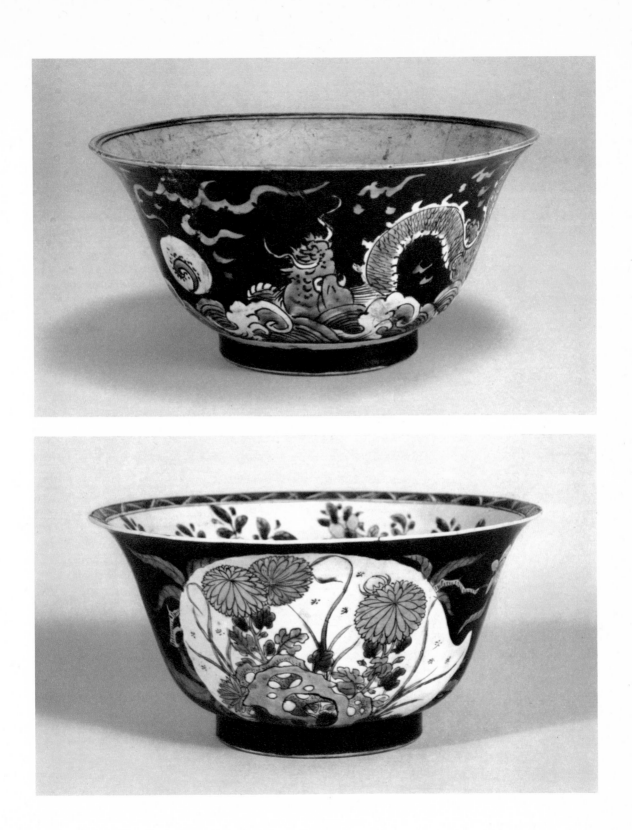

FAMILLE ROSE

Two Large Covered Jars with *Famille Rose* Decoration and Black Ground (15.8.47 and 15.8.48)

H. 33 in. (83.8 cm); D. 18¾ in. (47.6 cm). Ch'ing dynasty (1644–1912).

Description: On each jar two large leaf-shaped reserves frame compositions showing two deer in the foreground between a towering rock and a tree peony; above are plum branches on one of which perches a bird. Two scroll-shaped reserves frame compositions with four ducks; and two smaller and very highly stylized leaf reserves frame roses and chrysanthemums and, in one instance, a butterfly. The black background is densely decorated with scrolling vines, chrysanthemums, and selections from the Hundred Antiques. Around the bases, the shoulders, and the rims of the lids are diaper patterns with floral panels in reserve. The lids are decorated in similar style and are topped by green lions which are largely restorations. The bases are unglazed.

Condition: Both pieces are intact except for the restored lion finials noted above.

In spite of the fact that there are differences in the backgrounds, these two jars are treated as a pair.

Exhibited: New York, Metropolitan Museum, 1895, Cases 3, 22 (Nos. 1157, 1158), lent by James A. Garland. New York, Metropolitan Museum, 1907, Case XXXVIII (Nos. 913, 914), lent by J. Pierpont Morgan.

Collections: Duveen, said to have belonged before 1891 to the Duke of Marlborough[1] and to have been at one time in a church in Mexico. James A. Garland, 1895. Duveen. J. Pierpont Morgan, London and New York, 1902. Duveen. Frick, 1915.

NOTES

1 Identified in the 1895 Garland catalogue (J. Getz, *Metropolitan Museum of Art: Hand-Book of a Collection of Chinese Porcelains Loaned by James A. Garland,* New York, pp. 32–33) as: "From the Marlborough collection."

148

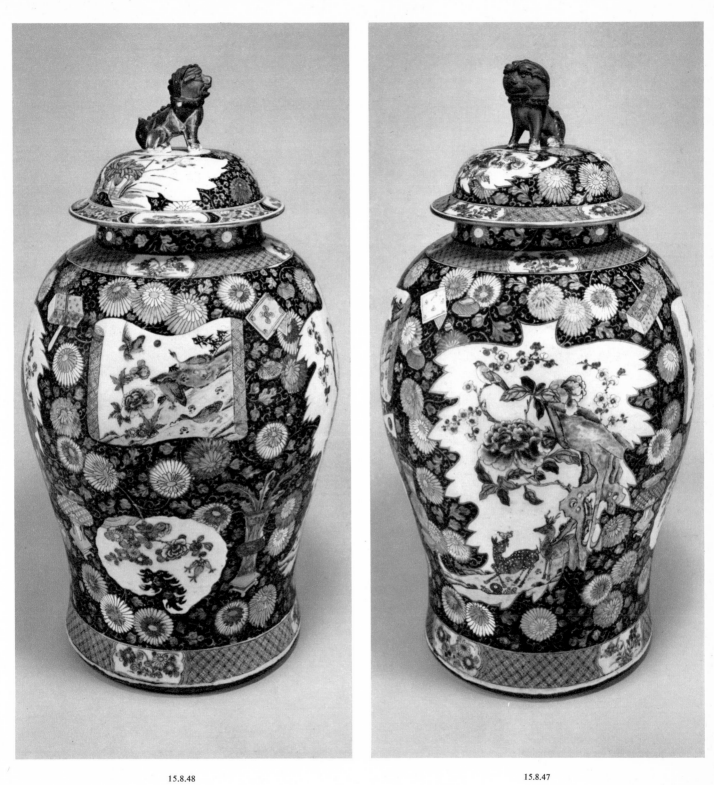

15.8.48 15.8.47

Four Covered Jars with *Famille Rose* Decoration (15.8.49–15.8.52)

H. (average) 17¾ in. (45 cm); D. (average) 10 in. (25.4 cm). Ch'ing dynasty (1644–1912).

Description: Panels of various shapes are reserved in white on the solid rose-pink grounds, and on these are painted such scenes as a cock in a landscape, a flowering spray, and so on. Occasional chrysanthemum blossoms and feathers in colored enamels are distributed freely directly on the pink surface. Diaper borders with reserved panels for flower sprays or floral scrolls surround the rims of the lids and the necks of the vessels. The finials consist of lotus buds treated in different ways. There are traces of gilding on some of the decoration. All the jars have flat glazed bases.

Condition: Numbers 15.8.50 and 15.8.52 are intact. The other two have chips, breaks, and repairs in varying degrees, including extensive damage to one of the principal panels.

The pink ground of these four jars is unusually deep and rich in tone.

NOS. 15.8.49 AND 15.8.50

Exhibited: New York, Metropolitan Museum, 1895, Case 4, lent by James A. Garland. New York, Metropolitan Museum, 1902, Nos. 1005, 1006, lent by J. Pierpont Morgan.

Collections: James A. Garland. Duveen. J. Pierpont Morgan, London and New York, 1902. Duveen. Frick, 1915.

NOS. 15.8.51 AND 15.8.52

Exhibited: New York, Metropolitan Museum, 1895, Case 4 (Nos. 896, 898), lent by James A. Garland. New York, Metropolitan Museum, 1907, Case XL (Nos. 963, 964), lent by J. Pierpont Morgan.

Collections: Lord Burton. James A. Garland. Duveen. J. Pierpont Morgan, London and New York, 1902. Duveen. Frick, 1915.

15.8.49

15.8.50

15.8.51

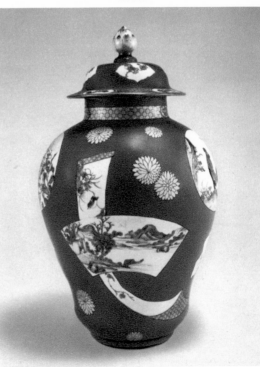

15.8.52

Four Covered Jars with *Famille Rose* Decoration (15.8.53–15.8.56)

H. (average) 17¾ in. (45 cm); D. (average) 10 in. (25.4 cm). Ch'ing dynasty (1644–1912).

Description: The decoration of these four jars is very similar to that of the preceding four, except that on these the principal panels are painted with flowering sprays instead of landscapes. Numbers 15.8.55 and 15.8.56 have been embellished with decorative metal bands around the edges of the lids, the necks, and the foot rims.

Condition: Numbers 15.8.53 and 15.8.55 are intact. The other two have been badly broken and repaired, and some of the overpainting has discolored.

The pink grounds of these four jars are very pale and grayish in tone. The differences in detail in the decoration here and on the four preceding examples may to some extent be accounted for by the way in which such work was done. The workers who did the decorative painting on these jars were supplied with pattern books; and presumably they were told by their supervisors which pattern numbers to use on which jars, or lots of jars. The interpretation of detail could vary considerably from one worker to another, and from one factory to another, and that accounts for the differences we see today. For jars like these, although we treat them as sets today, may well have been made from similar patterns in use at different factories at various times.

NOS. 15.8.53 AND 15.8.54

Collections: Duveen, who is said to have bought them in Russia. J. Pierpont Morgan, 1906. Duveen. Frick, 1915.

NOS. 15.8.55 AND 15.8.56

Exhibited: New York, Metropolitan Museum, 1895, Case 3, lent by James A. Garland. New York, Metropolitan Museum, 1907, Case XLII (Nos. 1014, 1015), lent by J. Pierpont Morgan.

Collections: Duveen, 1890, said to have been acquired previously in China by M. Marquis, Paris. James A. Garland, 1895. Duveen. J. Pierpont Morgan, London and New York, 1902. Duveen. Frick, 1915.

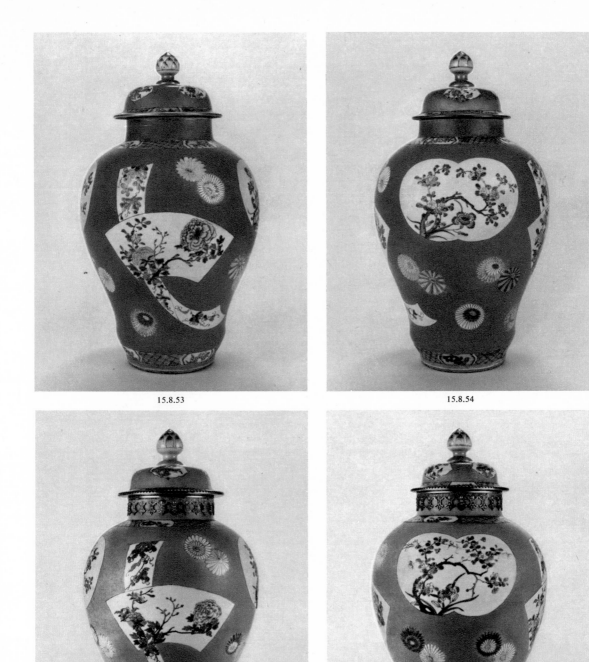

15.8.53

15.8.54

15.8.55

15.8.56

Two Large Covered Jars with *Famille Rose* Decoration
(15.8.57 and 15.8.58)

H. 25 in. (63.5 cm); D. 14 in. (35.6 cm). Ch'ing dynasty (1644–1912).

Description: On each jar the main panel shows a scene in a scholar's garden. The old gentleman sits in a typical high-backed chair by the end of his table on which are some books and a vase of flowers. A vase with some scrolls protruding from it stands by the table. On his knee the scholar holds a book which he is reading to a young boy who stands by two porcelain vases in front of a bird on a perch by a pot of flowers. The usual fan- and ribbon-shaped panels framing various scenes with flowers, birds, and domestic fowl appear on other parts of the jars, and on the pink ground are scattered chrysanthemum sprays and some single blossoms. The customary diaper borders surround the base and shoulder of the jars and the rim of the lids. The finials, in lotus-bud form, show traces of gilding.

Condition: Number 15.8.57 has a crack in one upper panel. Number 15.8.58 is much broken and repaired in both the vessel and the lid.

Similar in form and decoration to the covered jars in the two preceding groups, these examples differ significantly only in their considerably greater size and in the subject matter of the principal panels. The ground color is closer to the deep red of the first group of four than to the grayish pink found on the second group.

As noted in connection with the preceding jars, the decoration on pieces such as these derived from pattern books, and similar pieces may well have had their origins in different factories.

Exhibited: New York, Metropolitan Museum, 1907, Case XLI (Nos. 1000, 1001), lent by J. Pierpont Morgan.

Collections: Duveen, said to have belonged to the Marquis de Voz (or de Vos), Lisbon.[1] J. Pierpont Morgan, London and New York, 1904. Duveen. Frick, 1915.

NOTES

1 Although no record has been found to indicate that these vases were ever in the Garland collection, they may be identical with a pair described in detail in the 1895 Garland catalogue (J. Getz, *Metropolitan Museum of Art: Hand-Book of a Collection of Chinese Porcelains Loaned by James A. Garland,* New York, pp. 34–35): "Two jars, with covers.... Deep-rose color, with reserve medallions and scrolls, showing a

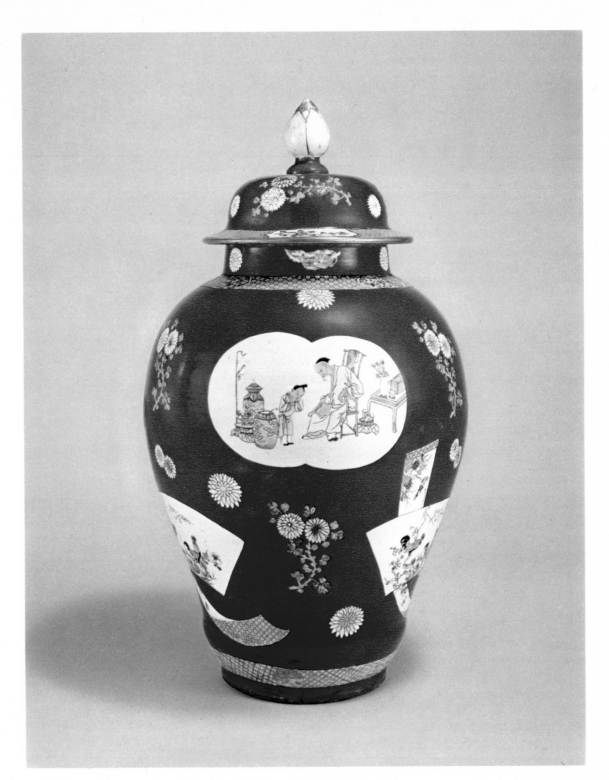

15.8.57

Two Very Tall Covered Vases with *Famille Rose* Decoration
(58.8.274 and 58.8.275)

H. 51 in. (129 cm); D. 20 in. (50.8 cm). Ch'ing dynasty (1644–1912).

Description: Each vase has a main decoration consisting of five very elaborate vertical panels which frame scenes of various birds on flowering branches. The ground between the panels is an intricate diaper pattern in pale blue enamel on which are various blossoms. Four dark whorl circles appear between each pair of panels, and on the shoulder are lappets of pink diaper patterns. The diaper pattern on the necks, matching that of the bodies, is interrupted in each case by three panels framing compositions of the Hundred Antiques, with all six of the compositions identical. The lids are decorated with related motifs, and each has a large lotus-bud finial. Bands of tall panels around the bases show tassels hanging from elaborate frameworks.

Condition: Number 58.8.274 is intact. Its companion has been cracked and repaired.

Collections: Gift of Miss Helen C. Frick, 1958.

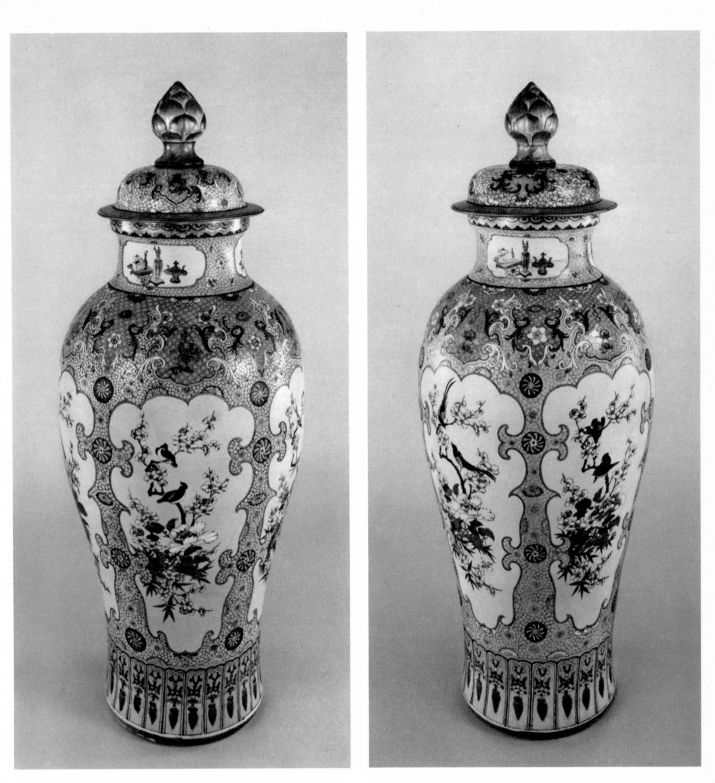

58.8.274 58.8.275

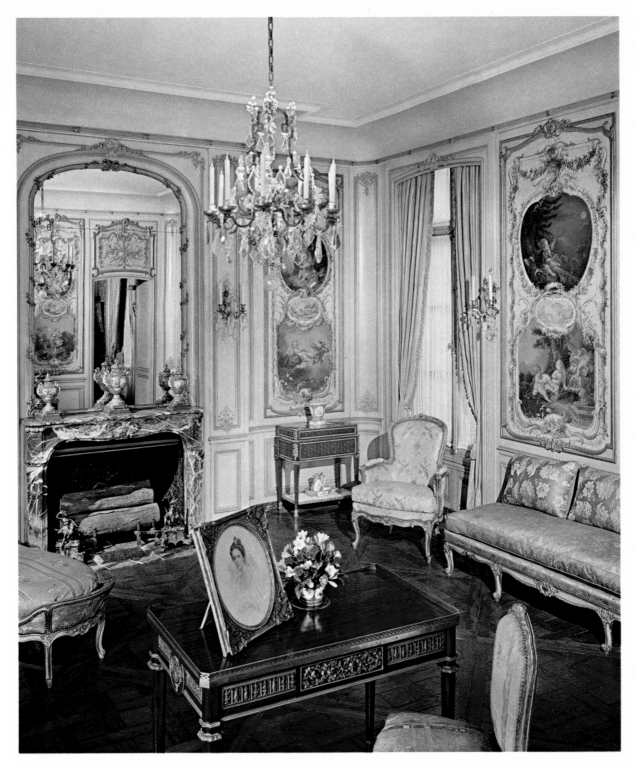

BOUCHER ROOM · THE FRICK COLLECTION

FRENCH POTTERY AND
PORCELAINS

SAINT-PORCHAIRE POTTERY

All but forgotten since the Renaissance, the ceramics of Saint-Porchaire suddenly kindled new interest during the reign of Louis-Philippe and became, under various designations, the subject of impassioned discussion that would continue throughout the remainder of the nineteenth century.

The debate was opened in 1839 by Pottier,[1] who listed twenty-four complete pieces and five fragments of what he termed "faïence de Henri II"—because the royal arms appeared on several examples—and proposed for them an Italian origin. Delange,[2] writing in 1847, suggested a possible attribution of the "poteries de Henri II" to Girolamo della Robbia. And in 1860 the presumed Italian influence led Tainturier[3] to envisage the contribution of a metalworker trained by Benvenuto Cellini; he put forth the name of Ascanio. Also in 1860 de Ris,[4] pursuing a parallel course, saw a possible connection between the "faïences de Henri II" and a problematical jeweler-craftsman included among the Italian artisans summoned by François I to decorate the Château de Fontainebleau.

These hypotheses relied on scant evidence. But in 1861 there appeared the great illustrated album of Delange,[5] a tool of inestimable value for further study. All the known pieces and fragments, totalling forty-seven, were represented,[6] and the remarkably faithful plates aroused the keenest enthusiasm among devotees. The following year Piot,[7] without refuting the tendency to seek an Italian origin for the "faïences de Henri II," suggested the possibility that the workmanship might in fact be French, though he did so with cautious reserve.

In 1864 Fillon[8] introduced a new set of arguments. Examining a leaf from a Book of Hours made for Claude Gouffier, Lord of Oiron, *Grand Écuyer de France,* and friend of King Henri II, he had been struck by an illustration showing a man at an outdoor repast drinking from a flask of yellowish-white earthenware decorated with black interlace and the arms of Gouffier. Fillon assumed that the flask must be an example of "faïence de Henri II," and to substantiate his theory he set off for Poitou and Saintonge. He stopped near Thouars at the village of Oiron, the former haunt of Claude Gouffier and his mother, Hélène de Hangest.

The latter, a patron of arts and letters, is known to have had in her employ in 1529 a potter named François Charpentier and a librarian called Jehan Bernart, charged with the care "de la lybrairie et du vergier où est basty le four et appentisz d'iceulx."[9] At Thouars, Fillon saw in a private collection three saltcellars which suggested to him the idea of a collaboration between two such persons: a craftsman and a man of letters familiar with the ornamental vocabulary of the printed book as well as with coats of arms, both of which were frequently used to decorate the pottery in question. It was then that "faïence de Henri II" took on the name "faïence d'Oiron." Aided by his imagination and a pun on the name of Oiron—which derives from "rond d'oies," or circle of geese[10]—Fillon even thought he recognized some geese in the decoration of a cup then in the collection of Baron James de Rothschild.[11]

But the name "faïence d'Oiron" was short-lived. Writing in 1888 under the title "Les Faïences de Saint-Porchaire," Bonnaffé[12] refuted the earlier arguments and introduced a new theory based on a set of inventories. In one of these, made after the death of François de la Trémoille at the Château de Thouars in 1542, he found listed among a group of precious objects "2 coppes de terre de Saint-Porchayre" along with "2 sallières de Saint-Porchayre." In an inventory made after the death of Louis III de la Trémoille in 1577, he turned up a more perplexing reference: "de la vesselle de terre d'Angleterre et d'aultre faite à Saint-Porchayre." By "terre d'Angleterre," did the writer of the inventory mean the clayey earth that abounds in the area of nearby Bressuire, the whiteness of which had been noted by Bernard Palissy during his travels in Poitou? Saint-Porchaire was a feudal dependency of Bressuire, and Bressuire, situated at the border of Poitou and Saintonge, was a domain of the house of Laval-Montmorency. As it happens, the arms of Pierre de Laval appear on at least three pieces, and—an important detail—bear characteristics by which they can be dated prior to 1528.[13]

Bonnaffé's opinion seemed well founded, and a new battle arose between the partisans of Oiron and those of Saint-Porchaire. Acting as mediator, de Saint-Marc[14] attempted in 1889 to reconcile the opposing camps with a report entitled "Les Faïences d'Oiron en terre de Saint-Porchaire," a proposal not too improbable in view of the rather modest distance separating the two villages. But this hypothesis rapidly succumbed to new arguments invoked by Bonnaffé,[15]

168

who in 1895 uncovered the existence of potters at Saint-Porchaire as early as the fifteenth century. That their reputation was well established by the sixteenth century can be assumed from a reference in Charles Estienne's *Guide des chemins de France* of 1552, in which travellers are advised: "Saint-Porchaire, beaux pots de terre."

The problem was complicated anew by Migeon.[16] Writing in 1896 under the title "Bernard Palissy ou Saint-Porchaire," he attempted to prove that certain pieces attributed to Saint-Porchaire could be claimed instead as the work of Palissy, principally on the basis of applied reliefs—such as grotesque masks and small animals—and marbleized effects, both of which were dear to the master of Saintes. This hypothesis could hardly be disproved by the ewer in The Frick Collection (see p. 174), the adornment of which includes both animals and masks and a marbleized handle

Finally, the publication by Mirot[17] in 1920 of the inventory of furnishings "estans en l'hôtel neuf de Montmorency" in 1556 fueled the long debate with new references to various objects "de terre esmaillez de blanc façon de Poitou" and once again "de terre émaillée de blanc et noir et de mesme façon de Poitou." Moreover, the list "des meubles de l'hostel de Montmorency à Paris, inventoriez le XIII^e jour de janvier mil VLXVIII"—that is, one year after the death of the Connétable Anne de Montmorency—cites among other works: "Item ung grand vase à bec d'asne de terre cuite émaillée de noir, façon de Sainct-Porchère.—Item une esquyère et un goubellet couvert de pareille terre et façon." There is no mention of Oiron or Bernard Palissy, even though Palissy is known to have worked for Anne de Montmorency.

Of the various foregoing hypotheses, only that of "faïence de Saint-Porchaire" seemed tenable,[18] and it was this name that would henceforth prevail. Subsequent studies have sanctioned its use to designate this ceramic ware so original in both composition and appearance.

In a nineteenth-century analysis made by Salvétat using a fragment from the foot of a covered cup *(drageoir)* preserved in the Musée de Sèvres,[19] the clay of Saint-Porchaire was found to contain 59 percent silica, 40.24 percent alumina, no lime, no magnesia, and only a trace of iron.[20] A new study undertaken about 1948 by Munier and Fourest determined the same percentages of silica and alumina, along with traces of titanic and phosphoric acids.[21] The nearly total absence of

iron oxide contributes to the whiteness of the material, which may, however, take on a slightly grayish cast during firing.

The broken lid of the cup at Sèvres reveals in part one of the secrets of a somewhat enigmatic method of manufacture. Two distinct layers can be seen: an inner body molded of rather coarse earth, and an outer covering of finer clay. The outer covering was laid down after the body had been scored with shallow notches to facilitate adhesion, but during firing it lifted in places in the form of flakes. Before it was applied, the outer layer had been thinned out flat and decorated using one or more techniques. It is generally agreed that the design was impressed into the outer layer while it was still soft, using molds, stamps, cutting-wheels, and so on, and that the resulting cavities were then filled with colored clays.[22] Evidence for such a procedure is supplied by two items preserved in the Musée du Louvre, Paris, one a fragment of a clay mold, the other a segment from a platter with corresponding decoration.[23] Close study reveals that the motif legible in the mold is the reverse of the decoration on the platter, proving that a direct impression has been made. This observation contradicts a second opinion suggesting the use of an intermediary parchment sheet to transfer the decoration from the mold, where it had been worked in advance, onto the layer of fine clay; if such were the case, the decoration would follow the same direction as that on the mold. That the latter method was not used elsewhere remains to be proved. It is also possible that enamel inlays were used, or even local applications of plain or colored slip,[24] with various undecorated areas perhaps receiving a broad coating of slip.[25]

Once the outer layer was decorated it had still to be transported onto the inner form, a process fraught with difficulties. This transfer is what accounts for the faulty alignment at the junctures—particularly in motifs made up of small squares or interlace—visible on certain pieces, among them the ewer in The Frick Collection and the platter in the Louvre.

The decorative patterns, in monochrome colors, ran the range from black-brown to beige sometimes tinged with pink. The ornamental reliefs were molded separately and affixed with slip to the finished pieces, which explains why the interlace designs are found to be continuous where parts of the relief have been cut away.

The clay of Saint-Porchaire required firing at a high temperature. After the

first firing the pieces were covered with a lead-base flux, and a second firing, at a lower temperature, rendered them lustrous under the transparent glaze. The resulting material, of a fine, close grain, is sometimes extraordinarily light in weight.

It will be noted that the ceramic ware under discussion is not a true faïence, which by definition is baked clay naturally colored to some degree and coated with a tin enamel to give it an opaque white finish. In technique the present material is nearer to glazed pottery, and in texture it falls within the class of so-called *faïences fines,* or fine earthenware. In the latter category it figures as a precursor—unique in its time though close to certain "terre blanche de Poitou"[26] and to fragments unquestionably by Bernard Palissy[27]—of the fine, cream-colored English earthenware[28] that followed it by nearly two centuries, as well as to the development of fine French earthenware.[29]

The forms and decoration of Saint-Porchaire ceramics, characteristic of the French Renaissance, took their inspiration from various other artistic disciplines and from the designs of ornamentalists. Architecture and metalwork strongly influenced the forms, which, though they reflect at times a vaguely Oriental character, most often reproduce objects in precious metal, enamelled or otherwise. This is particularly so of ewers, candlesticks, and saltcellars, which took on the appearance of miniature monuments laden with architectonic elements. The decorative schemes were influenced by niello work and by the art of the bookbinder. The foliage, flowers, narrow interlaced friezes, chains, and strapwork recall, for example, the decorative frames that surround the printed pages of a Geoffroy Tory, or the ornamental repertory used on the bindings made for Jean Grolier. Coats of arms appear rather frequently and have helped determine the approximate dates of certain pieces. Religious subjects also are met with. Marbling and colored highlights on the glaze—greens, blues, violets—relieve the monotony of the general tonality. The elements in applied relief evidence a taste that leans toward the grotesque; the *mascarons,* masks, and chimeras bring to mind the furniture of the same period, while the small animals inevitably recall the work of Bernard Palissy.

The classification of Saint-Porchaire ceramics is a difficult and deceptive task. Fourest, abandoning earlier attempts at chronological grouping, which he found "sujets à caution," put forward a convincing proposal when he wrote: "Les grosses différences observées nous paraissent moins liées à un décalage éventuel de quel-

ques décennies dans la fabrication, qu'à la diversité des ateliers ou artisans, appliquant tous une technique semblable, propre au sud-ouest à l'époque considérée. On pourrait d'ailleurs envisager, non plus des périodes mais des catégories principales. La première serait celle de l'application par transfert d'une couche de terre plus fine sur la forme et le décor. La seconde montre l'emploi d'une légère incrustation d'émail suivant une technique assez mal définie qui est la seule signalée par les auteurs du XIX^{ème} siècle."[30]

Thus, various studios grouped together under the name of Saint-Porchaire, working in a more or less restricted area and using analogous methods, could have produced simultaneously pieces of the same type while conferring on them the character and technical refinements peculiar to each given shop. This suggestion, logically supported by the obvious differences in quality and especially in skill, merits further study. The mysterious "faïences de Saint-Porchaire" have yet to give up all their secrets.

NOTES

1 N. X. Willemin and A. Pottier, *Monuments français inédits pour servir à l'histoire des arts,* Paris, 1839, p. 65, Pl. 289.

2 C. and H. Delange, *Notice biographique sur Girolamo della Robbia,* Paris, 1847.

3 A. Tainturier, *Notice sur les faïences du XVI^{ème} siècle dites de Henri II,* Paris, 1860.

4 C. de Ris, "Les Faïences de Henri II," *Gazette des Beaux-Arts,* V, 1860, pp. 32–48.

5 C. and H. Delange, *Recueil de toutes les pièces connues jusqu'à ce jour de la faïence dite de Henri II et Diane de Poitiers,* Paris, 1861.

6 For the ewer in The Frick Collection, then part of the Hope collection, see Pl. 45.

7 E. Piot, *Le Cabinet de l'amateur,* Paris, 1862, No. 19, p. 5.

8 B. Fillon, *L'Art de terre chez les Poitevins,* Niort, 1864.

9 H.-P. Fourest, "Faïences de Saint-Porchaire," *Cahiers de la Céramique, du Verre et des Arts du feu,* No. 45, 1969, p. 16. The quotation is from a letter of Claude Gouffier.

10 *Idem,* p. 25, note 8.

11 Delange, 1861, Pl. 35.

12 E. Bonnaffé, *Gazette des Beaux-Arts,* 2^e pér., XXXVII, 1888, pp. 313–17.

13 Fourest, p. 25, note 9.

14 C. de Saint-Marc, report presented to the Conseil général de Statistiques, Sciences, Lettres, et Arts du Département des Deux-Sèvres, citing "Les Eglogues et autres oeuvres poëtiques de Jacques Bereau, poictevin, Poitiers, Bertrand Mascereau, 1565" (see Fourest, p. 21 and p. 25, note 10).

15 E. Bonnaffé, "Les Faïences de Saint-Porchaire," *Gazette des Beaux-Arts,* 3^e pér., XIII, 1895, pp. 277–84.

16 G. Migeon, *Gazette des Beaux-Arts,* 3^e pér., XV, 1896, pp. 382–87.

17 L. Mirot, *L'Hôtel et les collections de*

Montmorency, Paris, 1920.

18 Fourest (p. 23) recalls, in passing, one additional opinion which denied the existence of Saint-Porchaire ceramics in the sixteenth century and considered them belated—and fraudulent—products of the nineteenth century. The documents quoted above repudiate any such theory. Furthermore, a cup in the Musée de Cluny, Paris (Fourest, Pl. 8), appeared in a sale of furniture from the convent of Saint-François de la Flèche in 1793, and a second cup, now in the Musée du Louvre (O. A. Revoil 105), was known at the time of the Revolution. Nevertheless, it is true that the very high prices brought by Saint-Porchaire ceramics in the nineteenth century did tempt forgers to restore damaged specimens and even to fabricate entire pieces. W. B. Honey *(European Ceramic Art from the End of the Middle-Ages to About 1815,* London, 1952, I, p. 538, Pls. 22, 23) calls attention to a number of known imitations and exact copies made at the Minton works, Stoke-on-Trent, about 1875.

19 No. 2447. Reproduced in Fourest, Pls. 6, 7.

20 A. Brongniart, *Traité des arts céramiques,* Paris, 1844; 2nd ed., revised and expanded by A. Salvétat, Paris, 1854, II, p. 175; 3rd ed., Paris, 1877, II, p. 177.

21 This composition is close to that used by Bernard Palissy in the decoration of the grotto at the Tuileries, fragments of which are analyzed by P. Munier in "Contribution à l'étude des céramiques de Bernard Palissy: La Grotte des Tuileries," *Bulletin de la Société française de céramique,* No. 3, 1949, pp. 3–28.

22 Apart from the difference in materials, the technique is not unrelated to that of niello or even that of champlevé enamels.

23 Fourest, Pls. 9, 10.

24 Slip *(barbotine)* is ceramic paste in its liquid state.

25 A coating of slip *(engobe)* was sometimes applied over a piece already fashioned in clay.

26 See Fourest, caption to Pl. 12, commenting on a platter in the Musée de Sèvres (No. 8329) formerly attributed to Saint-Porchaire.

27 The fragments are those from the Tuileries grotto mentioned in note 21, above.

28 For which see D. Towner, "Faïence fine anglaise de couleur crème," *Cahiers de la Céramique, du Verre et des Arts du feu,* No. 10, 1958, pp. 80–91.

29 For which see *Les Faïences fines françaises des origines à 1820,* catalogue of an exhibition held at the Musée National de Céramique de Sèvres in 1969, published in *Cahiers de la Céramique, du Verre et des Arts du feu,* No. 44, 1969, pp. 171–227.

30 Fourest, pp. 24–25.

Ewer with Interlace Decoration and Applied Reliefs,
Sixteenth Century (18.9.1)

Fine earthenware. H. including handle 9 in. (23 cm); H. at top of collar 7⅞ in. (20 cm); W. including handle and spout 4½ in. (11.5 cm); D. of foot 3¼ in. (8.3 cm).

Description: The ewer's tall, rounded form recalls those of the highly ornamented metalware flagons of the French Renaissance. The foot, in the form of a wide-mouthed bell, is adorned with four narrow bearded masks in relief, above which alternate four consoles set against a broad stem supporting the ovoid body. The body is cut at the middle by a protruding horizontal band which divides it into two distinct zones: the lower zone is embellished with four chimeras in relief, and the upper zone has four bosses in the form of oculi alternating with two salamanders, a frog, and a heart-shaped shield which follows the curve of the shoulder. The shield extends upward over a shallow ridge marking the juncture of the body with a cylindrical neck, the latter ornamented with two masks emerging from cartouches simulating drapery and scrolled leather. Directly opposite the shield a tall handle springs from the shoulder, then turns down to merge with a flaring collar set above a protruding band which marks the top of the neck. Toward the front the collar is cut vertically and scrolls inward, again imitating leather, to frame a projecting, pointed spout. The cream-colored ground is entirely covered on the body, the collar, and the rounded section of the foot with a network of bold interlace in light brown bordered with dark brown, within which runs a secondary network of brown-black filigree. This somewhat confused motif recalls Arabic art, in particular the decoration of Near Eastern damascened metalware as it was adapted to ornament the bookbindings made for Jean Grolier. On the ewer the patterns are awkwardly aligned, and in places the motif lacks coherence. The vertical shaft of the neck is covered with the same type of decoration, denser and more complicated but consisting basically of geometric patterns in which direct motifs in several tones of brown oppose other motifs in reserve. The frieze of dark brown star-shaped lozenges on the foot may also derive from bookbinding or from typographic ornament, or possibly from marquetry. The applied reliefs belong to the vocabulary of Renaissance ornament used in architecture as well as in furniture, metalware, painted enamels, tapestries, and, broadly speaking, all the decorative arts. Raised above the reddish-brown ground of the heart-shaped shield are indistinct animal figures, possibly representing a fox or dragon with birds, which may or may not have a heraldic intention; in either case their significance is obscure. The entire ewer is coated with a thick, transparent, colorless glaze (see *Condition*). Brown accents appear in the form of occasional bold splotches and also fill the centers of the bosses. Here and there, green highlights have melted into the glaze. Touches of blue occur on the cartouches at the neck, the bosses, the chimeras' heads and wings, and the consoles. The handle, marbled in blue and brown-red

174

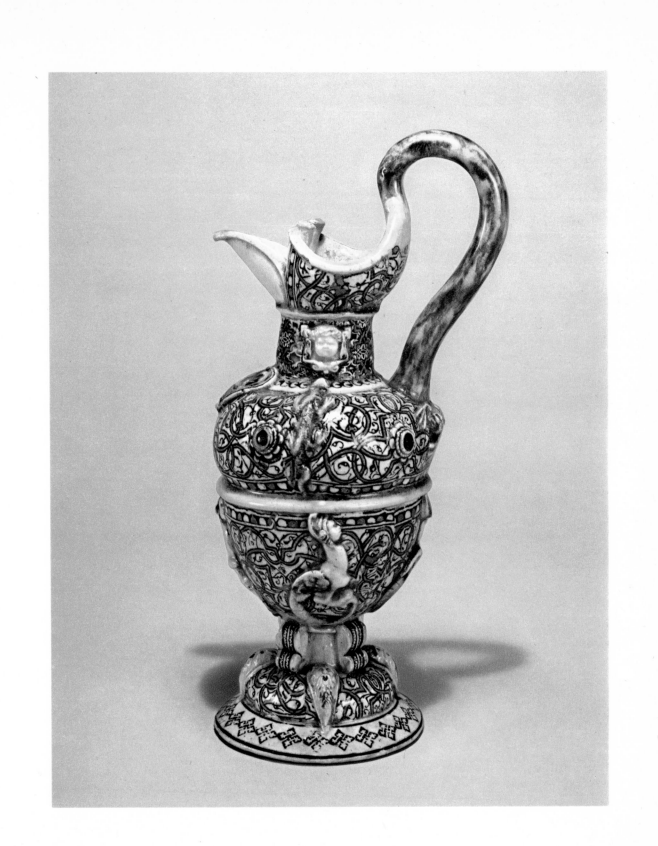

tinged with yellow, introduces a different note in curious contrast to the treatment of the spout, which is undecorated. The reliefs are heavily encrusted with glaze, but the interlace behind them still shows clearly through the open parts of the chimeras.

Condition: Though the ewer appears to be in good condition, examination under ultra-violet light reveals restorations in the top and bottom of the handle, the ends of both collar scrolls, the point of the spout, one of the bosses, and a small section of the foot at the bottom. The restorations are skillfully concealed beneath a subsequent coat of glaze.

Various pieces published by Delange[1] and Fourest[2] are closely related to the Frick ewer either in form or in decoration.

The ewers similar in form are all more or less elongated, with the body either flowing in a single unbroken line[3] or divided, like that of the Frick example, by a protruding horizontal band.[4] Almost invariably, the spout is detached from the flaring collar and the severed ends of the collar scroll inward.

The decorative elements found on the Frick ewer recur on several pieces of different types. Broad geometric interlace of the same design and coloring appears on a covered cup *(drageoir)* in the Musée de Sèvres (see p. 169),[5] and the same interlace, with the same faulty alignment at the junctures, is seen on parts of an oval cup and cover in the Alain de Rothschild collection, Paris.[6] The frieze that surrounds the Rothschild cup reproduces the geometric motif used on the cylindrical neck of the Frick ewer and recalls a niello pattern by J. Androuet du Cerceau.[7] The frieze design on the upper projection of the Rothschild cup's foot is very similar to the band of star-shaped lozenges on the foot of the ewer. Each of these three pieces abounds with ornament in relief. Though the bearded masks on the cup at Sèvres and the masks framed by cartouches on the Rothschild cup differ from those on the ewer, their character and the way they are disposed on each object do present analogies. It may therefore be supposed that these three pieces issued from the same workshop.

It is tempting to add to this group a segment of a platter in the Musée du Louvre, Paris (p. 170).[8] Though its ground pattern of squares is quite different, its applied reliefs of a splayed frog and a salamander, both thickly encrusted in the glaze, seem to have come from the same mold as those on the Frick ewer. These little creatures inevitably call to mind the animals in the work of Bernard Palissy, but on the basis of surviving fragments from the Tuileries grotto it appears that

176

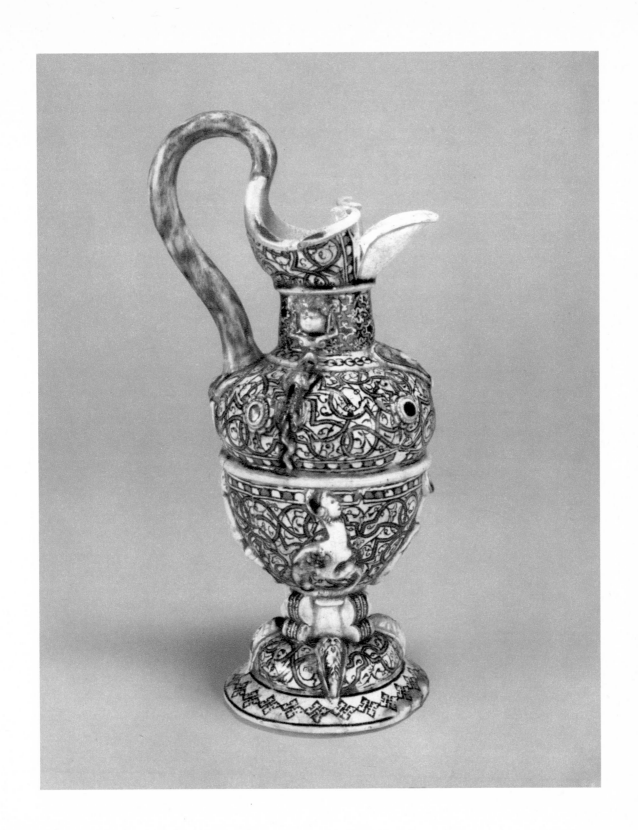

Palissy's animals were executed with greater precision. The Louvre platter and the Frick ewer share other characteristics as well: the back of the platter is marbleized like the handle of the ewer (though with stronger contrasts), and the surface of the platter displays similar green highlights.

No attempt is made here to determine whether the ceramics of Bernard Palissy preceded or followed those of Saint-Porchaire in the use of small animals molded from nature as decorative elements in relief. But such questions aside, it is generally agreed that this type of ornamentation was inspired by the *Hypnerotomachia Poliphili,* translated from the Italian in 1546.[9] If this opinion is accepted, it would be proper to place the ewer in The Frick Collection after that date, along with the above-mentioned pieces of the same category.

Exhibited: London, South Kensington Museum, Special Exhibition of Mediaeval and Renaissance Works of Art, 1862.

Collections: Recorded in 1847 in the Debruge-Duménil collection, Paris.[10] Prince Soltykoff. H. T. Hope, Deepdene, Surrey. Duveen. Frick, 1918.

NOTES

1 C. and H. Delange, *Recueil de toutes les pièces connues jusqu'à ce jour de la faïence dite de Henri II et Diane de Poitiers,* Paris, 1861. For the Frick ewer, see Pl. 45.

2 H.-P. Fourest, "Faïences de Saint-Porchaire," *Cahiers de la Céramique, du Verre et des Arts du feu,* No. 45, 1969, pp. 12–25.

3 Delange, Pls. 42, 46.

4 *Idem,* Pls. 30, 31.

5 No. 2447. Reproduced in Fourest, Pls. 6, 7.

6 Fourest, Pls. 4, 5.

7 Cabinet des Estampes, Bibliothèque Nationale, Paris, Ed.2.0.in-4°. Reproduced in D. Guilmard, *Les Maîtres Ornemanistes,* Paris, 1881, II, Pl. 2.

8 Fourest, Pl. 9.

9 The *Hypnerotomachia Poliphili* of Francesco Colonna (d. 1527) was first printed by Aldus Manutius in Venice in 1499. The work met with great success, less perhaps for its romantic text—which describes in the medieval tradition the extraordinary adventures of Polyphilos and his beloved Polia, symbol of the feminine ideal and personification of antiquity—than for its remarkable woodcuts, the work of an unknown artist who has sometimes been identified, without proof, as Mantegna, Giovanni Bellio, Giovanni Andrea, or the Bolognese metalworker Peregrini. The first French edition of the *Songe de Poliphile* was published in Paris by Jaques Kerver in 1546, with new printings in 1556 and 1561. The woodcuts were French interpretations of the scenes illustrated in the Italian edition, and again the artist remains

178

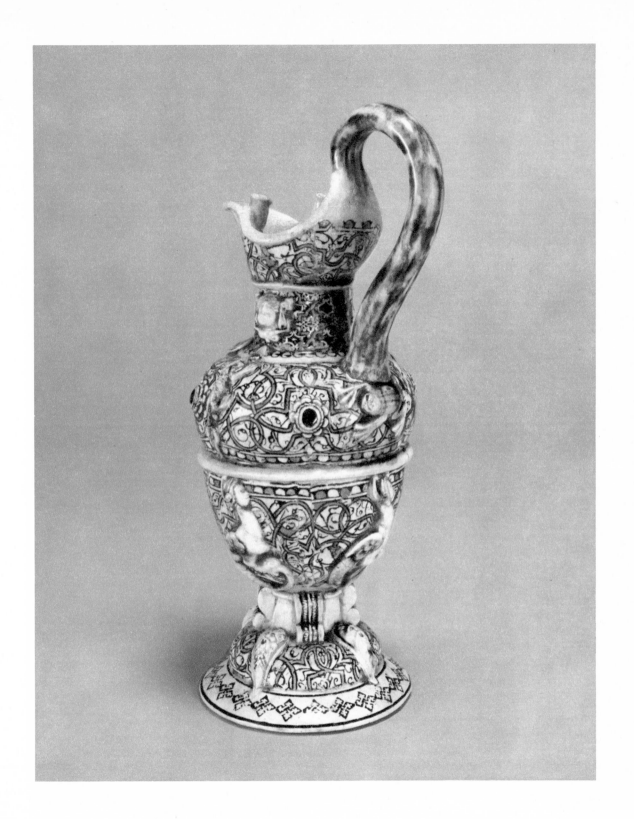

anonymous, though the names of Jean Goujon and Jean Cousin have been proposed. A rare copy of the Italian edition of 1499, which was included in an exhibition of bookbindings held at Baltimore in 1957 (No. 289, Pl. 65), figured in the Raphaël Esmérian sale of 1972 (June 6, Palais Galliéra, Lot 19, p. 30), along with a copy of the Paris edition of 1546 (Lot 50, p. 79); the sale catalogue reproduces on facing pages (pp. 76, 77) an illustration of the same subject taken from each of the two editions, permitting an interesting comparison. The original drawing for the frontispiece of the 1546 edition (see *L'École de Fontainebleau,* Grand Palais, Paris, 1972, No. 678, p. 463) is preserved in the Musée Condé at Chantilly (F.R.I.

No. 400). It was acquired by the Duc d'Aumale at the posthumous sale of the architect Destailleur (May 26–27, 1893, Galerie Georges Petit, Lot 33). The drawing, which bears on the verso the inscription *P. Mariette 1660,* was exhibited at Chantilly in 1973 beside a copy of the printed book ("François I^er et l'art renouvelé au XVI^ème siècle dans les collections du Château de Chantilly," *Le Musée Condé,* IV, March 1973, No. 137).

10 J. Labarte, *Description des objets d'art qui composent la collection Debruge-Duménil,* Paris, 1847, No. 1169, p. 306. Delange (p. 34) states that the ewer was bought at the Debruge-Duménil sale for 505 francs by the London dealer Forest.

VINCENNES AND SÈVRES PORCELAINS
UNDER THE ANCIEN RÉGIME

By the seventeenth century, attempts to manufacture a white, brilliant, and vitrified porcelain like that of the Far East, long known and admired in the West, had become a widespread preoccupation in Europe. A climate of latent rivalry prevailed among the rulers of countries where the porcelains of China and Japan were most in demand. European ceramists had begun by imitating the surface appearance of the material in tin-glazed earthenware—faïence—but this counterfeit resemblance satisfied no one.

On the basis of samples collected in China by a Jesuit missionary, Père d'Entrecolles, it was known that the manufacture of porcelain demanded a particular white clay called kaolin and a natural frit[1] of feldspar mixed with quartz. But all attempts to discover kaolin in Europe had met with failure. Faced with this deficiency, the French potters multiplied their experiments using other elements in the hope of arriving at a material having the appearance and certain of the inherent qualities of porcelain, notably its translucence.

HISTORICAL AND ADMINISTRATIVE CONSIDERATIONS

In point of fact, the Medici workshops of Florence had succeeded in producing a kind of artificial porcelain as early as the late sixteenth century, but this singular achievement had been short-lived. Toward the end of the seventeenth century, however, a faïence-maker of Rouen, Louis Poterat, obtained results of sufficient quality to warrant application for a patent, the date of which—1673—marks the earliest beginnings of artificial, soft-paste porcelain in France.

Despite efforts to retain the secret of an invention so laboriously achieved, the inevitable dispersal of workers, often lured into the service of outright imitators, contributed to the spread of the early formulas, however rudimentary they may have been at that stage. In this manner began the factories of Saint-Cloud shortly before 1700, Lille in 1711, Chantilly in 1725, and Mennecy in 1735. Finally, in 1738 two runaway workers from Chantilly who had taken refuge with the *Concierge* of

the Château de Vincennes were introduced to Orry de Fulvy, *Conseiller d'État, Intendant des Finances,* and director of the Compagnie des Indes. Fulvy, encouraged by his brother Orry de Vignory, *Contrôleur Général des Finances,* became passionately interested in the idea of producing porcelain.

It happens that an event of prime importance had taken place in Saxony in 1709: the discovery of kaolin deposits. Thanks to the talents of von Tschirnhaus and Böttger, the Elector Augustus the Strong had been able to set up a hard-paste porcelain factory at Meissen. Production quickly reached a level of excellent quality and sufficient quantity to create a continuous flow of exports, spurred by the rage for porcelain then sweeping through all Europe and France in particular.

To watch powerless as capital poured out of the country was distressing enough to Fulvy in itself, but all the more bitter since the reason behind it might reflect on the artistic supremacy of France. The presence at Vincennes of the brothers Gilles and Robert Dubois, who claimed to know the secrets of porcelain manufacture, seemed an act of providence. Fulvy readily furnished them with the equipment needed to conduct tests in the castle keep at Vincennes, a royal property, and obtained from the King a loan of 10,000 livres to support the project.

But the brothers' boasts proved hollow. Their ineptitude grew evident, and had they not sent for a friend from Chantilly, François Gravant, the entire enterprise would have collapsed. Gravant, an industrious, shrewd, and determined individual who had previously followed such diverse careers as faïence-maker and grocer, eventually found an opportunity to profit from the brothers' drunken sleep by stealing their secrets (or so legend has it) and set to work on tests of his own. At the very moment when Fulvy—disillusioned, weary of supplying funds, and sensing defeat—was at the point of giving up, Gravant won a delay. Working relentlessly, he soon brought his experiments to a successful conclusion, narrowly saving the day.

Only after several years of trial and error was it possible to speak of actual production, and then but on a modest scale. Nevertheless, the interest aroused by the fledgling workrooms at Vincennes justified application for a patent, which was granted by the Conseil d'État on July 24, 1745, in the name of Charles Adam, a shadowy figure who was in reality Fulvy's *valet de chambre*[2] and may have been acting as his front man as well. The patent, issued for twenty years, was immediately turned over to a company consisting at the start of seven members, nearly

all of them *fermiers-généraux*. Whether or not they invested in hope of profitable returns, there can be no doubt that they felt considerable pride in finding themselves in control of a porcelain factory, on equal terms with such notables as the Prince de Condé and the Duc de Villeroy.[3] With the new business financially safeguarded, it would seem, by the exclusive privilege "de fabriquer de la porcelaine façon de Saxe, c'est à dire peinte et dorée à figure humaine," the company assumed the title Manufacture Royale, organized briskly under the direction of Boileau de Picardie,[4] and grew rapidly. The number of personnel rose from about twenty before 1745 to a hundred and twenty in 1749, thanks in part to the vogue for porcelain flowers, the manufacturing monopoly for which had been added to the original patent and accounted for the employment of forty-five young women.

Despite the appearance of prosperity the factory suffered serious financial difficulties, due both to the inefficiency of a management ill prepared to administer an industrial enterprise and to the initial absence of a competent and stable work force. The partners were obliged to pour in additional funds each year until, tired, disappointed, and crushed by heavy costs, they concluded that only the King, who had already advanced substantial subsidies, could rescue them from their predicament. An appeal for assistance led to the revocation of the patent issued to Adam, by a decree of the Council passed October 8, 1752, and to their reimbursement for the security they had put up.

If the operation were to continue—and it was judged worthy of further support by an administrative and technical investigation[5]—the time was ripe to enlist the more direct participation of Louis XV. It happens that Vincennes is located on the opposite side of Paris from Versailles. No one knows who first thought of transferring the factory, but it is possible that one of the most active partners, Jean-François Verdun,[6] had proposed the idea to Madame de Pompadour, a great connoisseur of porcelain as well as a powerful influence at court. The favorite, who was always anxious to provide the King with diversion and who "à cet effet s'était attachée à développer chez lui le goût des arts,"[7] had just had the Château de Bellevue built for herself on the slopes of Meudon adjoining Sèvres. That it was she, then, who suggested transplanting the workrooms from Vincennes to Sèvres seems plausible, its location on the road from Paris to Versailles proving ideal. In any event, in 1752 the transfer to Sèvres was agreed upon in principle.

On August 19, 1753, a decree of the Council retroactive to October 1, 1752, granted to Éloi Brichard, a front man who would be rewarded with a figurehead title, the privilege of manufacturing for twelve years and three months[8] "toutes sortes d'ouvrages et pièces de porcelaine peintes ou non peintes, dorées ou non dorées, unies ou de relief, en sculpture ou en fleurs…pour en jouir privativement et exclusivement…dans toute l'étendue du royaume…." It was only at this date that the title Manufacture Royale and the right to use the royal cipher as a mark were officially accorded—thus legitimating what had long existed in practice. Beginning in 1753, a date-letter was simply incorporated into the cipher. In addition to the King, who subscribed a quarter of the capital, the new company consisted of sixteen members, five of them holdovers from the previous partnership. The new investors were again principally *fermiers-généraux* or *secrétaires* to the King.

Construction of the future Manufacture Royale de Sèvres began in 1753, with design and supervision under the architect Lindet and the engineer Perronnet. In planning the interior one consideration was paramount: the preservation of the factory's secrets. Access to the room in which they were locked could be gained only by passing through the director's apartment, which had its own private entrance and stairway and was barred by an inner gate. Visitors, customers, and the curious could reach the exhibition gallery only by a grand staircase which bypassed an entire floor, and this in turn was walled off from the staff stairway leading to the different workrooms on each floor. The King's apartment, not far from the director's, connected with the exhibition gallery and the various service areas, and was reached from the exterior by passing through a special side entrance and crossing the royal courtyard.

Completion of the main edifice and its outbuildings took three years. Hardly finished, the factory became the object of heated criticism directed against its supposed lack of solidity. Time has proven these intrigues baseless. After more than two centuries of existence the structure still stands, and all that has changed is its function.[9]

The transfer from Vincennes to Sèvres, made in stages throughout the year 1756, would henceforth enable the King to visit the factory without going out of his way. But the construction of such a folly was ruinous to the company. Despite a more efficient organization, it soon experienced financial troubles as serious as

its predecessor's if not worse. Burdened with mounting debts and pursued by creditors, the partners on several occasions during 1759 requested help from Louis XV, who granted various sums. Finally, on February 17, 1760, the patent issued to Brichard was revoked by a decree of the Council retroactive to October 1, 1759. The King had decided to reimburse the shareholders for their investments and to liquidate the debts incurred by the enterprise itself, thereby becoming the sole owner of the buildings and all they contained. The private business ceased to exist, and "jusqu'à la révolution, la Manufacture allait être la propriété du roi seul, exploitée en son nom et pour son compte."[10] This new arrangement was tantamount to the incorporation of the factory within a parallel institution, the Manufacture Royale des Meubles de la Couronne, which was inaugurated in 1667 at a time when no porcelain was being made in France. Sergène sums up the situation thus: "L'idée de profit, qui animait ses promoteurs et les associés successifs de cet établissement, disparaît car la monarchie va s'attacher dorénavant à maintenir une industrie de luxe en vue du seul prestige."[11]

Proud of the factory's new creations, Louis XV encouraged their success by organizing an annual exhibition at Versailles during the Christmas holidays, a sale at which every good courtier owed it to himself to acquire something—to the detriment of his purse. In addition, by offering the finest pieces as diplomatic gifts the King assured a worldwide distribution for the porcelain of Sèvres. Its prestige, already dazzling in the eighteenth century, would endure through changing political regimes and persist even into this last third of the twentieth century.

TECHNICAL AND ARTISTIC CONSIDERATIONS

The administrative complexities of a private business—and later the management of an industry in the service of the State—constituted only the routine facets of the challenges that faced the factory. Contrary to the view of Orry de Fulvy and Gravant that the technical aspects of porcelain production should take precedence over artistic considerations, renowned artists were called to Vincennes even before there was any solid technical organization ready to absorb them. The task of forming such an organization was assigned to the eminent Jean Hellot, member of the Académie des Sciences, while a certain "Monsieur Hults," an *amateur* member of the Académie de Peinture et de Sculpture and man of celebrated

taste, was asked to advise on new creations.[12] It was only at Fulvy's death in 1751 that the *Contrôleur Général* Machault d'Arnouville[13] charged Hellot with the task "de faire les épreuves du secret des compositions de la pâte et de la couverte, de la dorure, des couleurs et émaux qui appartiennent à la Compagnie."[14] The scientist set to work with a zeal attested to by the documents he has left behind: two hundred pages of small, squeezed writing compressed into three books— his *registre,* bound in blue leather and fitted with a lock; a small *recueil* of miscellaneous observations; and a bound *cahier*—as well as a set of cards which he exchanged with the men in charge of various experiments.[15] The first page of the *registre* contains a clear, precise profession of faith which deserves inclusion here:

"Ce registre contient toutes les recettes et procédés pour composer la pâte dont on fait le biscuit, la couverte qui le vernit et le rend porcelaine, les couleurs servant à peindre cette porcelaine, la dorure qui l'enrichit...trouvés aussi dans les manuscrits des nommés Gérin, Caillat et Massue, dans celui du Sr Gravant inventeur et fournissant la pâte et la couverte, lesquels Mss... j'ai rendus à M. de Courteille Intendant des Finances, après les avoir vérifiés. Il contient aussi les corrections pour remédier aux vices de la pâte et en durcir le biscuit, les changements que j'ai faits à la couverte, ceux des fondants des couleurs pour en ôter le nébuleux, les nouvelles couleurs bleues, pourpres, rouges, jaune, orangé, vertes etc. Enfin tout ce que j'ai fait pour perfectionner les opérations... en exécution des ordres de Mgr. le Garde des Sceaux. J'ordonne qu'immédiatement après ma mort ce registre soit fermé à clef, puis enveloppé et cacheté et ensuite remis en main propre à Monseigneur le Garde des Sceaux ou à M. de Courteille et non à aucun intéressé de cette Manufacture attendu que le Roy s'en est réservé les secrets et qu'ils m'ont été confiés. A Paris ce premier Mai Mil sept cent cinquante trois."[16]

Further on, Hellot dutifully acknowledges that before his arrival "la Manufacture de Vincennes avait déjà un biscuit, fort blanc et une couverte parfois très belle...." He transcribes the formula with affecting simplicity: "Copie corrigée quant à l'ortographe du sécret de la pâte de porcelaine de Vincennes et de la couverte, en deux feuilles de papier à lettre, écrit de la main du Sr Gravant. Méthode générale pour faire toutes sortes de porcelaine: Pour faire 2020 Livres de composition:

188

cristal minéral	440 1.
sel gris de gabelle	146
alun de roche	74
soude d'Alicante	74
gypse de Montmartre	74
Pilez le tout. Ajoutez à ces	808 1. de
matière 1 fois ½ de sable de Fontainebleau,	1212
le tout réuni et mélé fera la composition .	2020 1.

Mettez cuire ou fritter sous le four de biscuit, retirer, piler. Pour faire la pâte prendre 90 livres de cette fritte, bien broyer, jeter 30 livres de corps:

> 20 1. blanc d'Espagne
> 10 1. terre d'Argenteuil.

bien méler au moulin, délayer, passer au tamis de soie, faire sécher, employer.— Pour une pâte plus dure augmenter la proportion de blanc d'Espagne, soit $22^{1}/_{5}$ et diminuer la terre soit d'Argenteuil, soit de Luzarches, soit d'Ecouen."

The resulting paste, the formula for which remained much the same during the eighteenth century despite constant efforts to perfect it, was barely plastic and difficult to work. To facilitate handling it was necessary to add a mixture of black soap and a parchment glue called *chimie*.

Before pieces fashioned from the paste could be enamelled, they had to be fired into biscuit at a temperature of about twelve hundred degrees centigrade. Biscuit in its natural state is translucent but matte. By polishing it with "le grais et l'eau" and removing the "sels végétés"[17] it was given a perfectly smooth surface. It was then ready to be dipped in a glaze consisting of lead monoxide, Fontainebleau sand and calcined flint, carbonate of soda, and carbonate of potassium. After retouchings were made by brush, the piece was refired at a lower temperature and became porcelain—that is to say, lustrous.

The fact that the soft surface of the glaze can easily be scratched with a steel point gave rise to the name soft-paste porcelain. The term refers to this external property and not to the inner composition, which warrants no such description.

Though the glaze was admirably suited to painted decoration, it was unfavorable to porcelain sculpture since it collected in hollows and thereby weakened the

189

elements in relief. It was this deficiency that gave birth to the idea of leaving statuettes and groups in the biscuit state, an innovation that met with immediate and lasting success.

If the name of Hellot is inseparably linked with soft-paste porcelain, that of Pierre-Joseph Macquer—his collaborator and, beginning in 1766, successor—is associated above all with hard-paste porcelain. While travelling with Millot, foreman of the kilns, in the winter of 1768–69, Macquer recognized some kaolin deposits at Saint-Yrieix, not far from Limoges. He began experimenting with the material immediately, and by 1770 Sèvres was set up for the production of hard-paste porcelain. Macquer was followed as technical director by Montigny, Darcet, Desmarest, and Cadet-Gassicourt successively, while the general administration was assumed by Parent after Boileau's retirement, then by Régnier until 1793. Delegates of the Revolutionary government took over during the period of unrest.

Both types of porcelain were produced simultaneously until 1804. At that time Alexandre Brongniart, who is to be credited with setting the factory back on its feet after the Revolution, abandoned the manufacture of soft paste in the belief that it had become technically obsolete. He could not foresee that it would be vindicated by time and become the porcelain most sought after by collectors. All of the Sèvres pieces in The Frick Collection are of soft paste, richly decorated.

GROUND COLORS AND GILDING

The glaze used on soft-paste porcelain melts at a relatively low temperature and thus is suitable to receive a great variety of colors. Hellot assembled in his register the formulas for those colors that had already been tested by the painters—notably by Pierre-Antoine-Henri Taunay, who on a cup dated 1748[18] juxtaposed and enumerated, as if on a palette, a group of small compositions in monochrome purple, carmine red, violet, blue, bistre, and green. Hellot also redid a number of tests, assisted by Bailly, an enthusiastic researcher who entered the factory as a painter in 1746 and held the post of preparer of colors from 1754 to 1790. But the learned chemist was not content with merely describing and improving the formulas of others: he created some himself. The factory's delivery records mention a *bleu Hellot,* which is probably a turquoise blue though Hellot also refers to a different shade as "mon beau bleu de cobalt." In connection with the Pyrenees

190

cobalt he tested for the latter, he specifies that this metal should be oxidized at a moderate heat in order to remove most but not all of the arsenic, "car si on l'en privait tout à fait il [the blue] ne serait pas si vif."[19] Cobalt blue grounds were the first to appear at the factory. Generally cloudy and known under the name of *bleu lapis,* they are the ancestors of *bleu de Sèvres,* temporarily called *bleu nouveau* in 1763.

From all appearances, *bleu Hellot* is the ground color "bleu du Roy, nommé avant les fêtes de Noël 1753, bleu ancien et dont S. M. a été si satisfaite." Its creator defined it as: "Bleu pour donner le fond nommé V. C'est le bleu de Roy, ou bleu turquoise du service complet de S. M. trouvé en 1753 par moi. 3 parties d'aigues marines, 1 partie de la couverte de Gravant. On ne les fond pas ensemble. On prend ensuite 3 parties de verd-bleu meslé avec la couverte et 1 partie de minium. On mèle…on fond au grand feu dans un creuset. On les coule dans un mortier de fer, on pile dans un mortier de porcelaine, on tamise cette poudre sur du mordant…." It was necessary to repeat the operation twice for successful results, and then "cuire deux fois au four de peinture, alors il devient d'un beau bleu turquoise d'ancienne roche au jour et verd de malachite aux lumières."[20]

The turquoise blue ground knew a considerable vogue in the years 1756–57, though it was more expensive than *bleu lapis.*[21] The *marchand-mercier* Lazare Duvaux, who arranged an exhibition of part of the King's service and who was consulted by the members of the Compagnie de Vincennes to determine the preferences of the trade, sold turquoise blue pieces to Madame de Pompadour, the Dauphine, and the Princesse de Condé among others. A large proportion of the Vincennes and Sèvres pieces in The Frick Collection have turquoise blue grounds, and the variations in tone to be found among them attest to the changes made in the formula over the years. The coincidence of dates and the exceptional beauty of the two Duplessis vases with children in relief (see p. 200) suggest that their turquoise ground may correspond to the formula invented by Hellot for the King's service.

The green ground was introduced as the factory was being set up at Sèvres. Decoration consisting of painted green ribbons was much in fashion, as evidenced both by surviving examples dated 1756, such as the Frick sugar bowl (p. 214), and by entries in the *Livre-Journal* of Duvaux. Various formulas for green were confided to Hellot by Gravant and Bailly and by the painters Taunay *père,* Massue,

and Caillat, the last of whom invented several. The base of this color was copper.

Monochrome grounds were soon supplanted in popularity by juxtaposed colors in bold hues. The Frick *vaisseau à mât* and matching *vases à oreilles* (pp. 224, 232) are splendid examples on which apple green appears side by side with cobalt blue. Other, less frequent combinations vied for the favor of seekers after novelty, who welcomed enthusiastically the pink ground invented about 1757 by the painter Xhrouuet. An entry in the factory's personnel register for January 1, 1758, specifies that "après avoir fait de luy-même plusieurs essais de couleurs [Xhrouuet] a trouvé un fond couleur de rose très frais et fort agréable, il a eu pour cette découverte à peu près 150 Livres de gratification."[22] An element of mystery surrounds this matter, however, in that Hellot, in his last notebook, transcribes the secret of "Couleur de rose fait par M. Bailli en mai 1757," adding the marginal notation "bon." It is tempting to reconcile the two references by assuming that Bailly brought to a state of practical application a discovery that had previously been in an experimental stage.

For a brief period the pink ground was used as the basis for variegated effects in conjunction with blue and gold. The Frick set of three pots-pourris (p. 246) offers a sampling of fanciful inventions of this type, ranging from jagged streaks which follow no definite pattern to delicate and precise traceries imitating lace-work.

Formulas for violets, yellows, reds, purples, and browns also were recorded and discussed at length by Hellot, thus providing the firmest foundations for the technicians and artists. Without discarding the earlier formulas, the artists constantly elaborated their individual palettes, incorporating in them the benefit of personal experience.

The final step in the enrichment of Sèvres porcelain was the application of gold. An exclusive privilege of the Manufacture Royale, gold occupies an important place in Hellot's manuscripts, and it was from firsthand knowledge that he transcribed the "Sécret de l'or, corrigé des fautes de la description de M. de Fulvy après l'opération complette qu'a fait en ma présence le frère Hypolithe Bénédictin de St. Martin des Champs, le 16 juillet 1751." The process is fully explained and annotated. Though the formula had been bought in 1748, the monk continued to sell the factory gold that he himself prepared: "en 1770 il reçoit encore 12 Livres par once d'or."[23]

192

It is undeniable that gold applied to the lead glaze used for soft-paste porcelain took on a fullness it never attained on the feldspathic glaze of hard paste. Still, a highly specialized knowledge was required to control the temperature of the firing in relation to a white or a colored ground, the latter rendering the glaze more vulnerable to heat. Indeed, the firing of porcelain and of its decoration, a matter too often passed over in silence, was of capital importance. The artisans who watched over the kilns held the key to success.

FORMS AND INSPIRATION

All the factory's scientific expertise, great as it was, would have amounted to little had it not been destined to adorn so sumptuously the forms invented by Jean-Claude Ciamberlano (or Chiamberlano), called Duplessis, goldsmith to the King. Hired at Vincennes as early as 1745 or 1747, Duplessis was the driving force behind the factory's general artistic evolution. His autograph drawings preserved at Sèvres betray the hand of a metalworker who learned to adapt his talents to the demands of a different material. Until his death in 1774 Duplessis invented both decorative and utilitarian forms marked by an elegance beyond equal, conceived in a *rocaille* style that was generally kept under restraint and grew progressively more sober. Not limited to the creation of models, he also supervised the work of those who executed them—the turners and molders. If Hellot's judgment can be accepted, he was "un très habile homme utile à la manufacture, mais fort lent."[24]

But Duplessis was not the only designer of forms. Étienne-Maurice Falconet, director of sculpture from 1757 to 1766, attached his name to several types of neoclassical vases in addition to creating sculpture models. Even within the workrooms, the turners and molders sometimes rose above the passive role of production men: Jacques-François Deparis and Charles-François Bolvry, who during the half-century they spent at Vincennes and Sèvres attained the ranks of foreman of repairers[25] and turners respectively, both executed forms of their own inspiration or borrowed from the drawings and engravings of ornamentalists.

In 1773 Louis-Simon Boizot took over the directorship of sculpture abandoned by Falconet seven years earlier.[26] He and his collaborator Josse-François-Joseph Leriche, who became foreman of sculptors in 1780, maintained under Louis XVI

the tradition of grace and charm that preceded them while forming the transition toward the more austere style that followed. At the prompting of the Comte d'Angiviller, *Directeur des Bâtiments du Roi,* the collection of Etruscan vases assembled by Vivant Denon[27] was made available as a source of inspiration for new forms.

Finally, there were the forms invented by the painters. About 1766 Jean-Jacques Bachelier designed a stately vase with rigid lines which was to be adapted and ornamented in various fashions. And on the eve of the Revolution Jean-Jacques Lagrenée *le jeune,* deeply influenced by Pompeian examples, invented some of the forms and decorative themes for the table service of the Queen's *laiterie* at Rambouillet.

DECORATION

The role of Bachelier was far more important in the field of decoration. Hired at Vincennes in 1751, he served as director of decoration until 1793, doubling as director of sculpture during the period 1766–73. A flower painter, Bachelier contributed, through patterns proposed to the artists, in freeing the decoration of Vincennes from Far Eastern influence, whether direct or as interpreted in European porcelain. Flower painting at Vincennes was at first somewhat heavy and opaque in the manner of Meissen, but it grew softer and more supple under the brush of French artists. It is perhaps noteworthy that several decorators at the factory had been trained as painters of ornamental fans.

If the flowers that decorate the porcelains in The Frick Collection are studied chronologically, it will be noted that the style of painting, personal peculiarities aside, evolves toward a naturalism which reaches its fullest expression on the jug and basin with flowers and fruit (p. 284). The central bouquets on the Frick dessert plates and fruit dishes (p. 295) reveal a striving after both elegance and realism. But even these are surpassed by the ornamentation of the two porcelain plaques mounted by Martin Carlin into a bronze *guéridon* now also in The Frick Collection (No. 15.5.61); the composition on the upper plaque, a basket suspended by a ribbon and spilling over with exuberant flowers, is a masterpiece of the genre.

The development of floral decoration is paralleled in the treatment of birds. First used simply for the decorative value of their movement and brilliant color, as on the *vaisseau à mât* and *vases à oreilles* (pp. 224, 232), they became increasingly

realistic, as seen on the Frick tea service (p. 260). It is significant that in 1784 the Comte d'Angiviller arranged for the purchase from the heirs of Alexandre-François Desportes of more than six hundred paintings and studies from that master's studio in order to renew the inspiration of the decorators. As the trend continued, flowers and birds, studied with scientific objectivity, were painted on porcelain as realistically as they appeared in books of natural history. The Encyclopedic spirit also reigned in art. The birds of Buffon were particularly appreciated.

In addition to the painters of flowers and landscapes, animals and ornament, there was a smaller and more highly paid group of figure painters who began by copying the drawings and engravings of François Boucher, an artist who contributed a number of designs directly to the factory and had a deep and lasting influence on its production.[28] Scenes of children were often painted in monochrome or natural color within *rocaille* cartouches—witness the Frick *vase hollandais* (p. 209). Similar compositions of children were interpreted both in painting and in sculpted figures and groups. If The Frick Collection lacks freestanding subjects in the round, it does include, by way of the figures on the Duplessis vases with children in relief (p. 200), a rare example of Vincennes enamelled decorative sculpture.

Over a period of several years, engravings after Flemish paintings were used as source material for compositions of the type found on the Frick set of three potspourris (p. 246). Many dissociated elements borrowed from scenes of Flemish celebrations and festivities after Teniers were worked into new compositions according to the whims of the porcelain painters. There was also a prolonged vogue for military subjects and views of sea fishermen—frequently, like those on the Frick jug and basin with marine scenes (p. 290), the work of Jean-Louis Morin.

Encouraged by the success of genre scenes in which the choice of colors was left to their initiative, the figure painters began copying celebrated portraits and paintings, a task which demanded both superior ability and an infinitely rich palette in order to render faithfully the colors and modelling of the originals.

Though The Frick Collection includes no tours de force of the latter type, admirable in their virtuosity but debatable in principle, it does offer a selection of Vincennes and Sèvres soft-paste porcelains that reflect the tastes of a refined society enamored of luxury, elegance, and harmony—the very qualities that characterize French art of the eighteenth century.

The royal cipher, adopted by the Manufacture de Vincennes at its inception, was the only mark employed by the Manufacture Royale during the eighteenth century. Its use was made official by a decree of the Conseil d'État on August 19, 1753. Initiated at the same time was the practice of adding to the cipher a date-letter designating the year of manufacture—the letter A standing for 1753, B for 1754, and so on. After the alphabet had been exhausted, the letter was doubled—AA for 1778, BB for 1779, CC for 1780. The date-letter was generally drawn within the cipher, but it sometimes appears at the side, especially after the doubling of the letters; in such cases a slight pause may occur if other letters—the artists' signatures—accompany the mark. The date-letter and signature, like the cipher, were invariably painted on by the artist responsible for the decorating or gilding. Usually in blue, they may also be in any other color or in gold.

The royal crown surmounting the cipher was reserved for hard-paste porcelain. Its introduction in 1770 affected in no way the system of dating. The royal mark legally ceased to exist on July 17, 1793, when it was replaced by the letters RF and the word *Sèvres,* generally with no indication of date during the last years of the eighteenth century. Subsequently the mark varied according to changes in political regime. After World War II it returned to a device recalling that of the pre-Revolutionary era, and in 1970 it was revised anew.

The marks of workers and artists are of two types: incised or painted. The first served to identify the maker of the piece—the turner, molder, repairer, trimmer, or whomever—and could only be scratched into the paste before its first firing. No contemporary table of these marks has been discovered, and it is only on the basis of keen observation that Dauterman[29] and Eriksen[30] have been able to put forward various hypotheses, often plausible and always ingenious.

The second type of mark, painted on the piece after firing and more or less fused into the glaze, designates the decorator. These initials or distinctive signs are far from being fully identified, due again to the fact that no systematic tables were drawn up at the time they were in use. Since 1845[31] these marks have been the subject of numerous publications,[32] none of which can claim to be strictly exact or exhaustive. It can only be hoped that rigorous study will provide new observations to refute false interpretations and lengthen the list of secure attributions.

196

1 Frit is the fusible part of the paste which, when fired at the proper temperature, gives porcelain its translucence.

2 A. Sergène, *La Manufacture de Sèvres sous l'Ancien-Régime,* Nancy, 1972, I, p. 59.

3 Patrons of the Chantilly and Mennecy porcelain factories respectively.

4 A former chief clerk in the army commissariat, Boileau became factory overseer at Vincennes in 1745 and served as director at Vincennes and Sèvres from 1751 to 1772.

5 The investigation was headed by the chemist and Académie member Hellot.

6 Jean-François Verdun de Monchiroux was a shareholder in the *Fermes du Roi* and *fermier des fermes* for Lorraine. See Sergène, p. 83.

7 Sergène, p. 139.

8 *Idem,* p. 144.

9 The building is presently occupied by the Centre International d'Études Pédagogiques. The Manufacture Nationale de Sèvres was moved in 1876 to quarters near the Seine, a few hundred yards from the former site. The old building still preserves the interior gate that guarded the room in which the factory secrets were kept.

10 Sergène, p. 204.

11 *Idem,* p. 215.

12 S. Eriksen, *The James A. de Rothschild Collection at Waddesdon Manor: Sèvres Porcelain,* Fribourg, 1968, pp. 16–17.

13 Machault was *Conseiller Ordinaire* to the Conseil Royal and became *Contrôleur Général des Finances* after Orry de Vignory fell from favor in 1745.

14 Sergène, p. 113, note 344.

15 The cards were made of pasteboard taken from a deck of playing cards.

16 Archives de la Manufacture Nationale de Sèvres, Y. 49, p. 1.

17 *Idem,* p. 90.

18 Musée de Sèvres, No. 6638.

19 Archives de Sèvres, Y. 51 bis, p. 70.

20 *Idem,* Y. 50, p. 23.

21 The higher price resulted from the additional operations required, in particular the repeated firings.

22 Archives de Sèvres, Y. 8, fol. 44.

23 P. Verlet, S. Grandjean, and M. Brunet, *Sèvres,* Paris, 1953, I, p. 22.

24 Archives de Sèvres, Y. 49, p. 2. At the start of his register Hellot offers various opinions of the principal personalities at the factory. These sometimes prove harsh.

25 The term *répareur,* or *mouleur-répareur,* designates a sculptor charged with the delicate task of molding the separate pieces that make up a single sculpture, assembling them to reconstitute the original model, and retouching the assembled sculpture before it is fired.

26 In 1766 Falconet was called to Russia to work for Catherine II.

27 Baron Dominique Vivant Denon (1747–1825), French diplomat and engraver. He accompanied Napoleon Bonaparte during the Egyptian campaign of 1798 in order to draw ancient monuments, landscapes, ethnic types, and the like; his most notable publication is *Voyage dans la Basse et Haute Égypte,* published in 1802.

28 Boucher's direct collaboration with the

Manufacture Royale is documented by a payment of 1756 (Archives de Sèvres, F. 2): "Ordre de la Compagnie du 8 Avril 1756, payé à M. Boucher pour tous les desseins qu'il a fourni à la manufacture pendant l'année 1755 et sans quittance de 485 Livres."

29 C. C. Dauterman, in *Decorative Art from the Samuel H. Kress Collection,* London, 1964; "Sèvres Incised Marks and the Computer," *Computers and Their Potential Applications in Museums: A Conference Sponsored by The Metropolitan Museum of Art,* New York, 1968; and *The Wrightsman Collection, IV: Porcelain,* New York, 1970.

30 S. Eriksen, *The James A. de Rothschild Collection at Waddesdon Manor: Sèvres Porcelain,* Fribourg, 1968.

31 A. Brongniart and D.-D. Riocreux, *Description méthodique du Musée Céramique de la Manufacture Royale de Porcelaine de Sèvres,* Paris, 1845, I, pp. 451 ff.

32 Among the recent studies is *Les Marques de Sèvres,* Vol. II of Verlet, Grandjean, and Brunet (see note 23, above).

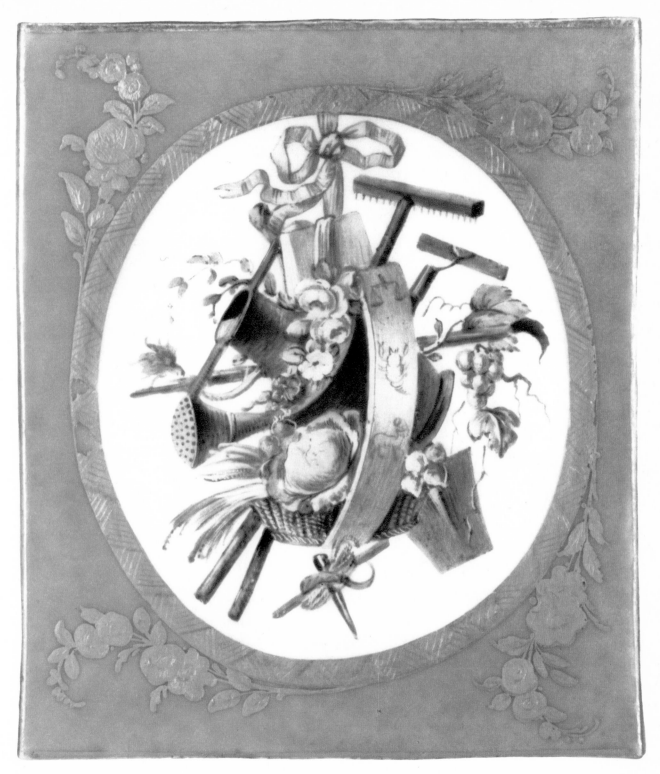

34.9.33 · DETAIL

Pair of Duplessis Vases with Children and Flowers in Relief, Partial Turquoise Blue Ground, 1753 (18.9.2 and 18.9.3)

Porcelain, soft paste. Number 18.9.2: H. excluding gilt-bronze plinth 8⅜ in. (21.3 cm); W. at top 5⅝ in.﹐ (14.4 cm); D. at top 5¾ in. (14.6 cm); W. at handles 5¼ in. (13.4 cm). Number 18.9.3: H. excluding gilt-bronze plinth 8⁷/₁₆ in. (21.4 cm); W. at top 5⅞ in. (14.9 cm); D. at top 5¹⁵/₁₆ in. (15 cm); W. at handles 5¼ in. (13.4 cm). Painted in blue on the base of No. 18.9.2 only: interlaced L's enclosing the date-letter A and surmounted by a six-pointed star, the mark of Antoine Caton.

Description: Set on a square porcelain base with chamfered corners, each vase rises in a continuous undulating line, first curving inward to form the foot, then swelling out, narrowing again, then mounting in an ever-broadening arc to terminate at the lip in four large lobes separated by four smaller ones. Attached to the body at its fullest curve are two s-shaped handles which emerge from scrolled foliage and turn outward to form supports for small flowers modelled in the round. Garlands of leaves in low relief emphasize the vertical movement as they rise to form arched frames around four tall panels reserved in white within the predominating turquoise blue ground. Set above the fullest curve of the body on the front and back panels are figures of children modelled in high relief, symbolizing the Four Seasons. On one side Summer clutches a sheaf of wheat as Autumn raises to his lips a vine branch laden with grapes, painted green on No. 18.9.2 and violet on the pendant. On the other side Spring holds up a garland of multicolored flowers and Winter, wearing a pink cloak with flowers reserved in white on No. 18.9.2 and a striped cloak of lavender and mauve on the pendant, rests his right arm on his companion's thigh and warms his outstretched left hand over glowing twigs. The gilding, rich but restrained, echoes the primary lines of the vases and sets off the delicate coloring of the flowers and the salmon-pink flesh of the children. The gilt-bronze plinths are of a later date.

Condition: The condition of the vases is good. Number 18.9.2 has some minor fire cracks and repaired breaks, notably on one of the large lateral lobes and one of the smaller lobes of the lip; the base and part of the foot below the figure of Winter have been restored. The second vase has a repaired break on the lobe over Winter and a restored handle, as well as the same type of break in the foot as its companion.

The form of these vases is named after its creator, Jean-Claude Duplessis, who was hired to design models at Vincennes as early as 1745 or 1747. A schematic drawing preserved in the Sèvres archives suggests the basic outline of the prototype,

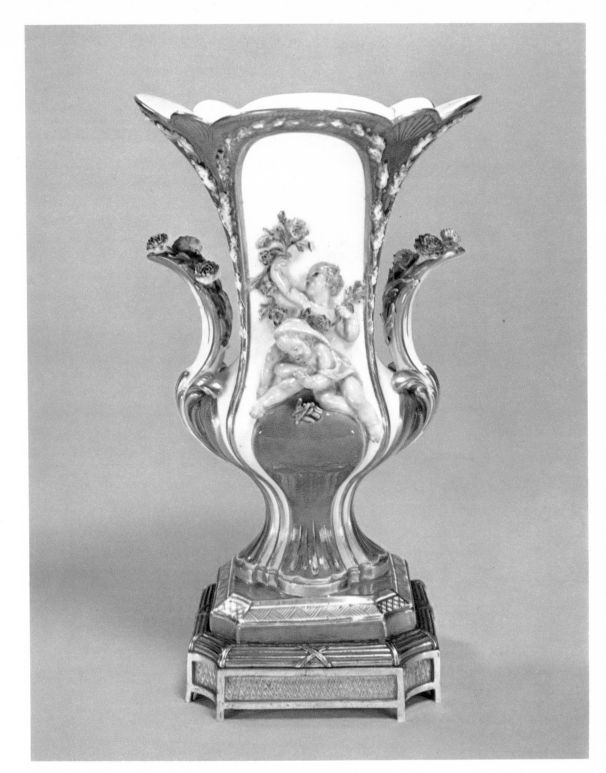

18.9.2

which was intended to hold flowers. Various interpretations and additions led to the evolution of several distinct models.

A plaster model of the Duplessis vase with children also survives at Sèvres. In an inventory made at the factory early in the nineteenth century it was listed as a "vase à fleurs Duplessis à reliefs,"[1] to distinguish it from versions designated "uni" or "orné" which vary both in details of overall form and in the design of the handles. The plaster model has no handles, and it further differs from the pieces studied here in that the fluting on the foot continues directly onto the attached base, which on the Frick examples is in the form of a plain square. The model has similar sculpted ornaments.

These comparisons show that such vases were molded, assembled, and finished in the same manner as the freestanding figures and figure groups made at Vincennes. The latter also were enamelled in the early years of the factory, though later they were left in the biscuit (see pp. 189–90).

The Sèvres archives do not reveal the name of the sculptor who modelled the chubby little children symbolic of the Seasons, almost certainly after drawings by François Boucher. But this was the period when Leboiteux (1752), Blondeau (1753), Fernex and Larue (1754), and other outside sculptors, as well as those regularly employed at the factory, were furnishing models to Vincennes under the supervision of Duplessis and Jean-Jacques Bachelier. Their works have survived, but rarely is it possible to make definite attributions to specific artists.

The first mention of "3 vases Duplessis à enfans" occurs in a list of objects taken from the kiln on December 28, 1752. In a list dated June 18, 1753, however, there appears "un vase Duplessis sans enfans."[2] These references prove that the term "vase Duplessis" was indeed being used for vases both with and without sculpted ornaments.

The descriptions given in sales records are less precise. The factory register for 1753 lists the delivery on May 29 "à M. le Grand pour M. le Duc de Duras 2 vases Duplessis à enfans fleurs berceaux 300–600 Livres,"[3] and on December 31 "à M. Duvaux 2 vases Duplessis bleu céleste enfans colorés 360–720 Livres."[4] In neither case is specific mention made of sculpted relief. However, among a number of objects delivered to Lazare Duvaux between December 5 and December 31, 1754, were recorded "2 vazes enfans bleu céleste reliefs 480–960 Livres,"[5] and in the last quarter of 1755 there appear "un vase Duplessis enfans de relief 480

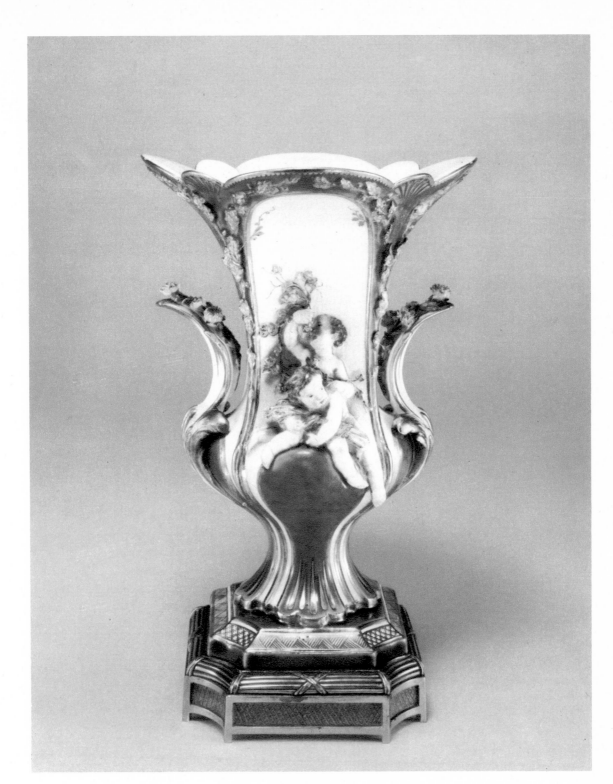

18.9.3

Livres et un idem cassé 360 Livres."[6] Losing no time, the dealer noted in his *Livre-Journal* for December 1755: "2323. Du 19.—S. A. S. Mme. la Duchesse d'Orléans: Un vase de Vincennes, bleu-céleste, à enfans de relief 480 l.—Un autre dont le pied est cassé 360 l."[7] Despite minor differences in the descriptive phrases, the identical prices and the peculiarity of one vase being already broken—with the added specification of a "pied cassé"—suggest that the vases listed by Lazare Duvaux may well be those now in The Frick Collection; the break in the foot of the second Frick vase could have occurred any time subsequently.

A pair of vases of the same date, dimensions, and decoration, also bearing the mark of Caton, is in the Philadelphia Museum of Art;[8] in these the disposition of the blue and white grounds is reversed, and both feet are intact. A similar pair with green and white grounds was reproduced by Garnier as in the collection of G. de Rothschild.[9] Yet another pair, whose decoration was perhaps painted at a later date, was sold at the Wetmore auction in Newport, Rhode Island, in 1969.[10]

While the mark of Antoine Caton (active 1749–98) does not appear with great frequency, neither is it exceptional. An example from the same period can be seen on a watering pot dated 1755 in the Musée de Sèvres.[11]

Collections: Duchesse d'Orléans (?). Comte N. P. Chérémeteff, St. Petersburg.[12] Duveen. Frick, 1918.

NOTES

1 Archives de la Manufacture Nationale de Sèvres, U. 3, Vases 1740–1780, No. 57.

2 Bibliothèque de l'Institut de France, Paris, Mss. 5673.

3 Archives de Sèvres, Vy. 1, fol. 12.

4 *Idem,* fol. 29.

5 *Idem,* fol. 71.

6 *Idem,* fol. 114.

7 *Livre-Journal de Lazare Duvaux,* ed. L. Courajod, Paris, 1873, II, p. 265.

8 F. Kimball and J. Prentice, "French Porcelain Collection of Mrs. Hamilton Rice," *Philadelphia Museum Bulletin,* XXXIX, No. 201, March 1944, Nos. 56 A&B, p. 105, Pl. VII.

9 É. Garnier, *La Porcelaine tendre de Sèvres,* Paris, n.d., Pl. VII.

10 September 16–18, 1969, Lot 777.

11 No. 21593. P. Verlet, S. Grandjean, and M. Brunet, *Sèvres,* Paris, 1953, I, Pl. 17 and p. 201.

12 Recorded in an inventory of the Chérémeteff collection of Sèvres porcelains in 1894; see *Connoisseur,* XV, 1906, repr. p. 243.

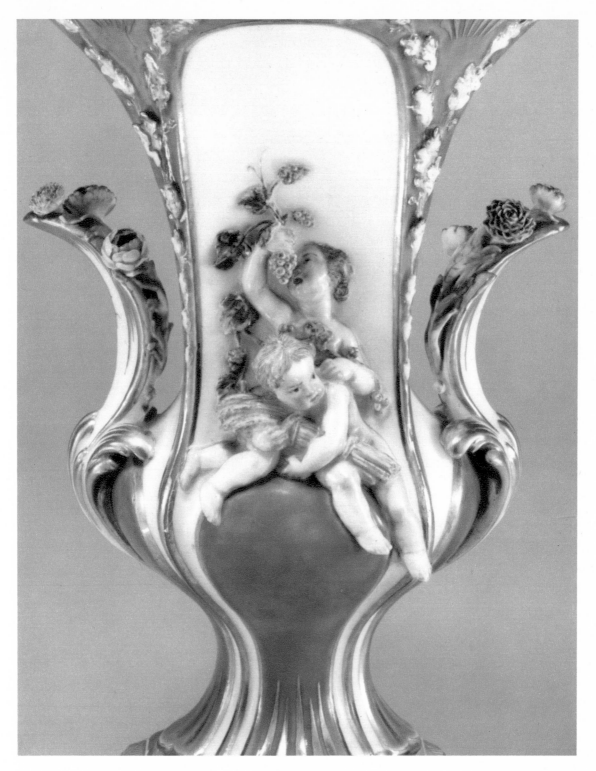

18.9.2 · DETAIL

Pair of Vases with Floral Garlands, Partial Turquoise Blue Ground, 1755 (34.9.4 and 34.9.5)

Porcelain, soft paste. Number 34.9.4: H. 7½ in. (19.1 cm); D. of base 3⁵/₁₆ in. (8.5 cm); D. of body 3¹⁵/₁₆ in. (9.9 cm); D. of neck 2¾ in. (7.1 cm). Number

34.9.5: H. 7¹³/₁₆ in. (19.8 cm); D. of base 3⁵/₁₆ in. (8.5 cm); D. of body 3¹¹/₁₆ in. (9.4 cm); D. of neck 2¹³/₁₆ in. (7.2 cm). Painted in blue on the base of each piece: interlaced L's enclosing the date-letter C and surmounting the letter L, the mark of Denis Levé.

Description: The narrow, fluted foot of each vase rests on a circular, lobed base ornamented with eight scallop shells. The white ground of the body is separated from zones of turquoise blue at the lip and foot by garlands of leaves painted in gold and forming a series of regularly spaced but slightly asymmetric arches. Garlands of polychrome flowers fall across the body diagonally from right to left, beginning at the extremities of the gold leaves at the top and descending to corresponding points in the leaves at the bottom. Plain or striated bands of gold border the lip, foot, and base and accentuate the ribs and outlines of the shells. The handles, made up of reeds twisted together and covered entirely with gold, rest directly on the shoulders of the vase, mingling below with clusters of small flowers modelled in full relief and painted in vivid natural color. The reeds and flowers develop out of four green vines that rise from clusters of leaves at the base.

Condition: The vases are in good condition. Number 34.9.4 has a repaired break at the base. The foot of its companion has been repaired, and both handles have been broken and reattached; in addition there are a hair crack at the neck, a fire crack under one handle, and a small chip at the base.

Jean-Claude Duplessis was no doubt responsible for the form of these vases, with their pure and simple profiles swelling out in unbroken curves between two narrow points. Though there are no identifiable references in the Sèvres archives to this type of vase, it was made in at least five different sizes and appears to be one of the oldest designs employed by the factory. Chavagnac and Grollier, referring to a vase they called "de Vincennes," described it as "à fond blanc et à fleurs de relief," with a form "plus tourmentée" than the *vase à oreilles* (see p. 232) "et ornée de deux anses enroulées et généralement dorées."[1] There is no vase listed under the name "de Vincennes" in the sales records of the Vincennes factory, but it is possible that Lazare Duvaux sold vases of this type, as he recorded on December 30, 1749: "402.—M. de Boulogne [*Contrôleur Général*]: Deux

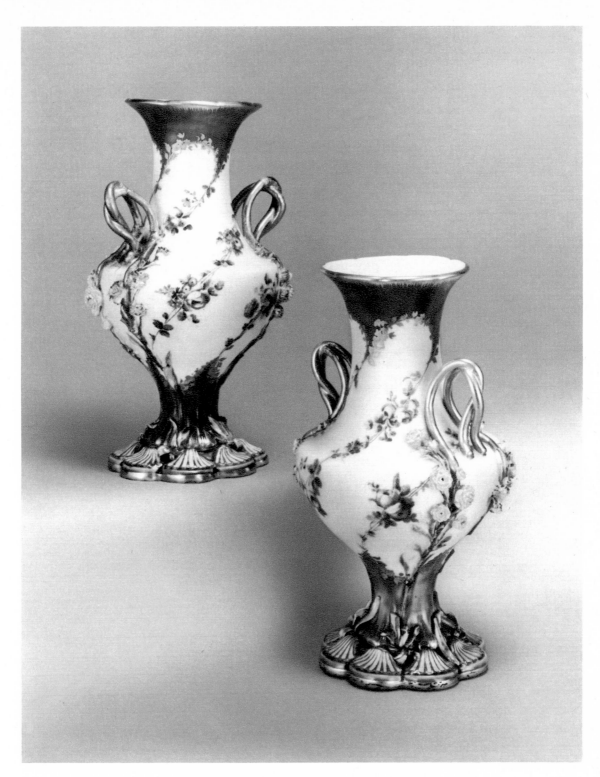

34.9.5 34.9.4

vases de Vincennes peints à fleurs, avec des anses & fleurs en relief, 312 1."[2]

Vases of this model are found in many collections, sometimes singly, sometimes in sets of three or five. Slight variations occur in the swell of the forms, which may be more or less pronounced, and in the lip, which may be plain or notched. Two very different types of base exist: either a wreath of shells, as here, or one resembling a mound of foam swept up by the tide.

All the known examples have a white ground and tinted flowers in relief. Sprays of painted flowers or flowering branches are the most frequent decoration, with the occasional addition of butterflies and native or exotic birds. A set of three small vases in the Musée du Louvre, Paris, is decorated only with lines and striations in gold.[3] The motif of diagonal garlands is rare, though it recurs on a similar vase in the Musée des Arts Décoratifs, Paris.[4] Since most of the examples are not dated, they presumably were made before 1753.

During his long career at the Manufacture Royale Denis Levé (active 1754–1800) signed his pieces with a Roman L. Some authorities also attribute to him, correctly, an alternative mark of an *L* in script.[5] A specialist in flowers and ornament, Levé collaborated in the decoration of various dinner services, including one presented by Louis XV to Christian VII of Denmark in 1768[6] and another sent by Louis XVI to Gustavus III of Sweden in 1784.[7] He did single pieces as well, such as an allegorical cup celebrating the birth of the Dauphin dated 1781.[8]

Collections: Comte N. P. Chérémeteff, St. Petersburg. Gift of Miss Helen C. Frick, 1934.

NOTES

1 Comte X. de Chavagnac and Marquis de Grollier, *Histoire des manufactures françaises de porcelaine,* Paris, 1906, p. 146.

2 *Livre-Journal de Lazare Duvaux,* ed. L. Courajod, Paris, 1873, II, p. 39.

3 Nos. O.A. 6240 a, b, c.

4 No. D. 31866.

5 See for example the list by D.-D. Riocreux published in A. Jacquemart and E. Le Blant, *Histoire artistique, industrielle et commerciale de la porcelaine,* Paris, 1862, p. 541.

6 P. Verlet, S. Grandjean, and M. Brunet, *Sèvres,* Paris, 1953, I, Pls. 62–65 and p. 213.

7 *Les Grands Services de Sèvres,* Musée National de Céramique de Sèvres, 1951, No. 8.

8 Verlet, Grandjean, and Brunet, I, Pl. 84 and p. 218.

Fan-Shaped Jardinière and Stand with Children, Turquoise Blue Ground, 1755 (34.9.6)

Porcelain, soft paste. H. overall 7½ in. (19 cm); H. of upper section 5⅝ in. (14.3 cm); W. of upper section at top 7¹¹/₁₆ in. (19.5 cm); D. of upper section at top 5¹¹/₁₆ in. (14.5 cm); W. of stand 7¼ in. (18.5 cm); D. of stand 5⁵/₁₆ in. (13.5 cm). Incised on the base of the upper section: the number *6* or *9*. Painted in blue on the base of each section: interlaced L's enclosing the date-letter C and surmounted by three dots connected by a horizontal line, the mark of André-Vincent Vielliard, with below the cipher an unexplained fourth dot.

Description: The jardinière, oval in plan, consists of two separate sections. The upper part, a broad, fan-shaped vase intended to hold soil or moss, terminates below in a hollow, perforated foot. This in turn rests within a large opening in the top of the stand, so that water stored in the stand can supply moisture to plants or cut flowers placed in the vase.[1] The ground color is a rather dark turquoise blue. The gold decoration includes a running frieze of pointed dentils around the lip; fillets outlining certain of the projecting elements and surrounding the smaller openings on the upper surface of the stand; an egg-and-pearl band along the bottom of each section; and frames of very rich *rocaille* motifs, made up of curves, countercurves, flowers, foliage, and panels of mosaic and granular patterns, surrounding the eight cartouches reserved in white on the blue ground. The two large cartouches enclose polychrome scenes of children's pastimes: on the front a young fowler leans against an open cage into which he seeks to lure a bird, and on the reverse the tiny figure of a fisherman hurries toward a pond. Within the side cartouches are trophies of music combining various instruments suspended from bows of blue ribbon. On the stand are two delicate landscapes centering on a small house in one case and a tower with a dovecot in the other, alternating at the sides with groups of flowers among gardening tools.

Condition: The vase is in generally good condition, but two holes have been drilled through the bottom of the stand, depriving it of its usefulness.

A working drawing related to the form of this jardinière proposes two profile views, one of which seems to have been discarded and another that conforms to the outline and moldings of pieces of the present type. An inscription in ink specifies: "Vazes ou caisse de cheminé pour metre des fleurs par ordre de Monˢ de Verdun le 29 Mars 1754." The plaster model of the upper section alone, without the stand,

209

is preserved in the model room at Sèvres, and was probably made over in the nineteenth century.[2]

The theme of the young fowler on the main cartouche derives from François Boucher, who interpreted it in various ways. The same figure, seated in the same position opening a similar cage, appears on a fan painted by Boucher,[3] though on the fan the boy is naked and turns his head over his shoulder to look at a second child.

Mention of "1 vaze à l'holandoise 2ème gr." appears six months after the date on the working drawing in connection with a biscuit firing of September 28, 1754. This is soon followed by "1 vaze à l'holandoise 1ère gr." in a glaze firing of November 14. Hence, unlike various other types of flower holders (see p. 238), this form of vase was simultaneously executed in two sizes from the start. A third size appears in 1758, under the simplified name, adopted in 1756, of "vase hollandois."

Delivery records abound, numbering more than two hundred from the garniture consisting of "un vaze à l'holandoise 1ère et 2 idem 2ème bleu céleste fleurs" sold to Lazare Duvaux between December 5 and 31, 1754, at the considerable price of 1,200 livres, to the last "vase hollandais" (no description), delivered to Louis XVI on August 5, 1789, priced at 384 livres. One of these listings, in which the ground color is not indicated, could be related to the vase presently under discussion: "Livré au sieur Duvaux et vendu par luy depuis le 1 8bre jusqu'au 31 Xbre 1755...1 vaze à l'holandoise 2ème enfans colorés encadrés 300 livres." This comparatively high price for a vase of the intermediate size, the dimensions of which correspond to those of the present example, could be accounted for by the colored ground, the rich gold decoration, and the figures painted in polychrome.

Nearly all large collections include examples of the *vase hollandais,* either isolated, in pairs, or in sets of three. The diversity of ground colors and types of decoration attests to the success of the form not only among collectors but also among the artists, to whom it offered an elegant field on which to display their various talents.

The incised number *6* or *9* is found on other *vases hollandais,* notably under the upper section of one of a pair in the Musée de Sèvres dated 1754[4] and again under both the upper and lower sections of one of a pair in the Wrightsman collection, New York, dated 1757.[5] This cipher also appears on pieces of different

210

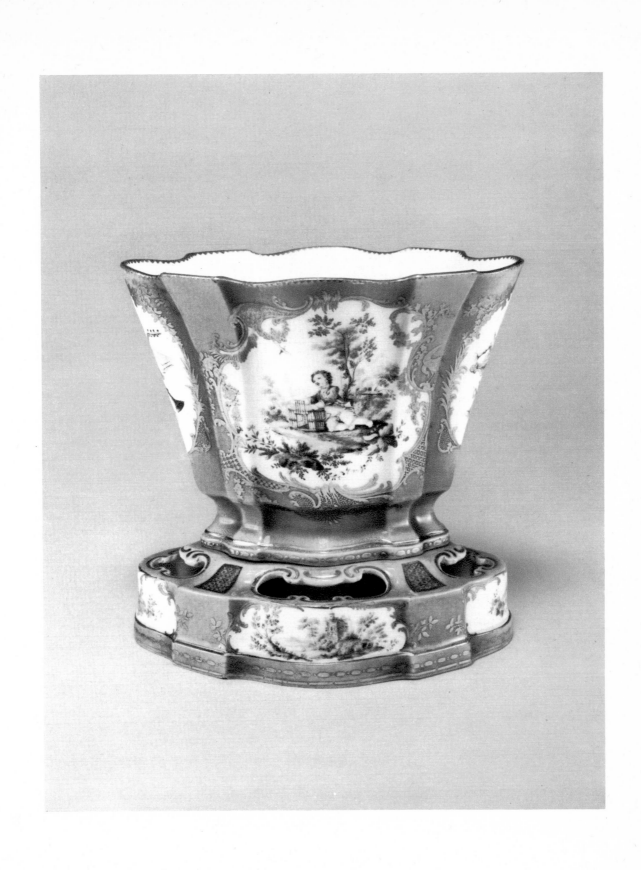

form, for example a covered tureen from the dinner service of Madame du Barry, dated 1771, at the Musée de Sèvres.[6]

The painted marks on the above-mentioned pair of *vases hollandais* in the Musée de Sèvres, which are decorated with scenes of children in monochrome blue and flesh tones of salmon pink, are comparable in all respects to that reproduced here: the schematic device of André-Vincent Vielliard (active 1752–90), resembling a three-pointed heraldic label, surmounts the royal cipher with a dot underneath, and only the date-letters differ. The same applies to a saucer dated 1761 in the Wrightsman collection,[7] with polychrome decoration inspired by a scene in the manner of Teniers, and again to a small tray dated 1767 at Waddesdon Manor, Buckinghamshire,[8] decorated with a medallion containing allusions to gardening. These few examples give only an inkling of the fertility and variety of Vielliard's talents.

Collections: Duveen. Gift of Miss Helen C. Frick, 1934.

NOTES

1 This type of jardinière, common in the Netherlands, is widely referred to as a *vase hollandais,* a term adopted by such authorities as Chavagnac (Comte X. R. M. de Chavagnac, *Catalogue des porcelaines françaises de M. J. Pierpont Morgan,* Paris, 1910, No. 99, p. 82) and Verlet (P. Verlet, S. Grandjean, and M. Brunet, *Sèvres,* Paris, 1953, I, Pl. 29 and p. 204).

2 The model is listed, under the erroneous name "vase à fleurs à cartels," in the inventory made at Sèvres early in the nineteenth century (Archives de la Manufacture Nationale de Sèvres, U. 3, Vases 1740–1780, No. 121).

3 Reproduced among the engraved works of Boucher (VII, pp. 32–33) in the Cabinet des Estampes, Bibliothèque Nationale, Paris, as: "éventail peint par F. Boucher (appartenant au Dr. Piogey)."

4 No. 23180^1.

5 C. C. Dauterman, *The Wrightsman Collection, IV: Porcelain,* New York, 1970, No. 84 A, p. 208.

6 No. 23246.

7 Dauterman, No. 101, p. 244.

8 S. Eriksen, *The James A. de Rothschild Collection at Waddesdon Manor: Sèvres Porcelain,* Fribourg, 1968, No. 74, p. 204.

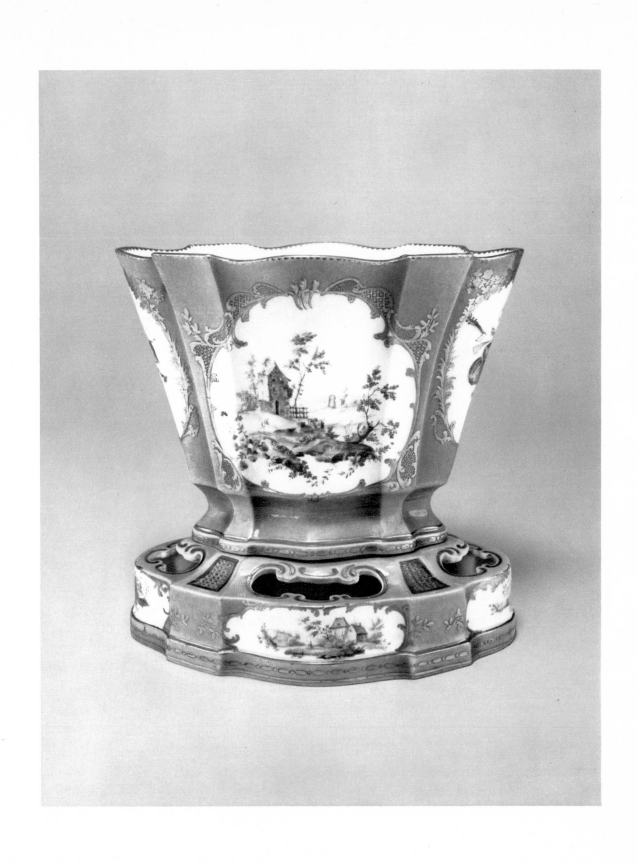

Sugar Bowl with Diagonal Floral Garlands and Green Ribbons, 1756 (34.9.13)

Porcelain, soft paste. H. overall 3¹⁵/₁₆ in. (10 cm); H. of body 2⅝ in. (6.7 cm); D. of lid 3⅝ in. (9.2 cm). Incised on the base: the letter T. Painted in blue on the base: interlaced L's enclosing the date-letter D and surmounting a fleur-de-lis, the mark of Vincent Taillandier.

Description: The piece consists of a cylindrical body drawn in at the foot and a gently rounded lid surmounted by a knob in the form of a delicate flower in full relief. The principal decoration is made up of green ribbons bordered with gold bellflowers; twisting over themselves in spirals, they fall diagonally from the knob of the lid to a point just above the base of the body. Set between the ribbons and following their movement are finely painted sprays of roses, tulips, bellflowers, anemones, and other blossoms in vivid natural colors which stand out crisply against the exceptional whiteness of the reserved ground.

Condition: The piece is in good condition.

A drawing in the Sèvres archives showing a comparable profile bears the inked inscription: "Sucrÿe Calabre n° 2ᵉᵐᵉ grandeur rectifie suivan l'ordre de La Comande du 19 fevrÿe 1753. fait." The same order also called for "gobelets Calabre."[1] The plaster mold of the bowl alone, without the lid, is preserved in the model room at Sèvres and was entered without comment in the nineteenth-century inventory.[2]

Forms designated *Calabre* owe their name to a partner in the Compagnie Éloi Brichard (see p. 186), Pierre Calabre, *écuyer, Conseiller Secrétaire du Roy, Maison Couronne de France et de ses Finances.* Even before the company had been constituted and its membership had been fixed by the *Garde des Sceaux* on August 8, 1753,[3] the names of certain associates were being borrowed to designate particular forms. Thus, in a biscuit firing of August 6 there appear, among similar terms, mentions of "gobelets Calabre." The name and the form have continued in use until the present day, and *tasses Calabre* are still manufactured.

Various deliveries of sugar bowls recorded during 1757, with no indication of form or size, bear witness to the vogue for decoration with green ribbons that

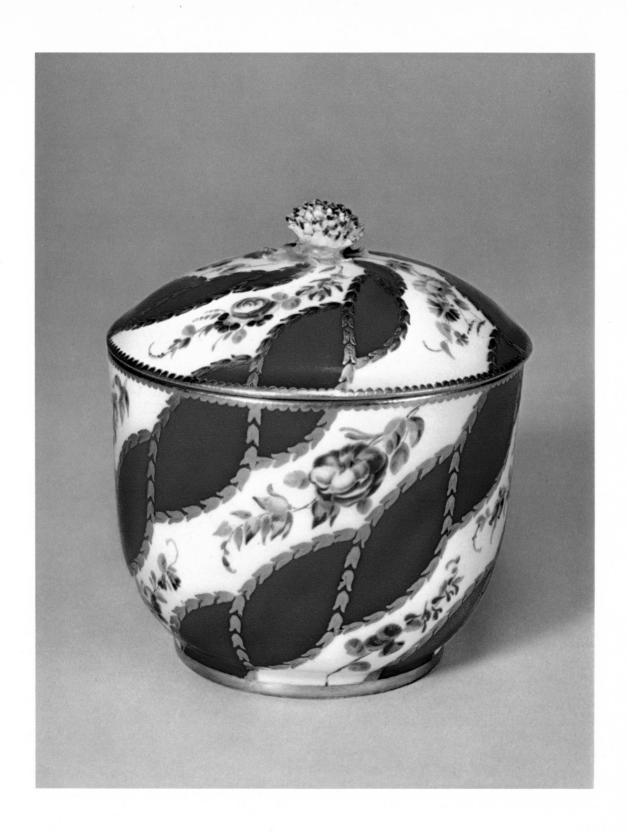

had begun the previous year. Madame Victoire, fourth daughter of Louis XV and an admirer of the color green, had delivered to her in October of 1757: "Le 18 dudit 1 pot à sucre verd rubans 96 livres."[4] At about the same time the *marchands-merciers* Sayde, Bailly, and Lazare Duvaux were buying various pieces adorned with green ribbons, among them sugar bowls valued at 72 or 102 livres.

Lazare Duvaux noted in his *Livre-Journal* on August 16, 1757: "2852.—M. le Dauphin: Un déjeuner...en blanc & vert à rubans, sans peinture, 288." In March of the following year he entered: "3065. Du 7.—Mme la Marq. de Pompadour: Une tasse à rubans verts, riche, & soucoupe, 84 1.—Le pot à crème, 60 1.—Un pot à sucre assorti. Le tout posé à Paris dans le cabinet doré, 72 1." It may be added that the service, dated 1757,[5] presented by Louis XV to the Empress Maria Theresa in 1758 was decorated with splendid intercrossed green ribbons. The use of the ribbon as a decorative element would long continue—witness the Frick dessert plates and fruit dishes of 1782 (see p. 295).

A cup and saucer in the Victoria and Albert Museum, London,[6] bear the same decoration as the Frick sugar bowl, and the saucer is painted with exactly the same mark. It is not impossible that these pieces originally belonged to the same *déjeuner,* and that the latter may be identified with the above-mentioned delivery made to Madame de Pompadour in 1758.

Exhibited at the Musée du Louvre, Paris, is a *gobelet Bouillard*[7] dated 1757[8] on which green ribbons with undulating borders and a narrow overlaid garland in gold are arranged on the bias like those on the Frick sugar bowl. Also displayed is an undated spyglass with its cylinder encompassed by a network of slender green ribbons punctuated with gold and crossed so as to leave in reserve white lozenges enlivened with flowers painted in natural colors.[9]

The incised letter T on the Frick sugar bowl is not uncommon and is often accompanied by other marks. Eriksen[10] suggests, probably correctly, that it may be attributable to the turner Pierre-Aymond Tristant (active 1758–88). He notes it under various pieces finished on the lathe, such as a *sucrier Hébert*[11] of 1763.[12] Dauterman records it on several pieces in the Wrightsman collection, New York, notably a sugar bowl (or jam pot) of similar form dated 1760.[13]

The fleur-de-lis of Vincent Taillandier (active 1753–90) is familiar to collectors of Vincennes and Sèvres porcelain who admire flowers. It is found both on small

objects, such as the Frick candlestick (see p. 243) and a sugar bowl of 1754,[14] and on such important ornamental pieces as a *vase myrte*[15] dated 1777 in the Wallace Collection, London.[16] It also appears among a set of plaques painted by various artists in 1758–60 mounted on a commode bearing the stamp of Bernard Vanrisamburgh.[17]

Collections: Gift of Miss Helen C. Frick, 1934.

NOTES

1 For the *gobelet Calabre,* see p. 270, note 19, p. 271, note 21.

2 Archives de la Manufacture Nationale de Sèvres, U. 3, Pièces diverses, pots à sucre 1760–1780, No. 3.

3 *Idem,* Y. 2², session of August 14, 1753. See A. Sergène, *La Manufacture de Sèvres sous l'Ancien-Régime,* Nancy, 1972, I, pp. 149–50.

4 Archives de Sèvres, Vy. 2, fol. 38.

5 P. Verlet, S. Grandjean, and M. Brunet, *Sèvres,* Paris, 1953, I, Pl. 32 and pp. 204–05. *Les Grands Services de Sèvres,* Musée National de Céramique de Sèvres, 1951, No. 1.

6 No. 1382&A–1919.

7 For the *gobelet Bouillard,* see p. 268 and p. 270, note 11.

8 No. O.A. 7237.

9 Verlet, Grandjean, and Brunet, I, Pl. 51b and p. 210.

10 S. Eriksen, *The James A. de Rothschild Collection at Waddesdon Manor: Sèvres Porcelain,* Fribourg, 1968, p. 337.

11 For forms designated *Hébert,* see p. 270, note 12.

12 Eriksen, No. 58, p. 166.

13 C. C. Dauterman, *The Wrightsman Collection, IV: Porcelain,* New York, 1970, No. 100 B, p. 243.

14 Eriksen, No. 8, p. 48.

15 The *vase myrte* has an ovoid body and is not to be confused with the *pots-pourris myrte* discussed on pp. 246–55.

16 Verlet, Grandjean, and Brunet, I, Pl. 81 and p. 217.

17 *Idem,* Pl. 39 and pp. 206–07. The commode is in a private collection, Paris.

Small Four-Lobed Jardinière with Birds, Turquoise Blue Ground, c. 1756 (34.9.19)

Porcelain, soft paste. H. 3⅝ in. (9.1 cm); D. at top 5¾ in. (14.5 cm); D. at bottom 3⁵⁄₁₆ in. (8.5 cm). Incised on the base: the letter B. Painted in blue on the base: interlaced L's without date-letter surmounting an unidentified mark.

Description: Of the same circular, four-lobed plan as the two following baskets and similar in profile, this low vase could be regarded as a jardinière or a shallow flowerpot holder. On each of its lobes, which widen toward the top, reserves are worked into the overall turquoise blue ground. The two larger reserves, surrounded by simple *rocaille* motifs broadly treated in gold, each contain a brightly colored bird, one perched in a tree and the other on the ground. The two smaller reserves, framed by floral garlands of finely chased gold, are enlivened with flying birds, also in polychrome.

Condition: The vase is in good condition except for a short crack above the bird shown on the ground.

It is hazardous but tempting to associate the vase reproduced here with a mention of "deux vases en forme de corbeille" found in a list of biscuit removed from the kiln on December 22, 1756. On the other hand, on September 30, 1757, there were delivered to M. Chonen, cashier of the Sèvres factory, for M. de Montarant "deux corbeilles unies fleurs 30/60 l."[1] that could correspond to the form of this jardinière if not to its decoration, for which a higher price might be expected.

A similar piece, with a turquoise blue ground and floral decoration, is exhibited at the Musée des Arts Décoratifs, Paris.[2] It has preserved its garniture of "branchages en laiton verni imitant la nature ornés des plus belles fleurs assorties à chaque plante."[3] This type of embellishment was a specialty of Lazare Duvaux, who used it for porcelain vases from Meissen as well as those of Vincennes and then Sèvres.

Collections: Gift of Miss Helen C. Frick, 1934.

218

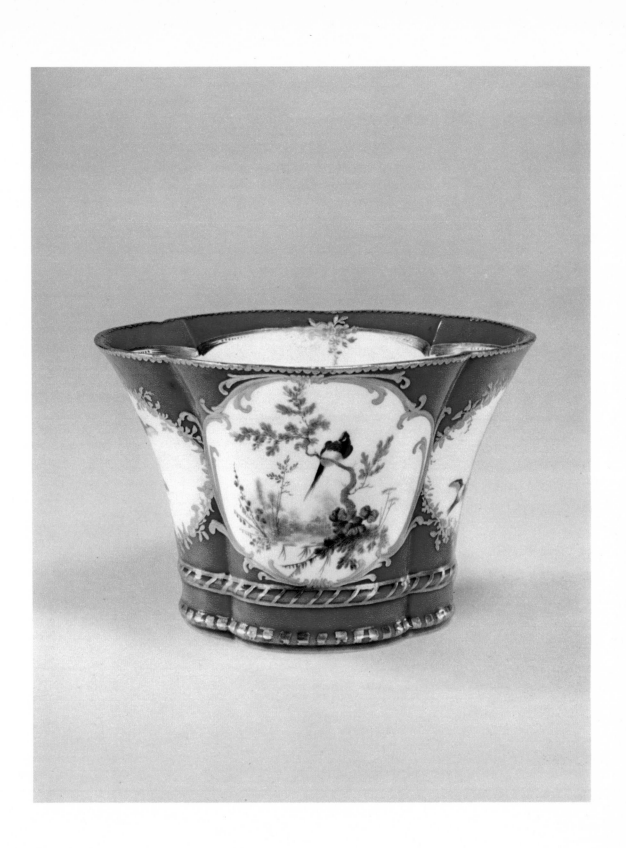

1 Archives de la Manufacture Nationale de Sèvres, Vy. 2, fol. 35 vo.

2 No. 28689. Inscribed: "22 Mai 1933, legs Miss M. G. Gould."

3 Descriptions of this sort recur frequently in the *Livre-Journal*—for example in connection with a delivery made to M. Boucher de Saint-Martin on October 26, 1748; another to M. de Caze, *fermier-général,* in December 1749; and several made to the Marquise de Pompadour on various occasions.

Pair of Small Basket-Shaped Jardinières, Turquoise Blue Trim,
c. 1756–57 (34.9.17 and 34.9.18)

Porcelain, soft paste. H. 3 in. (7.5 cm); D. at top 5¼ in. (13.4 cm); D. at bottom 3¹⁵/₁₆ in. (10 cm).

Description: Each low vase is circular in plan and divided into four lobes. The sides, which widen toward the top, are treated to resemble those of a basket, with the spaces between the simulated reeds left solid instead of being cut away. From the base, which is encircled by a band of imbricated triangles in low relief between two shallow moldings, rise parallel reeds paired vertically. The reeds, of two alternating lengths, arch over at their highest points and then return to the base, with the result that continuous arcades are formed at two different levels; the juxtaposed upper arches constitute the scalloped rim of the vase, while from the intersections of the lower arches rise stylized flowers. Two-thirds of the way up, a gold ribbon binds and supports the reeds. All parts of the basket that normally would be open are painted turquoise blue, as are the band around the base and a double festoon on the inside of the rim. The outlines of the white reeds, which stand out in low relief, are broadly accented in gold, and the two moldings on the base are treated with diagonal gold lines to simulate twisted ribbon.

Condition: Number 34.9.17 has a small fire crack on the inside and minor chips at the base. Its companion has wide fire cracks visible on the inside and bottom and a break at the base.

Several models of baskets of various sizes, proportions, and forms have survived, some with similar elements identically arranged. The nineteenth-century Sèvres inventory christened the present type *corbeilles tulipes*,[1] no doubt in allusion to the stylized flowers below the rim, which do not in fact precisely resemble any specific plant.

The lists of glazed and unglazed items taken from the kiln during 1754 and subsequent years also specify baskets of different forms. On February 10, 1757, appear "2 cuvettes à fleurs rondes, forme de corbeille" along with "2 corbeilles pleines." On August 31 of the same year, the *marchand-mercier* Lair bought "2 corbeilles pleines 30/60 livres," and on September 8 "3 corbeilles pleines 120/360 livres" were sold for cash.[2]

Writing in connection with a solid-walled basket vase dated 1757, similar to that represented here but larger, Verlet[3] reveals that "la manufacture fournit, dans ces mêmes années, des corbeilles pleines, en biscuit, en vert, en bleu céleste, parfois à fleurs, rondes ou ovales, dont les prix varient de 30 à 120 livres." It may

221

be added that on December 24, 1756, Lazare Duvaux delivered to the Dauphine, among other items: "2669... —Deux corbeilles pleines, bleu clair dehors, 240 1."

The former Chappey and Pierpont Morgan collections included such baskets, and Verlet[4] notes that "la collection Thiers, au Louvre, possède trois corbeilles pleines, à décor 'carmin' et or, deux rondes [that is, of the same model as those in The Frick Collection], datées de 1756,[5] et une ovale de 1755." Pieces of identical form are in the Victoria and Albert Museum, London,[6] decorated in blue and white and dated 1756, and in the Musée des Arts Décoratifs, Paris,[7] decorated in green, white, and gold.

Collections: Gift of Miss Helen C. Frick, 1934.

NOTES

1 Archives de la Manufacture Nationale de Sèvres, U. 3, Pièces diverses, corbeilles 1740–1760, No. 8.
2 *Idem,* Vy. 2, fols. 33, 34 vo.
3 P. Verlet, S. Grandjean, and M. Brunet, *Sèvres,* Paris, 1953, I, Pl. 23a and p. 202.
4 *Idem.*
5 Reproduced in P. Verlet, "Sèvres en 1756," *Cahiers de la Céramique, du Verre et des Arts du feu,* No. 4, 1956, p. 34.
6 Jones Collection, No. 745–1882.
7 Grandjean Collection, No. Gr. 200.

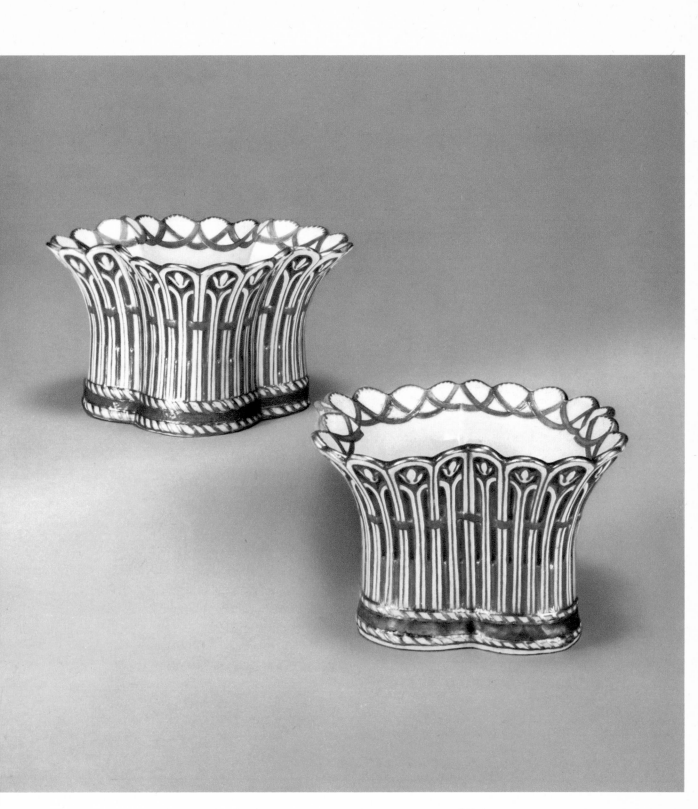

34.9.17 34.9.18

Set of Three Vases with Birds, Dark Blue and Green Grounds
(16.9.7–16.9.9)

POT-POURRI IN THE SHAPE OF A MASTED SHIP, c. 1759 (16.9.7)

Porcelain, soft paste. H. overall excluding gilt-bronze plinth 17½ in. (44.3 cm); H. of body 8 to 9¾ in. (20 to 24.8 cm); H. of lid 9¾ in. (24.8 cm); W. 14⅞ in. (37.8 cm); D. 7½ in. (19 cm).

Description: This pot-pourri[1] on an oval plan, conceived in the form of a fanciful ship,[2] consists of two separate sections. The body, representing the hull, rests on an open porcelain base supported by four elaborately scrolled feet. Immediately above the base it shrinks inward, producing a puckered effect suggesting waves, and then it swells amply up to the level of the two bearded masks from whose mouths emerge the ship's bowsprits. The rim, describing a sort of bracket accentuated by rich curves, is bordered below by a concave zone pierced with large openings resembling portholes. The openwork lid, representing the ship's sails, rests within the rim of the body, and its base describes the same bracket-shaped line. The lid tapers rapidly inward as it rises to the top of the single mast. The sails, suggested by scale-like perforations, are separated by four shrouds. From a gilded ball atop the mast spreads a long white pennant covered with gold fleurs-de-lis; it twists and turns in response to an imaginary wind, resting its tips at a point halfway down the sails. The juxtaposed ground areas of dark blue and apple green are set out according to a skillfully balanced plan and are overlaid, except for the green end panels under the masks reserved in white, with networks of gold in *caillouté* and *mosaïqué* patterns.[3] Gold also emphasizes the principal outlines, enriches the sculptural details, and sets off the frames of the two oval reserves decorated with exotic, brilliantly colored birds amid lush vegetation. The gilt-bronze plinth is of a later date.

Condition: The vase is in good condition except for slight fire cracks on the interior and a point broken off one tip of the pennant.

In the absence of a working drawing, in which it would have been gratifying to recognize the hand of Jean-Claude Duplessis, the Manufacture de Sèvres has preserved a plaster model, inventoried in the nineteenth century under the name *vaisseau à mât*.[4] The model, lacking the masthead, combines various suggestions: on one side the bearded mask appears with its mouth closed and the profile of the piece is somewhat straighter; on the other side a bowsprit issues from the mouth and the profile is a bit more convex.

The lower section of this form corresponds to three models of pieces created during the same period and intended for different uses.[5] The first model is a

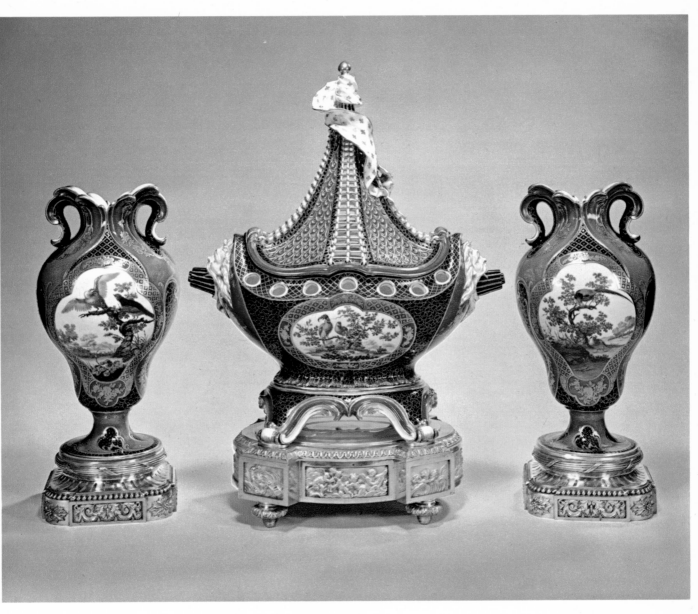

16.9.9 16.9.7 16.9.8

cuvette à masques without a cover, decorated with simple bearded faces and having a narrower concave zone below the rim. Eriksen has demonstrated in connection with an example of 1754[6] that this form probably was the earliest in date of those compared here.[7] Next comes a pot-pourri in the shape of a gondola.[8] The masks have disappeared, and in their place are scrolled elements forming small handles. Though this model has a very tall openwork lid provided with four hollow receptacles for bulbs—which in the nineteenth century led to its being christened *vase oignonière*—its lower section is closely comparable to that of a third form, a *terrine en gondole,* a plaster model of which is in the reserves of the Sèvres archives.[9] The lid of the latter type retains the same general outline but is lower.

To these forms—all members of the same family, equivalent in dimensions, and conceived at roughly the same time—can be added those of a sugar bowl and a saltcellar. The former has a lid which again takes up the theme of the ship but without the perforations;[10] a plaster specimen exists in the archives, along with another, simplified version. A pair of the saltcellars dated 1757, lacking lids and shaped like canoes with raised and pointed ends, was formerly in the J. Pierpont Morgan collection.[11] All six of these forms are directly inspired by models in metalwork.[12]

References to "1 pot pourry en navire" and "1 pot poury à vaisseau" found respectively in biscuit firings of November 2, 1758, and July 27, 1759, no doubt relate to vessels comparable to that in The Frick Collection. Only four deliveries are recognizable as pieces of this type:

1. On December 30, 1758, for the Prince de Condé at Versailles: "1 pot poury vaisseau roze enfans 1200 livres."

2. In December 1759, for Madame de Pompadour at Versailles: "1 pot poury vaisseau, safre et verd Tesnières 960 livres."

3. On May 30, 1760, for cash: "1 vaisseau en trois couleurs 720 livres."

4. On September 7, 1762, for cash: "1 vaze vaisseau fond verd 720 livres."

The designation "safre[13] et verd" in the 1759 listing could fit the pot-pourri in The Frick Collection, but the description of the painted panels as "Tesnières," suggesting small scenes in the manner of Teniers, bears no relation to the birds on the present piece.

Other vessels of this type have in all likelihood formed part of numerous indeterminate "vases et pièces d'ornement" sold at times for very high prices.

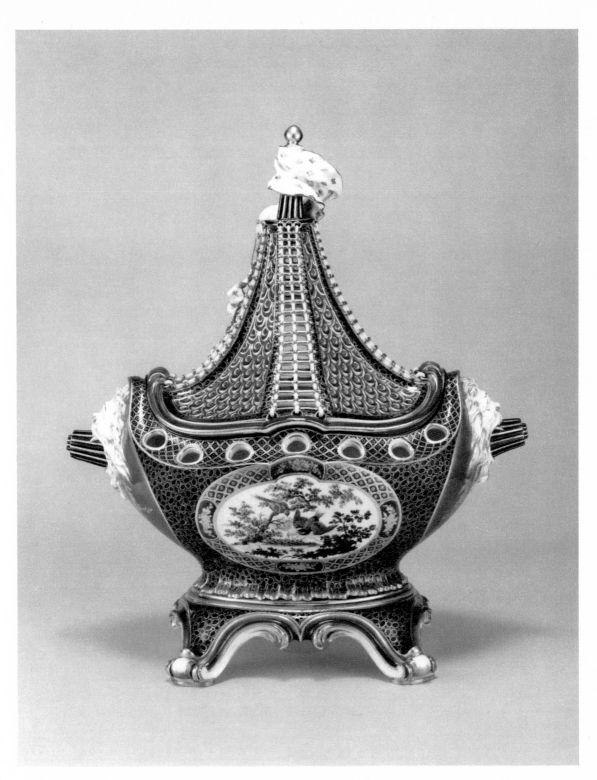

16.9.7

Dauterman[14] lists eleven such vessels still extant, while Eriksen[15] adds: "It is known that two others were made, but they do not seem to have survived." Among the known examples,[16] an undated vase in the Wallace Collection, London,[17] is decorated in a manner so close to the one in The Frick Collection that it could almost be considered a pendant were it not that the gold network on the dark blue ground is *vermiculé* instead of *caillouté* as on the present example.

The juxtaposition of opposing ground colors, such as green and blue, pink and green, pink and blue, was in fashion around the years 1758–60, and this is the period to which the vessel studied here can properly be dated.

Collections: J. Auriol. Hon. G. Byng, M. P., Wrotham Park. Alexander Barker. Earl Dudley. Frick, 1916.

NOTES

1 In ceramics, the term pot-pourri designates a covered vase or receptacle pierced with holes. It was intended to contain a shredded mixture of fragrant plants and flowers and to emit through its openings their subtle aromas.

2 The tradition which holds that the idea of the porcelain vessel derives from the ship depicted in the arms of the City of Paris seems rather questionable. Reference to the *Histoire générale de Paris* establishes that the symbolic ship, used since the Middle Ages in a number of variants, has always been of a different design. The origins of the ship are associated with the purveyors of water. The oldest known seal of the water purveyors, which dates from the year 1200, shows a river boat reminiscent of the "nautes parisiens" of the Gallo-Roman era.

3 In the listings preserved in the Sèvres archives, the term *caillouté d'or* designates a network made up entirely of juxtaposed irregular ellipses, such as that covering most of the blue ground on the present vessel. When the network more nearly resembles the sinuous embroidery of braid or frogging, it is called *vermiculé;* none of the pieces in The Frick Collection bears this type of decoration. The term *mosaïqué,* which applies primarily to lacework, is used here to describe the type of geometric pattern seen on the green frames of the reserved panels and on the concave zones below the rim.

4 Archives de la Manufacture Nationale de Sèvres, U. 3, Vases 1740–1780, No. 12. Reproduced in A. Troude, *Choix de modèles de la Manufacture Nationale de Porcelaine de Sèvres appartenant au Musée Céramique,* Paris [1897], Pl. 92.

5 The analysis that follows was included by the author of the present catalogue in an unpublished lecture given November 8, 1966, for the Société des Amis du Musée National de Céramique de Sèvres, under

228

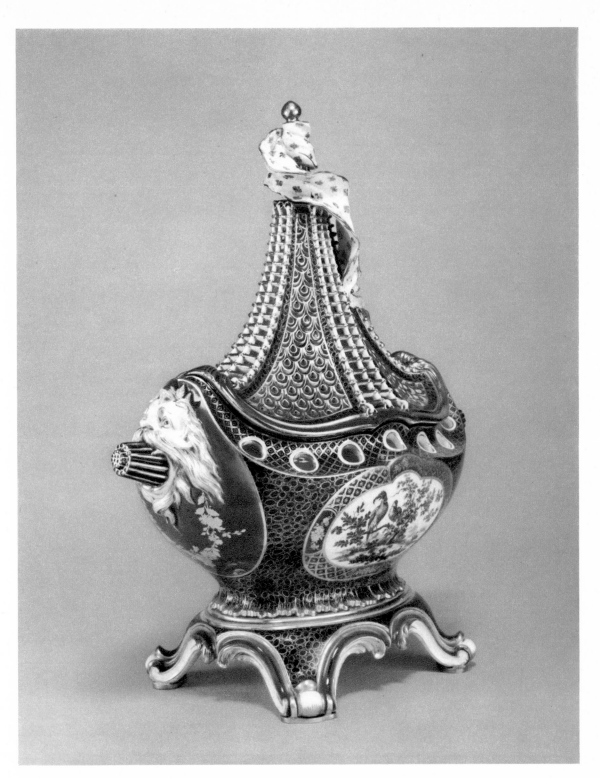

16.9.7

the title "Aperçus sur des vases de Sèvres au XVIII^ème siècle." Study of this subject was resumed and published by S. Eriksen in *The James A. de Rothschild Collection at Waddesdon Manor: Sèvres Porcelain,* Fribourg, 1968, No. 48, p. 136.

6 In the collection of the Marquess and Marchioness of Cholmondeley. Reproduced in S. Eriksen, "Rare Pieces of Vincennes and Sèvres Porcelain," *Apollo,* LXXXVII, 1968, p. 39.

7 Other examples of the *cuvette à masques,* both dated 1757, are in the Wallace Collection, London (P. Verlet, S. Grandjean, and M. Brunet, *Sèvres,* Paris, 1953, I, Pl. 27 and p. 203), and in the Collection of Her Majesty the Queen (G. F. Laking, *Sèvres Porcelain of Buckingham Palace and Windsor Castle,* London, 1907, No. 15).

8 Pots-pourris of the gondola type are found in several large collections, including those of Her Majesty the Queen (Laking, No. 14, Pl. 3), dated 1757, pink ground; the Metropolitan Museum of Art, New York (C. C. Dauterman, in *Decorative Art from the Samuel H. Kress Collection,* London, 1964, No. 35, pp. 199–201, Figs. 143–44), turquoise green ground; the Wallace Collection (Verlet, Grandjean, and Brunet, I, Pl. 25 and p. 203), dated 1757, green ground; the Philadelphia Museum of Art (F. Kimball and J. Prentice, "French Porcelain Collection of Mrs. Hamilton Rice," *Philadelphia Museum Bulletin,* XXXIX, No. 201, March 1944, No. 37, p. 77, cover illustration), dated 1757, green ground; and the Hermitage Museum, Leningrad, dated 1756, green ground.

9 Two tureens of this type formed part of the service decorated with green ribbons, polychrome flowers, and groups of children on the larger pieces that was presented by Louis XV to the Empress Maria Theresa in 1758. For one of these see *Les Grands Services de Sèvres,* Musée National de Céramique de Sèvres, 1951, No. 1, Pl. I.

10 Eriksen *(Rothschild Collection,* p. 136) cites two examples at Woburn Abbey, both dated 1778. Another, dated 1757, is exhibited at the Musée des Arts Décoratifs, Paris, No. AA 7090.

11 Chavagnac (Comte X. R. M. de Chavagnac, *Catalogue des porcelaines françaises de M. J. Pierpont Morgan,* Paris, 1910, No. 87, Pl. XXVI) describes them as small saltcellars "ou baguiers en forme de canot sans avant ni arrière." These pieces, precious in appearance, are decorated in tones of monochrome purple.

12 In connection with the present piece, W. R. Hovey recalls in *The Frick Collection Catalogue* (VIII, 1955, p. 36) that "Table ornaments of silver gilt in the form of sailing vessels had long been popular," and cites as an example the celebrated illumination for the month of January in the calendar of the *Très Riches Heures du Duc de Berry,* where the prince is shown seated at a dinner table set with numerous utensils including a tall ship's hull in *orfèvrerie.* In the Middle Ages, the *cadenas* of kings and princes, in which their plates, knives, spoons, spices, and other table necessities were kept locked, took on the form of a ship. This form gave way toward the seventeenth century to a flat chest, and the custom disappeared in the eighteenth century. The *cadenas* were intended to pro-

230

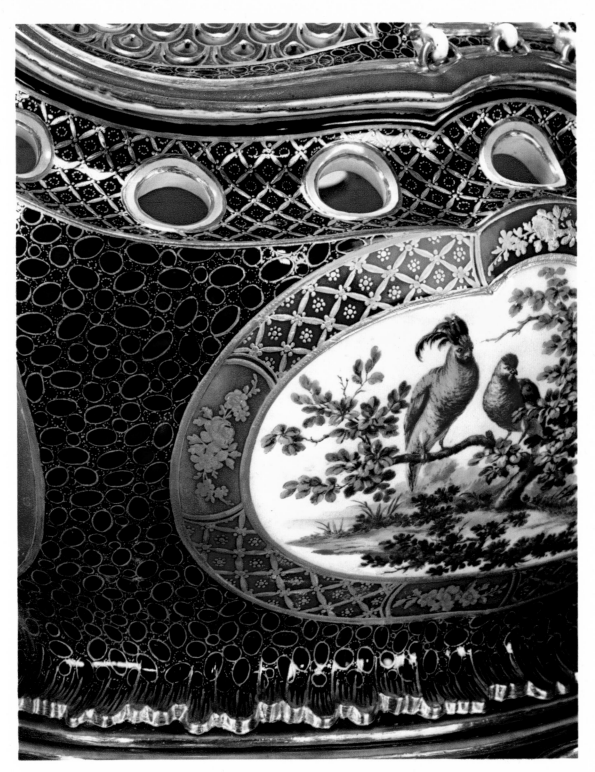

16.9.7 · DETAIL

tect against attempts at poisoning.

13 The term "safre" refers to the oxide of cobalt used to obtain *bleu de Sèvres.*

14 Dauterman, p. 195.

15 Eriksen, *Rothschild Collection,* No. 48, pp. 136–38.

16 One of these, a vessel with a blue ground of rare beauty formerly in the Hodgkins collection and now in the Walters Art Gallery, Baltimore, differs from the others in the form of the perforations in the upper section. In place of scales it has vertical lines suggesting pronounced folds in the sails. This fancy demonstrates the extent to which the *mouleurs-répareurs,* newly arrived at an exceptional technical virtuosity, ventured in their desire to bring variety to the models they repeated.

17 Reproduced in *Les Porcelainiers du XVIII*e *siècle français,* Paris, 1964, p. 188.

PAIR OF *VASES À OREILLES,* 1759 (16.9.8 and 16.9.9)

Porcelain, soft paste. Number 16.9.8: H. excluding gilt-bronze plinth 12½ in. (31.7 cm); D. at shoulder 6⅝ in. (16.8 cm); D. of foot 4⅞ in. (12.4 cm). Number 16.9.9: H. excluding gilt-bronze plinth 12¾ in. (32.3 cm); D. at shoulder 6⅝ in. (16.8 cm); D. of foot 4⅞ in. (12.4 cm). Painted in blue on the base of No. 16.9.8: interlaced L's, weakly drawn and incomplete; and on No. 16.9.9: interlaced L's enclosing the date-letter G and surmounted by a mark in the form of a crescent, generally attributed to Jean-Pierre Le Doux.

Description: Set on a broad, low foot, the body of each vase swells in an undulating line as it rises, reaching its maximum diameter three-quarters of the way up and then contracting at the neck. The irregularly notched lip turns down at each side to form two broad curves which rejoin the body above the shoulder, bending inward as they fall so as to suggest the profile of a human ear. The ground consists of dark blue and apple green zones harmoniously distributed over the entire surface except for the white exterior of the "ears" and for two four-lobed panels left in reserve, their contours corresponding to the general outline of the vase. The gold decoration includes floral garlands and clusters, scrolling tendrils, accents on the projecting elements, a *caillouté* overlay on most of the blue zones, and a *mosaïqué* pattern on the green frames of the reserved panels. Each panel contains a scene showing two birds in polychrome and a tree with a gnarled, abruptly bent trunk and one or two branches. On one side of each vase both birds are perched in the tree, while on the reverse one bird is on the ground. The background landscapes, subdued and lacking any indication of sky, consist essentially of a few trees set on a hillock; in one panel on No. 16.9.8 a stream flows before some small houses painted with great precision, and on one side of the pendant a flock of tiny birds passes in the distance. The gilt-bronze plinths are of a later date.

Condition: The vases are in good condition.

232

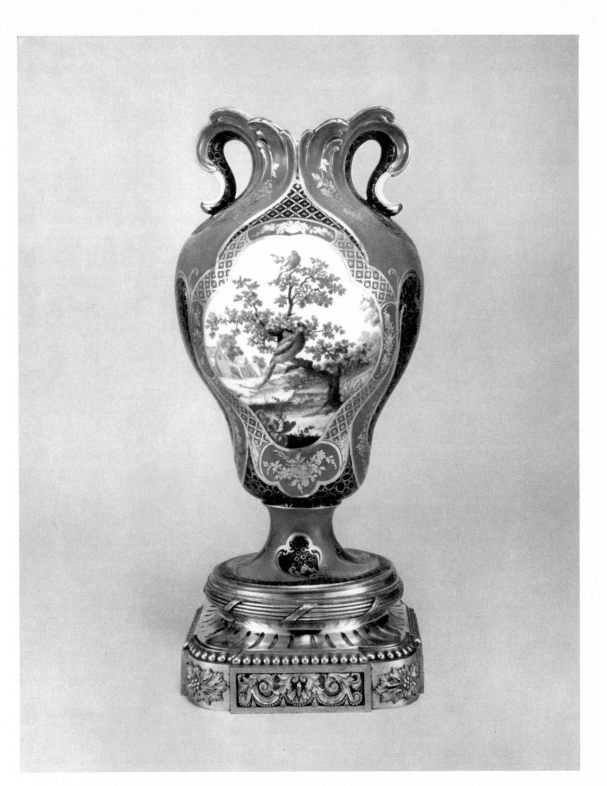

16.9.8

Two drawings in the Sèvres archives, the work of an expert hand which could be that of Jean-Claude Duplessis himself, supply valuable information by way of their dimensions and accompanying inscriptions. The first, 8½ in. (21.5 cm) high, is inscribed: "vase à oreile 3ème grandeur Suivan la Comande du 20 janvier 1755." On the second, only 4¹⁵/₁₆ in. (12.5 cm) high, is written: "vase à oreille 5ème grandeur 1755." From this it can be assumed that by about 1755 the *vase à oreilles* was already being produced in five sizes. By comparing the dimensions of examples preserved in various collections—that is, of porcelains already subjected to the variable shrinkage that results during firing—it is possible to determine the approximate heights corresponding to all five sizes:

> First size, about 15 in. (38 cm).
> Second size, about 12½ in. (31.5 cm).
> Third size, about 9 in. (23 cm).
> Fourth size, about 7 in. (18 cm).
> Fifth size, about 4¼ in. (11 cm).

The pair of *vases à oreilles* in The Frick Collection are of the second size and demonstrate, through the differences in their heights, the degree to which the dimensions given here may vary.

The plaster model in the Sèvres archives[1] is probably a nineteenth-century casting. It measures 11 in. (28 cm) in height. If the average rate of shrinkage during firing (about twelve percent) is taken into account, it can be assumed that a porcelain vase cast from such a mold would measure approximately 9⅝ in. (24.5 cm), a height intermediate between those of the second and third sizes.

Though the name *vase à oreilles* appears belatedly in the Sèvres manufacturing records—it figures in a list of glazed pieces taken from the kiln on December 30, 1764—the earliest record of delivery dates from December of 1754,[2] when "2 vases à oreilles, bleu céleste oiseaux 144/288 livres" were supplied to Lazare Duvaux, their sizes unspecified. This form proved to be one of the most successful produced at Vincennes and Sèvres and continued in use until the last years of the *ancien régime,* first in soft paste alone and after the introduction of hard paste in both media. In a list of glazed pieces in hard paste taken from the kiln on May 1, 1786,[3] there appear no less than twelve *vases à oreilles* of the third size and twenty-seven of the fourth.

234

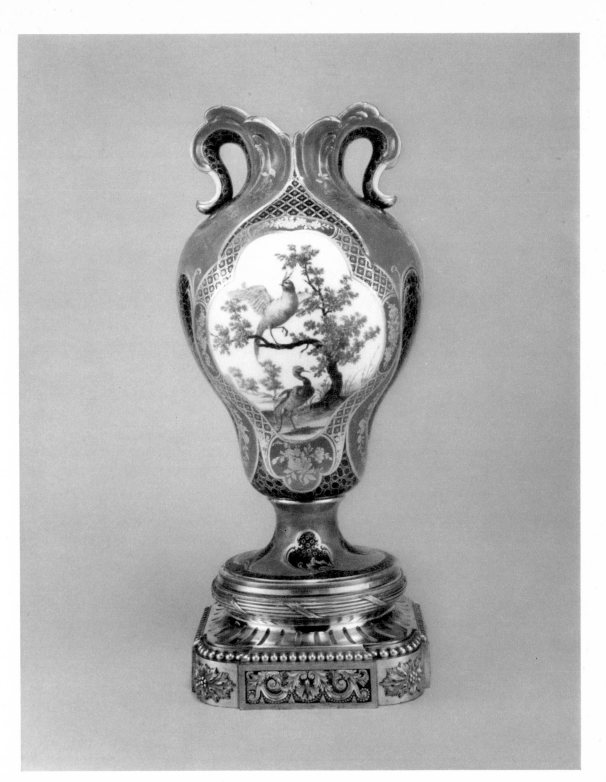

16.9.9

Delivery records are legion, especially up until about 1760. The descriptions, always terse, indicate ground colors and various decorative motifs,[4] including flowers, children, ribbons, landscapes, and even portraits.[5] None of the vases specified as "à oiseaux" can be identified with the pair in The Frick Collection.

Among the *vases à oreilles* that most resemble the Frick examples, special notice must be drawn to a pair at Waddesdon Manor, Buckinghamshire, dated 1761.[6] In size, in the disposition of the same ground colors, and in the shape of the reserved panels these vases are closely similar, and the principal decoration again consists of birds. However, the present vases differ from the Waddesdon Manor versions in the same way that the Frick *vaisseau à mât* (p. 224) differs from the undated *vaisseau à mât* in the Wallace Collection, London: namely, the gold tracery on the blue ground is *caillouté* on all three of the Frick pieces and *vermiculé* on their three counterparts. This evidence suggests the previous existence of a three-piece garniture of the same type as that in The Frick Collection which has since been dispersed.

Few large collections of Vincennes and Sèvres porcelain lack *vases à oreilles,* and some have several. This is especially so of the earlier collections, including those of J. Pierpont Morgan (most of which is now in the Wadsworth Atheneum, Hartford), E. M. Hodgkins (Walters Art Gallery, Baltimore), and the Lords Hillingdon (Kress Collection, Metropolitan Museum of Art, New York), as well as the Wallace Collection, the Rothschild Collection at Waddesdon Manor, and the Musée du Louvre and Musée des Arts Décoratifs in Paris.

The crescent-shaped mark on No. 16.9.9, attributed in lists published since the mid-nineteenth century to Jean-Pierre Le Doux, painter of birds and landscapes (active 1758–61), has been the subject of some controversy.[7] It is significant that in 1845 Brongniart and Riocreux,[8] who took pains to publish only marks whose accuracy they could guarantee, neglected to reproduce the crescent. Some years later Jacquemart and Le Blant[9] included it in a table that was more complete than the earlier one and still serves as an authority.[10] The possibility must be considered that the same crescent was used as the mark of two different painters, since it is met with both before 1758 and after 1761—that is, beyond the brief period during which Le Doux was regularly salaried by the factory.

In the case of the present examples the coincidence of dates argues in favor of Le Doux. There seems no reason, then, to deny him the skillful and seductive

236

painting of these remarkable birds, whose dazzling and varied colors attest to the mastery of an artist possessed of an infinitely rich palette and the ability to extract the best from it.

Collections: J. Auriol. Hon. G. Byng, M. P., Wrotham Park. Alexander Barker. Earl Dudley. Frick, 1916.

<div align="center">NOTES</div>

1 Archives de la Manufacture Nationale de Sèvres, U. 3, Vases 1740–1780, No. 50. Reproduced in A. Troude, *Choix de modèles de la Manufacture Nationale de Porcelaines de Sèvres appartenant au Musée Céramique,* Paris [1897], Pl. 91.

2 This discrepancy in dates may be explained by the fact that every second folio has systematically and inexplicably been cut out from four registers of firings prior to 1772. Under such circumstances the dates when new pieces appeared is problematical.

3 Archives de Sèvres, Vc' 3.

4 Mention should also be made of the great many deliveries of undecorated *vases à oreilles* in biscuit, either isolated or accompanying table centerpieces. The smaller sizes were much in demand for such purposes, and prices rose to 9 livres for the fifth and fourth sizes, 12 livres for the third, 18 for the second, and 24 for the first.

5 Louis XV acquired in 1773 "2 vases à oreilles bleu dagatte 3ème à portraits de Madame et de Madame Elisabeth" for 600 livres. In 1777 the figure painter Pithou *aîné* received 72 livres for executing a "portrait de la Reyne" on a *vase à oreilles* and a like sum for "un portrait" of an unspecified subject. In the same year the records list: "Présent du Roi à l'Empereur, 2 vases à oreilles portraits de la Reyne, 600/1200 livres."

6 S. Eriksen, *The James A. de Rothschild Collection at Waddesdon Manor: Sèvres Porcelain,* Fribourg, 1968, No. 45, p. 130.

7 See Eriksen, No. 13, p. 58.

8 A. Brongniart and D.-D. Riocreux, *Description méthodique du Musée Céramique de la Manufacture Royale de Porcelaine de Sèvres,* Paris, 1845.

9 A. Jacquemart and E. Le Blant, *Histoire artistique, industrielle et commerciale de la porcelaine,* Paris, 1862, p. 541.

10 Eriksen (p. 25) reproduces the later table, which also was supervised by Riocreux.

Oval Jardinière with Birds, Turquoise Blue Ground, 1760 (34.9.20)

Porcelain, soft paste. H. 4³/₁₆ to 4⁷/₁₆ in. (10.6 to 11.2 cm); W. at top 9⅜ in. (23.8 cm); W. at bottom 7¼ in. (18.5 cm); D. at top 4½ in. (11.5 cm); D. at bottom 3¾ in. (9.5 cm). Incised on the base: the letters *ap*. Painted in blue on the base: interlaced L's enclosing the date-letter H and surmounting an incomplete and unidentifiable mark.

Description: A rather pale turquoise blue forms the ground on the front and back, leaving the sides and the two oval panels in reserve. Broad gold accents highlight all the projecting elements, and a garland of gold flowers appears at either side of the reserved panels, which themselves are framed by a band of chased and burnished gold. Within each panel are two exotic birds in vivid color, one perched in a small tree, the other poised on a bit of ground amid summary vegetation.

Condition: The piece is in good condition. Like much soft-paste porcelain it is marked with a few fire cracks. Small pits in the glaze appear on the interior.

A working drawing at Sèvres emphasizes the curved outlines of this form both in plan and in elevation. Three sizes are proposed. The inscription—"Caise à fleurs unÿe Contourne fait le 7 Mars 1754 par ordre de Mos. de Verdun plus en juillet 1759 fait 2ème et 3ème grandeur"—supplies information on the probable date of creation of the largest size as well as that of the diminished versions. It is noteworthy that in 1760 the expenditures of the factory were to be reduced, in particular the pay of the workers and artists, "du moins jusqu'à ce que les tems deviennent plus heureux, les ventes plus abondantes."[1] This suggests the possibility that during the preceding year or two, coincident with the reorganization of the factory's financial structure, an effort was being made to produce pieces of lesser dimensions and lower prices. Other flower holders of different form follow the same evolution, large at the outset and reduced in size afterward.

The plaster model preserved in the factory archives bears no inscription. It figures neither in the inventory made at the beginning of the nineteenth century nor among the models reproduced by Troude.

The name of Jean-François Verdun de Monchiroux, *fermier-général* and one of the most active partners in the company, recurs on drawings of various forms. As has been noted (see p. 214), the names of the partners were frequently used to

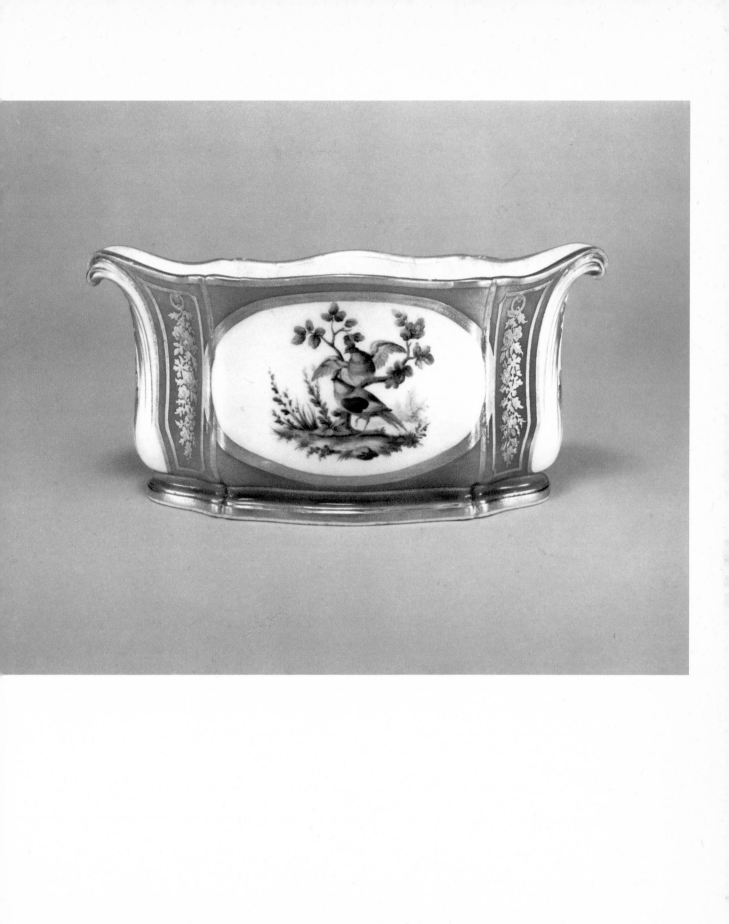

designate particular forms—for example, the *broc la Boëxière* (i. e., la Boissière) and the *plateau Bouillard.*

In connection with an earlier discussion[2] of the present form, Eriksen[3] writes: "Verlet...suggests, though with some hesitation, that this type of jardinière may have been called a *cuvette à fleurs Verdun.* Jardinières so named appear about twelve times in the sales records between 1755 and 1760 and, as the records show, were made in three different sizes. About thirty-six other entries during the same period refer to a *cuvette à fleurs unie* but these were made in one size only. It is not wholly impossible that both names may have been applied to jardinières of this shape." The simultaneous presence of "2 cuvettes ovales unis" and "2 idem Verdun" in a biscuit firing of December 3, 1755,[4] suggests a dissimilarity of some unspecified nature but throws no clear light on the problem; it would be logical to suppose that these four *cuvettes,* all of them oval, had other distinguishing characteristics.

The delivery registers from 1755 onward are no more explicit. The name *cuvette unie* disappears in 1760, while that of *cuvette Verdun* is met with up until 1774. Ground color and decorative motif are generally indicated, but curiously there is no specific mention of decoration "à oiseaux." It is probable, then, that the *cuvette à fleurs* in The Frick Collection was delivered without its characteristics having been noted. Pieces qualified simply as "d'ornement" fill entire pages of the record books.

Many examples of similar form are known. It will be observed that those dated 1755 are of the largest size, while those dated 1758, 1759, 1760, and 1763 are smaller. One such piece—with a *bleu de Sèvres* ground veiled by a fine crackle pattern in gold, with additional broad gold accents, and with a central panel containing polychrome birds—is visible in The Frick Collection's portrait of the Comtesse d'Haussonville by Ingres (No. 27.1.81).[5]

Incised letters *ap* similar to those on the Frick jardinière appear on a cup forming part of a *déjeuner* of 1757 at Waddesdon Manor, Buckinghamshire;[6] on a water jug of 1757 in the Musée Condé, Chantilly;[7] on a pair of *caisses à fleurs unies* of 1768 in the Musée du Louvre, Paris;[8] and on a pair of vases of 1772 in the Metropolitan Museum of Art, New York.[9]

Collections: Gift of Miss Helen C. Frick, 1934.

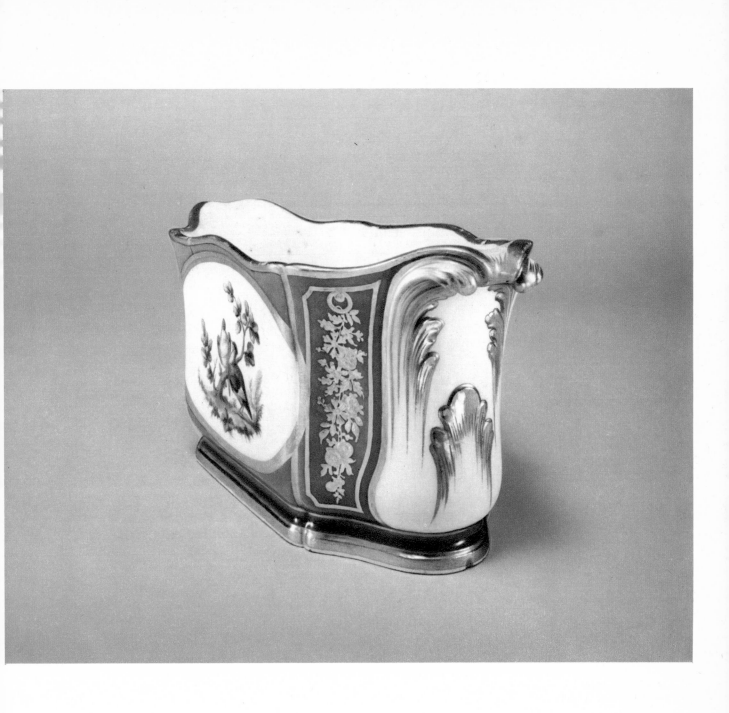

1 Archives de la Manufacture Nationale de Sèvres, D.1, L.1. In a statement of February 23, 1760, there appears a list of "apointemens actuels, de l'augmentation à faire pour les uns et de la réduction à faire pour les autres." In the margin of the section pertaining to the painters' studio, a note indicates: "Monsieur de Courteille ayant décidé et parlé même aux ouvriers pour diminuer leurs apointemens...on estime que cette diminution peut être de 10% ou à peu près, mais l'intention de M. de Courteille étant qu'on ne retranche rien à ceux qui n'ont que ce qu'il faut pour vivre on ne fera aucune diminution que les apointemens de 36 et au dessous. Il est des ouvriers qui méritent quelque augmentations, pour leur en tenir lieu on laissera leurs apointemens au taux actuel. Il en est même qui sont dans le cas d'être augmentés réellement soit par rapport à la modicité de leur apointemens soit relativement aux progrès qu'ils ont fait." In actuality, some artists were dismissed outright while the remainder experienced little or no reduction in pay, but for a period of about three years raises in salary were very rare.

2 P. Verlet, S. Grandjean, and M. Brunet, *Sèvres,* Paris, 1953, I, Pl. 18 and p. 201.

3 S. Eriksen, *The James A. de Rothschild Collection at Waddesdon Manor: Sèvres Porcelain,* Fribourg, 1968, No. 27, p. 84.

4 Bibliothèque de l'Institut de France, Mss. 5673, fol. 52.

5 *The Frick Collection: An Illustrated Catalogue,* New York, II, 1968, repr. pp. 135, 137.

6 Eriksen, No. 25, p. 80.

7 Château de Chantilly, Porcelaines, No. 43.

8 No. O.A. 6238.

9 C. C. Dauterman, in *Decorative Art from the Samuel H. Kress Collection,* London, 1964, No. 52a–b, p. 227, Figs. 183–86.

Candlestick with Floral Sprays, Partial Turquoise Blue Ground, 1760 (34.9.14)

Porcelain, soft paste. H. overall 2¾ in. (7 cm); H. of saucer ¾ in. (2 cm); D. of saucer 4¾ in. (12 cm); W. including handle 6⅜ in. (15.7 cm). Painted in blue on the base: interlaced L's, small and finely executed, enclosing the date-letter H and surmounting a fleur-de-lis, the mark of Vincent Taillandier.

Description: The saucer is bordered by a plain rim interrupted at one point by the crossing of a band forming an elongated loop, open at the center and turned up at the end, which serves as a handle. Attached to this lower section is a simple sconce with an undulating base. A band of turquoise blue edged and punctuated with gold runs around the rim of the saucer and crosses over on itself to follow the movement of the handle. On the white area within the blue band is a circular garland of flowers painted in polychrome. The sconce is blue above and below, and the intervening white area, the outlines of which suggest a series of incomplete Vitruvian scrolls, is decorated with groups of flowers freely and boldly painted.

Condition: The piece is in very good condition.

The model storeroom at Sèvres preserves the lower section of this form of candlestick,[1] ready to receive a sconce chosen from among several different types. The model is not in plaster but in eighteenth-century soft-paste biscuit, indicating that an unfinished piece has been retained instead of a true model. It was perhaps intended to be mounted with a metal sconce, as was frequently the case; in the years prior to 1758 the *Livre-Journal* of Lazare Duvaux mentions on several occasions "un bougeoir de porcelaine de Vincennes la bobèche de bronze doré d'or moulu, 27 livres."

Candlesticks listed in the registers of biscuit, glaze, and enamel firings are indicated in so summary a fashion that it is impossible to connect the example discussed here with any one of the forms identified as "ordinaire," "ancienne," or "nouvelle."

Delivery records are hardly more detailed. It can be established, assuming the form involved to be the same, that in 1758 a "bougeoir roze" cost 60 livres and a "bougeoir vert" 48 livres. In 1760 the *marchande* Madame Lair bought "2 bougeoirs fleurs à 24/48 livres," a relatively modest price which precludes the possibility of a colored ground. No particulars are given for the candlesticks delivered

in 1761 and 1762 to the *marchands* Dulac, Poirier, Machard, and Madame Lair, nor even to certain "Seigneurs de la cour," at such variable prices as 15, 18, 24, 36, 42, and 48 livres.[2]

A candlestick of comparable form dated 1766, with its sconce set on a more slender stem and further differing in its very elaborate, rather complicated decoration, is in the Musée du Louvre, Paris.[3]

The decoration of the Frick candlestick is signed with the fleur-de-lis of Vincent Taillandier (active 1753–90). Comparison with the Frick sugar bowl (see p. 214) done four years earlier reveals a change in the artist's palette, in that the flowers painted on the candlestick are stronger in color. It must be remembered that the Sèvres laboratory, benefiting from the tests directed by Hellot (p. 190), was regularly furnishing new chemical compositions to the artists, and that the latter were adapting them in turn to their own formulas, continually on the lookout for new color possibilities. That Taillandier had begun using some of the recent materials is not impossible. That he had a taste for innovation is established beyond doubt by the creation of the ground which bears his name (p. 334).

Collections: Gift of Miss Helen C. Frick, 1934.

NOTES

1 Archives de la Manufacture Nationale de Sèvres, U. 3, Pièces diverses, bougeoirs 1780–1800, No. 1.

2 *Idem,* Vy. 3, fols. 35 ff.

3 No. O. A. 6243.

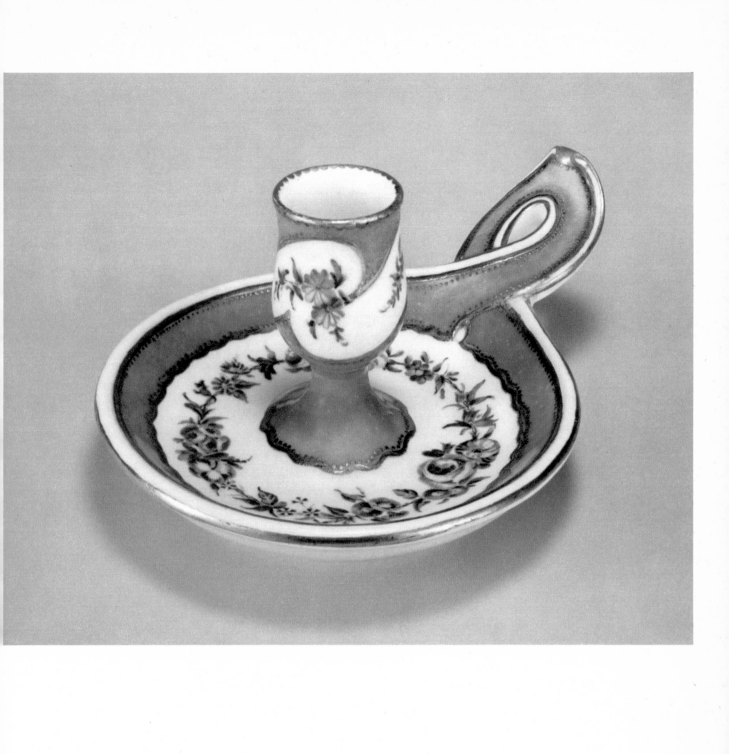

Set of Three *Pots-Pourris Myrte* with Flemish Scenes and Landscapes, Pink Ground with Blue and Gold Overlay, c. 1762 (18.9.10–18.9.12)

Porcelain, soft paste. Number 18.9.10: H. overall excluding gilt-bronze plinth 14 3/16 in. (36 cm); H. without cover 10 7/8 in. (27.5 cm); D. at shoulder 7 1/8 in. (18 cm); D. of foot 4 5/8 in. (11.8 cm); D. of neck 3 3/8 in. (8.5 cm); W. including handles 8 1/2 in. (21.5 cm). Numbers 18.9.11 and 18.9.12: H. overall excluding gilt-bronze plinth 11 in. (28 cm); H. without cover 8 1/4 in. (21 cm); D. at shoulder 5 1/4 in. (13.3 cm); D. of foot 3 1/2 in. (8.8 cm); D. of neck 2 3/8 in. (6 cm); W. including handles 6 3/4 in. (17 cm). Incised on the base of No. 18.9.11: the letter *N* in script; and on No. 18.9.12: the letters FR.

Description: The three pots-pourris are identical in form. A molded foot with the outline of a cyma curve supports a short, narrow cylinder above which rises the body of the vase. The body's undulating profile, similar in conception to that of the *vase à oreilles* (see p. 232) but squatter, swells amply up to the shoulder, then contracts abruptly to form a rather low neck atop which rests a lid with a tall vertical handle. On the neck and shoulder and on the lid are perforated zones incorporating plant motifs, each zone set off by the loop of an undulating ribbon reserved in white and bordered in gold. On the neck and shoulder the ribbon mingles

with foliage in relief painted in natural colors, and at each side it ends in an enlarged scroll curved back on itself like a crook. At the same level begins a similar scrolled element which, in a play of curves and countercurves, simulates a handle echoing the line of the vase as it transforms itself into a broad leaf, the lobes of which rejoin the body below. Additional foliage in relief climbs the sides of the vase, and miniature flowers in relief adorn the lid. The dominant pink ground of the vases is overlaid throughout with blue,[1] creating on the lid, neck, and bottom molding a marbled effect of jagged diagonal streaks, and on the body of the vase a play of motifs, direct or in reserve, imitating Flemish and Valenciennes lace in artful and varied tracery generously enhanced with gold.[2] A Greek key pattern in blue charged with a frieze of ovals reserved in pink surrounds the cylindrical stem, introducing a neoclassical note into an ensemble otherwise in the purest *rocaille* style. Large, serrated green leaves with red berries trail to the left as they follow the curve of the foot down to the marbled bottom molding. The only difference in the ornamentation of the three pots-pourris is the subject matter of the central peasant scenes and landscapes, all of them of the same genre and all framed by a broad, chased fillet of gold defining a cartouche whose form follows exactly the curve of the vase; for these scenes, see below. The gilt-bronze plinths are of a later date.

Condition: The set is in very good condition.

246

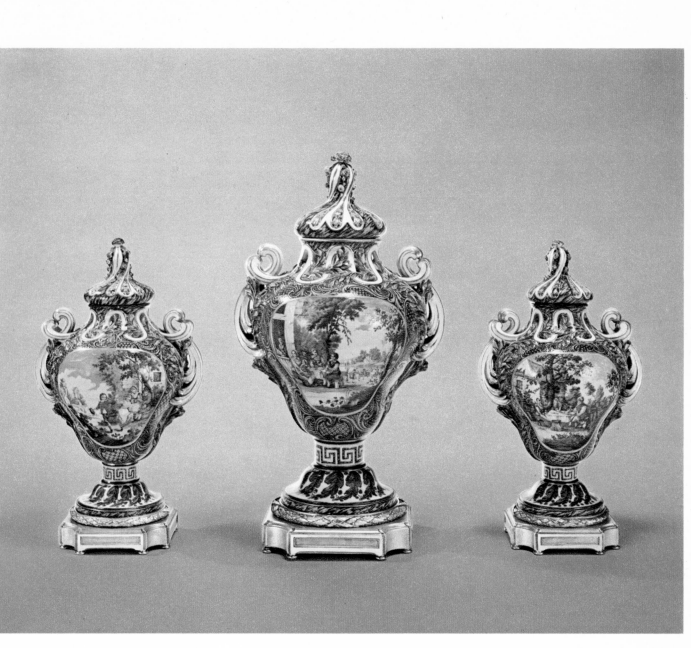

18.9.11 18.9.10 18.9.12

Two working drawings preserved at Sèvres, neither one inscribed, show vases of the present type in three sizes:

First size, 15¾ in. (40 cm).
Second size, 12¾ in. (32.5 cm).
Third size, 7 7/16 in. (24 cm).

The Frick set is made up of pieces of the first and second sizes.

A plaster model in the factory reserves corresponds to the second size. It was entered in the nineteenth-century inventory[3] under the name "pot-pourri myrthe," a designation little different from those assigned to such pieces in the eighteenth century. To judge from its general form, its decoration in relief, and its handles, the vase seems directly inspired by a model in metalwork. There can be no doubt that Duplessis, once again, was the creator of this model.

In a list of items taken from the glazing kiln on August 14, 1761, there appear for the first time "2 pots-pourris feuilles de mirtre." The following April 30, mention is made of "11 pots pourris à feuillage et à vaisseau," a loose reference interpretable as relating both to pots-pourris with myrtle leaves and to others corresponding in form to the Frick *vaisseau à mât* (see p. 224). On December 30, 1764, still in connection with glaze firings, "4 vazes mirtre" are encountered, and later, at an unspecified date, appear "1 vase mirte" and again "2 vazes mirthe." In no case is the size stipulated.

Elsewhere the records show that the painter Xhrouuet, also known under the name of Secroix,[4] received 36 livres in 1762 for work "en extraordinaire" in connection with the decoration of "2 pots-pourris à feuillage 3ème."[5] This confirms that the vase was actually made in all three of the sizes proposed on the drawings.

Five deliveries of "pots-pourris à feuillage," always in pairs, turn up between December 1761 and the end of 1764. Only once is the size specified—"2ème grandeur"—and even then without any allusion to decoration, making recognition of the pieces impossible. Also recorded are deliveries of "2 vazes à feuillage" in 1763 and "2 vazes feuilles de mirtre" in 1766. It is difficult to determine whether these mentions refer to additional pots-pourris or simply to vases of the same form without perforations.[6] In any event, none of the pairs referred to here can concern the set of three in The Frick Collection.

248

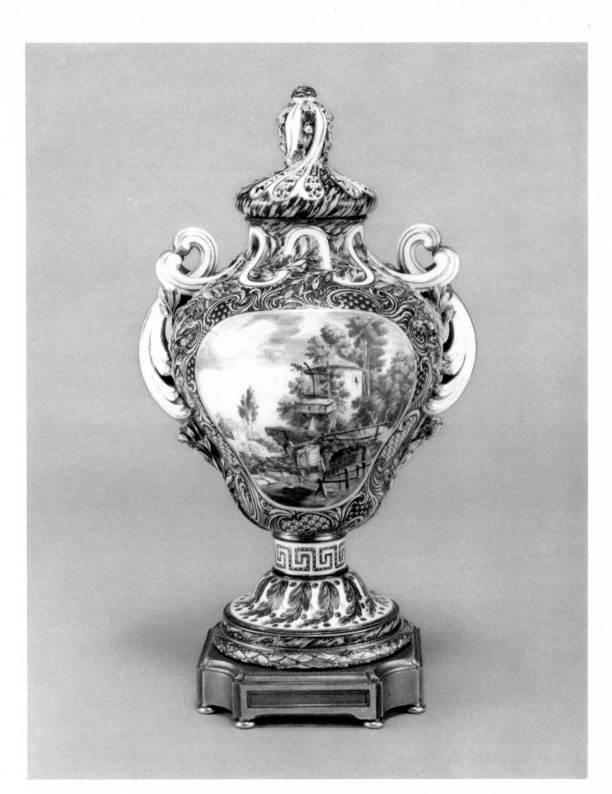

18.9.11

The decorative scenes on the Frick pots-pourris derive at least in part from engravings made after paintings. Their disposition on all three vases is the same: on one side a Flemish peasant scene in rich polychrome; on the reverse a landscape bathed in soft light.

The peasants seated at table before the corner of a house on the front of the larger vase, No. 18.9.10, are all borrowed from the *4ème Fête Flamande,* painted by David Teniers the Younger and engraved by Jacques-Philippe Lebas with the dedication: "à Madame la Marquise de Pompadour, gravé de même grandeur que l'original qui est du Cabinet de Mr. le Comte de Choiseul." The Sèvres painter has combined several elements of the engraving in composing his version, for which he invented a color scheme based on contrasting hues. On the reverse is a landscape dominated by a tall tree with two trunks rising above a river. On the opposite bank a small figure heads toward a narrow, turreted house which guards the walls of a park. Other buildings rise in the distance at right. Yellowish clouds part to reveal a streaked blue sky.

The couple seen at left on the front of No. 18.9.12—a standing youth caressing the face of a young girl seated at the end of a table—were reproduced many times by the Sèvres decorators, either isolated or incorporated into groups.[7] They are taken, along with the standing man and the bagpiper seated on a cask, from *La Feste de Village,* again painted by Teniers and engraved by Lebas "D'après le tableau original du Cabinet de Madame la Comtesse de Verrüe." In an apparent effort to lighten the composition, the Sèvres painter has eliminated the person who in the engraving occupies the stool in front of the table. The landscape on the reverse, dominated by a water mill built on pilings, is copied from the engraving *Première Veue de Charenton,* dated 1747, made by Lebas after a painting by François Boucher and dedicated: "à M. Portail, peintre du Roy et garde des plans et tableaux de Sa Majesté."

The dancing couple and the couple seated beneath a tree before a house on the front of No. 18.9.11 are taken from the same *Feste de Village* as the group on the preceding vase. The decorator has rendered the rapid rhythm of the dance with great verve, contrasting it with the tranquillity of the watching piper seated on a cask. The landscape with a dovecot on the reverse is directly inspired by an engraving entitled *Seconde Veue des Environs de Charenton,* dated 1747, made after a painting by Boucher[8] and dedicated: "à M. Descamps membre de l'Aca-

250

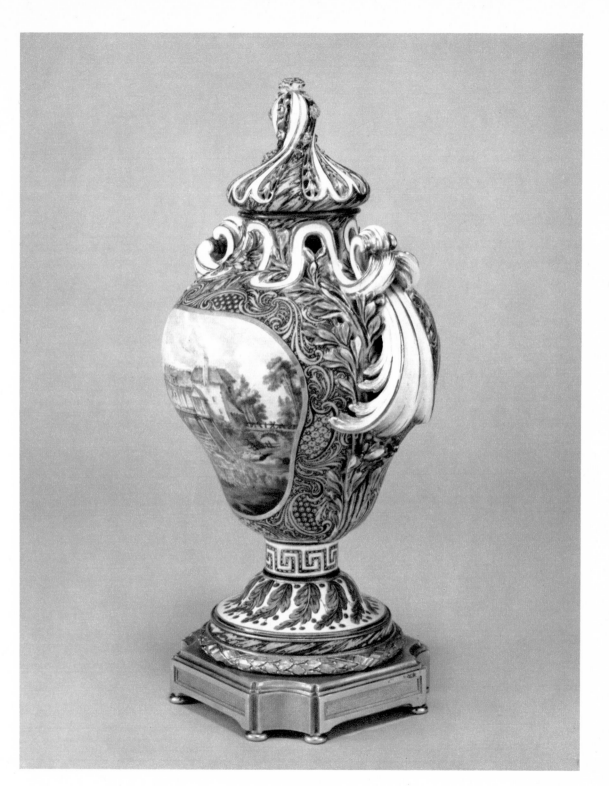

18.9.12

démie des Sciences, Belles-Lettres et Arts de Rouen, par son serviteur et son amy J. Ph. le Bas graveur du Cabinet du Roy."

Flemish scenes, sometimes designated in the factory records under the name *tesnières,* were in vogue at Sèvres in the years 1758–63, and continued in use thereafter until 1778.[9] Often, as here, they are not signed, but occasionally the marks of Dodin, Morin, or Vielliard turn up. The style of the painter who executed the scenes on the Frick pots-pourris seems closer to those of Vielliard and Morin than to that of their colleague. In any event, the lively tones and the high coloring of the flesh on the Frick pieces invite comparison with a *tesnière* scene on a *vase hollandais nouveau* in the Forsyth Wickes Collection, Boston Museum of Fine Arts,[10] which presents obvious stylistic affinities quite independent of the similar color and decoration of the ground.

A fairly large number of *pots-pourris myrte* or *à feuillage* have survived. A set of three is in the Huntington Art Gallery, San Marino, California,[11] and pairs are preserved in the former Hodgkins collection[12] now in the Walters Art Gallery, Baltimore, and the Hamilton Rice Collection of the Philadelphia Museum of Art, the latter pair accompanied by an isolated specimen.[13] In England such pieces can be seen at the Wallace Collection, London,[14] and at Waddesdon Manor, Buckinghamshire.[15] The Musée des Arts Décoratifs, Paris, exhibits an undecorated example.[16] Similar pots-pourris appeared at Christie's in 1946[17] and at Sotheby's in 1955.[18]

The mark FR incised on the unglazed bottom ring of the base on No. 18.9.12 recurs on one of the above-mentioned *pots-pourris myrte* at Waddesdon Manor, dated 1761.[19] Eriksen suggests that it may be attributable to the *répareur* Fresne, or Dufresne (active 1756–67).[20] The same letters are engraved in the same location on the isolated *pot-pourri myrte* in the Hamilton Rice Collection,[21] a small, undated version, and have been noted on a small, square tray with pierced border forming part of a one-cup *déjeuner* dated 1764 in the Musée de Sèvres.[22] The mark is again seen on a *pot-pourri myrte* with a turquoise blue ground and a painted cartouche representing *La Bonne Aventure,* a composition after Boucher,[23] sold at Sotheby's in 1955.[24]

The letter *N* in script on the base of No. 18.9.11 is incised under the glaze inside the foot. The same letter, preceded by a sign resembling the number *3,* is found on a small milk jug dated 1756 in the Musée de Sèvres.[25] Given the in-

252

18.9.10 · DETAIL

compatibility of dates, this mark cannot in the present instance relate to the *répareur* Nantier (active 1767–76), who has been cited by Eriksen[26] in connection with pieces that are undated and by all evidence of later manufacture.

Collections: Possibly Thynne sale, Christie's, May 18, 1911, Lot 58.[27] Duveen. Frick, 1918.

NOTES

1 Pink grounds appear on Sèvres porcelains at the earliest in 1757 and are not mentioned in any delivery prior to 1758. The technique of the blue marbling is explained by Eriksen (S. Eriksen, *The James A. de Rothschild Collection at Waddesdon Manor: Sèvres Porcelain,* Fribourg, 1968, No. 54, p. 152) as follows: "First, the pink ground colour was applied, and then fired. Secondly, a blue coating was applied, which completely covered the pink ground. Before this was dry it was partially scraped away, leaving a blue marbled pattern on the original ground, and the jardinière was fired once more." This is the technique called "gratté dans le fond," which demands extreme skill and great sureness of hand. It should be noted, however, that the scraping was done not while the outer coat was fresh, but after it had dried sufficiently to avoid the risk of running. After the blue tracery had been fired, the gold was applied and the piece was fired yet again.

2 The same motifs of lace and marbling in blue and gold on a pink ground are seen not only on the pair of *vases hollandais* studied by Eriksen *(loc. cit.),* but again on an undated *vase hollandais nouveau* in the Forsyth Wickes Collection at the Boston

Museum of Fine Arts (No. 65.1791). The latter vase is unusual in that the reverse is covered entirely with this masterly pattern, producing an extraordinary effect.

3 Archives de la Manufacture Nationale de Sèvres, U. 3, Vases 1740–1780, No. 54.

4 The same Philippe Xhrouuet was the inventor of the first Sèvres pink ground (see p. 192).

5 Archives de Sèvres, F. 6, 1762.

6 The five deliveries of pots-pourris are recorded as follows: in December 1761 "au Roy à Versailles 2 pots-pourris à feuillages verd marines 600/1200," forming a set with a *vase Boileau;* in 1762 "à Madame de Pompadour 2 pots-pourris à feuillages verd Chinois 432/864 livres"; in 1763 "à M. Lemaître [agent for a third party] 2 pots-pourris à feuillages 2ème 360/720 livres"; in 1763 "à Madame 2 pots-pourris à feuillage rozes 192/384 livres"; and in 1764 "à Mgr. Bertin pour la Chine: 2 pots-pourris à feuillage b. c. [*bleu céleste,* or turquoise blue] mignature 600/1200 livres." The other two deliveries are: in 1763 "au comptant 2 vazes à feuillage petit verd 600/1200 livres," forming a set with a *vase à cordons;* and in 1766 "à Mgr. Bertin 2 vazes feuilles de mirtre 300/600 livres." Archives de Sèvres, Vy. 3 and Vy. 4.

254

7 The same couple appear, for example, on a cup and saucer with a pink ground covered in blue, dark red, and gold mosaic, painted by Vielliard and dated 1761, in the Musée des Arts Décoratifs, Paris (No. A. 6284); on a tray dated 1763 at Waddesdon Manor (Eriksen, No. 58, p. 167); and on a *caisse à fleurs* in the Stichting Nederlands Kunstbezit, Amsterdam (see note 9, below).

8 Boucher was fond of the theme of the dovecot or pigeon house—witness the canvas dated 1748 that figured in the Eugène Kraemer sale, Galerie Georges Petit, Paris, April 28–29, 1913, Lot 3, and in the Coty sale, Galerie Charpentier, Paris, November 30—December 1, 1936, Lot 19.

9 H. van der Tuin, in "Reproduction et imitation de vieux tableaux flamands ou hollandais sur porcelaine de Sèvres (1756–1847)," *Oud-Holland,* I/II, 1950, pp. 41–64, cites a number of Sèvres vases and *caisses à fleurs* with *tesnière* decoration made between 1758 and 1778, as well as plaques copied from paintings. One such plaque, signed by Dodin and dated 1776, was in the former Pierpont Morgan collection (Comte X. R. M. de Chavagnac, *Catalogue des porcelaines françaises de M. J. Pierpont Morgan,* Paris, 1910, No. 163).

10 No. 65.1791 (see note 2, above).

11 R. R. Wark, *French Decorative Art in the Huntington Collection,* San Marino, California, 1962, Fig. 100, p. 106.

12 S. de R[icci], *Catalogue d'une importante collection d'ancienne porcelaine de Sèvres, époque Louis XV et Louis XVI, appartenant à E. M. Hodgkins,* Paris [c. 1911], Nos. 2, 3.

13 F. Kimball and J. Prentice, "French Porcelain Collection of Mrs. Hamilton Rice," *Philadelphia Museum Bulletin,* XXXIX, No. 201, March 1944, Nos. 39 A&B, p. 81, Pl. II, and No. 50, p. 99, Pl. VI.

14 No. IV-B, 160–161.

15 Eriksen, No. 52, p. 148, No. 56, p. 156. The latter pair vary in that the forms are devoid of leaves and ribbon in relief and the perforations at the shoulder are conceived as palmettes.

16 No. A. 13034. The museum also exhibits a very tall vase of exactly the same form as the *pots-pourris myrte* but sculpted in stone.

17 June 13, 1946, Lot 30.

18 November 15, 1955, Lot 112.

19 Eriksen, No. 52, p. 148.

20 *Idem,* p. 324.

21 Kimball and Prentice, No. 50, p. 99, Pl. VI.

22 No. 8854. P. Verlet, S. Grandjean, and M. Brunet, *Sèvres,* Paris, 1953, I, Pl. 52 and p. 210.

23 The theme of *La Bonne Aventure* was repeated several times in the decoration of Sèvres porcelains, notably on a pot-pourri at Waddesdon Manor (Eriksen, No. 55, p. 154).

24 See note 18, above.

25 No. 19064.

26 Eriksen, No. 99, p. 274.

27 Wark, *loc. cit.*

Square Tray with Bracket-Shaped Sides and Floral Sprays, Openwork Turquoise Blue Rim, 1764 (34.9.15)

Porcelain, soft paste. H. 1¾ in. (4.4 cm); W. at points of brackets 6⅞ in. (17.5 cm). Incised on the base: an unidentified mark resembling a treble clef. Painted in blue on the base: interlaced L's enclosing the date-letter L and surmounting a Saint Andrew's cross, the mark of Jacques-François Micaud.

Description: The turquoise blue rim of the tray, raised and slightly concave, incorporates a succession of pierced motifs suggesting waves, with their crests forming a series of scallops along the lip. On each side the waves flow in opposing directions toward the central point of the bracket and away from the emphatically rounded corners, into which are worked pierced white palmettes. Rich gold decoration both inside and out accentuates the perforations and the elements in relief and on the exterior forms a frieze filled with checkered geometric motifs. Strewn over the white ground of the flat center section are four small polychrome floral sprays of varying size and composition.

Condition: The piece is in good condition except for some pits in the glaze.

The plaster model for this tray, lacking the perforations, is preserved in the Sèvres archives but bears no inscription that might help determine the specific name of this form, unrecognizable among the various mentions of "platteaux quarés à jour." Several pieces of this description were listed among the items taken from the glazing kiln on February 15, 1759. Neither the deliveries of "platteaux différens" made to *marchands-merciers* in 1764 nor those of "déjeuners quarés" give particulars.

The records of work done "en extraordinaire" during the course of 1764 reveal that Micaud received 30 livres for painting "trois platteaux quarrés à jour, 3ème avec 3 gobelets et 3 soucoupes."[1] It is clear from this reference that "platteaux quarrés à jour" were made in at least three sizes, but the points of comparison are lacking to determine just which size is represented by the tray discussed here.

The association of a tray with various pieces from a tea or coffee service was generally designated a *déjeuner,* qualified according to the form of the tray.[2] The number of pieces, which varied widely, determined the size of the tray but did not affect its form. Very small *déjeuners* consisting only of a diminutive square

tray with cup and saucer constituted a refined gift in harmony with the elegance of the eighteenth century.

Perforations following the same pattern as those on the present piece are seen on a triangular tray and a pair of lozenge-shaped trays in the Musée des Arts Décoratifs, Paris.[3] Other common traits are found in the contours, which on all three forms are not rectilinear but extremely sinuous, and in the height of the openwork sides.

The mark of the flower painter Jacques-François Micaud (active 1757–1811) consists of a Saint Andrew's cross drawn in two bars of unequal width. At times plain, the bars may also widen toward the ends or terminate, as here, in short perpendicular strokes.

In the course of a long and exemplary career Micaud decorated innumerable pieces, of minor, average, and great importance. The Musée de Sèvres exhibits a *vase hollandais* (see p. 209) dated 1760 with a green ground illuminated by a cartouche of flowers and fruit painted in polychrome,[4] as well as some pieces from the so-called Talleyrand service of about 1798.[5] The flowers on the latter are considered more from a botanical than an artistic point of view, probably under the influence of the developing scientific spirit encouraged by Diderot's *Encyclopédie* and perhaps also that of the service being produced at about the same time by the royal factory of Copenhagen on the theme of *Flora Danica*.[6] Micaud also executed several large still lifes of flowers, one of which was given by Louis XVI to Gustavus III of Sweden in 1784.[7] In 1786 he copied on a plaque "Quaré long de 16½ pouces sur 12 pouces 3 lignes, un vase de fleurs d'après Desportes."[8] Weathering the Revolutionary storm, Micaud remained faithful to his post until shortly before his death in 1811.

Collections: Gift of Miss Helen C. Frick, 1934.

NOTES

1 Archives de la Manufacture Nationale de Sèvres, F. 8.
2 The square trays most frequently encountered have straight sides, either solid or pierced. Rectangular trays of the same type also exist, and they too must have been designated by the term *plateaux carrés*, implying "carré long" (as is the case with furniture plaques, for example); a *déjeuner* with such a tray is in the Wallace

258

Collection, London (P. Verlet, S. Grandjean, and M. Brunet, *Sèvres,* Paris, 1953, I, Pl. 35 and p. 205). After the *déjeuner* with a single cup came one composed of an elongated tray with curved sides called *en porte-huilier,* which included a cup and sugar bowl (S. Eriksen, *The James A. de Rothschild Collection at Waddesdon Manor: Sèvres Porcelain,* Fribourg, 1968, No. 25, p. 80). Then there were *déjeuners* with trays in the form of triangles, lozenges (see p. 272), and so on, which could include a cup, a sugar bowl, and a milk jug, the latter sometimes replaced or accompanied by a teapot. Since the nineteenth century the *déjeuner* with only one cup has been termed a "solitaire" and that with two cups a "tête-à-tête." There was no limit to the number of cups included in a *déjeuner;* however, it is curious to note that even when the cups are numerous the compan-ion pieces do not increase in capacity, but remain small in size.

3 Grandjean Collection.

4 No. 17547. Verlet, Grandjean, and Brunet, I, Pl. 42b and p. 207.

5 No. 1890. Verlet, Grandjean, and Brunet, I, Pl. 96 and pp. 221–22.

6 For which see B. Grandjean, *The Flora Danica Service,* Copenhagen, 1950.

7 Illustrated in *Les Porcelainiers du XVIII^e siècle français,* Paris, 1964, p. 236.

8 In 1784 Louis XVI had the atelier of François Desportes acquired as an impetus to the inspiration of the Sèvres painters (see p. 195). Micaud used it on several occasions. The Musée de Sèvres preserves a reduced copy of a large work by Desportes painted on a porcelain plaque by Philippe Castel in 1786 (Verlet, Grandjean, and Brunet, I, Pl. 87 and p. 219).

Tea Service with Birds, Turquoise Blue Ground,
1767 (18.9.21–18.9.31)

Porcelain, soft paste. Painted in blue on the base of each piece except Nos. 18.9.23, 18.9.24, and 18.9.26: interlaced L's, drawn with a small spine rising from either side, enclosing the date-letter O and surmounted by the letters *cp,* the mark of Antoine-Joseph Chappuis. (For dimensions and incised marks, see separate entries below.)

General Description: The eleven-piece service consists of a teapot, a sugar bowl, a milk jug, four cups, and four saucers. All are similarly decorated with a turquoise blue ground spangled throughout with bold, regularly spaced gold disks. A string of rounded gold dentils runs along the lip of each piece, and a broad gold band frames the reserved panels, all of which contain polychrome birds in landscape settings.

Condition: On the whole, the service is in very good condition. A hair crack runs down from the lip of the sugar bowl, and minor chips have been restored on the lips of saucer No. 18.9.27 and cup No. 18.9.28, the latter chip coinciding with the top of a hair crack. The gold is slightly damaged in places on the cups and saucers, and an attempt has apparently been made to rub the gold inscription off cup No. 18.9.28.

Antoine-Joseph Chappuis, painter of birds and flowers (active 1756–87), generally depicted his birds in or below a tree with a gnarled trunk. His rich and delicate palette gave subtle variety to their colorful plumage, and he was fond of illuminating the very dark pupils of their eyes with a single touch of reflected light, a device that imparts special intensity to their penetrating glances.

In 1767 Chappuis received 168 livres for executing "112 cartouches peints en oiseaux sur différentes pièces à 1.10."[1] For these he no doubt borrowed from among the hundred models that he and his colleague Aloncle,[2] also a painter of birds, had drawn the preceding year, at a rate of 1 livre apiece, while copying "oiseaux différens d'après des tableaux pour servir de modèle à la Manufacture."[3] Though this wording leaves the source of the models in doubt, the porcelain paintings based on their drawings exhibit such concern for naturalistic detail that it may be assumed the originals were of real ornithological value.

Birds by Chappuis also appear, for example, on a large punch bowl dated 1779 in the Forsyth Wickes Collection at the Boston Museum of Fine Arts and on a small *gobelet litron*[4] dated 1761 in the Thiers Collection at the Musée du Louvre,

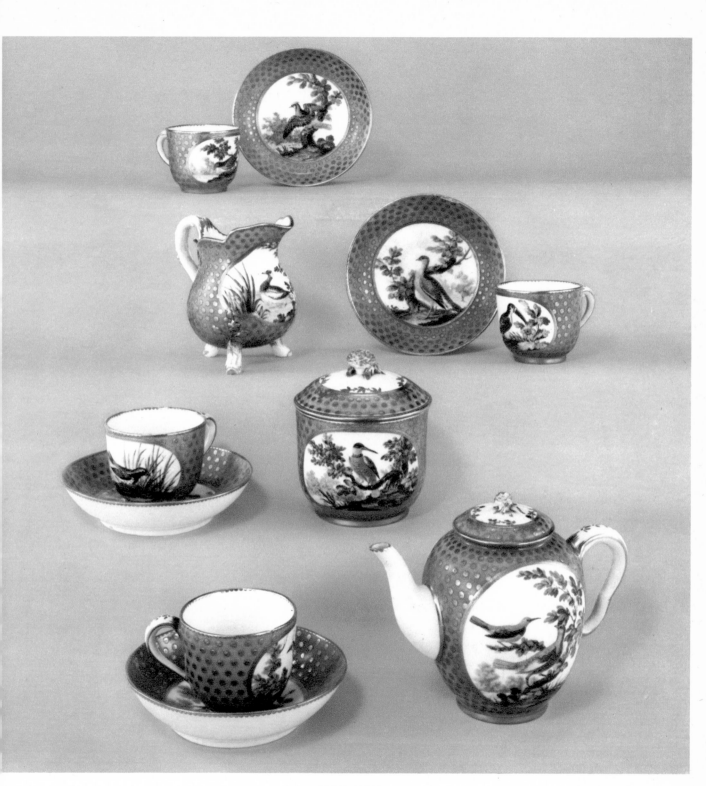

18.9.21—18.9.31

Paris.[5] Except for the date-letter, the painted mark on the Louvre cup is identical to that on the present pieces.

The same system of decoration with gold disks over a colored ground appears on a milk jug and basin in the Wallace Collection, London.[6] These pieces too are dated 1767.

TEAPOT (18.9.21)

H. overall 5½ in. (14 cm); H. of body 4⅝ in. (11.7 cm); D. 4⅛ in. (10.5 cm); W. including handle and spout 7³/₁₆ in. (18.2 cm). Incised on the base: the letter or cipher o, deeply engraved.

Description: On each side of the ovoid body is a broad oval panel containing two birds. In one panel both birds are perched in a small, gnarled tree with a leafy branch shooting out from a bend in the trunk. In the other a bird about to take wing glances up from the ground at a second bird chirping in the branch of a tree. The lid, decorated with a broad blue band encircling a rounded center section reserved in white, terminates above in a flower in full relief intended as a knob. A garland of gold sprigs weaves between the blue and white areas, and the knob is accented in gold.

A working drawing at Sèvres corresponding to the form of this teapot is inscribed in ink: "theÿere Verdun 2ᵉᵐᵉ grandeur Rectifie suivan La comande ordoné du 19 feurÿe 1753 La ditte est adapté aux goblet Calabre insÿ quau goble Verdu."[7] The inscription is accompanied by the notation "fait." The drawing represents the teapot in vertical section and includes the handle and spout.

A second drawing, showing the body alone and in a reduced size, is inscribed: "petitte theÿere bouret[8] 1760." Despite the similarity in outline, it seems advisable, given the difference in size, to retain the name *théière Verdun* for the form presently under discussion.

The *théière Verdun* knew a long and unwavering success. It was included, for example, in a *déjeuner Duvaux*[9] of 1763 at Waddesdon Manor, Buckinghamshire,[10] where it is accompanied by a *gobelet Bouillard,*[11] a *sucrier Hébert,*[12] and a milk jug of a less familiar form. Several specimens of the *théière Verdun* bearing different dates are in the Musée de Sèvres, notably among the pieces of hard paste dated 1772 that make up the *déjeuner* with the arms of Paul Petrovich, the future Czar Paul I. For this service the *théière Verdun* is grouped on the same tray with

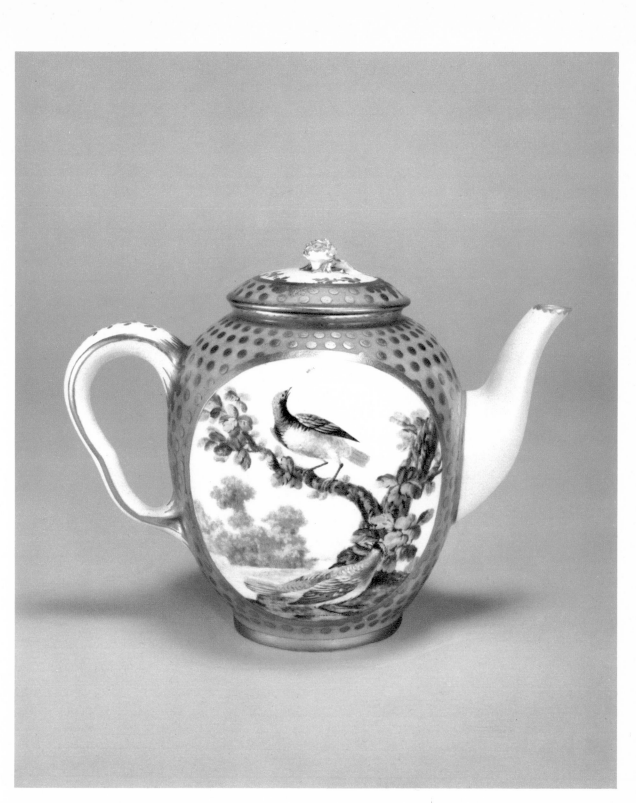

18.9.21

some *gobelets litron,* a *sucrier Hébert,* and a three-legged milk jug like the one in the present set. The association of pieces of unrelated forms was common practice at the Sèvres factory during the eighteenth century and continued into the nineteenth.

The incised o is met with on several *gobelets* and *soucoupes Bouillard,* dated from 1765 to 1768, in the Wrightsman collection, New York.[13]

SUGAR BOWL (18.9.22)

H. overall 4¾ in. (12.1 cm); H. of body 3³/₁₆ in. (8.1 cm); D. 3⅞ in. (9.8 cm). Incised on the base: the number *8.*

Description: Each of the two elliptical panels frames a single bird. On one side, a large bird at the base of a tree strikes an alert stance, turning back its head as if in response to a sudden sound. On the other, a bird with a black crest striped with yellow and plumage painted in vivid colors perches on the low branch of a gnarled tree. The lid is similar in design and decoration to that of the teapot.

The form of this *sucrier Calabre* is the same as that of the somewhat smaller Frick sugar bowl with floral garlands and green ribbons dated 1756 (see p. 214).

The incised number *8* appears on several cubical jardinières, including one at Waddesdon Manor dated 1754,[14] four in the Wrightsman collection dated 1755 and 1756,[15] and an undated pair in the Victoria and Albert Museum, London.[16]

THREE-LEGGED MILK JUG (18.9.23)

H. 4⅝ in. (11.8 cm); D. 3½ in. (8.8 cm); W. including handle 5 in. (12.7 cm).

Description: Set on three short rustic feet, the bulging body of the jug contracts slowly as it rises, then flares out toward the top to end in a notched rim. At the front the rim continues upward and outward to form a spout, while at the rear a handle rises directly from the rim, curves back broadly, then turns downward and inward to rejoin the body just above its fullest bulge. Flowers and foliage in relief issue from the junctures of the body with the feet and the handle, introducing a note of elegant refinement into a somewhat heavy ensemble. Below the spout, a triangular panel with a three-lobed base contains an aquatic scene in which a duck, its plumage tinted in colors ranging from violet-purple to orange-red to white tinged with pink, swims with an arrogant air, darting a black eye circled with red. All the elements in relief are accented with gilding.

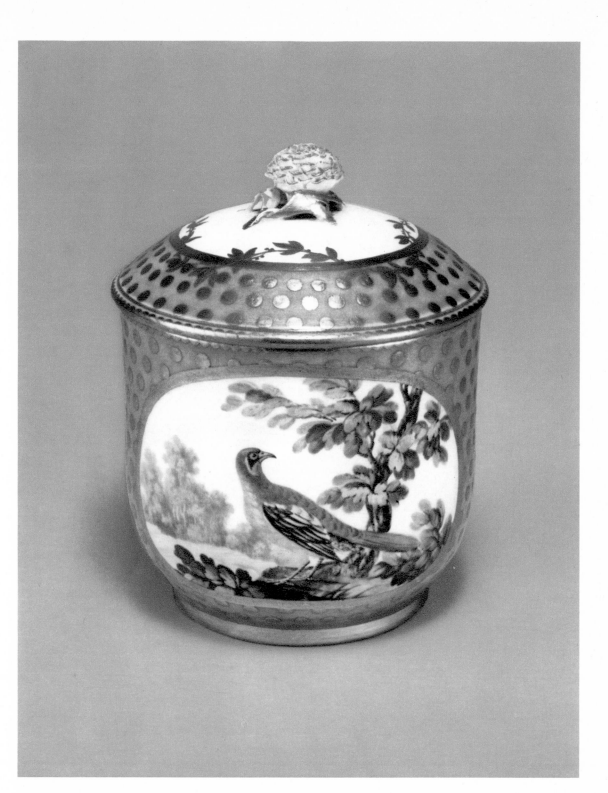

18.9.22

Jugs of this type were intended to serve as milk pitchers or creamers, according to their size. Though no precise drawing for this form has survived, the Sèvres archives do preserve a plaster model, probably cast after the eighteenth century, which was incorrectly included in the early nineteenth-century inventory among models created between 1760 and 1780. In fact, this form had figured in an inventory of 1752,[17] as "un petit pot à lait à trois pieds." In a list of biscuit taken from the kiln on November 15, 1757, there appear "pots à lait à pieds 1ère 2ème 3ème," revealing that the three-legged jug was by then being produced in three sizes simultaneously.

Numerous milk jugs of this type are found in public and private collections of the United States and Europe. The Musée de Sèvres houses several isolated specimens in soft-paste porcelain, as well as the above-mentioned example in hard paste included in the 1772 *déjeuner* with the arms of Paul Petrovich.

FOUR CUPS AND SAUCERS (18.9.24–18.9.31)

Cups: H. 2⅜ in. (6 cm); D. 2⅞ in. (7.2 cm); W. including handle 3¹¹/₁₆ in. (9.3 cm). Saucers: H. 1¼ in. (3.2 cm); D. 5⁷/₁₆ in. (13.8 cm). Incised on the base of all four cups: the letter s; on cup No. 18.9.28: the letters AR; on saucers Nos. 18.9.29 and 18.9.31: the letters *Sp;* and on saucer No. 18.9.25: a monogram open to various interpretations, possibly a combination of the letters *S* and *p*.

Description: At the front of each cup is a broad elliptical panel occupying nearly the entire height and a third of the circumference. Each panel contains a single bird poised on a low knoll and surrounded by varied vegetation. On the saucers, a circular reserve fills the entire center section. Three of these reserves show a gnarled tree with a single bird perched in it or nearby, while on the fourth saucer, No. 18.9.29, the bird stands beside a tall flower, with sketchy trees indicated in the distance. Cup and saucer Nos. 18.9.28 and 18.9.29 differ from the others in that each bears the gold inscription T.[or J.] H.AD.X.[or K.]*a*D. drawn in odd characters across the top of the reserved panel; its significance has yet to be deciphered.

266

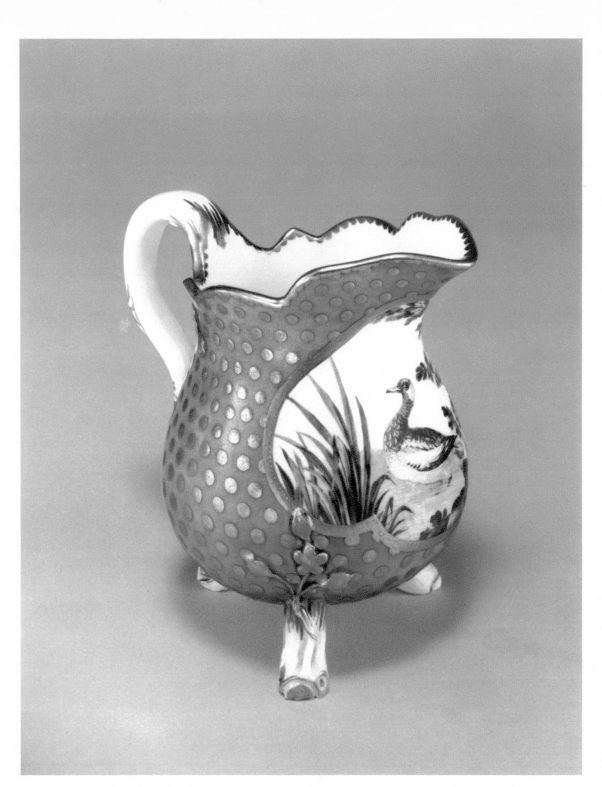

18.9.23

Three drawings of cups in the Sèvres archives relate to the form of the cups in the present service. The closest is a line drawing showing a *gobelet* in vertical section, its rounded handle attached to the body by small elements that can hardly be considered *rocaille* and were in fact abandoned before the cup went into production. The drawing is inscribed in ink "goblet pour Le dejeune boilliard[18] fait suivan La Comande du 19 feurÿe 1753," with the notation "fait" added in pencil at the center.[19]

A line drawing of the saucer, also in vertical section, indicates that it too was designed to hold liquid. This assumption is supported by the breadth of the saucer, the steep slope of its sides, and the secure foundation provided by its wide base.[20]

References to "gobelets Bouillard" appear in a list of biscuit taken from the kiln on November 22, 1753—that is, about nine months after the order referred to on the Sèvres drawing.[21] Mentions of "déjeuners Bouillard" recur frequently in the records. The *gobelet Bouillard,* simple and rational in form yet not without elegance, was much admired and was often selected up until the Revolution for use in other types of *déjeuners*.

Examples of the *gobelet Bouillard* appear in numerous collections, either isolated or included in complete *déjeuners*. Their decoration varies from the simplest to the richest and most artfully elaborated. The Musée de Sèvres and the Musée des Arts Décoratifs, Paris, exhibit several fine specimens.

The incised letter s on all four of the present cups recurs on a saucer, also dated 1767, forming part of a group of *gobelets* and *soucoupes Bouillard* in the Wrightsman collection.[22] It also appears on a *compotier feuilles de choux*[23] dated 1755 in the Musée de Sèvres. The *Sp* incised on two of the Frick saucers is visible on several of the other cups and saucers in the Wrightsman group.

Collections: Duveen. Frick, 1918.

NOTES

1 Archives de la Manufacture Nationale de Sèvres, F. 9, 1767, "État des pièces de porcelaine que différents peintres ont travaillé en frizes colorées et autres genres, hors de la Manufacture, pendant l'année 1767, avec le prix auquel le prix de chaque pièces [sic] leur est payé." Before the decimal system was adopted in France in 1795, the French livre was divided into twenty sols.

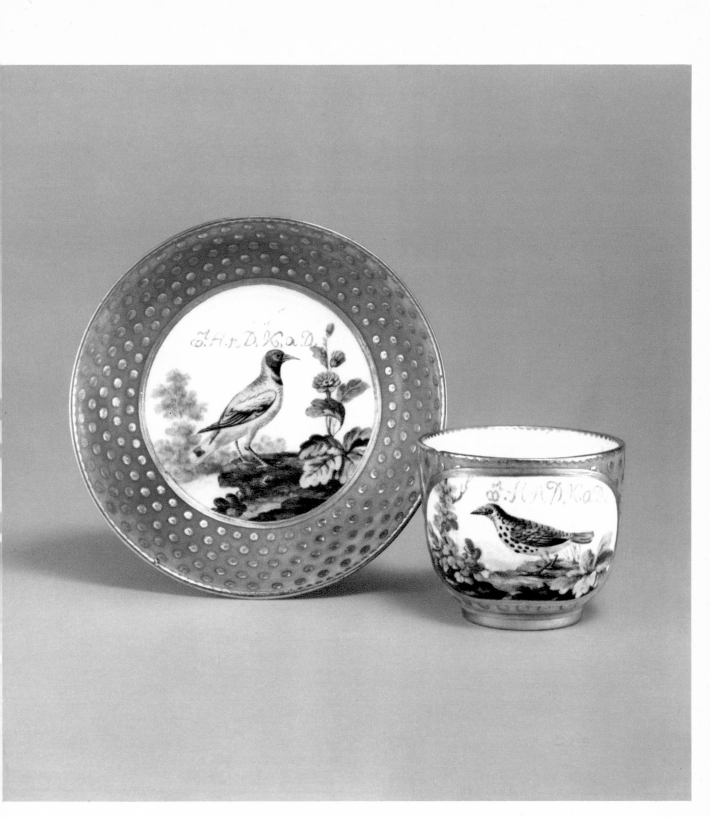

18.9.29 18.9.28

2 François-Joseph Aloncle (active 1758–81). Before entering the factory at the age of twenty-four, Aloncle had worked as an easel painter.

3 Archives de Sèvres, F. 8, 1766, "État des pièces de porcelaine...pendant l'année 1766" (see note 1, above).

4 The form of the *tasse* or *gobelet litron,* in continuous production from the early days of Vincennes until the present, is that of a simple cylinder. It takes its name from an old measure of capacity.

5 No. O.A. Th. 1260. The pink ground of this cup is streaked with blue like that of the three *pots-pourris myrte* in The Frick Collection (see p. 246).

6 P. Verlet, S. Grandjean, and M. Brunet, *Sèvres,* Paris, 1953, I, Pl. 59 and p. 212.

7 For Jean-François Verdun de Monchiroux, see p. 238. For Pierre Calabre, see p. 214.

8 In reference to Bouret d'Érigny, *écuyer, fermier-général,* and partner in the Compagnie Éloi Brichard.

9 Created probably for the *marchand-mercier* Lazare Duvaux, this *déjeuner* includes a tray of complex form rather infrequently encountered. A *déjeuner Duvaux* dated 1768 is in the Wadsworth Atheneum, Hartford (Comte X. R. M. de Chavagnac, *Catalogue des porcelaines françaises de M. J. Pierpont Morgan,* Paris, 1910, No. 132).

10 S. Eriksen, *The James A. de Rothschild Collection at Waddesdon Manor: Sèvres Porcelain,* Fribourg, 1968, No. 58, p. 166.

11 Named after Antoine-Augustin Bouillard, investor in the Fermes du Roy and partner in the Compagnie Éloi Brichard.

12 Named probably after Thomas-Joachim Hébert, *marchand-mercier* of the Rue Saint-Honoré and a regular customer of the factory. The various forms designated *Hébert* are remarkable for their pear-shaped profiles. See Eriksen, No. 2, p. 38.

13 C. C. Dauterman, *The Wrightsman Collection, IV: Porcelain,* New York, 1970, No. 95 A-FF, pp. 229–32.

14 Eriksen, No. 5, p. 44.

15 Dauterman, Nos. 77–79, pp. 194–96.

16 D. M. Currie Bequest, C. 424-425-1921.

17 Bibliothèque de l'Institut de France, Paris, Mss. 5673, "État des porcelaines trouvées en biscuit lors de l'inventaire des effets remis par Charles Adam à Éloi Brichard le 18 8bre 1752."

18 That is, the *déjeuner Bouillard;* see note 11, above.

19 The other two drawings concern *gobelets Calabre* in two different sizes. These cups, slightly taller in relation to their diameter than the *gobelet Bouillard,* are accompanied by suggestions for "anses à Conssolles" drawn at the side.

20 In "À propos de six Sèvres du dix-huitième siècle," *Kunstindustrimuseets Virksomhed,* Copenhagen, IV, 1969, p. 148, S. Eriksen makes the following ingenious observation: "Un trait caractéristique de la plupart des tasses créées à Vincennes et à Sèvres, leurs soucoupes sont notablement grandes et larges. Faut-il en conclure que dans la pratique celles-ci devaient remplacer celles-là? Se servait-on des soucoupes pour refroidir les boissons chaudes avant de les verser dans les tasses? Peut-être. Ce qui est sûr, c'est qu'il existe une estampe en couleurs du Français

Louis-Martin Bonnet, The woman taking coffee, datée 1774, qui représente une dame vidant sa tasse de café dans la soucoupe."

21 *Gobelets Calabre* are mentioned in a list of biscuit removed from the kiln on August 6, 1753 (Mss. 5673 cited in note 17, above).

22 See note 13, above.

23 The term *feuilles de choux* is applied to a service the pieces of which are treated in shallow relief so as to simulate the slightly curled edges of cabbage leaves. Generally the painted decoration heightens the effect with blue and gold ribs, while flowers complete the ornamentation. This type of service was repeated often during the eighteenth century. A service with *feuilles de choux* decoration, this one in kaolinic soft paste, was ordered in 1913 as a gift from the French Government to George V and Queen Mary of Great Britain.

Lozenge-Shaped Tray with Roses, Turquoise Blue Ground, 1769 (18.9.16)

Porcelain, soft paste. H. of rim 1¼ in. (3.2 cm); H. including handles 2⁷/₁₆ in. (6.2 cm); W. including handles 13¾ in. (35 cm); W. without handles 13⅜

in. (34 cm); D. 10¹¹/₁₆ in. (27.2 cm). Incised on the base: the letters *gp* and an unidentified mark. Painted in light blue on the base: interlaced L's, inelegantly drawn, enclosing the date-letter *q*.

Description: The tray is in the form of a lozenge with flowing lines and rounded corners. The rim rises steeply, and on each side its outline describes a shallow bracket. Attached to either end is a raised handle in the form of a double foliated scroll which flares out at the two points where it joins the sides. The even-toned turquoise blue ground is interrupted by thirty-eight small circles reserved in white, each surrounded by a garland of foliage painted in gold and containing either an isolated red rose in full bloom or a sprig of two rosebuds. At the center of the tray a large oval reserve surrounded by a similar gold garland contains a cluster of roses. In each case the roses are set off by green foliage tinged with yellow. The outside of the rim is decorated with foliated garlands in gold.

Condition: The tray has been fractured and repaired down its entire length.

An old plaster model at Sèvres, described as a "plateau de déjeuner losange à reliefs,"[1] has suffered considerable damage over the years. The partial remains of wax reliefs suggest two types of raised decoration. On one side are crossed reeds intended to form the solid elements of an openwork rim. On the other side are the recognizable beginnings of a scrolled handle of the type that appears on the present tray.

The Sèvres manufacturing records include references to "platteaux carrés" (see the Frick example, p. 256), "platteaux triangles," and "platteaux ovales." In a list of pieces taken from the glazing kiln in June of 1756 appear "2 platteaux lauzange,"[2] and similar mentions recur frequently after that date.

During the course of 1769 a number of flower painters were recorded as having decorated various pieces with "rozes détachées," but the painters Pierre *jeune,*[3] Noël,[4] Tandart,[5] and Bertrand[6] are specifically credited with the decoration of

272

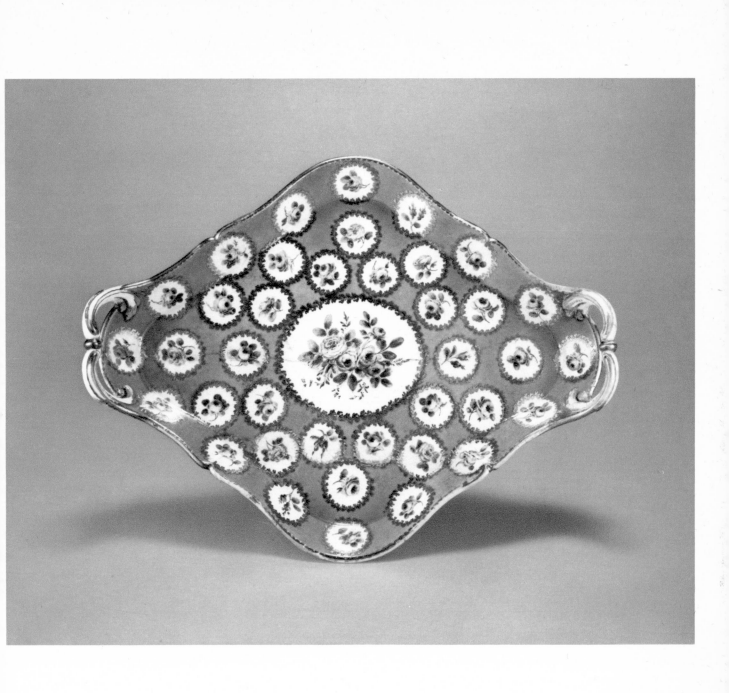

"déjeuners lozange à quatre pièces"—that is, sets made up of a tray, a cup, a sugar bowl, and either a milk jug or, less frequently, a teapot.

Among the deliveries made in 1769 appear several "platteaux lozange" priced at 24 livres. During 1770 and 1771 occasional "déjeuners lozange" are listed, but neither the number nor the nature of the pieces is given. Details are so rare that even color goes unmentioned in the record of two "déjeuners lozange" sold for cash on September 12, 1771, priced at 276 and 360 livres respectively. Included in the gift "fait par le Roy à S. M. suédoise, au Prince Frédéric son frère et à un Seigneur de la suite" were "4 platteaux lozange 48/192 livres." Over a number of years appear mentions of the same type in which trays are delivered either singly or included in *déjeuners*. Seldom are the entries as detailed as one of December 1772 which reads merely "1 déjeuner lozange à jours, bleu enfans colorés, 504 livres"[7]—a description that obviously precludes any association with the present piece.

Lozenge-shaped trays of the same design, with either solid or openwork rims, are in the collections of the Musée des Arts Décoratifs, Paris,[8] and the Wadsworth Atheneum, Hartford.[9] The type of decoration on the present tray, with a colored ground containing circular white reserves surrounded by gold foliage and enclosing a rose, is found frequently on pieces dating from around 1770, particularly on vases mounted in bronze.[10] It was also borrowed for use on *déjeuners,* including a number of sets that have since been dispersed. Examples of the latter are a *gobelet* and *soucoupe litron* dated 1770 and a *sucrier Bouillard,*[11] all with green grounds, in the Musée des Arts Décoratifs.

The incised letters *gp* on the Frick tray also appear on a tray dated 1759 and a pair of fruit dishes dated 1763 in the Wrightsman collection, New York,[12] as well as on a cup dated 1758 and a triangular dish of about 1766–67, part of the so-called Razoumovski service, at Waddesdon Manor, Buckinghamshire.[13] Eriksen[14] suggests that they "could be the signature of Claude-Jean-Baptiste Grémont, known as Grémont *père*... employed between 1746 and 1775." Dauterman,[15] after "a comparison of the handwriting of the marks with that of signatures on Sèvres payroll records," makes a more affirmative attribution of the mark to Grémont *père*.

Collections: Duveen. Frick, 1918.

274

1 Archives de la Manufacture Nationale de Sèvres, U. 3, Pièces diverses, platteaux 1740–1760, No. 1.

2 Bibliothèque de l'Institut de France, Mss. 5674.

3 Jean-Jacques Pierre *jeune,* flower painter from 1763 to 1800.

4 Guillaume Noël, flower painter and gilder from 1755 to 1804.

5 Jean-Baptiste Tandart *l'aîné*, flower painter from 1754 to 1800 (see p. 335).

6 Bertrand, flower painter from 1757 to 1774.

7 Delivered to M. Beaudoin, *maître des requêtes,* at Versailles.

8 Grandjean Collection. These pieces lack handles.

9 Formerly in the Pierpont Morgan collection (Comte X. R. M. de Chavagnac, *Catalogue des porcelaines françaises de M. J. Pierpont Morgan,* Paris, 1910, No. 116 dated 1763, No. 121 dated 1765, No. 149 dated 1773.

10 The Grandjean Collection of the Musée des Arts Décoratifs includes a group of vases decorated in this manner with a green ground, as well as a pair with blue ground. Another pair is in the Musée Île-de-France, Saint-Jean-Cap-Ferrat (Fondation Ephrussi de Rothschild). Sets of five, three, or two vases with turquoise blue grounds are recorded in the former Pierpont Morgan collection (Chavagnac, No. 168, Pl. XLVIII); in the former Hodgkins collection (X. de Chavagnac, "Porcelaines de Sèvres, collection E. M. Hodgkins," *Les Arts,* No. 89, May 1909, repr. p. 7); and in the Huntington Art Gallery, San Marino, California (R. R. Wark, *French Decorative Art in the Huntington Collection,* San Marino, 1962, Fig. 111, p. 113). The mark, when it exists, is nearly always concealed by the mount, though one of the Huntington vases is dated 1775. Particularly fine examples were sold from the Fribourg collection in 1963 (Sotheby's, June 25, Lot 58) and the James de Rothschild collection in 1966 (Palais Galliéra, December 1, Lot 58).

11 For Antoine-Augustin Bouillard, see p. 270, note 11.

12 C. C. Dauterman, *The Wrightsman Collection, IV: Porcelain,* New York, 1970, No. 87, p. 219, No. 102, p. 247.

13 S. Eriksen, *The James A. de Rothschild Collection at Waddesdon Manor: Sèvres Porcelain,* Fribourg, 1968, No. 32, p. 94, No. 75, pp. 207, 214–15.

14 *Idem,* p. 94.

15 Dauterman, p. vi.

Pair of Cubical Jardinières with Cupids and Trophies, Turquoise Blue Ground, 1769 (34.9.32 and 34.9.33)

Porcelain, soft paste. H. overall 5¾ in. (14.6 cm); H. of plaques 4⁵/₁₆ in. (11 cm); W. overall 4⁵/₁₆ in. (11 cm); W. of plaques 3⁹/₁₆ in. (9.1 cm). Painted in blue on the base of each piece: interlaced L's enclosing the date-letter Q and surmounting the letter A, the mark of Charles-Éloi Asselin.

Description: Each piece consists of four rectangular plaques joined to four corner posts, oval in section, which continue below to form the feet. The posts terminate above at the same level as the plaques, and each post is surmounted by a smooth finial in the form of a pine cone. Reserved in the turquoise blue ground at the center of each plaque is a broad oval panel surrounded by a wide gold band chased with imbricated triangles. From the band issue flowering branches of chased and burnished gold which curve outward toward the corners, creating an effect of circular movement. Gold bands outline all four edges of the plaques, the bases of the white corner posts, and the bases and tops of the white finials. On the front of each piece is a Cupid supported by clouds, and on each side is a group of attributes arranged as a trophy and suspended from a ribbon tied in a large bow at the top. The Cupid on No.

34.9.32, his flesh delicately tinted with pink, his brows broadly arched over large blue eyes, leans against a shadowy cloud as he spreads a pair of wings edged in the same blue as the band across his chest. In one hand he holds a wreath of flowers, in the other a rose plucked, it would seem, from the mass of flowers that spills from his swirling, wind-blown drapery. This composition may be intended as an allusion to Spring, in opposition to the panel on the reverse containing a harvest basket suspended from a thyrsus and overflowing with branches laden with grapes. Behind the basket are a tambourine and various implements used in the cultivation of the vine, all suspended by a crimped lavender-pink ribbon. On one of the remaining sides are instruments related to navigation suspended by a blue ribbon, including a chart, a ship's compass, an axe, an anchor, a rudder with tiller, and a rope, all surmounting a bright red hourglass and surrounded by handsome shells, coral, and marine plants. On the last side, a red ribbon sustains a terrestrial globe which partially conceals an open scroll, a gyroscope, and a telescope, all above an artful jumble made up of a thick book, a directional compass, a geometric compass, a protractor, and a square. Suspended in air above fleecy clouds on the front of No. 34.9.33 is a Cupid looking downward, his foreshortened face dominated by crisply drawn eyes above nostrils and lips indicated by touches of red. Only one of his red-and-white wings is visible. With hands nearly

276

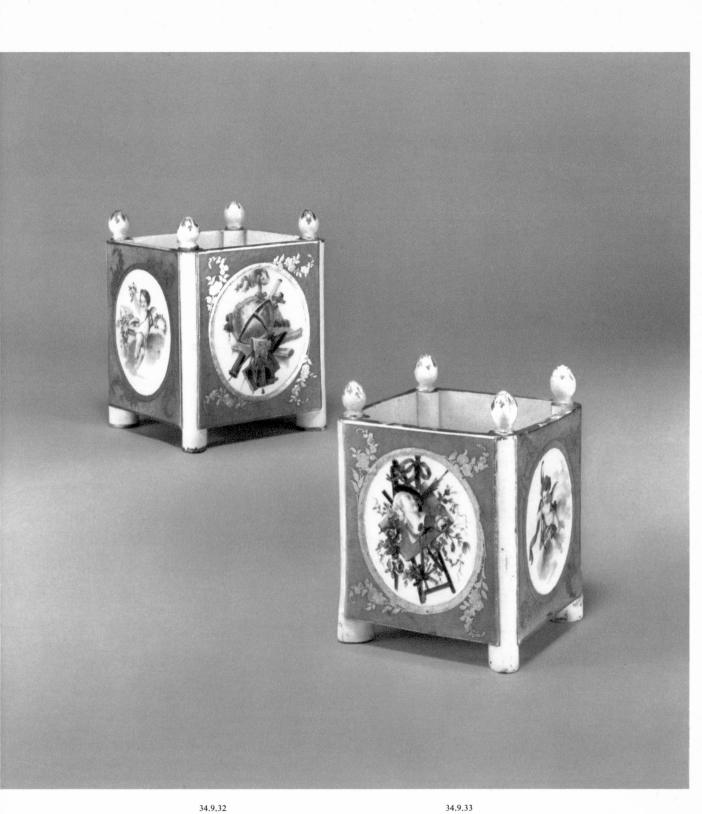

34.9.32 34.9.33

joined he clutches a bow and arrow, while his drapery, colored blue with violet shadows, flutters about him. On the reverse is a trophy of garden tools grouped around a flower-bedecked copper watering can and a basket of vegetables, both surrounded by a curved band marked with signs of the zodiac. Behind them, suspended by a mauve ribbon, are a rake, a hoe, a spade, and a stick around which coils a vine branch with white grapes. Hanging under the basket is a secondary trophy of smaller garden tools. On a third side, before an easel, a blue ribbon sustains a blank canvas, a bust of a young woman painted in tones of gray, a circular palette daubed with colors, several brushes, and a maulstick. Falling at capricious angles around these objects are groups of varicolored flowers, one of which terminates behind a small complementary trophy made up of a gold collar, a portcrayon, and a scraper all joined by the end of the blue ribbon, thus completing the allusions to painting. On the remaining panel is an allegorical group which apparently pertains to lyric poetry. This somewhat confused composition, suspended by a green ribbon, includes a scroll, a book of Homer, two more books, a long trumpet, and various flowers, all in front of a lyre from which hangs a laurel wreath and behind which are a caduceus and a long palm frond; below, a second ribbon sustains a richly bound book, a scroll, a quill, a horn, and a tiny box.

Condition: On No. 34.9.32 one finial and one entire upper corner, including the finial, have been broken off and glued back. The gold on the lip is heavily abraded. Number 34.9.33 is in good condition. Some fire cracks, two of them filled, are visible on the interior of the corner posts. The base of each piece is pierced with four holes forming a square around a fifth hole at the center (see below).

Neither working drawing nor model has survived to help assign to its proper place this type of jardinière, generally referred to simply as a *caisse*. The form recalls the wooden tubs used in the eighteenth century to grow orange trees.

The Sèvres manufacturing records contain numerous references to "caisses carrées." In June of 1753, notably, there appear on a list of pieces taken from the biscuit kiln "1 caisse carrée" and "2 caisses à fleurs carrées." In a list of items taken from the glazing kiln on May 13, 1757, there appears a sequence of *caisses* and trays—"2 caisses 1ère, 1 platteau, 1 caisse 2ème, 1 platteau, 9 caisses 3ème, 3 platteaux"—that may possibly suggest an association between the two. But despite this inconclusive evidence, it does not appear that *caisses* of the present type were delivered accompanied by supporting drip-trays.[1]

The records of work done "en extraordinaire" for the year 1769 show that Asselin received 245 livres in connection with various pieces decorated "d'enfans en camaieu" and "en coloris."

Deliveries of "caisses" and "caisses carrées" are found in especially large

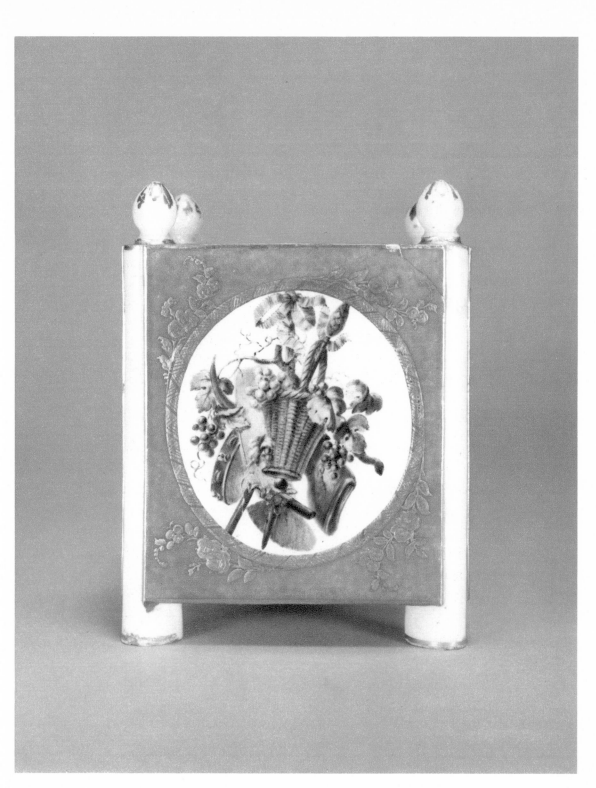

34.9.32

numbers up until 1760. But the vogue persisted, and they still turn up in 1782 in the selection made by Prince Bariatinski for the Comte and Comtesse du Nord:[2] "2 caisses fond verd 120/240 livres."

The form of the cubical *caisses* in The Frick Collection is exceptional in that the corner posts are visible on the exterior. Generally such pieces take on the appearance of perfect cubes, set on four square feet and surmounted, as is the case here, by finials at the corners. All such pieces, including the Frick examples, are pierced with five holes in the base, suggesting that they were intended to contain live plants.[3]

Great care has been taken in the decoration of the present pieces. The delicately shaded figures of the Cupids, the wide variety of attributes, and the finely detailed flowers painted in fluent strokes all reveal great ability and undeniable artistic qualities. The grouping of the trophies, particularly difficult on a small surface only slightly higher than it is wide, shows a true knowledge of composition.

The Sèvres artists often turned to such combinations of objects alluding to a given theme. Allegorical references to Love, Gardening, Hunting, Navigation, the Arts and Sciences, even to War, furnished an inexhaustible repertory from which the porcelain painters drew according to their personal tastes and the prevailing fashion, borrowing freely from the great variety of models engraved by designers of ornament. The creator of the trophies on the present pieces worked directly within the tradition established notably in the different stages of construction and decoration of the Château de Versailles—a tradition that began during the reign of Louis XIV,[4] continued under Louis XV,[5] and would survive until the fall of the monarchy.[6]

The mark of Charles-Éloi Asselin (active 1765–1804) is relatively uncommon despite his nearly forty years of service in the Sèvres studios, indicating no doubt that he often neglected to sign his work. It is known that he decorated numerous pieces with figures of children—for example, a milk jug and bowl dated 1767 in the Wallace Collection, London.[7] The archives show that he also did arabesques and scenes "en mignature," and sometimes filled in the faces on pieces decorated by other artists. His name is attached to some very important works. In 1780 he executed, on his own, two of the nine plaques in the series *Les Chasses du Roi* for the King's dining room at Versailles,[8] employing compositions slightly modified from Oudry's cartoons for a set of tapestries woven at the Gobelins.[9]

280

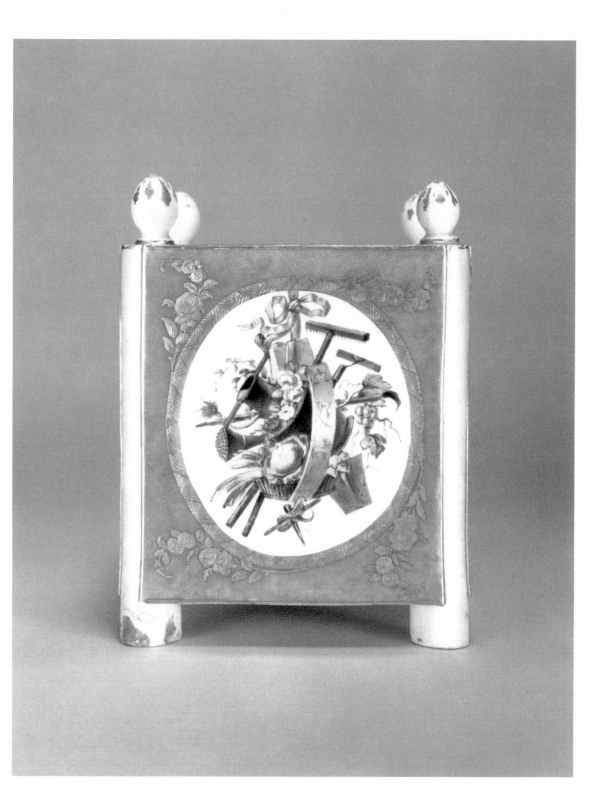

34.9.33

Asselin also collaborated on the famous table service ordered by Louis XVI for Versailles in 1783, a project scheduled to cover twenty years but halted by the Revolution.[10] In 1782 he helped decorate a set of toilet articles for the Comtesse du Nord,[11] and he painted some of the porcelains intended for Marie-Antoinette's *laiterie* at Rambouillet.[12]

Collections:[13] Baron Foley, Ruxley Lodge, Claygate, Surrey. Duveen. Frick, 1918. Gift of Miss Helen C. Frick, 1934.

NOTES

1 The absence of drip-trays is discussed by S. Eriksen in *The James A. de Rothschild Collection at Waddesdon Manor: Sèvres Porcelain,* Fribourg, 1968, No. 4, p. 42.

2 The title Comte du Nord was adopted by the future Czar Paul I, son of Catherine II, while travelling in France with his wife in 1782.

3 Eriksen *(loc. cit.)* notes that "Lazare Duvaux sold numerous *caisses* but on only two occasions does his *Livre-Journal* record them as holding flowers: on 20th July 1757, he sold a pair each planted with heliotrope which does not seem to have been artificial; and on 24th March 1758, he sold a pair with 'les branchages garnis en fleurs de porcelaine.'"

4 The trophies on the façades, the religious trophies on the pillars of the Chapel, and the gilt-bronze trophies of the Galerie des Glaces are among the most perfect examples.

5 Handsome vestiges are preserved in the Council Room and the apartment of Louis XV.

6 One of the last examples, especially exquisite, is the decoration of the dressing room beyond the bedroom of Louis XVI. Work on it was contracted in 1788 and had just been completed at the time of the storming of the Bastille.

7 P. Verlet, S. Grandjean, and M. Brunet, *Sèvres,* Paris, 1953, I, Pl. 59 and p. 212.

8 This set of plaques has been the subject of several studies: G. Lechevallier-Chevignard, "Les Chasses du Roi," *Musées et monuments de France,* No. 9, 1906, pp. 131–34; P. Verlet, "Emplacement à Versailles des Chasses de Louis XVI," *Céramique, verrerie, émaillerie: Bulletin des Amis de Sèvres,* No. 18, June 1937, pp. 235 ff.; M. Brunet, "À propos de la salle à manger de Louis XVI à Versailles," *Revue des Amis suisses de Versailles,* No. 40, 3ᵉ trimestre, 1970, pp. 29–32.

9 The tapestries represent *Les Chasses de Louis XV.* The models for the porcelain plaques were modernized by updating the costumes and changing certain of the faces among the spectators surrounding the huntsmen.

10 Pieces from this service, belonging for the most part to the Collection of Her Majesty the Queen, were included in the exhibition

34.9.32 · DETAIL

34.9.33 · DETAIL

Les Grands Services de Sèvres held at the Musée National de Céramique de Sèvres in 1951 (No. 13). This service has been studied by: G. F. Laking, *Sèvres Porcelain of Buckingham Palace and Windsor Castle,* London, 1907, No. 235, p. 132, Pl. 59; P. Verlet, "Le Grand Service de Sèvres du Roi Louis XVI," *Faenza,* XXXIV, 1948, fasc. IV–VI, pp. 120–21; M. Brunet, "À propos de la salle à manger de Louis XVI à Versailles," *Revue des Amis suisses de Versailles,* No. 41, 4ᵉ trimestre, 1970, pp. 23–27.

11 The toilet set, including a mirror framed in a biscuit composition designed by Louis-Simon Boizot as well as numerous ac-cessories with a *beau bleu* ground enriched with enamel, was presented to the Com-tesse du Nord by Marie-Antoinette. The young woman's surprise is related by É. Bourgeois in *Le Biscuit de Sèvres au XVIIIᵉ siècle,* Paris, 1908, I, p. 182.

12 The designs for the forms and decoration of these pieces, conceived in the Etruscan style, were the work of Jean-Jacques La-grenée *le jeune,* chief artist of the factory from 1785 to 1800.

13 Attached to the bottom of No. 34.9.32 is an old round label with the printed head-ing "Heirloom 1869" followed by an indecipherable inscription.

283

Water Jug and Basin with Flowers and Fruit, Turquoise Blue Ground, 1776 (34.9.42 and 34.9.43)

Porcelain, soft paste. Jug: H. including lid 7⁹/₁₆ in. (19.2 cm); D. 4⁷/₈ in. (12.3 cm); W. including handle 5¼ in. (13.3 cm). Basin: H. 2¹³/₁₆ in. (7.2 cm);

W. 10⅝ in. (27 cm); D. 8⅜ in. (21.2 cm). Incised on the base of the jug: the letter R and the number 4. Painted in purple on the base of each piece: interlaced L's enclosing the date-letter Y and surmounting a heraldic ermine, the mark of Cyprien-Julien Hirel de Choisy.

Description: The pure, simple form of the water jug, perfectly adapted to its use, finds its inspiration among the pewter and silver jugs of preceding centuries. A hinged, gilt-metal mount at the top of the handle links the lid to the pear-shaped body. The oval basin, with its sinuous contours broken at the sides to form a projecting center section, also derives from models in metalwork. The turquoise blue ground is enlivened throughout with rich gold decoration, finely chased and burnished. On both pieces, gilt floral garlands fall in festoons from gold bosses immediately below the rim, broad bands of chased gold surround the white reserves, and long sheaves of gold reeds and myrtle sprigs, joined at the bottom by floating ribbons tied in loose bows, follow the lower outlines of the reserves. The center of the basin is decorated with a wreath of flowers and foliage surrounding a small circular bouquet, all in gold, and the lip is outlined with gold fillets which on the outside terminate in pointed dentils. The white handle of the jug is embellished with gold fillets, occasional accents, and a garland of leaves. Within an elaborate gilt border on the lid of the jug, a heart-shaped reserve contains a polychrome bouquet centering on a large pink rose with brilliant white highlights surrounded by mauve convolvulus, blue ranunculus, and yellow anemones with red edges and dark centers in which the stamens are indicated by tiny lines slightly broadened at the tips with touches of bister. On each side of the jug is a pear-shaped reserve enclosing a pyramidal composition of flowers and fruit built up around a large pink peach delicately shaded with mauve and yellow, a large, half-open pink rose, and some purple plums. On one side the surrounding flowers are white haw-thorn, small pink roses, and striated pink anemones, above which rise miniature pale blue flowers, bright blue delphiniums, and a superb tulip in yellow and red-brown with white highlights at the top. On the other side, bright blue convolvulus minor, yellow umbels, and anemones are the secondary blooms, and the composition is crowned by two pale pink flowers with vertical red striations.

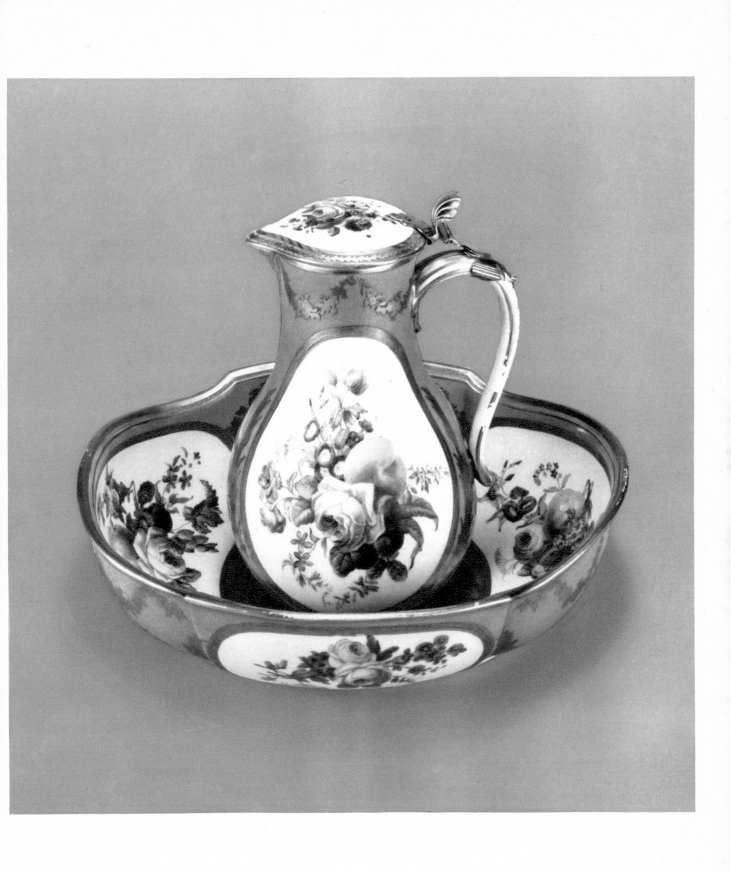

The two kidney-shaped reserves inside the basin are decorated with floral arrangements based on the same principle but developing horizontally, again around similar centers of peaches, large roses, and purple plums. On one side are gooseberries streaked with white and violet, small red flowers, a large leaf, a flowering branch bent to follow the upper edge of the reserve, and a series of small blue flowers rising from above green plums and pink roses. On the other side, on stems turned downward to echo the contours of the panel, are small pale roses, bright blue convolvulus minor, and yellow anemones bordered in red, with a yellow umbel at the bottom. The reserves on the outside of the basin contain clusters of branches filled with the same sorts of flowers in the same colors.

Condition: Both jug and basin are in good condition except for local abrasion of the gold.

A drawing in the Sèvres archives, inscribed "pot à l'eau lizone n° 1 rectifié suivan l'ordre de la comande du 19 fevrÿe 1753," shows a jug similar in outline to the two examples in The Frick Collection (see also next entry), but it differs in that the surface of the jug is ribbed instead of smooth.

A very large plaster model survives in the Sèvres factory reserves,[1] where it is designated in terms of its capacity: "pot à l'eau de deux pintes."[2] Evidently this type of jug was produced in several sizes, the smallest of which was suitable for use as a milk jug.[3]

It is known that Lazare Duvaux was frequently commissioned by his customers to mount pitchers and water jugs in gold or gilt metal and that he also stocked porcelains with mounts already on them.[4] But references to mounts do not appear in the Sèvres archives, which record frequent deliveries of a "pot à l'eau et jatte," either together or separately, to dealers and private customers during 1776, 1777, and 1778, with no indication of size or decoration. Prices for such sets vary widely, ranging from 132 to 168 and 192 livres. In 1776, for example, Louis XVI acquired "1 boc [sic] et jatte 168 livres."

The basin associated with the covered water jug was not always of the same form. A similar covered jug of 1757 in the Wallace Collection, London,[5] for instance, is paired with a somewhat narrower and lower basin, its lip describing a series of shallow brackets. On the other hand, a basin of 1763 in the Victoria and Albert Museum, London,[6] identical in form and size to that in The Frick Collection, is accompanied by a pitcher of a different type, with a twisted handle and no lid. A pitcher and basin of the same forms as the Victoria and Albert examples, dated 1757, are in the Musée Condé, Chantilly,[7] along with a water jug and basin

286

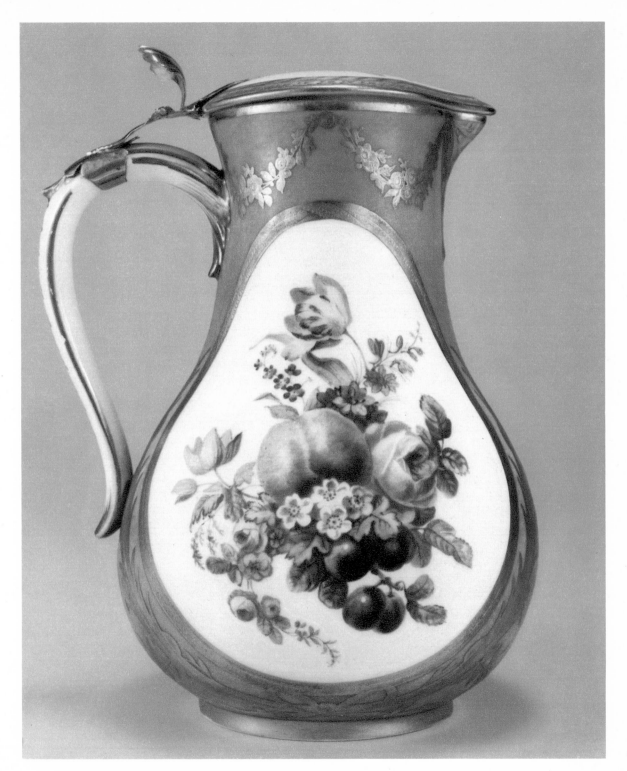

34.9.42

dated 1767 which, except for their cloudy blue ground color, might have served as models for the present pieces.[8]

The incised number *4,* accompanied by the letters *Bo* instead of an R, is found on a jug of 1756 at Waddesdon Manor, Buckinghamshire, and also appears alone on two cylindrical pots of 1757 in the same collection.[9]

The heraldic ermine used as a mark by Cyprien-Julien Hirel de Choisy (active 1770–1812) is reproduced with exaggerated detail in the tables drawn up by Riocreux.[10] On porcelain it is generally simplified to the degree of the marks on the present pieces.[11] It is found on a cup dated 1785 in the Thiers Collection at the Musée du Louvre, Paris;[12] on a cup of 1789 in the Musée de Sèvres;[13] and again on a coffee service of 1805 delivered to Prince Borghese on August 26, 1809.[14]

Compositions combining flowers and fruit, long popular in Flemish still-life painting, gained favor among the Sèvres decorators from the factory's earliest years, providing an alternative to the more delicate bouquets and strewn blossoms preferred by the artists still working in the miniaturist tradition established by the pioneers at Vincennes. The earlier tradition is represented in The Frick Collection by the delicate garlands of Denis Levé (see p. 206), while the floral clusters of Jacques Micaud (p. 256) indicate an effort to break away from it.[15] By comparison, Choisy seems to have been closer in temperament to a painter in oils than a decorator of porcelain. The glittering white highlights reflected off many of the flowers on the present pieces, the pink roses with dark centers where newborn petals press almost tangibly against one another, the intense blue delphiniums, the vivid blue convolvulus with green shadows on their white centers, the peaches shaded in indefinable gradations of color, the purple plums trailing off toward pink, all these have the flavor of Impressionism. This is the charm of Choisy's talent, and what distinguishes him from his emulators.

Collections:[16] Baron Foley, Ruxley Lodge, Claygate, Surrey. Gift of Miss Helen C. Frick, 1934.

NOTES

1 Archives de la Manufacture Nationale de Sèvres, U. 3, Pièces de service, 1740–1760, No. 3.

2 The old French pint *(pinte),* a measure of capacity used before the adoption of the metric system in 1795, varied from prov-

ince to province. In Paris it was the equivalent of 93 centiliters, or just under one U.S. quart.

3 P. Verlet, S. Grandjean, and M. Brunet, *Sèvres,* Paris, 1953, I, Pl. 59 and p. 212.

4 For example, Duvaux delivered in December of 1753: "1641.—S. M. le Roy... Un pot à l'eau & jatte de Vincennes bleu-céleste, sujets d'enfans, 600 l.—La garniture en or" *(Livre-Journal de Lazare Duvaux,* ed. L. Courajod, Paris, 1873, II, p. 185). This must have been an unusually sumptuous ensemble.

5 Verlet, Grandjean, and Brunet, I, Pl. 24 and p. 202.

6 *Idem,* Pl. 48 and p. 209. *Catalogue of the Jones Collection, II: Ceramics, Ormolu, Goldsmiths' Work... and Prints,* London, 1924, Pl. 10, No. 123, p. 10.

7 Château de Chantilly, Porcelaines, No. 43.

8 *Idem,* No. 147 a–b.

9 S. Eriksen, *The James A. de Rothschild Collection at Waddesdon Manor: Sèvres Porcelain,* Fribourg, 1968, No. 20, p. 68, No. 26, p. 82. Additional examples are listed on p. 68.

10 Published in A. Jacquemart and E. Le Blant, *Histoire artistique, industrielle et commerciale de la porcelaine,* Paris, 1862, p. 541.

11 Choisy's mark has been reproduced in incomplete form in several publications, including G. Lechevallier-Chevignard, *La Manufacture de porcelaine de Sèvres,* Paris, 1908, II, p. 129, and Verlet, Grandjean, and Brunet, II, p. 36, where the proper mark is reproduced on p. 40 with the notation: "Marque parfois attribuée à Choisy."

12 No. O.A. Th. 1305.

13 No. 6032.

14 Private collection, Paris.

15 As early as 1760 Micaud had used compositions combining flowers and fruit to decorate a *vase hollandais* with green ground, now in the Musée de Sèvres (Verlet, Grandjean, and Brunet, I, Pl. 42b and p. 207).

16 Attached to the bottom of the basin is an old round label with the printed heading "Heirloom 1869" followed by the inked inscription "1736."

Water Jug and Basin with Marine Scenes, Turquoise Blue Ground, 1781 (34.9.44 and 34.9.45)

Porcelain, soft paste. Jug: H. including lid 8¼ in. (21 cm); D. 5⅛ in. (13 cm); W. including handle 5⅝ in. (14.2 cm). Basin: H. 3⅛ in. (8 cm); W. 11⁷/₁₆ in. (29 cm); D. 9⅞ in. (25 cm). Incised on the base of the jug: the number *3* followed by an illegible symbol and the letter *d;* and on the basin: the number *22.* Painted in blue on the base of each piece: interlaced L's flanked by the date-letters *dd,* weakly drawn and almost nonexistent under the jug, and the letter *M* in script, the mark of the painter Jean-Louis Morin, with below the cipher the letters HP, the mark of the gilder Henry-Marin Prévost.

Description: Apart from decoration, the present water jug and basin differ from those discussed in the preceding entry only in their somewhat larger dimensions, the darker tonality of their turquoise blue ground, and minor variations in overall form, in the shapes of the reserves, and in the embellishment of the metal mount joining the lid of the jug to the handle. The reserved panels are again framed by broad bands of gold, but here the chasing is lighter. On the sides of the jug and inside the basin the reserves are outlined below by gold palm fronds issuing from broad gold shells at the bottom, with gilt floral garlands above. The garlands inside the basin continue in uninterrupted curves to meet just below the lip at center, where they are fastened with gold bows of ribbon, while

those on the jug are linked by similar bows to swags of gold leaves falling from the lip. Gold oak leaves mixed with acorns form wreaths in the center and on the outer ends of the basin and fall in festoons from the basin's outer lip. Independent gold garlands decorate the spout and lid of the jug. Within the reserves are scenes of men unloading goods from moored ships or relaxing near the shore. In the circular panel on the lid of the jug, a small figure near a tall tree scans a shoreline dominated by ships' masts and a lighthouse. On one side of the jug, on a quay before a calm sea, a man in striped red trousers and a blue cap stands near some barrels chatting with a man in blue vest and trousers and a yellow turban. The latter puffs at a pipe as he sits on a crate marked with the number *40.* Partly hidden beyond the edge of the quay, a man with a hat gives orders to two seamen. Ships' masts are profiled against a sky dotted with fleecy clouds. On the other side of the jug, a man in striped red trousers and a blue vest pushes a heavy barrel marked with the numbers *7* and *4* toward a blue-striped tent which partially conceals a moored boat. Beyond him a man in striped violet pants and a red vest addresses a third figure, seen from the waist up, as he points toward a distant cliff. A strong

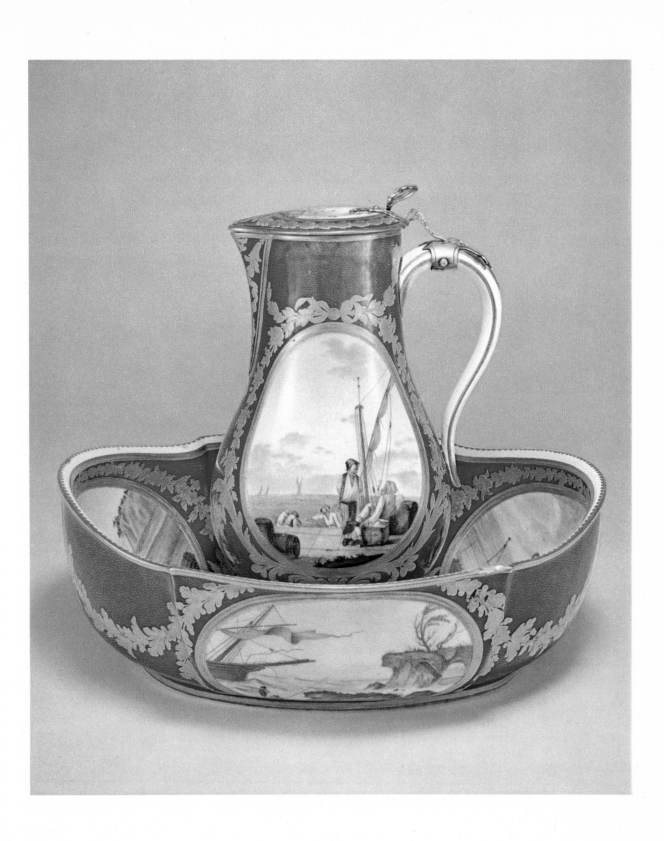

wind flattens the vegetation atop the cliff, whips at the shaggy hair of the foreground figures, and sustains birds hovering in the sky. One of the scenes inside the basin evidently shows the return of a fishing expedition, as indicated by the splendid skate spread out on the sand. Three seamen haul in ropes attached to some object out of view to the left as a heavy wind ruffles their hair, inflates their varicolored garments, and batters a ship tossing in the waves beyond them. The opposite scene depicts a paved quay on which a man in striped red pants and contrasting blue vest directs two seamen struggling with a heavy bale, one dressed in striped purple pants and red vest and the other in orange pants. Beyond the edge of the quay are two more men by a moored boat. In the distance rise a tower and silhouetted masts. The greenish sea is partly shadowed by storm clouds. Both scenes on the outside of the basin show shorelines with pierced cliffs. On one side is a lighthouse in calm weather, on the other a choppy sea. Figures dressed again in contrasting striped and solid fabrics form bright accents against the expanse of water.

Condition: The jug has a hair crack running from the lip through the panel with two men chatting. The basin is in good condition except for a chip on the lip.

The forms and early history of water jugs and basins of the present type are discussed in the preceding entry.

The sources of the painted and engraved models that inspired the maritime scenes in fashion on Sèvres porcelain during the second half of the eighteenth century remain obscure. Only one such model survives in the Sèvres archives, a gouache showing two marine views attributed to Jean-Baptiste-Étienne Genest, who was named head of the painting studio in 1753. Among his other functions, Genest was responsible for executing paintings "pour servir de modèles au peintres."[1] However, it seems improbable that he invented the models entirely on his own and more likely that he adapted ideas supplied by others. One of the seascapes in the gouache is recognizable on a cup in the Musée de Sèvres.[2]

The records of work done by the Sèvres painters reveal that on November 9, 1780, "1 pot à l'eau et jatte 1ère gr. bleu céleste idem [marine]" were delivered to Morin to be decorated. This information is followed by the notation "120 Livres —vu le 24 Avril 1781," indicating that the painter's work had been completed by the latter date, but not that of the gilder.

The collaboration of Morin and the gilder Henry-Marin Prévost is attested to in the lists of firings, where objects are summarily described followed by the names of painters and gilders: "Enfournement de peinture du 3 septembre 1781...1 pot à l'eau 1ère gr. fond bleu céleste, marine.—Morin—Prévost."

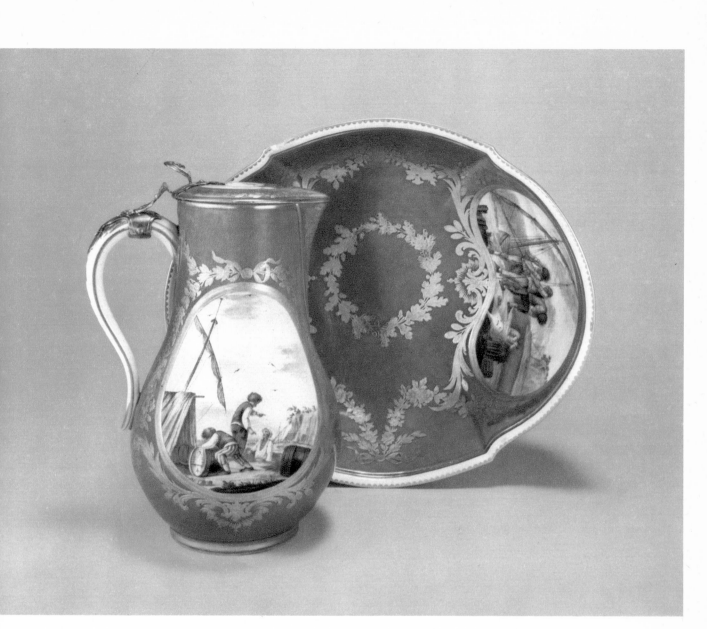

34.9.44 34.9.45

Delivery records for 1781 and subsequent years supply little information on sets of the present type. Usually the water jugs alone are mentioned, followed by prices staggered at 60, 120, 144, 288, 456, 960, and 1,080 livres. It would seem that during this period the presence of an accompanying basin was taken for granted, since specific references to basins do appear in connection with jugs when for various reasons returns were made to the factory.[3]

The letter *M* in script used as a mark by Jean-Louis Morin (active 1754–87) seems to have varied little during the course of his career at the Manufacture Royale. It appears often on important decorative pieces. Thanks to their dating it is possible to trace the evolution of the artist's talent, beginning at Vincennes, where he painted Cupids and infants after Boucher in both monochrome and mixed colors;[4] proceeding to a military period, during which he depicted camp life and battle scenes;[5] and culminating in a large number of coastal views similar to those on the present pieces.[6]

The initials HP, generally attributed in tables of marks to the flower painter Prévost *l'aîné* (active 1754–58), must henceforth be recognized as the mark also used by the gilder Henry-Marin Prévost (active 1757–97). These initials are found rather frequently in gold—for example, on various pieces of the table service ordered by Louis XVI for Versailles[7] dating from 1783 onward, and on a *gobelet litron* in *beau bleu* dating from the Revolutionary years, with an allegorical subject and rich gilding, now in the Musée Condé, Chantilly.[8] The Sèvres archives also specify that in 1784 Prévost gilded "1 gobelet litron 2ème gr. fond rouge, Wagnenton [i.e., Washington]" painted by Caton.[9]

Collections: Gift of Miss Helen C. Frick, 1934.

NOTES

1 S. Eriksen, *The James A. de Rothschild Collection at Waddesdon Manor: Sèvres Porcelain,* Fribourg, 1968, p. 326.

2 No. 22958. The cup is neither signed nor dated.

3 For example, an entry of December 2, 1783, records the delivery to "M. M. Bruneau et Malibran, 1 pot à l'eau, barbeaux, 60 Livres. Rendu la jatte du pot à l'eau, remise faite, 27 Livres 6 sols."

4 Eriksen, No. 12, p. 56, No. 33, p. 96.

5 P. Verlet, S. Grandjean, and M. Brunet, *Sèvres,* Paris, 1953, I, Pl. 60 and pp. 212–13.

6 Eriksen, No. 54, p. 152.

7 See p. 282 and accompanying note 10.

8 Château de Chantilly, Porcelaines, No. 55.

9 Archives de la Manufacture Nationale de Sèvres, VI'2, fol. 120 vo.

Part of a Dessert Service with Flowers and Turquoise Blue Ribbons, 1782 (18.9.34–18.9.41)

Porcelain, soft paste. Four plates: H. 1 in. (2.6 cm); D. 9⅜ in. (24 cm). Two round fruit dishes: H. 1⁹/₁₆ in. (4 cm); D. 8¼ in. (21 cm). Two square fruit dishes: H. 1⁹/₁₆ in. (4 cm); W. 8¼ in. (21 cm). (For incised and painted marks, see separate entries below.)

General Description: Despite the differences in their forms, all eight pieces are similarly decorated. In the center of each is a large polychrome bouquet, and around it rotate small, curved floral sprays set between the loops of a broad turquoise blue ribbon that surrounds the reserved white ground. The ribbon is divided by the loops into a series of long scallops, and its edges, bordered with fillets and dots of gold, undulate slightly to suggest crimping. Between the ribbon and the lip, and following the movement of the ribbon, is a slightly narrower band reserved in white and strewn with gold dots to form a network of small circles with bold centers. The scalloped effect of the ribbon and band is accentuated by a series of turquoise blue triangles introduced at the lip, each framed by rich gold motifs and set with its apex pointed toward one of the loops of the ribbon.

The slightly upturned rims of the four plates terminate at the lip in six large lobes alternating with six small ones, the former corresponding to the scalloped segments of the ribbon and the latter aligned directly with the ribbon's loops. The decoration totally ignores the curve separating the raised rim of the plate from its flat center. The two round fruit dishes differ from the plates only in their somewhat smaller diameter and greater depth, in the uninterrupted curve of the concave rim from the center of the dish to the lip, and in the highly irregular alignment of the notches on the lip with the scallops and loops of the ribbon. The two square fruit dishes resemble the round ones in that their concave rims rise uninterrupted from the flat center to the raised lip. Their rounded corners echo the smaller lobes on the four plates, but their sides depart from the lobed motif in favor of long, shallow curves. From the lip at each corner emanate two ribs which gradually diminish until they disappear into the center section.

Condition: All eight pieces are in good condition.

PLATE (18.9.34)

Incised on the base: the number *33*. Painted in blue on the base: interlaced L's flanked at left by the date-letters *ee* and at right by the letter *y,* the mark of Edme-François Bouilliat, with two dots below the cipher and an isolated third dot inside the foot rim painted in the same turquoise blue as the ribbon.

Description: The variety of flowers and colors employed by the artist is considerable. He gives a slightly hazy effect to the pink and yellow roses, anemones, poppies, ranunculus, blue bellflowers, indeterminate red flowers, yellow-green leaves, and tiny seeds all gracefully interspersed along the small sprays issuing from the tips of the ribbon's loops. The principal group is arranged around a large, dark-centered pink rose with its petals softly illuminated by reserved whites and their edges painted in graduated tones of luminous pigment to give an impression of transparence. Around the rose, the same species as in the sprays join China asters, delphiniums, and delicate, supple flowering shoots in an airy ensemble executed in deft strokes.

PLATE (18.9.36)

Incised on the base: the number *33*. Painted on the base: interlaced L's in blue enclosing the number *3* followed by two dots resembling a colon, all in black, over a row of three dots in blue, the mark of Jean-Baptiste Tandart, with below the cipher the unexplained letters *v* and *b* over an I, all in blue, and inside the foot rim a blue dot like that on the preceding plate.

Description: The artist uses the same types of flowers as on the preceding plate, but here they are a bit larger, with some convolvulus seen in perspective introducing an original note. The three large central flowers of the principal group effectively suggest a three-dimensional quality. Poppies seen from behind and some lighter flowering stems break away from the main cluster to give the composition a circular movement.

PLATE (18.9.38)

Incised on the base: the number *33*. Painted in blue on the base: interlaced L's surmounting the letters *cm*, the mark of Michel-Gabriel Commelin, followed immediately by the date-letters *ee*, with two dots below.

Description: The flowers in the peripheral sprays are rather dense at the start and become sparse toward the curled tips. Among them are yellow tulips streaked with red and some convolvulus minor. Arranged somewhat stiffly around the compact center of the principal group are various small flowers interrupted at one side by a very large, jagged poppy seen in profile and at the other by a large red rose with highlights reserved in white. This group does not reveal a brush as subtle as those that decorated the preceding pieces.

296

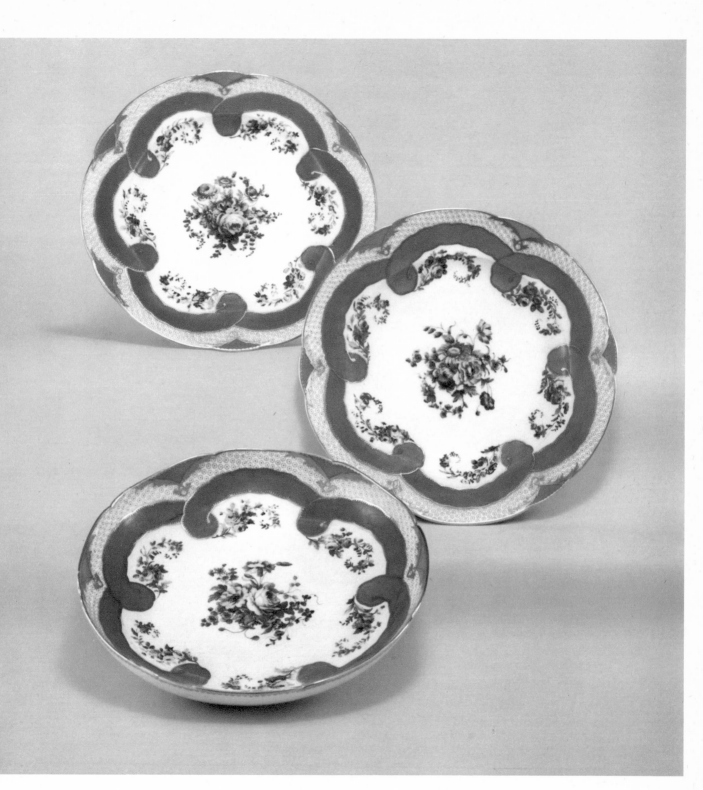

18.9.34, 18.9.36, 18.9.41

PLATE (18.9.40)

Incised on the base: the number *33*. Painted in blue on the base: interlaced L's enclosing the date-letters EE and surmounting a single dot above the letters *Bo*, with below them the three dots of Tandart.

Description: The curved sprays, all rather similar in composition, are heavier in appearance than those on the preceding plate. They include wildflowers and convolvulus seen frontally and in profile. The central bouquet is lithely grouped around three large flowers, including the customary pink rose with red shading. Springing out in turn are some stock, a large red-and-yellow double poppy and bud seen from behind, a few airy cornflowers, a hardy purple carnation flanked by a long leaf and bud, small blue flowers, ornamental grasses, and a delicate inflorescence of honeysuckle. The light, spirited composition of this well-balanced group seems to overflow with vitality.

TWO ROUND FRUIT DISHES (18.9.35 and 18.9.41)

Incised on the base of No. 18.9.35: the letters *rB;* and on No. 18.9.41: the letter *a* and the number *30*. Painted in blue on the base of each piece: interlaced L's, very broadly drawn, enclosing the date-letters *EE* in script and surmounting the letters *m* and *x* joined by a colon, possibly the mark of Marie-Claude-Sophie Xhrouuet (see below).

Description: Despite an attempt at variety, the supple stems filling the spaces between the loops of ribbon bear essentially the same types of flowers as those on the preceding pieces and end in similar curled tips. At the center of No. 18.9.35 two large violet-pink roses, weighing heavily over a violet China aster with a yellow disk, vibrate under sharp contrasts of light. The small interior petals of the roses are accented by curled edges. Around these three flowers radiate a large red-and-yellow double poppy, blue convolvulus with long, pointed green leaves, small brick-red flowers with yellow centers dotted with black, and several cornflowers, all mixed with slender grasses, yellow umbels, and broad rose leaves. The central bouquet on No. 18.9.41 is less symmetrically grouped around a very large pink rose and a yellow flower in full bloom which nearly overshadow a large blue-and-violet double poppy. The poppy's buds project toward some stock on one side and mauve convolvulus and delphiniums on the other. Above are a pink carnation with buds and a sprig of small blue flowers. The painting on these dishes is fresh, crisp, and spontaneous yet still exhibits a scrupulous respect for detail.

298

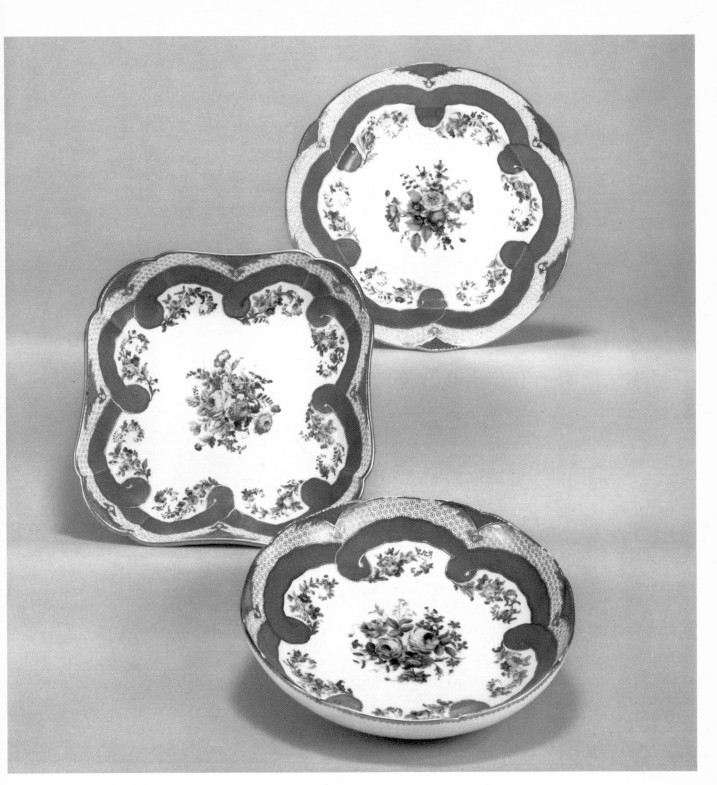

18.9.38, 18.9.37, 18.9.35

TWO SQUARE FRUIT DISHES (18.9.37 and 18.9.39)

Incised on the base of No. 18.9.37: the number *6* or *9;* and on No. 18.9.39: the number *25* followed by the letter *a.* Painted in blue on the base of No. 18.9.37: interlaced L's without date-letter surmounting an unidentified mark made up of four short vertical strokes descending from a single horizontal line, with three dots inside the foot rim; and on No. 18.9.39: interlaced L's, very broadly drawn, enclosing the date-letters *ee* and surmounting the unidentified mark *am,* with again three dots inside the foot rim.

Description: The painted decoration, of essentially the same design as that on the round pieces but adapted to the dictates of a quadrilateral form, abandons the rhythm based on multiples of three in favor of one built upon multiples of four. Thus there are four scalloped corners and eight loops to the ribbon, with the eight floral sprays drawn slightly closer together. The flowers on No. 18.9.37 reveal a predilection for the color yellow and for soft shades. The floral sprays on their supple stems are necessarily rather compact. In the central group a fresh-tinted pink rose with luminous highlights presses against a large white-and-violet ranunculus and a yellow anemone fringed with red. Around them spring a yellow-and-pink flower with a greenish center seen frontally and small blue flowers, poppy buds, and other blossoms seen in perspective, all balanced by blue convolvulus and bellflowers. The small sprays on No. 18.9.39 include pansies and striped tulips mixed with the usual varieties. In the central group, two violet-pink roses with petals that turn red toward the interior and curl over at the edges are enlivened by contrasts of reserved white highlights and applied shadows. A third flower, with yellow petals edged in mauve and a mauve center bristling with forked stamens, nestles against the two roses. From this compact center escape three double poppies which run counter to the resolutely triangular composition by inscribing themselves within a quadrilateral. Some lighter flowers in yellow, blue-mauve, and dark red, interspersed with green leaves tinged with blue or yellow, create a somewhat sharp harmony.

The eight pieces grouped here—four plates, two round fruit dishes, and two square fruit dishes—were by all evidence once part of a larger service that has since been dispersed. At least two pieces with matching decoration are known, a plate and an ice pail both in private Paris collections.

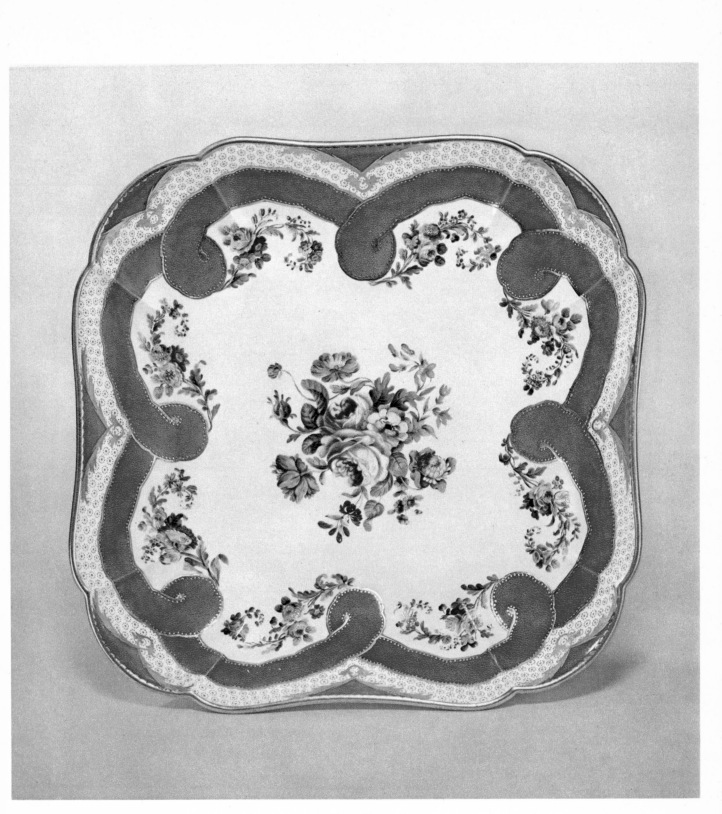

18.9.39

There are no working drawings for these forms in the Sèvres archives. The form of the plates derives from a model designed probably by Jean-Claude Duplessis, simplified here and lacking the ribs which on the earlier version descend from the flat rim onto the cavetto to disappear into the center. The number of scallops at the lip is reduced to six large lobes alternating with six small ones, as opposed to the eight large and eight small lobes on the original model. The resulting rhythm, based on multiples of three, is broader and freer. This noble yet simple form, perfected before 1782, was also chosen for the plates of the sumptuous dinner service ordered by Louis XVI in 1783 for Versailles.[1]

The forms of the round and square fruit dishes survive among the old models of the Sèvres factory, and are unusual in that they are not in plaster but in soft-paste biscuit of an extraordinary translucence. Dishes of this type are known through examples dating back to the Vincennes period, some specimens of which are preserved in the Musée de Sèvres.[2] Square fruit dishes are mentioned in connection with a glaze firing in October of 1754.[3]

Decoration consisting of gold dots on a white or colored ground appeared early—for example, on a *déjeuner* dated 1758 in the Wallace Collection, London.[4] Ribbons enjoyed a continuing vogue from the earliest days at Sèvres and are found in green (see the Frick sugar bowl, p. 214), in pink,[5] in turquoise blue,[6] and even reserved in white within a colored ground.[7]

The idea of decorating plates with crimped ribbon arranged in scallops can be traced back at least to an example of 1778 in the Musée des Arts Décoratifs, Paris.[8] Though the ribbon on this piece is green and the plate lacks an outer band punctuated with gold, the disposition of the scallops and the placement of the polychrome flowers are the same as on the Frick plates. On closer examination, however, it becomes evident that the decoration on the 1778 plate has been adapted to conform to the requirements of the earlier model, with its eight large and eight small lobes. The increased number of elements, necessarily drawn closer together to cover a roughly equivalent surface, gives an appearance at the same time more crowded and a bit affected, failing to attain as perfect an equilibrium.

A *gobelet* and *soucoupe Hébert*[9] dated 1757 in the Musée des Arts Décoratifs[10] are also decorated with turquoise blue crimped ribbon arranged in scallops and accompanied by small flowers, all closely comparable to the decoration on the pieces discussed here. But again the zones of gold dots are lacking.

During the nineteenth century, when old Sèvres was frequently imitated by Paris porcelain factories, the decoration on the Frick pieces was copied closely by the firm of Feuillet.[11]

Neither the lists of work done by the Sèvres painters in 1782 nor the records of deliveries made from that date until the end of the century contain descriptions close enough to the present pieces to warrant positive identification. However, by comparison with a schedule[12] in the Sèvres archives[13] listing the charges made for different types of decoration on plates, it is possible to estimate the price of the Frick plates at about 36 to 42 livres each. It would be tempting to associate the present pieces with a delivery made on March 4, 1790, "à M. Rittener négociant à Londre/Service feston bleu céleste etc./36 assiettes unies 42 1512 L./4 compotiers ronds 48 192/4 id. carrés 48 192." However, the reference to "assiettes unies" makes this hypothesis difficult to sustain, as the term "unies" was generally reserved for plates with plain circular edges.

The number *33* incised on all four of the Frick plates is found on several plates in the Wrightsman collection, New York.[14] The number *6* or *9* incised on one of the square fruit dishes has already been discussed in connection with the Frick *vase hollandais* with scenes of children (p. 209).

The painted letter *y,* the mark of Edme- (or Étienne-) François Bouilliat, called Bouilliat *père* (active 1758–1810), appears on a plaque mounted into a *secrétaire* in the Metropolitan Museum of Art, New York.[15] The *cm* of Michel-Gabriel Commelin (active 1768–1802) is found on two dishes of 1773 at Waddesdon Manor, Buckinghamshire,[16] and again on a cup and saucer from the Revolutionary years now in the Musée de Sèvres.[17] The three dots in a row used as a signature by the flower painter Jean-Baptiste Tandart, called Tandart *l'aîné* (active 1754–1800), occur, for example, on a furniture plaque decorated with an elegant bouquet in the Metropolitan Museum,[18] as well as various pieces from table services including a wine cooler from the service presented by Louis XV to the Queen of Naples in 1773.[19]

The initials *m:x* on the two round fruit dishes are here tentatively attributed to the flower painter Mademoiselle Marie-Claude-Sophie Xhrouuet (active 1772–88). The manner in which the *x* is drawn resembles the first letter of the artist's name as she signed it in the margins of the factory payroll sheets. The register of work done by painters from 1781 to 1783 indicates, without elaboration, that this

artist painted isolated bouquets on numerous plates and service pieces. However, it must be admitted that a direct attribution of the mark to her lacks documentary confirmation. The initials *m:x* also appear on a small *gobelet litron* dated 1783, decorated with strewn blue and carmine buds, in the C. Le Tallec collection, Paris.

The unidentified mark *am* on one of the square fruit dishes recurs under the saucer that accompanies the 1783 *gobelet litron* in the Le Tallec collection.

Exhibited: Nottingham, Museum and Art Gallery, 1908–10, lent by Mrs. Algernon Elwes.[20]

Collections: Mrs. Algernon Elwes, Staple Grove, Beckenham, Kent, and Oxton Hall, Nottinghamshire. Duveen. Frick, 1918.

NOTES

1 See p. 282 and accompanying note 10.
2 For example, a turquoise blue fruit dish with flowers dated 1756, No. 4387.
3 Bibliothèque de l'Institut de France, Paris, Mss. 5674.
4 P. Verlet, S. Grandjean, and M. Brunet, *Sèvres,* Paris, 1953, I, Pls. 34–35 and p. 205.
5 For example, a basin dated 1757 in the Musée de Sèvres, No. 19377.
6 For example, a plate dated 1770 in the Musée des Arts Décoratifs, Paris. Verlet, Grandjean, and Brunet, I, Pl. 98b and p. 223.
7 For example, a *vase hollandais* dated 1759 in the Wallace Collection. Verlet, Grandjean, and Brunet, I, Pl. 29 and p. 204.
8 No. 2261. See M. Brunet, "La Manufacture Royale de Sèvres," *L'Oeil,* No. 63, March 1960, p. 65.
9 For forms designated *Hébert,* see p. 270, note 12.
10 No. G. 233.

11 A plate signed by Feuillet, similarly decorated but differing slightly in the disposition of the ribbon's loops and scallops as related to the rim, was exhibited at the Musée National de Céramique de Sèvres in 1970 *(Porcelaines de Paris de 1800 à 1850,* No. 267). See R. de Plinval de Guillebon, *Porcelaine de Paris 1770–1850,* Fribourg, 1972, Pl. 119, p. 209.
12 See M. Brunet, "Les Grands Acheteurs choisissaient dans cet album," *Connaissance des Arts,* No. 170, 1966, pp. 102–09. See also T. Préaud, "L'Assiette de Sèvres de Saint-Aubin à Hajdu," *L'Oeil,* No. 188/189, August/September 1970, pp. 40–47.
13 Bibliothèque de la Manufacture Nationale de Sèvres, R.182 gr. in-f°.
14 C. C. Dauterman, *The Wrightsman Collection, IV: Porcelain,* New York, 1970, No. 97, pp. 237, 238, 240.
15 C. C. Dauterman, in *Decorative Art from the Samuel H. Kress Collection,* London, 1964, No. 28, pp. 158–59, 180.

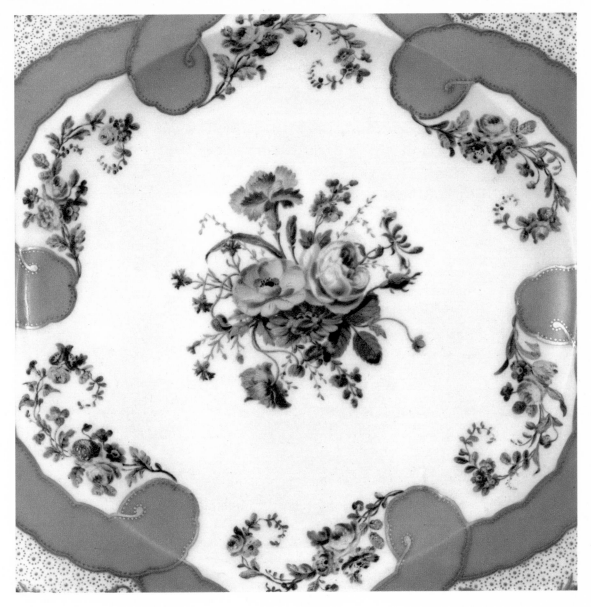

18.9.40 · DETAIL

16 S. Eriksen, *The James A. de Rothschild Collection at Waddesdon Manor: Sèvres Porcelain,* Fribourg, 1968, No. 94, p. 264.

17 Verlet, Grandjean, and Brunet, I, Pl. 100b and p. 224.

18 Dauterman, *Kress Collection,* No. 18, pp. 122–23, 190–91.

19 In the collection of the author.

20 Information from David Phillips, Keeper of Art, letter of February 27, 1973.

Fan-Shaped Jardinière and Stand with Shepherd Scene, Turquoise Blue Ground, n.d. (34.9.50)

Porcelain, soft paste. H. overall 6⅞ in. (17.4 cm); H. of upper section 5⅛ in. (13 cm); W. of upper section at top 6⅞ in. (17.4 cm); D. of upper section at top 4⅞ in. (12.4 cm); W. of stand 6¹¹/₁₆ in. (16.9 cm); D. of stand 4¹³/₁₆ in. (12.2 cm). Incised on the base of the upper section: the letters *cn;* and on the stand: the letter *c.*

Description: The form of this *vase hollandais* is similar to that of the Frick jardinière with scenes of children (see p. 209). Its turquoise blue ground is very pale, recalling a shade used on Sèvres pieces dated 1761.[1] The ground is interrupted at the front by an ovoid reserve containing a polychrome scene of a shepherd and shepherdess, at the sides by ovoid panels containing flowers and fruit, and on the stand by four horizontal panels with flowers. The rather simple gold decoration consists of trelliswork above and below the central reserve, intertwined floral garlands running down the vertical projections at either side of the central panel, and floral garlands, clusters, and single blossoms around the panels on the sides and on the stand.

Condition: The jardinière is in good condition.

The panel on the front of the vase depicts a scene from *La Vallée de Montmorency,* a theater piece by Favart popular at the middle of the eighteenth century.[2] The episode represented, known as *La Leçon de Flageolet,* was used by François Boucher as the basis of various compositions, and the Manufacture de Vincennes reproduced it in sculpture beginning in 1752.[3] A pretext for depicting graceful gestures, the lighthearted subject—a young shepherd come to the aid of a shepherdess unable to play the flute alone and content to blow into it as he lightly fingers the stops—appealed equally to the painters at Sèvres.

For the Frick jardinière, as also for a vase with twisted handles dated 1768 in the Collection of Her Majesty the Queen,[4] the artists were directly inspired by an engraving of René Gaillard after Boucher entitled *L'Agréable Leçon.*[5] On the Frick vase the painter has eliminated the sheep and the heavy stone fountain that figure in the engraving, but he has kept the same disposition of the figures and accessories. A similar treatment is seen on a *gobelet litron* in the Victoria and Albert Museum, London.[6]

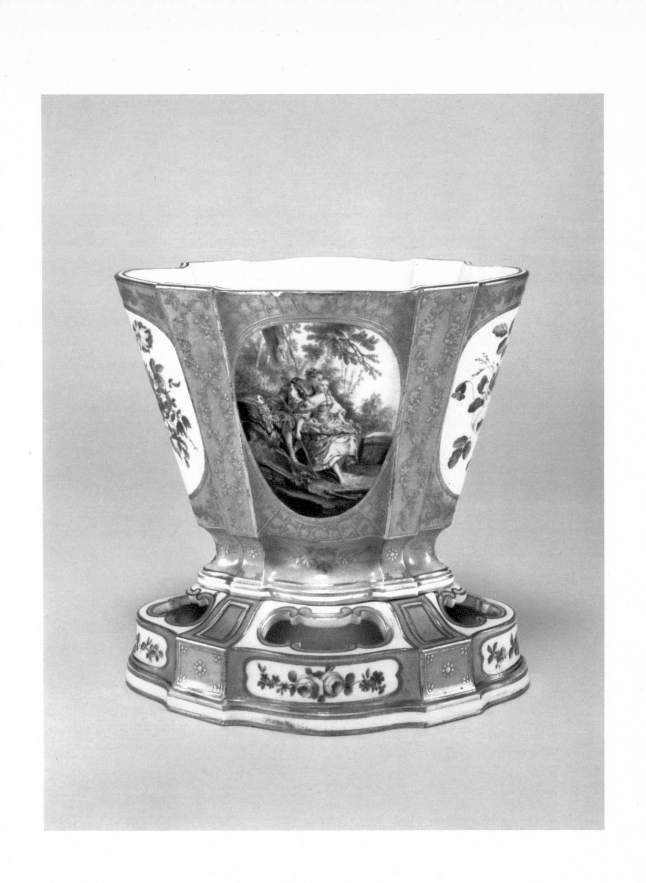

The incised mark *cn,* which occurs in capital as well as small letters, may be attributable to the *répareur* Cejourné (active 1754–67).[7] It appears frequently on *vases hollandais,* including five at Waddesdon Manor, Buckinghamshire—one dated 1758, one dated 1762, and a set of three dated 1764;[8] one in the former Pierpont Morgan collection dated 1758;[9] and one in the Musée de Sèvres dated 1760.[10] The mark is found again on a *verrière* of 1763/64 in the Wrightsman collection, New York.[11] The letter *c* alone is recorded on a *vase hollandais* dated 1757 in the Wrightsman collection;[12] on another dated 1760 in the Metropolitan Museum of Art, New York;[13] and on a third dated 1762 at Waddesdon Manor.[14] It also occurs on a water jug dated 1757 in the Musée Condé, Chantilly.[15]

In the case of the present vase, the absence of a painted mark, the color of the gold, and the handling of the paint all contribute to the supposition that the piece may have left the Manufacture Royale at some undetermined date with its decoration incomplete and that it was subsequently painted and gilded outside the factory.

Collections: Gift of Miss Helen C. Frick, 1934.

NOTES

1 See, for example, S. Eriksen, *The James A. de Rothschild Collection at Waddesdon Manor: Sèvres Porcelain,* Fribourg, 1968, No. 49, p. 140.

2 Charles-Simon Favart (1710–92), director of the Opéra-Comique, was a dramatic poet, the author of light comedies and comic operas, and a protégé of Madame de Pompadour. In 1752 he revived the pantomime *Les Vendanges de Tempé,* which had enjoyed great success since 1745, and made it into a ballet pantomime under the title *La Vallée de Montmorency.* This piece inspired several sculpted figures and groups in biscuit, through the intermediaries of painting and engraving; for this see G. Zick, "'D'après Boucher' die 'Vallée de Montmorency' und die europäische Porzellanplastik," *Keramos,* No. 29, 1965, pp. 3–47.

3 One such group in enamelled porcelain was in the former Pierpont Morgan collection (Comte X. R. M. de Chavagnac, *Catalogue des porcelaines françaises de M. J. Pierpont Morgan,* Paris, 1910, No. 50, p. 43, Pl. X) and is presently in the Wadsworth Atheneum, Hartford.

4 G. F. Laking, *Sèvres Porcelain of Buckingham Palace and Windsor Castle,* London, 1907, No. 79, p. 60, Pl. 26.

5 The engraving is inscribed: "Dédié à Monsieur le Comte de Coigny, d'après le ta-

bleau de Monsieur Périnet, par son très humble et très obéissant serviteur GAILLARD. A Paris, rue Saint-Jacques au-dessus des Jacobins entre un perruquier et une lingère."

6 Currie Bequest, No. C. 457–1921.
7 Eriksen, p. 320.
8 *Idem,* No. 34, p. 98, No. 54, p. 152, No. 61, p. 174.
9 Chavagnac, No. 99, p. 82.
10 No. 17547.
11 C. C. Dauterman, *The Wrightsman Collection, IV: Porcelain,* New York, 1970, No. 102, p. 246.
12 *Idem,* No. 84 B, p. 208.
13 C. C. Dauterman, in *Decorative Art from the Samuel H. Kress Collection,* London, 1964, No. 40, p. 208, Fig. 154.
14 Eriksen, No. 54, p. 152. This vase forms a pair with one of the Waddesdon pieces incised *cn.*
15 Château de Chantilly, Porcelaines, No. 43.

Inkstand with Turquoise Blue Ground and Gilt-Bronze Mounts, n.d. (34.9.46)

Porcelain, soft paste. H. of base 3⅜ in. (8.5 cm); W. of base 11⅞ in. (30 cm); D. of base 7⅞ in. (20 cm); H. of center vase excluding finial mount 3¹⁵/₁₆ in. (10 cm); D. of center vase 2¾ in. (7.1 cm); H. of lateral vases excluding finial mounts 3½ in. (9 cm); D. of lateral vases 2⅝ in. (6.6 cm). Painted in gold on the base: interlaced L's without date-letter, weakly drawn and partially obscured by a nut securing one of the vases, surmounting an unidentified mark.

Description: The ground color is turquoise blue, with all the elements in relief reserved in white and further accented by gold highlights. The base, on an oval plan with undulating edges, drops toward the rear to form an elongated receptacle, also reserved in white, intended for writing implements. The front of the base is molded with rich foliated scrolls framing a central bearded mask. Intricately worked into the lower contour of the base is a gilt-bronze support made up of similar rich scrolls and inset with turquoise blue cabochons. The three small vases, nearly ovoid in form, rest within shallow depressions in the upper surface of the base. A string of small white pearls surrounds the top of the foot of each vase, and a heavy band of large white pearls encircles the center vase, which is mounted as an inkwell. When the inkwell is in use, its lid fits over a deep metal cup set into an opening at the front of the base. Fitted within the lower section of the inkwell is a porcelain ring consisting of a central cup, open at the bottom, surrounded by a flat band pierced with three holes intended to receive goose quills. All three vases are mounted with gilt-bronze bands between the upper and lower sections and with gilt-bronze finials in the form of pine cones.

Condition: As presently constituted, the inkstand is in good condition.

Given the difference in style between the distinctly *rocaille* base and the neo-classical character of the vases, it may be assumed that the inkstand in its present form is made up of dissociated elements dating from different periods. Such later groupings are not uncommon.

Collections: Duveen. Frick, 1918. Gift of Miss Helen C. Frick, 1934.

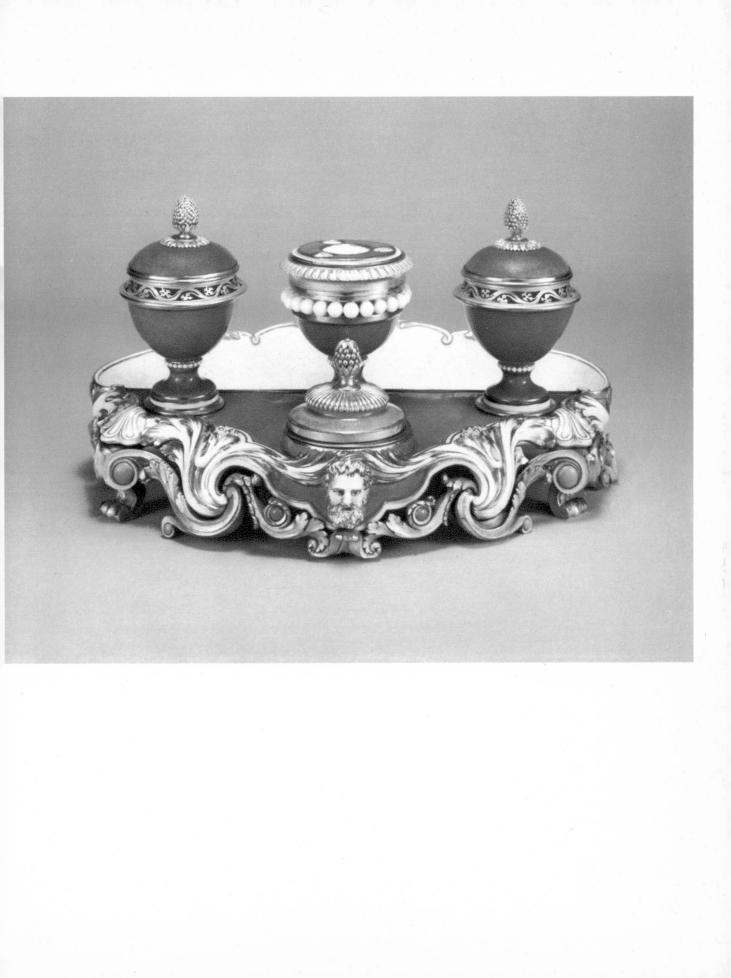

SAMSON PORCELAIN

Once the discovery of kaolin deposits near Limoges in 1768 made it possible to produce natural porcelain like that imported from China and Germany, numerous hard-paste factories began to spring up in France. At Paris such enterprises, organized along the lines of artisans' collectives, multiplied during the late eighteenth and early nineteenth centuries. The best of them, hard pressed by competition from both home and abroad, closed their doors before the middle of the nineteenth century, though a number of studios devoted solely to the decoration of plain white porcelain managed to survive, obtaining undecorated pieces from the provinces or from Paris itself.

The firm of Samson was founded in 1845 during the reign of Louis-Philippe, at a time when industrialization was transforming artistic production throughout the world. It took as its special vocation the reproduction of faïence and porcelain objects from previous centuries. These imitations were often quite successful, and have all the more readily led to confusion in that the various marks they bear are designed in the spirit of those used on the pieces copied—witness the intersecting bars recalling the crossed swords of Meissen and the four interlaced s's evoking the opposed L's of the Sèvres royal cipher. In principle, the letter s always appears in association with the mark.

The firm of Samson has from its inception produced natural hard-paste porcelain, and it is in this material that the original Vincennes and early Sèvres models are reproduced. However careful the workmanship, this fundamental distinction is always apparent to the practiced eye.

The taste of a public eager to surround itself with furnishings in the style of earlier times has favored the development of the firm, and Samson still continues to offer copies of eighteenth-century pieces.

315

Square Tray with Polychrome Decoration and Openwork Rim, n.d. (34.9.47)

Hard-paste porcelain. H. 1¼ in. (3.2 cm); W. 6 in. (15.3 cm). Painted in blue on the base: four interlaced s's, arranged in a pattern resembling the Sèvres royal cipher, enclosing the letter M, possibly a decorator's initial, and surmounted by the letter S, for Samson.

Description: The raised and pierced rim of the tray is treated as an undulating dark blue ribbon from which spring tulip-like flowers painted a dull red. Garlands of small gold leaves decorate the ribbon, and the notched lip of the rim is covered entirely with gold. The white ground of the flat center section is divided by a garland of green leaves suspended from the loops of a mauve ribbon running along the outer edge. The ribbon and garland frame eight panels, those at the corners decorated with a mosaic of intersecting red lines punctuated with blue and gold. The four intervening panels are enlivened with circles made up of tiny blue dots surrounding a single oval patera in plum red overlaid with fine gold lines suggesting petals.

Condition: The piece is in good condition.

The form of the tray and the design of the pierced motifs that constitute its rim are faithfully copied from a model produced at Sèvres in several sizes, either square or oblong in plan.[1] The square trays of this type were intended for use in *déjeuners* with only a single cup.[2] All the painted elements on the present tray are also borrowed from decorative motifs used on Sèvres porcelains, notably from pieces in the Louis XVI style.

Collections: Duveen. Frick, 1918. Gift of Miss Helen C. Frick, 1934.

NOTES

1 For examples of these square and oblong trays, see S. Eriksen, *The James A. de Rothschild Collection at Waddesdon Manor: Sèvres Porcelain,* Fribourg, 1968, No. 35, p. 102, No. 68, p. 188, No. 74, p. 204.

2 See p. 258, note 2.

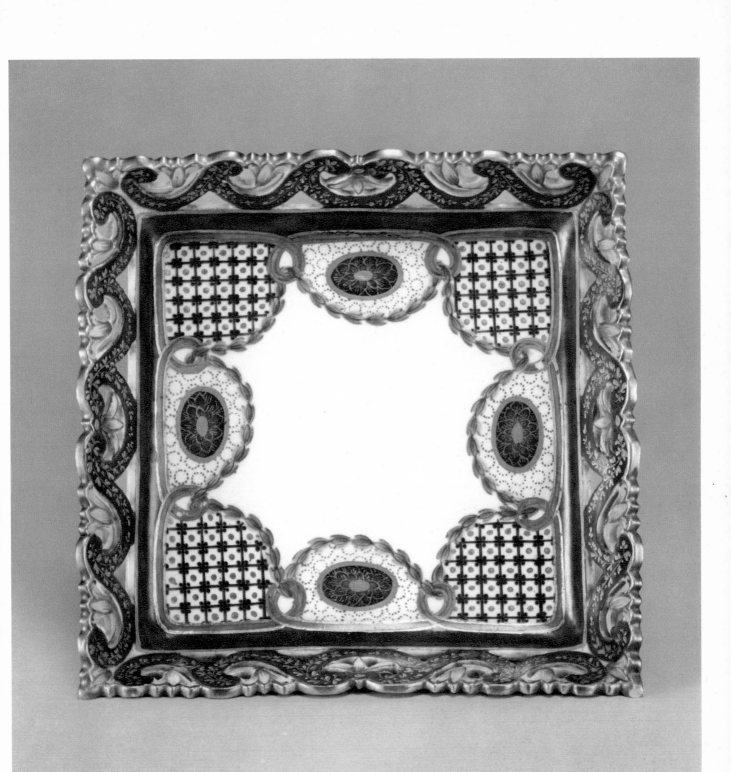

BIOGRAPHIES

These notes concerning the artists who collaborated on the Vincennes and Sèvres porcelains in The Frick Collection are based principally on a systematic study of the factory payrolls of the eighteenth and early nineteenth centuries preserved in the Archives de la Manufacture Nationale de Sèvres (F.1 to F.36, R.1 to R.7). They also borrow from material contained in the personnel files of various workers (Ob.1 to Ob.13), as well as from the enrollment register of painters in use until 1758 (Y.8).

Elsewhere, profiting from research done by Svend Eriksen in the parish registers of Vincennes and Sèvres, the author has drawn from Eriksen's 1968 catalogue of the Sèvres porcelains at Waddesdon Manor and from additional unpublished material which that generous scholar has kindly communicated. This information has been supplemented by personal investigation of the same sources.

In the entries that follow, frequent reference is made to work done "en extraordinaire." This term was defined in 1761 as follows: "Le travail extraordinaire a 3 objets differens, 1° les veillées depuis six heures et demie, que le reste de la Manufacture quitte l'ouvrage, jusqu'à neuf heures, 2° le travail des fêtes, 3° le travail des differens morceaux pressés et interessans que quelques peintres ont terminés chez eux hors des heures de travail de la Manufacture" (Archives de Sèvres, F.6, Régie pour le Roy 2° année 1761).

It may be helpful to note here that the date at which the franc replaced the *livre tournois* as the monetary unit of France coincides with the official promulgation of the metric system on April 7, 1795—"18 germinal An III" of the Revolutionary calendar. Theoretically, the value of the franc was one-eightieth lower than that of the livre.

ASSELIN, Charles-Éloi

Paris (?) c. 1743–Sèvres 1804.
Painter of genre scenes and portraits 1765–89; assistant foreman, then foreman of painters until 1804.
Mark: the capital letter A in Roman or script (see p. 276).

Son of Éloi Asselin of Paris,[1] Charles-Éloi entered the Manufacture Royale de Sèvres in May 1765 and continued to work there until the day he died, "le 27 fructidor An XII, Premier de l'Empire français [September 14, 1804] âgé de 61 ans."[2]

His initial salary of 30 livres a month advanced almost yearly until in 1775 it reached 100 livres. After he succeeded Caton as foreman of painters his monthly income rose to 167 francs in 1800, then to 200 francs in 1804.[3]

Asselin exercised his exceptional talent on many important pieces (see pp. 280, 282). In addition to regular studio work he painted a number of porcelains "en extraordinaire," including both modest items and elaborate decorative objects.

The presence at his marriage on February 10, 1774, of Melchior-François Parent, "Conseiller du Roy en sa cour des monnoies Intendant de la Manufacture roialle des porcelaines de france," and Jean-Baptiste-Étienne Genest, "chef des atteliers de Peinture de la Manufacture," attests to the esteem he enjoyed among his superiors. His wife was Marie-Julie Laleu, "fille mineure de Martin Laleu, garde-magasin de la manufacture."[4] She also worked at the factory, in the capacity of a burnisher.

A bust-length pencil sketch of Asselin, drawn in the form of a medallion and attributed to his colleague Pierre-Nicolas Pithou,[5] shows him in profile with swelling forehead, keen eye, hooked nose, finely proportioned mouth, rather prominent jaw, slight double chin, and mid-length hair curled at the ends and pulled back over the neck in a queue in the manner typical of the period. His expression is sprightly.

The Sèvres archives preserve two large gouaches from Asselin's deft brush, both teeming with anecdotal details as they recreate events that took place in 1788.[6] The first is a "fête de nuit donnée dans le parc de la Manufacture en l'honneur du Directeur Antoine Régnier," who had just been decorated with the Order of Saint-Michel. The second shows "la promenade des ambassadeurs de Tipoo-Saïb dans le bas-parc de Saint-Cloud."[7] These scenes, done from life, provide valuable information on the two sites as they appeared in the late eighteenth century, as well as on the costumes worn during that period.

NOTES

1 Information from the parish registers, communicated by Svend Eriksen.

2 Archives de la Manufacture Nationale de Sèvres, Ob. 1.

3 *Idem,* F. 8 to F. 36, R. 1.

4 See note 1, above.

5 Preserved in the Bibliothèque de la Manufacture Nationale de Sèvres, R. 183. Reproduced in M. Brunet, "À propos de la salle à manger de Louis XVI à Versailles," *Revue des Amis suisses de Versailles,* No. 40, 3e trimestre, 1970, p. 32.

6 Both gouaches are reproduced by J. Chauvisé in *Le Cinquantenaire de l'École Normale Supérieure de Sèvres: 1881–1931,* Paris, 1932, facing p. 46.

7 For this see M. Brunet, "Incidences de l'ambassade de Tipoo-Saïb (1788) sur la porcelaine de Sèvres," *Cahiers de la Céramique, du Verre et des Arts du feu,* No. 24, 1961, pp. 275–84.

BOUILLIAT, Edme- (or Étienne-) François, called Bouilliat *père*

c. 1740–Sèvres 1810.
Flower painter 1758–1810.
Mark: the letter *y* (see p. 295).

The spelling adopted here, "Bouilliat," conforms to that which the artist invariably used to sign the factory payrolls, though most other sources give "Bouillat." The peculiarity of the second "i" is confirmed in a statement by Brongniart[1] dated February 17, 1814, written on behalf of the painter's widow and certifying that "la d^e Thévenet veuve Bouilliat est bien la veuve du S^r. Bouilliat, peintre de fleurs à la Manufacture, que la véritable signature de défunt son mari était Bouilliat, ainsi que le constatait tous les états émargés et autres pièces qui sont entre ses mains."[2]

Hired in November 1758 at a monthly salary of 24 livres, Bouilliat won his first increase in January 1759. Regular raises of 3 or 6 livres a year brought his pay to 84 livres in 1775, a high figure for a flower painter, but Bouilliat apparently felt he deserved better and obtained permission to paint on a piecework basis from June 4, 1776, to February 1 of the following year.[3] Having demonstrated thereby that his total earnings during this seven-month period—1,332 livres 15 sols—far surpassed his previous fixed salary, he reappears on the regular payroll in March 1777 at 100 livres monthly. After the Revolution and its accompanying financial upheavals he is found at a salary of 100 francs a month in "l'An IV" (1795–96). He returned to piecework early in the nineteenth century[4] and continued at it until his death "à Sèvres le 26 septembre 1810, âgé de 70 ans passés."[5]

In 1778 Bouilliat received "en extraordinaire" a payment of 96 livres "pour avoir peint à l'huile chez Msgr. le Maréchal prince de Soubise 28 tableaux en fleurs,"[6] a project that was destined to furnish new models to the artists at the factory.

Bouilliat had married in 1768 Geneviève-Louise Thévenet, whose father, Louis-Jean Thévenet, was enrolled at the Manufacture de Vincennes as early as 1741 and numbered among the oldest flower painters at the factory. Through this marriage Bouilliat was related to several of his fellow workers, including the painters Denis Levé and Jacques Fontaine.[7]

Bouilliat's personnel file[8] contains an amusing request, unfortunately not dated, written in rather weak rhymes and addressed "au Citoyen Brongniart" on the subject of his being moved to more suitable quarters. The verses convey his thoughts on the merits of seniority and conclude thus:

> Eh-bien pour guider votre choix
> J'allègue librement les droits
> Que me donnent le long service
> Et de mes yeux et de mes doigts.
> Un vétéran peut quelquefois
> Intéresser moins qu'un novice
> Mais avec mes cadets je crois
> Pouvoir encore entrer en lice.

The request is signed: "J'ai l'honneur d'être Monsieur avec respect votre très humble serviteur Bouilliat."

1 Alexandre Brongniart, director of the Manufacture de Sèvres from 1800 to 1847 (see p. 190).
2 Archives de la Manufacture Nationale de Sèvres, Ob. 2.
3 *Idem,* F. 18, F. 19.
4 *Idem,* F. 4 to F. 37, R. 1, R. 2.
5 *Idem,* Ob. 2.
6 *Idem,* F. 18.
7 S. Eriksen, *The James A. de Rothschild Collection at Waddesdon Manor: Sèvres Porcelain,* Fribourg, 1968, p. 317.
8 Archives de Sèvres, Ob. 2.

CATON, Antoine

Faucogney-et-la-Mer, Haute-Saône, c. 1726–Sèvres 1800.
Figure painter 1749–86; assistant foreman, then foreman of painters until 1798.
Mark: a star made up of three intersecting lines (see p. 200).

Conflicting data in the enrollment register[1] and the factory payrolls have at times resulted in error[2] concerning the date when Caton entered the Manufacture de Vincennes. A former "peintre en tableau," he first appears on the payroll in July 1749 at a salary of 60 livres, brought to 72 livres in September and 80 in October. In January 1753 Caton signed for 100 livres, and in April of the same year for 140 livres "avec sa femme." The two salaries together were increased to 148 livres in 1754 and to 154 livres in 1756, but in 1764 the couple were entered separately at their respective maximums— 100 livres for him as a figure painter and 54 for her as a flower painter. In 1786 Antoine Caton became assistant foreman of painters, and in 1788 he was receiving in this new capacity a monthly income of 123 livres. Promoted to foreman after the death of Genest in 1789, he signed for 150 francs at the end of his career in 1798.[3] He died at Sèvres "le 26 prairial An VIII [June 14, 1800] âgé de 73 ans veuf de [Marie-Catherine Payot]."[4]

In view of Caton's regular appearance on the payrolls beginning in 1749, it is clear that the passage in the enrollment register under the name "Sʳ Caton" stating "il est entré à la Manufacture en avril 1753 aux appointemens de 40 L. par mois" is incorrect. A plausible explanation for this confusion is that it originated with the combining of Caton's 100-livre salary with the 40-livre salary of his wife, which did occur in April 1753.

The promise shown by Caton early in his career—"son genre de talens est la peinture en figure quoy que d'assez faible dessin il employe bien le coloris et laisse des progrès à espérer"—was in fact fulfilled. He painted both soft-paste and hard-paste porcelains including important ornamental pieces, among them several soft-paste Duplessis vases with children and flowers in relief (see p. 200) and a pair of large hard-paste vases decorated with two scenes from the

life of Belisarius now in the Swan Collection at the Boston Museum of Fine Arts.[5]

More fortunate than most of his colleagues, Caton was described flatteringly in the personnel register in 1755: "taille de 5 pieds 2 pouces, maigre, phisionomie assès belle, les yeux Bleux, les cheveux Blonds, assès bien pris dans sa taille."[6] A sketch

done shortly before the end of his career[7] shows him in profile wearing a square-crowned felt hat pulled down in back and front over a thin, expressive face with long nose and determined chin. Nearly half a century of hard work had failed to dim the distinction still evident in his face despite a suggestion of lassitude.

NOTES

1 Archives de la Manufacture Nationale de Sèvres, Y.8, fol. 40.
2 For example, in S. Eriksen, *The James A. de Rothschild Collection at Waddesdon Manor: Sèvres Porcelain,* Fribourg, 1968, p. 319.
3 Archives de Sèvres, F.1 to F.36.
4 *Idem,* Ob.3, copy of Caton's death certificate.
5 P. Verlet, "Some Historical Sèvres Porcelains Preserved in the United States," *Art Quarterly,* XVII, 1954, pp. 230–41. H. C. Rice, "A Pair of Sèvres Vases," *Bulletin of the Museum of Fine Arts, Boston,* LV, No. 300, 1957, pp. 31–37.
6 Archives de Sèvres, Y.8, fol. 40.
7 Bibliothèque de la Manufacture Nationale de Sèvres, R.183.

CHAPPUIS, Antoine-Joseph

Canton of Fribourg, Switzerland, c. 1743–Sèvres 1787.
Acheveur-répareur 1756–61; painter of birds and flowers until 1782; assistant foreman, then foreman of kilns until 1787.
Mark: the letters *cp* (see p. 260).

First designated *le jeune* to distinguish him from his brother, an *acheveur-répareur* who died in 1772, and later himself called *l'aîné,* Antoine-Joseph Chappuis entered the Manufacture Royale at the time it was being transferred from Vincennes to Sèvres. He too was admitted to the studio of *acheveurs-répareurs,* in all likelihood as an apprentice

in view of his tender age and his modest earnings of 9 livres a month from July until December of 1756. Five raises of 3 livres each brought his salary to 24 livres by October 1759, the level at which he remained until he entered the painters' studio in October 1761. In January 1762 his pay was increased by another 3 livres, and afterward came a succession of raises, principally of 6 livres each, until he arrived at 80 livres in January 1780. He became assistant foreman of the kilns, at no change in pay, in October 1782. In April 1784 he reached 90 livres, and a year later 100 livres. Finally in October 1786 he was promoted to foreman of the

kilns at 125 livres, succeeding Millot, who had died the preceding month. He continued working until his own death on July 30, 1787.[1]

This steady progress supports the appraisal made of the young Chappuis on January 1, 1757: "il est entré aprentif à la manufacture et par conséquent sans apointemens,[2] comme c'est un enfant qui donne des espérances on vient de luy accorder 12 L. par mois."[3]

Chappuis was a prolific painter who often worked "en extraordinaire," not only decorating porcelains but also copying models of birds from various paintings (see p. 260).

Little is known of his family or his possible relationship to other painters of the same name who worked at Sèvres.

NOTES

1 Archives de la Manufacture Nationale de Sèvres, F.2 to F.29.

2 This statement is disproved by the 1756 payroll records.

3 Archives de Sèvres, Y.7, fol. 125 (enrollment register of *sculpteurs, mouleurs,* and *acheveurs-répareurs*).

CHOISY, Cyprien-Julien HIREL de

Rennes 1748–Sèvres 1825.
Painter of flowers and ornament 1770–1800; gilder 1803–12.
Mark: a heraldic ermine (see p. 284).

Born in the Breton capital of Rennes on October 18, 1748, Choisy entered the Manufacture Royale in September 1770. He worked there as a painter until 1800, when like many of his colleagues he was dismissed as a part of a broad reduction in staff ordered by the *Ministre de l'Intérieur* pursuant to the "Ordonnance du 25 floréal An VIII" (May 15, 1800) effective "1 prairial An VIII" (May 21).[1] Not yet sixty years of age and therefore ineligible for retirement, he was fortunate enough to be reinstated as a gilder in "l'An XI" (1803) and worked "en extraordinaire" during his last years of activity. In 1812, after forty years of service, he was able to qualify for a pension, which he received from January 1 of that year until his death at Sèvres on March 30, 1825.[2]

Hired in 1770 at 30 livres a month, Choisy received gradual increases of 6 livres each until he arrived at 54 livres in 1778. By 1786 he was earning 60 livres, and he was up to 84 francs at the time of his dismissal in 1800. Afterward his earnings varied between 84 and 100 francs monthly.[3] Choisy was classified as a painter of the third category in 1776 at a time when his salary was modest.[4] His advancement was perhaps slower than that of certain colleagues, and it may be assumed that he was less gifted at rapid execution.

In 1787 Choisy had married Marie-Françoise Chabry, daughter of Jean Chabry, a sculptor at the factory, and sister-in-law of the figure painter Charles-Nicolas Dodin.[5]

A somewhat caricatured profile drawing probably made shortly before the Revolution[6] shows Choisy in a large, soft hat with truncated crown and broad brim turned up at the back, over a long, smiling face with prominent nose, keen eye, protruding jaw, and sketchily indicated hair pulled back at the neck in a queue. His expression is lively.

NOTES

1 Archives de la Manufacture Nationale de Sèvres, R.2, "Etat nominatif des artistes, ouvriers et employés de la Manufacture Nationale de Porcelaines de Sèvres qui, ayant atteints au p[er] floréal an huit leur soixantième année et comptent vingt ans de service, ont été gratifiés d'après une décision du Ministre de l'Intérieur en datte du 25 floréal an huit, d'une gratification annuelle à datter du p[er] prairial dit an, époque de leur licenciement...."

2 *Idem*, Ob.3.

3 *Idem*.

4 A. Jacquemart and E. Le Blant, *Histoire artistique, industrielle et commerciale de la porcelaine*, Paris, 1862, p. 511.

5 Information communicated by Svend Eriksen. See also Eriksen's entry on Chabry in *The James A. de Rothschild Collection at Waddesdon Manor: Sèvres Porcelain*, Fribourg, 1968, p. 320.

6 Photograph in the Bibliothèque de la Manufacture Nationale de Sèvres, R.183. Reproduced in *Les Porcelainiers du XVIIIe siècle français*, Paris, 1964, p. 21.

COMMELIN, Michel-Gabriel

Fresnoy-le-Grand, Aisne, c. 1747–
Sèvres 1802.
Painter of flowers and ornament 1768–1802.
Mark: the letters *cm* (see p. 296).

Born in the Thiérache region near Saint-Quentin, Commelin entered the Manufacture de Sèvres in 1768, "à l'âge de 21 ans,"[1] as a painter of flowers and ornament. He worked there without interruption until 1800, when he was dismissed for the same reasons as Choisy.[2] He died at Sèvres on "14 germinal An X" (April 5, 1802).

Hired at 12 livres a month, Commelin received regular increments of 6 livres each until by July 1774 he had reached 48 livres. Like his colleague Bouilliat he switched to piecework in June of 1776, earning over an indeterminate period a total of 1,149 livres and thereby justifying, evidently, a sizable increase in his fixed salary. He reappears on the regular payroll in 1778 signing for 60 livres a month, and he subsequently climbed in stages to 75 livres. After 1795 he fell back to 56 francs 25 centimes, but he was up to 84 francs at the time of his dismissal in 1800.[3] Some time later he requested the position of painter left vacant by the promotion of Asselin to foreman of painters replacing the late Caton. He benefited only briefly from the

appointment "accordé le 1 vendémiaire An X" (September 23, 1801), for he died the following April. A note by Brongniart preserved in Commelin's file judges him rather harshly: "faible de talent, travaillait avec facilité."[4]

In 1773 Commelin had married Marie-Antoinette Bulidon, daughter of a sculptor at the factory, and through this marriage became brother-in-law to the painters Nicolas Bulidon and François-Joseph Aloncle.[5] On April 15, 1817, Madame Commelin, aged and impoverished, petitioned for a pension, which was denied by Brongniart on the technical grounds that at the time of his dismissal Commelin had not yet reached the mandatory age of sixty, despite his thirty-one years of service to the factory.[6] Under these circumstances the widow's lot seems all the more pitiable.

A profile sketch from the same series as that of Choisy[7] shows Commelin bareheaded, with high, swelling forehead, eye set deep beneath the brow, nose hooked, mouth shrunken apparently by the loss of teeth, a slight smile accentuating the folds of his cheek. His hair is drawn back to reveal the ear and is gathered over the neck by a bow. A lace ruffle protruding from between the double lapels of a coat decorated with oversized buttons adds to his distinguished air and stamps him as somewhat of a dandy.

NOTES

1 Archives de la Manufacture Nationale de Sèvres, Ob.3.
2 *Idem,* R.1.
3 *Idem,* F.10 to F.36.
4 *Idem,* Ob.3.
5 S. Eriksen, *The James A. de Rothschild Collection at Waddesdon Manor: Sèvres Porcelain,* Fribourg, 1968, p. 322.
6 Archives de Sèvres, Ob.3.
7 Photograph in the Bibliothèque de la Manufacture Nationale de Sèvres, R.183. Reproduced in *Les Porcelainiers du XVIIIe siècle français,* Paris, 1964, p. 21.

LE DOUX, Jean-Pierre

b. Paris 1735.
Painter of birds and landscapes 1758–61.
Mark: generally assumed to be a crescent (see p. 232).

"Né à Paris, Paroisse Saint-Sauveur" in 1735, Le Doux entered the factory on April 7, 1758, "pour peindre le Païsage et les oiseaux." Previously "il peignait le tableau."[1] His stay at Sèvres was brief, and he left in January of 1762.

Eriksen[2] suggests: "In all probability he is the Jean-Pierre Ledoux, who became a member of the *Académie de Saint-Luc* and who was still active as a painter in 1786, having his studio in the rue Saint-Martin in Paris."

Hired in 1758 at 30 livres, he received his first increase only three months later. By January 1759 he had reached 42 livres, a salary he would continue to draw until his last month, December 1761.[3]

In the enrollment register he is described as having "taille de 5 pieds 3 pouces, les yeux et les cheveux bruns, le nez bien fait, le visage ovale d'un grand air de douceur, les jambes fortes."[4]

Uncertainty exists on the subject of his mark (see p. 236), inasmuch as the crescent attributed to him also appears on pieces dated prior to 1758. No document has yet been found to resolve this inconsistency.[5]

NOTES

1 Archives de la Manufacture Nationale de Sèvres, Y.8, fol. 111.
2 S. Eriksen, *The James A. de Rothschild Collection at Waddesdon Manor: Sèvres Porcelain,* Fribourg, 1968, p. 329.
3 Archives de Sèvres, F.4 to F.6.
4 *Idem,* Y.8, fol. 111.
5 The mark of Le Doux does not figure among the numerous marks inscribed in the register of work done by painters

(Archives de Sèvres, Vj'2, 1780–1783), which includes both contemporary decorators and some who had worked at the factory in previous years. In any event, the marks in the register, which are clearly drawn by the same hand and not by the painters themselves, are sometimes rather different from those that actually appear on porcelains done by the same artists.

LEVÉ, Denis

Saint-Germain-en-Laye 1730–d. 1816.
Painter of flowers and ornament 1754–1800.
Mark: the capital letter L in Roman or script (see p. 206).

A former clerk, Levé studied design in order to enter the Manufacture de Vincennes, to which he was admitted in August 1754. An appraisal of his work made the following year expressed some reservation: "son genre de talens est la peinture en fleurs qu'il possède médiocrement et peut encore faire des progrès." But by 1757 he was considered "dans son genre de travail, le plus expéditif de l'attelier,"[1] a judgment supported by the rapid and steady growth of his salary.

He received 30 livres for his first month's work, then 33 and 36 livres for each of the two months following. Four additional increases of 3 or 6 livres raised his pay to 54 livres by August 1755. After this, three yearly increments of 6 livres each, followed by two others at greater intervals, brought him by January 1773 to 84 livres, the sum he continued to draw until the Revolution. In 1800, when he was receiving a monthly salary of 90 francs, he was dismissed pursuant to the "Ordonnance du 25 floréal An VIII" (see p. 326). Because he was over sixty and had worked at the factory more than twenty years, he received an annual pension of 500 francs until his death on November 7, 1816.[2]

Levé had married in 1755 a "fille du S^r Thévenet,"[3] sister of the future Madame

Bouilliat.[4] The poverty in which the couple spent their declining years elicited the compassion of Brongniart, who in 1808 wrote to an unidentified correspondent: "les services, le grand âge, la bonne conduite, les malheurs non mérités, donnent droit à la bienveillance de toutes les personnes attachées au gouvernement et qui sont dans le cas de lui être utile."[5]

The artist had no doubt aged greatly since he was described in 1755—"taille de 5 pieds, gros et rablé, cheveux bruns"—but he may still have retained "la vüe basse et la voix rauque."[6]

NOTES

1 Archives de la Manufacture Nationale de Sèvres, Y.8, fol. 82.
2 *Idem*, F.2 to F.37, R.1 to R.7.
3 *Idem*, Y.8, fol. 82.
4 S. Eriksen, *The James A. de Rothschild Collection at Waddesdon Manor: Sèvres Porcelain,* Fribourg, 1968, p. 317, entry on Bouilliat.
5 Archives de Sèvres, Ob.7.
6 *Idem*, Y.8, fol. 82.

MICAUD, Jacques-François

Villeneuve d'Aumont, Jura, c. 1735–Sèvres 1811.
Flower painter 1757–1811.
Mark: a Saint Andrew's cross (see p. 256).

Micaud was born in the Franche-Comté bailiwick of Salins and entered the Manufacture de Sèvres in 1757 at the age of twenty-two, "avec un commencement de dessin qui promet et des témoignages surs qui l'annoncent comme un garçon sage."[1]

Hired at 30 livres a month, he received raises of 6 livres annually up to 1769, then less regularly until in 1774 he reached 100 livres, a high salary for a flower painter. His talents were considered sufficiently indispensible to prevent his being among those dismissed in the staff reduction of 1800 (see p. 326). He continued at the factory doing piecework until 1810, averaging a monthly income of 100 francs, then 125.[2] His application for a pension, dated January 1, 1811, hardly had time to take effect; he died on April 20, just six days after the death of his wife.[3]

In the course of over half a century of service, Micaud decorated a number of exceptional pieces (see p. 258). His name appears often in the lists of work done "en extraordinaire" in connection with a wide variety of objects. The copies he made after paintings are as highly regarded today as they were in his own time.

When he joined the factory in 1757 Micaud was described as "de visage ovale brun et marqué de petite vérole. Les yeux bruns, le front élevé, portant ses cheveux châtains et graseyant beaucoup." It was also noted that he always held "la tête beaucoup penchée sur l'épaule droite."[4] A

portrait of Micaud at an advanced age, from the same series as those of Choisy and Commelin,[5] shows him wearing a three-cornered hat adorned with a cockade. His ravaged, emaciated face appears to retain the smallpox scars recorded earlier.

NOTES

1 Archives de la Manufacture Nationale de Sèvres, Y.8, fol. 99.
2 *Idem,* F.4 to F.37, R.1 to R.4.
3 *Idem,* Ob.8.
4 *Idem,* Y.8, fol. 99.
5 Photograph in the Bibliothèque de la Manufacture Nationale de Sèvres, R.183. Reproduced in *Les Porcelainiers du XVIII^e siècle français,* Paris, 1964, p. 21.

MORIN, Jean-Louis

Vincennes 1732–Sèvres 1787.
Painter of children, military subjects, and marine scenes 1754–87.
Mark: the capital letter *M,* generally in script (see p. 290).

Born at Vincennes on October 5, 1732, the son of an army surgeon,[1] Morin, who "avant d'entrer à la Manufacture le 13 May 1754 apprenait la chirurgie," made an unencouraging first impression: "son dessein est passable quoy que faible dans l'employ de ses couleurs et laisse fort peu de progrès à espérer." Beginning in 1755 he had "commencé à peindre des enfans colorés et ses essais promettent." Finally, the initial judgment was revised in 1758: "son talens et son produit sont augmentés."[2]

Hired in 1754 at 24 livres a month, Morin received a raise of 6 livres that August. Similar increases followed annually until he reached 54 livres in 1759, and after an interruption of three years the same progress recommenced. By 1765 he had arrived at 78 livres, but it was not until eight years later, in January 1773, that he reached the level of 84 livres at which he remained until his death on September 2, 1787.[3]

In the course of a fruitful career Morin quickly abandoned paintings of children to devote himself to occasional genre scenes after David Teniers and especially to military and marine subjects (see p. 294). The models from which he drew his inspiration remain uncertain.[4] He often worked "en extraordinaire," and seems to have been particularly active in 1768–69. His wife was also a painter at the factory.

The description of Morin set down when he entered the Manufacture de Vincennes suggests that his physical appearance would have been a liability in any field of endeavor: "taille de 5 pieds 1 pouce cheveux roux, Les yeux louches et presque tous blancs les couleurs hautes et taché de roux. portant perruque, vilaine physionomie et mal baty."[5] In view of these handicaps, the triumph of his talent seems all the more praiseworthy.

NOTES

1 S. Eriksen, *The James A. de Rothschild Collection at Waddesdon Manor: Sèvres Porcelain,* Fribourg, 1968, pp. 332–33.
2 Archives de la Manufacture Nationale de Sèvres, Y.8, fol. 75.
3 *Idem,* F.2 to F.29.
4 Eriksen (*loc. cit.*) makes some interesting proposals.
5 Archives de Sèvres, Y.8, fol. 75.

PRÉVOST

Four artists with the surname Prévost worked at Vincennes and Sèvres during the eighteenth century. The first two, Prévost *l'aîné* and Guillaume Prévost *le jeune,* figure as painters in the payrolls covering the period 1754–60. If it seems likely that they were brothers,[1] their relationship to a third painter named Prévost who appears fleetingly in 1763–64 remains to be defined. The same problem of relationship arises with the gilder Prévost, who must certainly have participated in the decoration of the Frick water jug and basin with marine scenes (see p. 290). Such serious authors as Chavagnac and Grollier[2] make of Prévost *l'aîné* and the gilder Prévost one and the same person, "ancien éventailliste descendant des Chicaneau[3] entré en 1754 comme peintre de fleurs, passé à la dorure en 1759. Doreur de première classe en 1780...." But this claim is contradicted by the fact that during the period between October 1757 and November 1758 there were three Prévosts signing the payrolls simultaneously —one a gilder salaried at 40 livres a month, and the other two painters: Prévost *l'aîné,* who climbed from 57 livres in July 1757 to 63 livres in January 1758; and Prévost *le jeune,* who over the same period saw his salary rise from 39 to 45 livres. Prévost *l'aîné* disappears from the rolls in November 1758 "moins 7 jours" and Prévost *le jeune* in May 1760. During this time the salary of the gilder Prévost remained stationary at 40 livres. It is difficult to imagine Prévost *l'aîné* agreeing to abandon a salary of 63 livres as a painter in order to accept 40 livres as a gilder. It happens that the Henry-Marin Prévost who attended the marriage of the painter Denys Bienfait at Sèvres on August 23, 1768, is identified as "doreur à la Manufacture."[4] His signature in the parish register conforms to that found on the factory payrolls for the same year.

NOTES

1 Archives de la Manufacture Nationale de Sèvres, Y.8, fols. 84, 100.
2 Comte X. de Chavagnac and Marquis de Grollier, *Histoire des manufactures françaises de porcelaine,* Paris, 1906, p. 348.
3 The Chicaneau family managed the porcelain factory at Saint-Cloud.
4 Reference supplied by Svend Eriksen and completed by the author.

332

PRÉVOST, Henry-Marin

c. 1739—Sèvres 1797.
Gilder 1757–97.
Mark: the initials HP in Roman capitals (see p. 290).

Little is known concerning the life of the gilder H.-M. Prévost, who entered the factory in October 1757 at a monthly salary of 40 livres. After an unexplained delay he received regular increases each year beginning in 1764, arriving at 60 livres in 1769 and gradually climbing to 78 livres by the end of 1776. In April 1786 he reached his maximum of 84 livres.[1] He remained active until his death in December 1797 at the age of fifty-eight.[2]

That Prévost gilded a large number of works is attested to by the relative frequency of his mark, the initials HP. After 1780 in particular this mark is found associated with those of the best painters at the factory (see p. 294).

Prévost's widow, who received no pension after her husband's death, eventually found herself destitute, and on August 8, 1818, she wrote to Brongniart from Saint-Cloud requesting help, explaining in poignant terms that up until that time "ayant pu me soutenir par mon travail, je n'ai point voulu vous importuner mais maintenant mon grand âge—82 ans—et mes infirmités m'empêchent de continuer et je me trouve dans la plus affreuse misère."[3] A note in Brongniart's hand indicates that he did what was necessary to ease her plight.

NOTES

1 Archives de la Manufacture Nationale de Sèvres, F.4 to F.32.

2 *Idem,* Ob.9.
3 *Idem.*

SECROIX, see XHROUUET, Marie-Claude-Sophie and Philippe

TAILLANDIER, Vincent

Sceaux c. 1737–Sèvres 1790.
Flower painter 1753–90.
Mark: a fleur-de-lis (see pp. 214, 243).

Though still a boy when he entered the Manufacture de Vincennes in August 1753, Taillandier[1] had already been employed by the porcelain works at Sceaux. At Vincennes his future was considered promising: "Son genre de talen est la peinture pour les petits objets qu'il possède passablement bien.... Il laisse beaucoup de progrès à espérer."[2] With this in mind it is not surprising to see his salary grow at a rapid rate, despite an unfortunate experience that befell him together with his colleague the painter Vavasseur.[3]

From 30 livres a month in August 1753

he rose to 36 in September, 42 in November, and 48 in January of 1754. Additional increases brought him to 54 livres in January of 1755, 60 livres that July, 66 in September, then 72 in January of 1756. In January 1757, at the age of about twenty, he had already reached 78 livres, a high figure for a flower painter. But having attained this level he was obliged to wait until 1770 to arrive at his maximum of 80 livres, the salary which he continued to draw until he died on April 22, 1790.[4]

Taillandier's wife was the painter Geneviève Le Roy,[5] who worked at Sèvres both before and after her husband's death and was often employed in executing the *fonds Taillandier* that were in all likelihood named after their inventor. This term applies to a colored ground interrupted by very small, closely spaced white reserves each surrounded by tiny dots of gold or another color and marked at the center with a more prominent dot. A pink ground of this type borders the nine Sèvres plaques painted with strewn roses and cornflowers mounted into a small reading- and writing-table in The Frick Collection (No. 15.5.62), the work of the *ébéniste* Martin Carlin. The same sort of ground is seen in blue framing a floral bouquet on a large plaque painted by Bouilliat mounted into the drop front of a *secrétaire* in the Metropolitan Museum of Art, New York.[6] It is also found in green forming decorative bands on a dinner service painted with birds after Buffon in the Musée Nissim de Camondo, Paris;[7] a plate with similar decoration is in the Musée de Sèvres.[8]

Depicted more favorably than many of his colleagues when he entered the factory, Taillandier, who had yet to reach maturity, measured "5 pieds 1 pouce... assez bien baty, le visage rond taché de roux, fort maigre, les yeux petits. Cheveux châtains toujours en queue."[9]

NOTES

1 S. Eriksen (*The James A. de Rothschild Collection at Waddesdon Manor: Sèvres Porcelain,* Fribourg, 1968, p. 336) adopts the spelling "Taillandiez," interpreting the final flourish of the artist's signature on the payrolls as a "z" but without elaborating.

2 Archives de la Manufacture Nationale de Sèvres, Y.8, fol. 66.

3 *Idem,* fol. 57, entry on Vavasseur. See M. Brunet, "La Manufacture Royale de Sèvres," *L'Oeil,* No. 63, March 1960, p. 68.

4 Archives de Sèvres, Vj'5, fol. 202.

5 Eriksen, *loc. cit.*

6 C. C. Dauterman, in *Decorative Art from the Samuel H. Kress Collection,* London, 1964, No. 28, Fig. 123, p. 157.

7 No. 292.

8 P. Verlet, S. Grandjean, and M. Brunet, *Sèvres,* Paris, 1953, I, Pl. 100d and pp. 224–25.

9 Archives de Sèvres, Y.8, fol. 66.

TANDART, Jean-Baptiste, called Tandart *l'aîné*

Montcornet 1729—d. 1816.
Flower painter 1754–1800.
Mark: three dots in a row (see pp. 296, 298).

Born October 26, 1729, Jean-Baptiste Tandart worked as a fan painter before entering the Manufacture de Vincennes in April 1754. Hired at a monthly rate of 30 livres, he won an increase of 9 livres in September. Annual raises of 3 or 6 livres continued until October 1759, by which time he had reached 66 livres. Similar advances followed in January of 1763 and 1764, then again in 1770 and 1773 when he attained his maximum of 84 livres.[1] This high salary for a painter in his category supports the appraisal of his work entered in the personnel register in 1755: "se perfectionne journellement."[2]

In 1800 Tandart, like his colleague Levé, having passed the age of sixty and spent more than twenty years at the factory, was retired with an annual pension of 500 francs,[3] a sum he received until his death on April 2, 1816.

Tandart often did supplementary work "en extraordinaire," including wreaths "de roses et barbeaux" of the type that appear on the reverse of a pair of *vases à panneaux* in the Metropolitan Museum of Art, New York.[4]

In 1757 he had married Catherine-Josèphe Prisette, widow of his late colleague the painter Pierre Houry.[5]

More fortunate than most of his fellow workers, Tandart was described in favorable terms when he entered Vincennes: "bien fait, la physionomie fort douce, portant perruque ronde."[6]

NOTES

1 Archives de la Manufacture Nationale de Sèvres, F.2 to F.22.
2 *Idem,* Y.8, fol. 71.
3 *Idem,* R.1 to R.7.
4 C. C. Dauterman, in *Decorative Art from the Samuel H. Kress Collection,* London, 1964, No. 45a–b, Figs. 164–65, pp. 215–16.
5 S. Eriksen, *The James A. de Rothschild Collection at Waddesdon Manor: Sèvres Porcelain,* Fribourg, 1968, p. 336.
6 Archives de Sèvres, Y.8, fol. 71.

VIELLIARD, André-Vincent

Paris c. 1718–Sèvres 1790.
Painter of children, landscapes, and symbolic attributes 1752–90.
Mark: a heraldic label (see p. 209).

The spelling "Vielliard," already adopted by Eriksen,[1] conforms to the signature invariably used by the artist to sign the factory payrolls. Other sources generally spell the name "Vieillard."

André-Vincent Vielliard, who like Tandart had formerly been a fan painter, entered the Manufacture de Vincennes in September 1752 at a far more advanced age than most of his

colleagues. Hired at 30 livres, he received only two months later an advancement of 18 livres at a single step, followed by additional raises of 6 livres each in January, July, and October of 1753. This rapid progress began to abate in January 1754 after he had reached 80 livres, and in September 1755 he attained the maximum of 84 livres he would continue to draw for the remainder of his life. His career, brilliantly launched and faithfully pursued, ended with his death on June 8, 1790.[2]

The praise of his ability inscribed in the enrollment register—"son genre de talen est la peinture qu'il possède fort bien pour les fonds de paysages"—was tempered by the observation: "dessinant mal la figure, laissant peu de progrès à espérer."[3] The latter factor may explain why his salary eventually stagnated, despite the extraordinary speed with which he was credited in the register on January 1, 1756: "Vieillard produit plus d'ouvrage qu'aucun des peintres de l'attelier... il a eu 4 L. d'augmentation." His diversified talents and productivity assured him, nevertheless, a choice place among the painters at the factory. In addition to the children he depicted at the start of his career, to the landscapes which he often animated with tiny figures, and to his artful arrangements of garden tools and accessories—all of which appear on the Frick *vase hollandais* of 1755 (p. 209)—he was also responsible for genre scenes in the manner of David Teniers (see p. 250) and for various compositions employing attributes.

Already married when he entered the factory, Vielliard had a son, probably Pierre-Joseph-André, who also worked at Sèvres as a painter. Through the remarriage of his mother, who had been widowed at an early age, André-Vincent was the half brother of Étienne Evans, a painter of birds who was hired at Vincennes the same year he was.[4]

The description of Vielliard recorded when he entered the factory at the age of thirty-four was hardly complimentary: "Figure peu intéressante, teint et cheveux noirs."

NOTES

1 S. Eriksen, *The James A. de Rothschild Collection at Waddesdon Manor: Sèvres Porcelain,* Fribourg, 1968, p. 338.
2 Archives de la Manufacture Nationale de Sèvres, F.1 to F.30.
3 *Idem,* Y.8, fol. 55.
4 Eriksen, *loc. cit.*

XHROUUET, Marie-Claude-Sophie

Sèvres 1757–Sèvres 1788.
Burnisher and flower painter 1772–88.
Mark: tentatively attributed here with the letters *m:x* (see p. 298).

Daughter of Philippe Xhrouuet (see next entry), Marie-Claude-Sophie was born November 6, 1757,[1] and entered the Sèvres burnishing studio at the age of fifteen in

336

December 1772, salaried at 24 livres monthly. In May 1774 she was working in the *petit atelier de couleur,* and in July she moved to the *grand atelier de peinture* at no change in pay. In 1776 she received a total of 276 livres for piecework, followed by 569 livres 10 sols in 1777 and 771 livres in 1778, an uncommon progression which suggests that the young woman, orphaned at eighteen and the eldest child of the family, was attempting by the utmost exertion to provide for her brothers and sisters. The figures leave little to the imagination. In January 1779 she was paid 54 livres for work "en extraordinaire." Then in February she appears in the *atelier des desmoiselles* at a salary of 27 livres monthly, which she drew until the end of the year. Inexplicably her pay dropped to 21 livres a month in January 1780. It rose to 24 livres in March 1782, 27 livres toward the end of 1784, and 30 livres in April 1785, but she never exceeded the latter figure.[2]

She also continued to paint "en extraordinaire," and in July 1788, two months before her death, she earned 15 livres in this capacity for decorating "douze assiettes lyres."[3] But beginning the same month she no longer signed the payrolls herself, and on September 8 she died. The payroll was signed by her colleague Lebel, who added the notation "morte."

The surname of Marie-Claude-Sophie as it was inscribed on the payrolls appears variously as "Melle. Secroit," "Melle. Secoitte," and "Melle. Xhrouet." The signature with which she countersigned the rolls also varies considerably, even more than her father's, though it stabilized toward the end of her career at "xhrouwet." If her handwriting is studied it will be noted that when the initial "x" is used it is invariably small and never capitalized. This peculiarity, taken together with the coincidence in dates, suggests that the mark made up of the small letters *m* and *x* separated by a colon may stand for Marie Xhrouuet, and that the mark could, with all due reservation, be tentatively attributed to her.

NOTES

1 Communicated to the author by Svend Eriksen.

2 Archives de la Manufacture Nationale de Sèvres, F.14 to F.30.

3 *Idem,* F.30.

XHROUUET, Philippe

Beauvais c. 1726–Sèvres 1775.
Painter of flowers and ornament 1750–75.
Mark: a Maltese cross.

The spelling of this unusual name is extremely variable. The form adopted here, "Xhrouuet," is that which the artist used most often to sign the factory payrolls and the parish registers.[1] Other sources generally spell the name "Xhrouet." In the Sèvres archives, however, the painter is frequently designated, especially at the beginning of his career,

337

under the name "Secroix," or simply "Croix." The strange consonance of the name "Xhrouuet" has led to the somewhat hasty conclusion that it was perhaps a nickname resulting from a mispronunciation of the name "Secroix." Eriksen,[2] without directly refuting this opinion, expresses doubt that a sobriquet would have been accepted as a signature on important entries in the parish registers, which in the eighteenth century constituted official documents. But there is evidence to suggest that during this period sobriquets often served as legal names. A letter dated April 12, 1760, from M. de Courteille, *Conseiller d'État* and *Intendant des Finances,* to Boileau de Picardie, director at Sèvres, recalls the terms of a decree passed by the Council the previous February 17 (see p. 187) relative to the administration of the plant, and instructs Boileau: "Je vous recommande singulièrement et par préférence l'état général des noms et surnoms de tous les artistes, chefs d'Atteliers, ouvriers domestiques, employés pour la Manufacture."[3] This list, which might resolve the problem, has yet to be recovered.

Elsewhere, Eriksen[4] has called attention to several entries in Thieme-Becker[5] concerning a family of artists named Xhrouet from the Belgian town of Spa. Its genealogy has been established by Berger,[6] but without indicating the precise lines of kinship to a certain Lambert Xhrouet (1703–81) who is identified as follows: "fut un tourneur célèbre, qui confectionna des objets miniatures (services de table et à thé etc.). Il fut invité à Vienne en 1748, par l'Empereur François 1er et à Paris en 1757 par le Duc d'Orléans."[7] It happens that the records of the marriage

in Paris on November 11, 1755, of Philippe Xhrouuet, painter at the Manufacture de Vincennes, refer to him as "fils de Lambert Xhrouet, marchand à Beauvais."[8] Whether the Lambert Xhrouet "marchand à Beauvais" and the Lambert Xhrouet "tourneur célèbre" were one and the same person has yet to be determined.

Writing in 1870 on the subject of the name "Xhrouet," Davillier[9] noted: "Je rétablis l'orthographe de ce nom assez singulier d'après celle du nom d'un libraire de Paris, son contemporain et sans doute aussi son parent, nom que je trouve sur une édition de Marmontel." Though this mention throws no light on the nature of the presumed relationship, taken together with the preceding information it does argue in favor of "Xhrouet" as a surname and not a sobriquet.

Whatever the case, Philippe Xhrouuet, who had previously worked as a decorator of fans, entered the Manufacture de Vincennes in February 1750 at a monthly salary of 40 livres. His pay was increased by 10 livres in March and again in April, by another 6 livres in August of the same year, then reached 72 livres in April 1751 and 75 livres the following October. In January 1753 Xhrouuet was earning 80 livres, the level at which he would remain until he died on December 20, 1775, barely six months after the death of his wife.[10]

As has already been noted (see p. 192), an unusual entry in the personnel register dated January 1, 1758, credits Xhrouuet with the discovery of "un fond couleur de rose très frais et fort agréable."[11] This pink ground is in all likelihood that which has subsequently acquired the erroneous names "rose Pompa-

338

dour" and even, against all logic, "rose Du Barry," terms which are given no sanction whatever in contemporary factory records.

No doubt to improve the lot of his large family, Xhrouuet did a considerable amount of work "en extraordinaire," painting a wide variety of pieces including several decorated "en frises riches."[12] His eldest daughter also worked at Sèvres (see preceding entry).

The description of Xhrouuet recorded when he entered Vincennes is hardly encouraging: "visage pâle, cheveu châtain, portant perruque... son genre de talens est la peinture en Païsage qu'il ne possède que médiocrement dessinant mal et ne laissant aucun progrès à espérer."[13] To judge from the exceptional rapidity of his advancement, Xhrouuet must have been able to compensate for his apparent shortcomings with other qualities.

NOTES

1 All citations of the parish registers in this entry have been either extracted from S. Eriksen, *The James A. de Rothschild Collection at Waddesdon Manor: Sèvres Porcelain,* Fribourg, 1968, p. 339, or communicated by Eriksen directly to the author.

2 In correspondence with the author.

3 Archives de la Manufacture Nationale de Sèvres, H.1. This order figured as Article XI of the decree of February 17 (*idem,* Y.3, miscellaneous).

4 In correspondence with the author.

5 U. Thieme and F. Becker, *Allgemeines Lexikon der Bildenden Künstler,* Leipzig, XXXVI, 1947, p. 334.

6 J. Berger, *La Famille Xhrouet à Spa,* Brussels, 1947.

7 Communicated by Pierre Baar of Spa.

8 Eriksen, *Rothschild Collection, loc. cit.*

9 Baron C. Davillier, *Les Porcelaines de Sèvres de Madame du Barry,* Paris, 1870, p. 2, note 1.

10 Archives de Sèvres, F.1 to F.17. Eriksen, *Rothschild Collection, loc. cit.*

11 Archives de Sèvres, Y.8, fol. 44.

12 *Idem,* F.10, F.11.

13 *Idem,* Y.8, fol. 44.

INDEX

INDEX TO FRENCH POTTERY
AND PORCELAINS

346

CONCORDANCE

CONCORDANCE OF ACCESSION NUMBERS, TITLES AND PAGE NUMBERS

Note: The objects are listed by year of acquisition. The last digits of the accession numbers following the second period are identical to the numbers under which the same pieces were published in the folio catalogue of 1955, *An Illustrated Catalogue of the Works of Art in the Collection of Henry Clay Frick* (VIII). Oriental porcelains with accession numbers having final digits over 58 and French porcelains ending with numbers over 46 were not included in the folio catalogue.

ORIENTAL PORCELAINS

1915

FRENCH POTTERY AND PORCELAINS

1916

1918

1934